Bonnard

the complete graphic work

Bonnard

the complete graphic work

Francis Bouvet

introduction by Antoine Terrasse

with 536 illustrations, 60 in color

Rizzoli
NEW YORK

The list of contents for this volume appears on page 351

Translated from the French by Jane Brenton

First published in the United States of America in 1981
by Rizzoli International Publications Inc,
712 Fifth Avenue, New York, NY 10019

ISBN: 0-8478-0403-8
LC: 81-51311

Printed and bound in Switzerland

Introduction

When Pierre Bonnard's poster advertising the products of *France-Champagne* first appeared on the walls of Paris in March 1891, it so delighted Henri de Toulouse-Lautrec that he pointed it out with his stick to passers-by, and promptly announced his intention to try his own hand at poster-making. In 1896, when Renoir saw Bonnard's illustrations for Peter Nansen's book *Marie*, he at once wrote to Bonnard: 'You have a distinct quality of charm. Do not neglect it. You will encounter better painters than yourself. But yours is a precious gift ...' And Cézanne, when in 1900 he came across the lithographs for Verlaine's *Parallèlement*, asked the publisher Ambroise Vollard: 'Who is it by? It is the work of a draughtsman.' Evidently Bonnard, known today primarily as a colourist, made his reputation initially as an illustrator and lithographer. One can see how *France-Champagne* must have stood out amongst the gaudy posters of Jules Chéret, by virtue not only of its ingenious composition and bold distortions, but also its use of flowing lettering in free brushwork to contrast with the printed legend, and, above all, its restricted range of colour and subtle effects of black against the background. In 1908, Octave Mirbeau pin-pointed the importance at the time of this poster by an unknown artist. 'The first poster-print since Daumier to burst triumphantly onto the walls of Paris, a complete departure from the prettily coloured effusions of Chéret, *France-Champagne*, now unobtainable, is the work of Bonnard. It brought about a revival of the art of lithography – which Toulouse-Lautrec was to develop to such a degree of sophistication and skill.' It was Bonnard himself who took Lautrec to see his printer, Ancourt; then, acknowledging his genius, he virtually abandoned the field to him. In the course of a career far longer than Lautrec's, Bonnard was to produce no more than a total of ten posters.

It would however be quite wrong to deduce from this that Bonnard was a draughtsman *manqué* rather than a painter. That was far from being the case. But it is true that he embarked on his career in the company of a group of young artists who, half-seriously, half in jest, gave themselves the title of Nabis, or prophets, and that Bonnard shared with them a love of the painting of Gauguin, which they wanted to introduce to a wider public, and a desire to find a decorative application for the art of painting. 'Our generation', Bonnard was to say, 'always sought to link art with life. At that time I

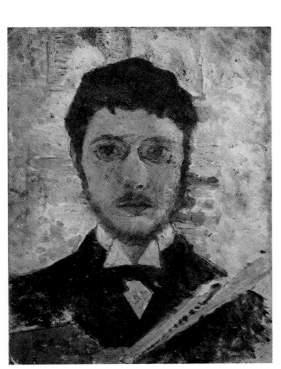

Pierre Bonnard, self-portrait
Oil on cardboard, 1889
Paris, private collection

personally envisaged a popular art that was of everyday application: engravings, fans, furniture, screens . . .' In holding such views he was indistinguishable from the companions of his early years – Edouard Vuillard, Ker-Xavier Roussel, Maurice Denis, Paul Sérusier, Paul Ranson, Gabriel Ibels, René Piot; also Félix Vallotton (who introduced his work in Switzerland), and Aristide Maillol, Georges Lacombe and Rippl-Ronaï, all later associates of the group. Hungry for new forms of expression, they discovered together Van Gogh, Monet, Pissarro, Redon, Seurat, Cézanne. Gauguin's example was their sanction for 'lyricism': using pure colours and experimenting delightedly with line, they explored between them all possible variations of a new manner of painting. Hence the proliferation of small panels, often disproportionately long or wide, unconventional in composition and using bright colours contained within a heavy outline; the motif tends to look like the enlargement of a detail from some bigger picture, while the exaggerated effects of checks and diamonds and the swirling lines reflect the decorative concerns of the time.

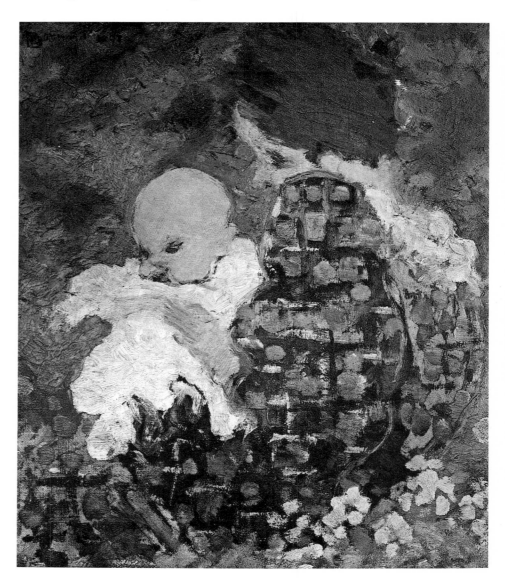

Mme Claude Terrasse and her son Jean
Oil, 1893
United States, private collection

In 1891, Pierre Bonnard was still only twenty-four. Already, as Maurice Denis wrote to Sérusier, he was 'inventing new rhythms and subtle harmonies'. Indeed, it was these new rhythms that made his drawings so striking right from the start. Long before he developed an individual use of colour, he had perfected a style particularly designed to express mobility. 'The painter's art', he was to say, 'gives objects a human value and reproduces things as the human eye sees them. This vision is changing and it is mobile.' Whether commas, dots or swirls, all the notations he invented express the rhythm of life itself, and also the way the thing observed is continually modified by the act of seeing. If he sometimes used a form of expressive simplification it was because of the influence of Japanese prints, an exhibition of which was held at the Ecole des Beaux-Arts in April 1890. There are two small lithographs by Bonnard which bear the common title *Family Scene* (one an upright format, the other horizontal), and these illustrate the extent of his debt at that time to Japanese techniques – the asymmetrical composition, use of figures in close-up standing out in profile against a monochrome ground, economical lines which taper or splay out to suggest modelling, minute detailing of a textile motif, and, once

6

Claude Terrasse and Franc-Nohain
Pencil, *c.* 1900
Paris, private collection

Sketch for The Laundry-Maid
Pencil, 1896
United States, private collection

again, the subtle effects of black or patches of dark colour. But where the Japanese would pin down a movement within a firm outline – whether that of a wrestler in action or a courtesan arranging her hair – Bonnard wanted to show the movement *in movement*, as though with a gesture; before long he was supplementing or replacing precise and economical lines with others far more tentative. To illustrate the *Petites scènes familières*, by his brother-in-law the composer Claude Terrasse, he created a series of lithographs which abound in verve and spirit – often highly appropriate to the subject matter and to the music itself. No detail or emotional nuance has been left unexplored – whether the little curtains at a window, the lips of a child singing or the inflated cheeks of a trumpet-player; or the sudden sadness induced by some passing thought. It is, one might say, the epitome of intimate or domestic art, so close is Bonnard to what he is re-creating, and so close does he bring the onlooker to the scene before him. At the same time it is a highly elaborated form of art, constantly changing in emphasis, and in that respect is not at all Japanese in character. Although Bonnard drew on outside influences, it was always for his own purposes and in a form that was adapted to his personal experience. This is why there are works of the same date that are totally different in style. What remains constant is a marked preference for the unusual and the unexpected and, underlying the humour and the irony, a distinct empathy with his models.

He must surely have observed at some length the shivering woman wrapped in grey who was his model for the poster *La Revue blanche*. And undoubtedly he had some feeling for the little laundry-maid whom he shows walking across the paving stones with her heavy square basket on her arm. However much we may admire the astonishing powers of suggestion of a few ingeniously distributed patches of colour, or of a few lines used to evoke a form, the simple truth is that this laundry-maid, once seen, is never forgotten. And the same holds true for all those passers-by he captured standing on a street corner, by the avenue du Bois or in a square, on a rainy evening. Every one of the series of lithographs grouped together under the title *Quelques aspects de la vie de Paris* possesses this uncanny quality of urban realism. They, together with the prints intended for the *Albums des peintres-graveurs* (which include *The Laundry-Maid*), are the first products of a long association with Ambroise Vollard.

It is perhaps slightly surprising that Bonnard made so few alterations or corrections in his graphic work. Although there are certain plates that have undergone quite major variations, in most cases there are very few states of any one plate. This is because Bonnard produced numerous preparatory drawings and sketches and in this way – using pen and ink, pencil or watercolour – explored various possible approaches to his subject matter. The astonishing thing is the spontaneity of the final plate. There is no hint of effort. Life flows from the gesture of the artist's hand in its pursuit of visual sensation. With seeming ease the artist passes from a rapid initial sketch to the core of the image that is by then burnt into his mind. It is

interesting to speculate whether he was conscious in his sheer élan of employing any particular technique – perhaps borrowing from the Japanese, or from Degas or Monet, whose drawings he had seen at Vollard's shop. Sometimes there is a detail of composition or a particular handling of the pigment that would suggest some such debt. But Bonnard was already in full control of his powers as an artist, able to express himself as he wanted, softening one passage and strengthening another as it suited the needs of his interpretation. He rarely liked to make a direct statement, preferring – like Mallarmé – to leave the mystery intact. It was for the observer to explore the meaning for himself, to read between the lines – lines which, as Bonnard noted, could be 'calm, vehement, pure, irregular, animated, wavering'.

In print-making as in painting, he blended the various outside influences together to achieve their greatest impact. In much the same way he would try to extract from one technique lessons useful in another. 'I've discovered a lot that applies to painting by doing colour lithography. When you have to judge tonal relationships by juggling with four or five colours, superimposing them or juxtaposing them, you learn a great deal.' The dimensions specified for an album of prints, or a particular book format, or even the requirements of an engraving technique, forced him to observe, if not a set of rules – which would have been anathema to his free-ranging imagination – then at least a discipline of which he was sometimes in need. The pink-coloured lithographs which spread over the margins and even into the verses of Verlaine's *Parallèlement* were followed by *Daphnis et Chloé*,

Pierre Bonnard, self-portrait
Drawing in ink, 1924
France, private collection

images 'of a more classical inspiration'. They have a standard rectangular format, a constraint Bonnard imposed on himself. It is noteworthy that the illustrations for these two books correspond to an important stage in the development of his painting, where composition began to play a more important role. And there are other examples too of an inter-relationship between paintings and prints. For example, the picture *Indolence* (1899) was reworked in *Parallèlement* (1900). And conversely, some of the fauns or nymphs from *Daphnis et Chloé* (1902) reappear in paintings over the next few years. In the period after 1909, when the experience of the light in the South of France had caused him, in his own words, to be 'led astray'

by colour, he found it a welcome corrective to return to pencil and pen, and he also took up etching, which by its nature demanded a concentration on line. In this medium he produced a set of illustrations for Octave Mirbeau's *Dingo* and for Vollard's text of *Sainte Monique*. Etching was not a technique particularly well suited to his talents, and he was always more at ease with the sheer flexibility of lithography. But it did force him to submit to a discipline he himself recognized was necessary – and some of the small landscapes for *Dingo* in particular are models of delicacy and precision in miniature.

Increasingly absorbed in his painting, Bonnard tended to cover the same subject matter in his later lithographs; this is certainly true of most of the plates collected together by the publisher Frapier from 1923 onwards, which include nudes, interiors and landscapes. But the character of the lithographs has changed. There is a new atmosphere about them, an altogether more sober attitude towards the outside world. The little everyday scenes of the past seem an eternity away from these women at their toilet, these faces sunk deep in thought at the table, almost as though the painter had retreated somewhat from his models. Now his concern was focused on the quality of mysteriousness emanating from people and things. He became increasingly obsessed with light until it dominated everything else, whether playing over ceramic tiles or bathing the countryside in a golden glow at sunset. His lithographic work seemed as though it might be destined to end on this note of twilight nostalgia. Yet in his paintings he overcame the melancholy that afflicted even his human figures, and went on to achieve a marvellous sublimation of the sadness born out of a consciousness of the beauty of the universe on the one hand and the brevity of life on the other. 'The light has never been so beautiful . . .' he wrote. And he had never before handled colour with such dazzling freedom as he did then.

In 1942, Bonnard was seventy-five. Louis Carré asked him to design a series of plates which would then be transferred to the stone by Jacques Villon. Bonnard followed the progress of the work state by state. Between 1942 and 1946 an extremely close collaboration and

Errand-girls.
Preliminary drawing in ink for the dry-point, 1927
Paris, private collection

a profound understanding were established between these two great artists. Villon showed an immense sensitivity in interpreting such elusive instructions as, for example, a marginal note by Bonnard asking for: 'A touch of muted strength.' Bonnard, who had been living permanently at Le Cannet since 1939, chose as his themes interiors set in the rooms of his house, landscapes of the surrounding countryside, seascapes, pieces of fruit, and the roses in his garden. There was also another nude study of a woman in a bath, in which the true subject was the flesh in the play of the light and shimmering water. The ceramic-clad walls and tiled floor send back reflections and are really no more than the pretext for a complex play of transposed colours. Indeed, it is only because of these astonishing effects of transposed colour that the bath-tub itself fades, as it does, into insignificance, leaving before the eyes and in the memory the

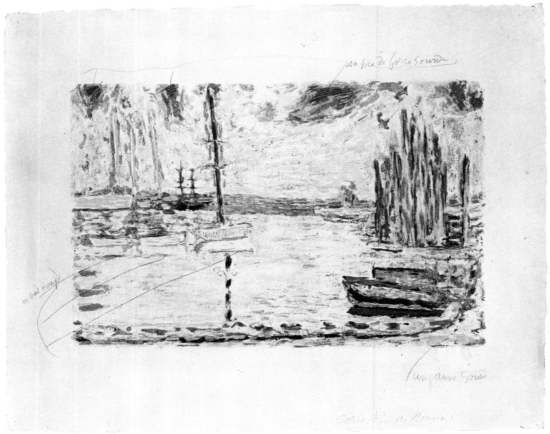

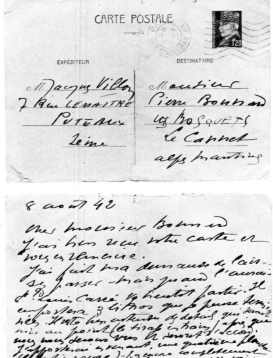

image of a body abandoned to the gentle lapping of the water in the orange-shot glow of daylight. Flesh has become light.

Bonnard's graphic work does not exist in isolation from his painting. At all stages it is related to the canvases; it complements and sometimes amplifies them. *Parallèlement* and *Daphnis et Chloé* are the book illustrations which represent the high point of his achievement; *Quelques aspects de la vie de Paris* is the supreme series of lithographic plates. The graphic works confirm the painter's genius for giving vivid expression to an emotion. They are like a private diary in the way certainty and doubt are committed to paper with total honesty. If in the end Bonnard's reputation is as a colourist, that is because it was his greatest gift.

Antoine Terrasse

Fishing Port. Lithography
Trial proof with Bonnard's corrections
and handwritten note by Jacques Villon
Paris, private collection

Card from Jacques Villon to Bonnard,
August 1942
Paris, private collection

Catalogue

Except where otherwise indicated, it is the final state of each print that is reproduced.

Dimensions are expressed in centimetres, height before width, with dimensions in inches shown in brackets.

Abbreviations used in the catalogue (for further bibliographical details see pp. 339–40):

TF: Charles Terrasse, Jean Floury, *Bonnard*, 1927
AS: Albert Skira, *Anthologie du livre illustré*, 1946
CRM: Claude Roger-Marx, *Bonnard lithographe*, 1952
ER: E. Rouir, 'Quelques remarques sur les lithographies de Pierre Bonnard', 1968
UP: Ursula Perucchi-Petri, *Die Nabis und Japan*, 1976
UJ: Una E. Johnson, *Ambroise Vollard, Editor*, 1944 and 1977

France-Champagne

1891

Lithograph printed in three colours $78 \times 50 \, (30\frac{3}{4} \times 19\frac{3}{4})$
Monogram PB, above r.
Printed by Edward Ancourt & Cie, 83 faubourg Saint-Denis, Paris.
Poster, first displayed on the walls of Paris at the end of March 1891 (letter
from Bonnard to his mother, 19 March 1891)

Bibliography: F. Fénéon, *Le Chat noir*, 6.6.1891; O. Mirbeau, 'Préface au catalogue de la vente
Thadée Natanson', June 1908; TF 1; H. Hahnloser, 1936; René-Marie (F. Jourdain), *Bonnard*,
Le Point, 1943; Th. Natanson, 1951; CRM 1; A. Vaillant, 1965; A. Fermigier, 1969; UP

A preliminary sketch is in the Musée de Reims (reproduced in TF, p. 21). Later in
1891, Bonnard designed, again for the firm France-Champagne, the title-page for a
piece of music (reproduced in UP)

2
Family Scene
Scène de famille

1892

Lithograph printed in three colours 21 × 26 ($8\frac{1}{4}$ × $10\frac{1}{4}$)
Dated and signed above l.
Printed in an edition of thirty (CRM)
Some proofs with the addition of blue on the child's eyes and grandfather's
spectacles (J. Floury)

Bibliography: TF 2; CRM 2; UP

A preliminary watercolour sketch is known to exist (reproduced in UP); also a
preparatory drawing
Compare with the lithograph of the same title in upright, as opposed to
horizontal, format

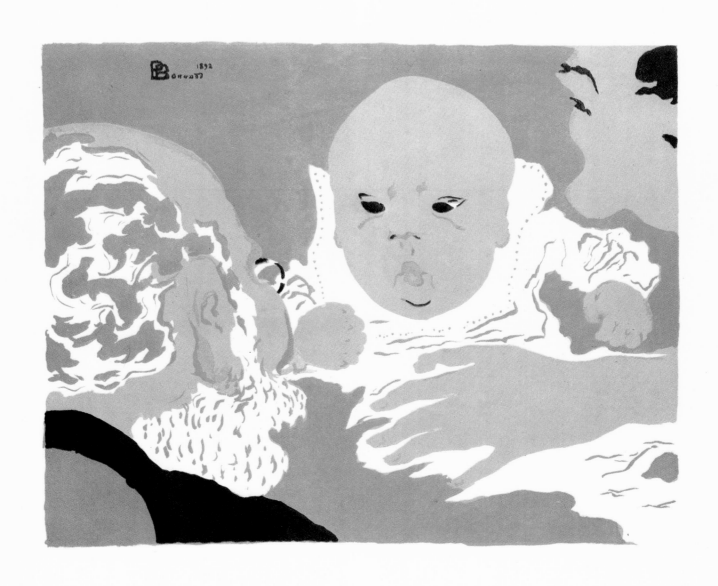

1892

Lithograph printed in four colours 19×26 ($7\frac{1}{2} \times 10\frac{1}{4}$)
Monogram PB, below r.
Cover for the book by Victor Joze published in 1892 by Henry Jullien, 32
rue Fontaine and 59 rue de Provence, Paris
A dozen proofs on thin wove paper, or Japanese paper, before the addition
of the publisher's name and, in the bottom l. corner, the words: 'En
préparation *Unter den Linden*: Moeurs berlinoises' (CRM; J. Floury)
There is a poster for the book by Toulouse-Lautrec; it is reproduced as a
frontispiece in the published volume

Bibliography: TF 3; CRM 3

One preliminary sketch in watercolours

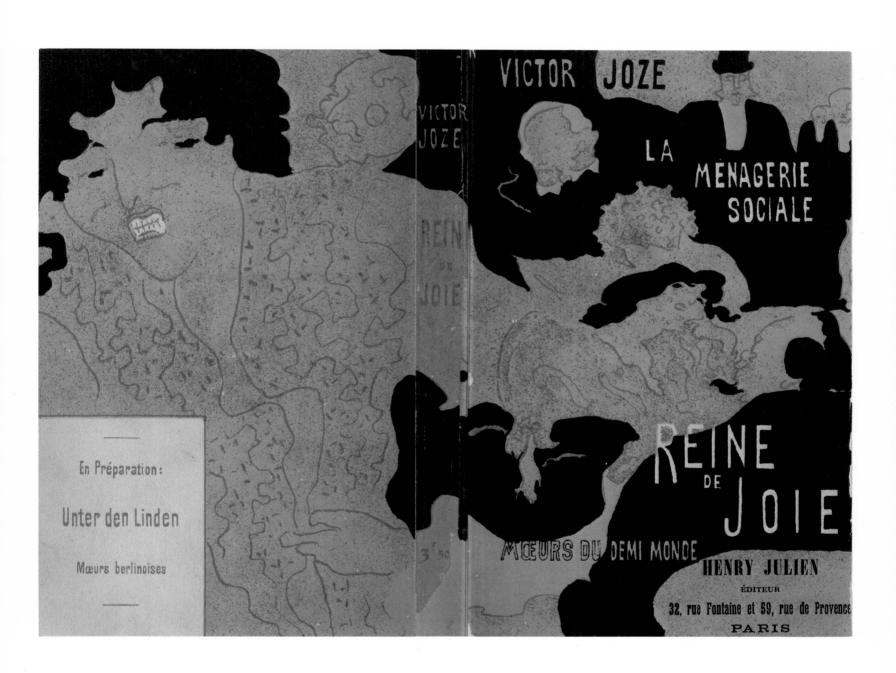

4
Family Scene
Scène de famille

1893

Lithograph printed in four colours 31×18 ($12\frac{1}{4} \times 7\frac{1}{8}$)
Signed and dated above l.
Printed in an edition of one hundred for the third publication of *L'Estampe originale* by Claude Roger-Marx and André Marty (January–March 1893).
For the most part the prints are signed and numbered and are mounted on a cardboard backing bearing the stamp of Charpentier, the identifying mark of the collection
A few proofs, not signed or numbered, modified by hand of the artist

Bibliography: TF 4; CRM 4

There are two known watercolours of this subject, and one painting (Dauberville, 01737). Compare with the lithograph of the same title in horizontal format

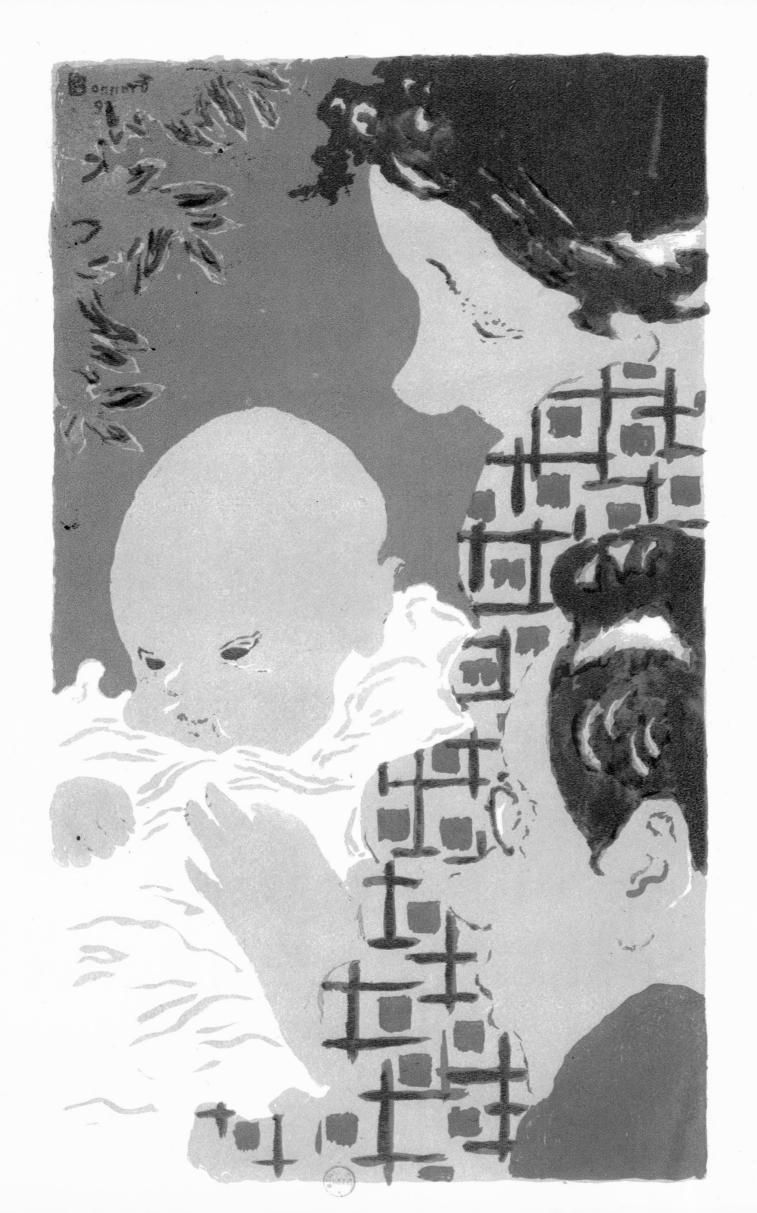

1893

Twenty lithographs printed in black, including the cover, to illustrate an album of music by Claude Terrasse; published by F. Froment, Boulevard Malesherbes (40 rue d'Anjou); printed by Crevel Frères, Paris

Some twenty sets of proofs before music on loose sheets of China paper, with the monogram PB in brushwork, in blue, red, black or violet. One or two proofs including the title are known to exist, printed on loose-leaf China paper. Also proofs on China and Japanese paper, without monogram; and preliminary drawings

5. Cover: title; baby's face above
6. Papa, maman 19.5 × 21.5 (7⅝ × 8½) – p. 1
7. Dodo, l'enfant do 14.5 × 23.6 (5¾ × 9½) – p. 4
8. Pensée triste 19.5 × 9.5 (7⅝ × 3¾) – p. 6
9. Départ des amis 16.1 × 22 (6⅜ × 8⅝) – p. 8
10. Prière 14 × 24 (5½ × 9½) – p. 10

11. La chanson du grande-père 22.6 × 10.6 (8⅞ × 4⅛) – p. 12
12. Le chevrier 23.7 × 7.9 (9⅜ × 3⅛) – p. 14
13. Les heures de la nuit 13.1 × 23.5 (5⅛ × 9¼) – p. 16
14. Arcachon. Qui veut des écopeaux! 11 × 22.5 (4⅜ × 8¾) – p. 19
15. Premier air de Fifi 17.2 × 11 (6¾ × 4⅜) – p. 20
16. Promenade à âne 9 × 23.7 (3½ × 9⅜) – p. 22
17. Rêverie 18 × 13 (7⅛ × 5⅛) – p. 26
18. Danse 21.5 × 8.5 (8½ × 3⅜) – p. 28
19. Dimanche matin 14.5 × 23 (5¾ × 9) – p. 32
20. L'angélus du matin 13.6 × 23 (5⅜ × 9) – p. 34
21. Boutique à cinq sous 12.5 × 22.9 (4⅞ × 9) – p. 37
22. La baraque 10.8 × 21.8 (4¼ × 8⅝) – p. 41
23. Au cirque… La haute-école 9 × 24 (3½ × 9½) – p. 48
24. Quadrille 11 × 23.5 (4⅜ × 9¼) – p. 55

Bibliography: TF 5; AS 32; CRM 5–24; UP

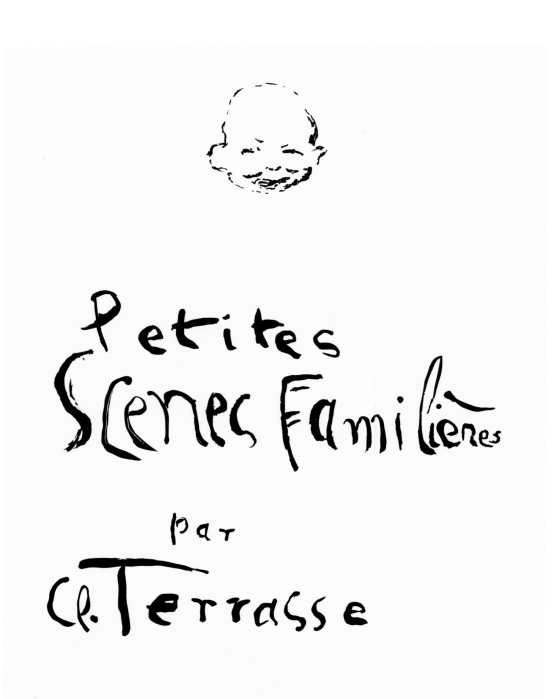

5

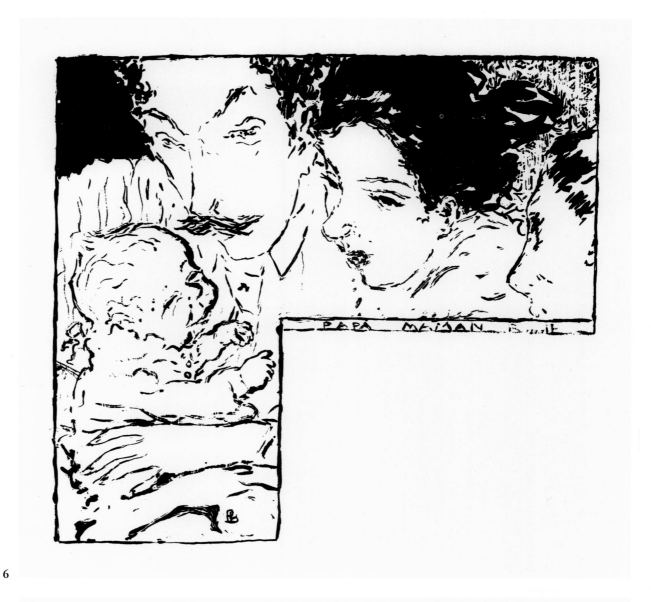

6

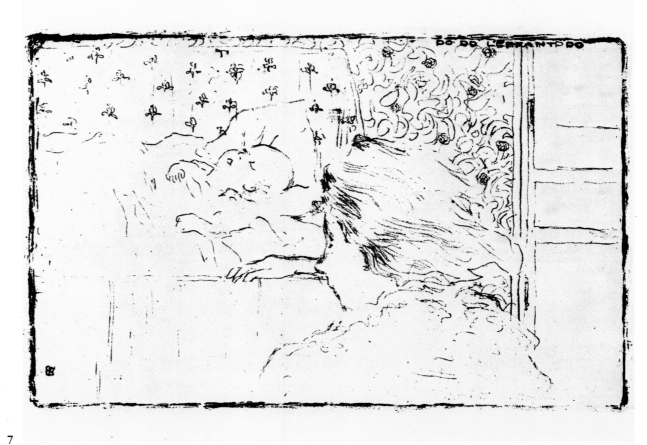

7

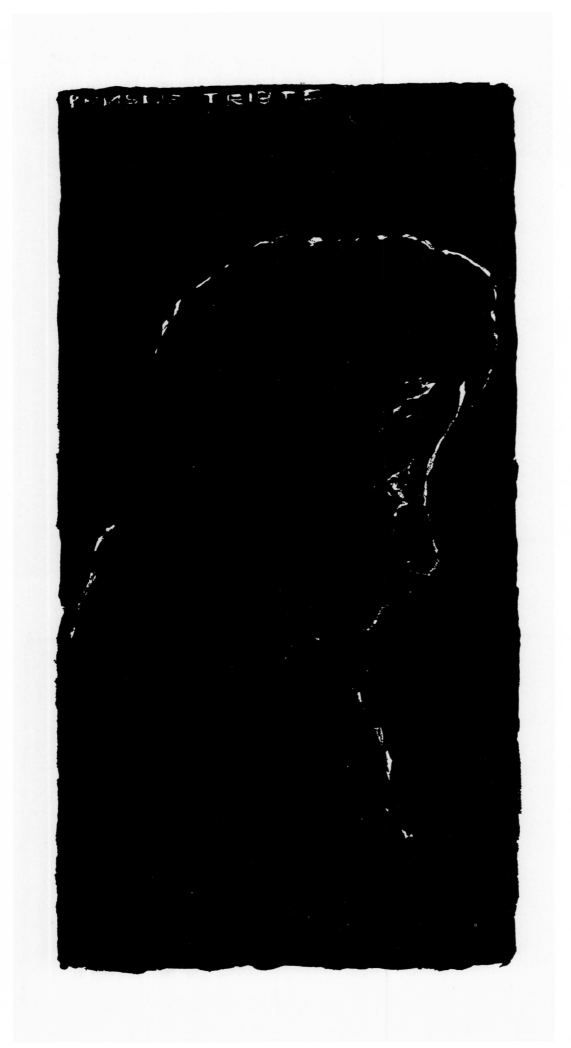

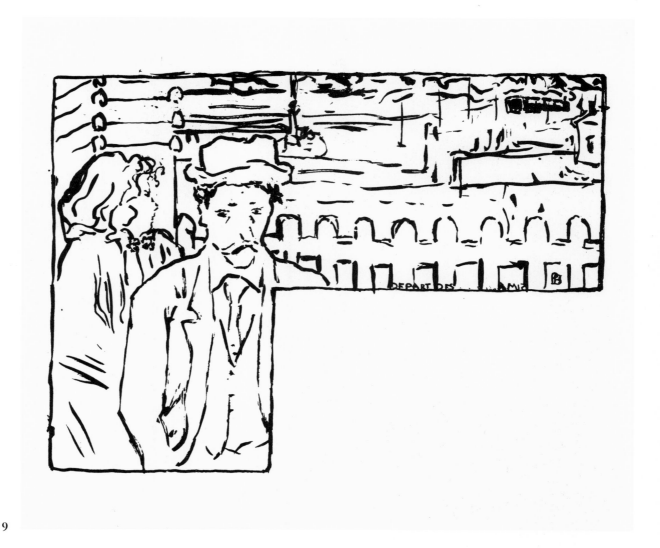

9

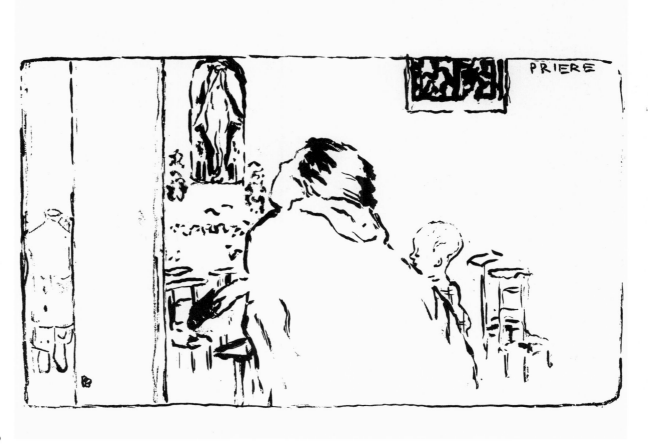

10

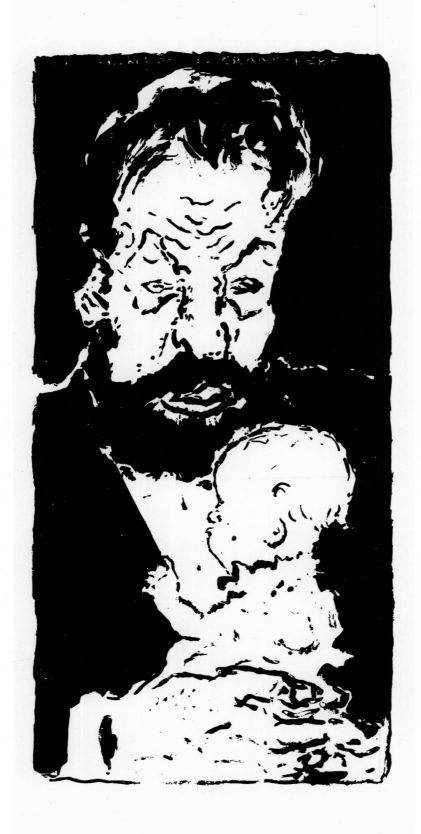

11

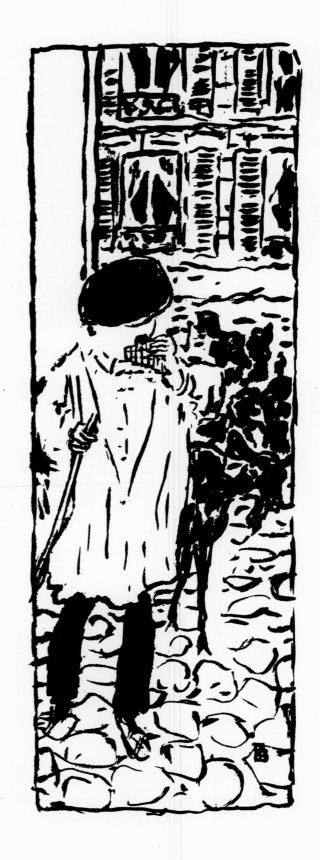

12

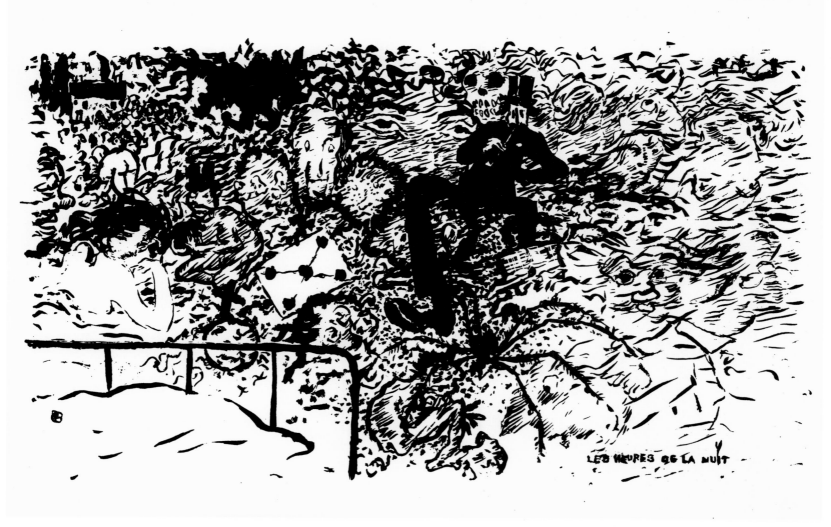

13

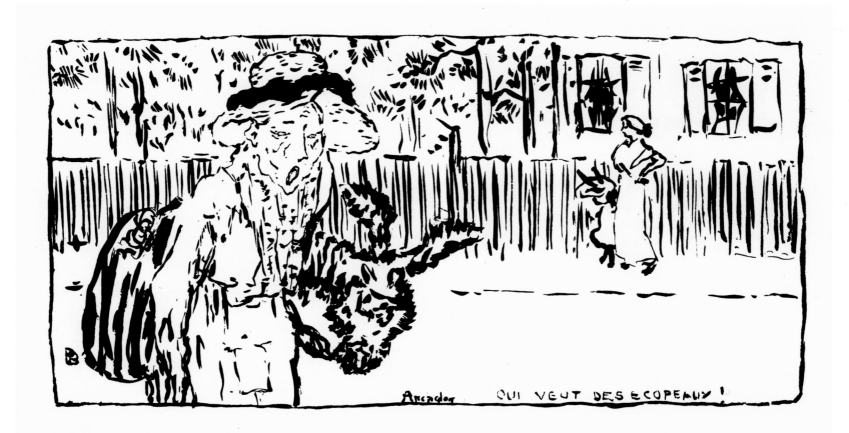

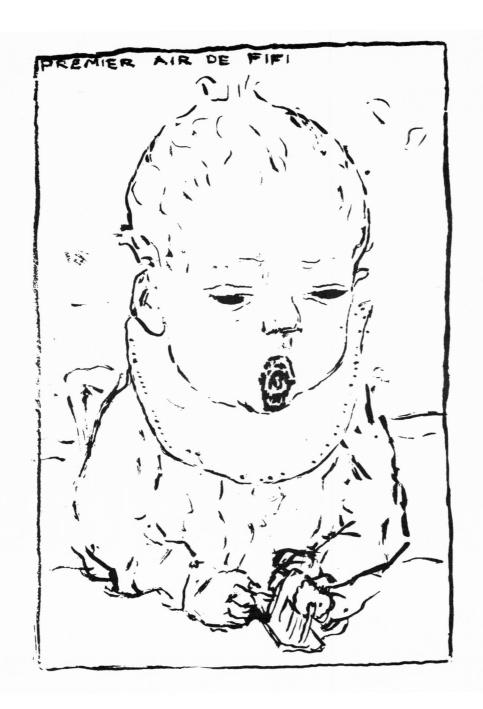

15

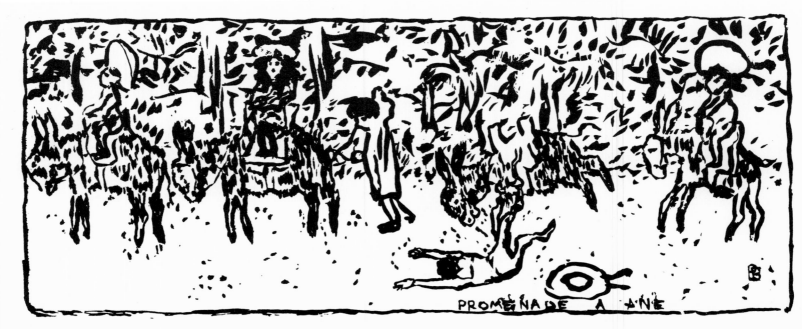

16

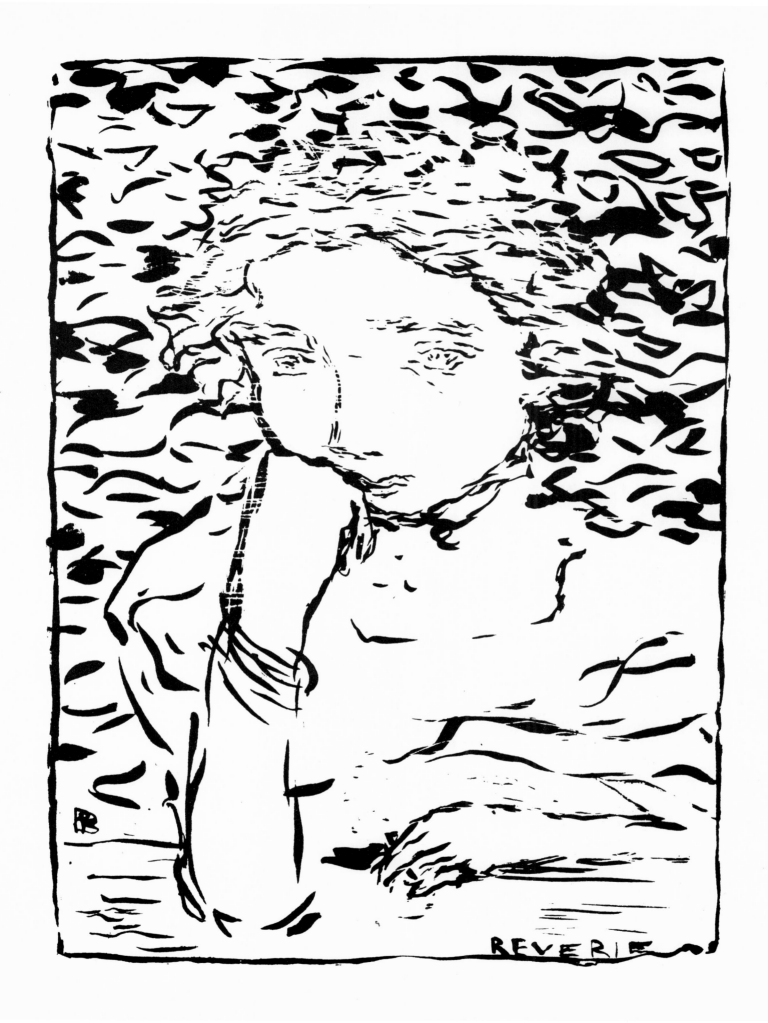

REVERIE

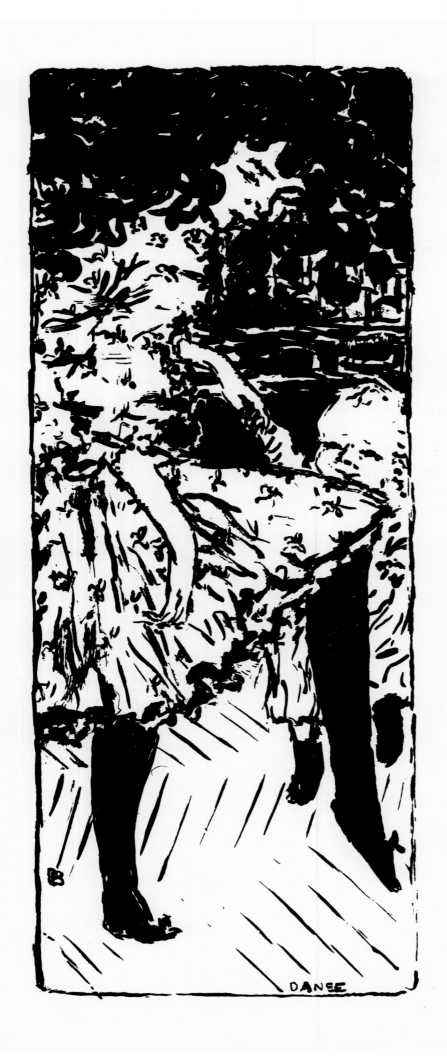

DANSE

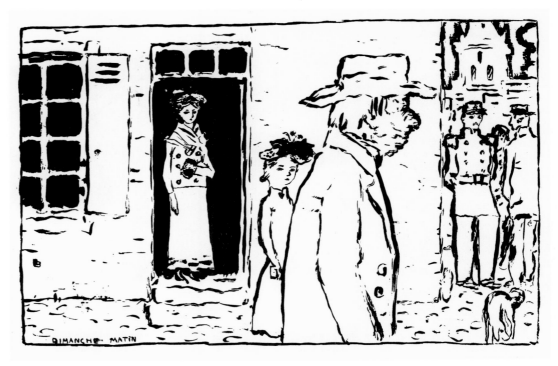

19

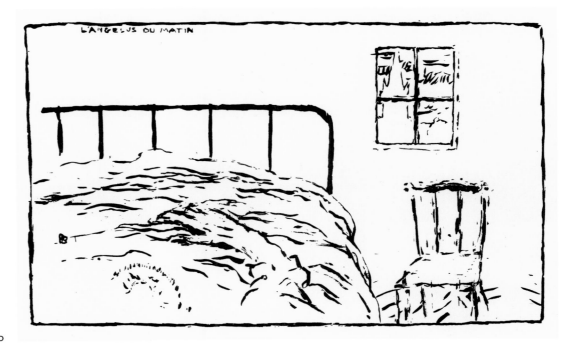

20

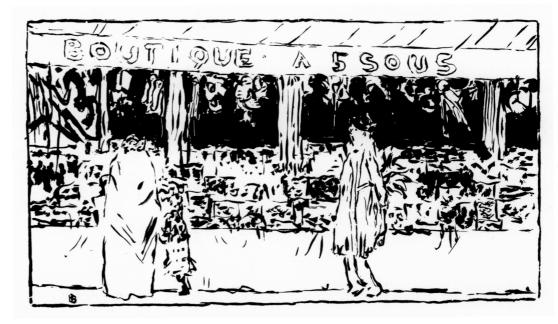

21

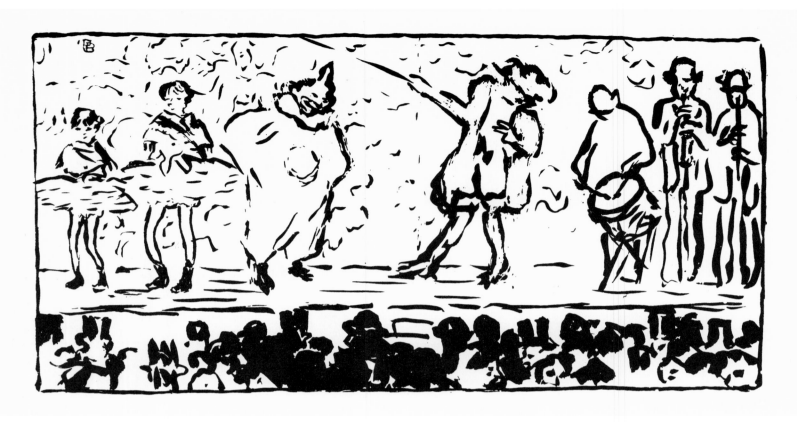

22

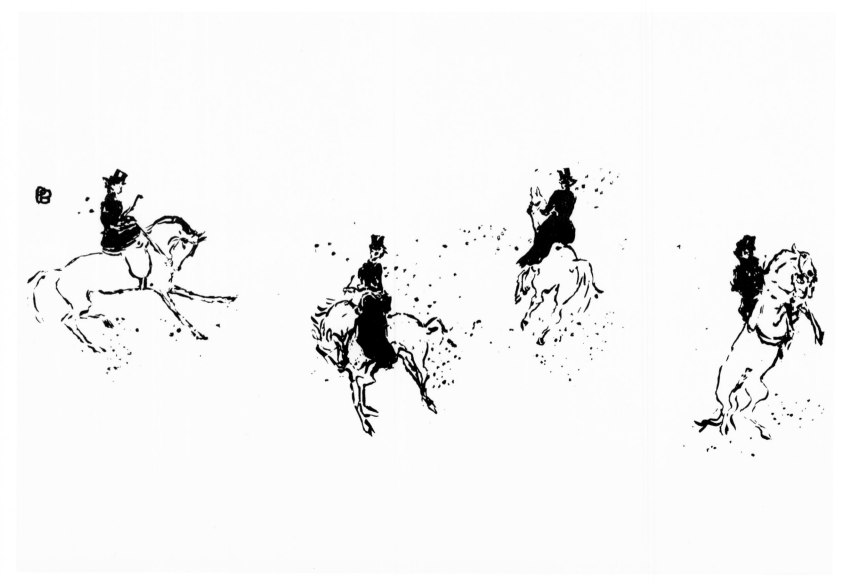

23

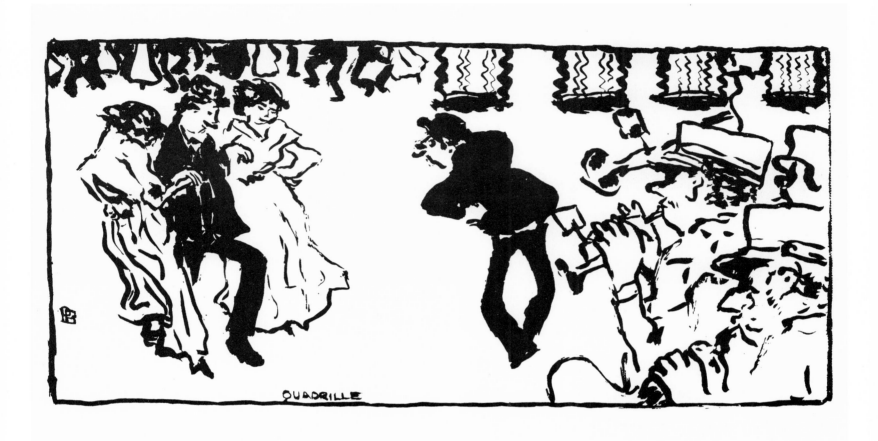

QUADRILLE

24

25
Dogs
Les chiens

1893

Lithograph printed in brownish-black 28 × 17 (11 × 6¾)
Monogram PB, below l.
Edition of one hundred, numbered and signed by the artist;
also twenty prints on Japanese paper
Reproduced in *L'Escarmouche*, No. 5, 10 December 1893

Bibliography: TF 6; CRM 25; UP

26
Municipal Guard
Garde municipal

1893

Lithograph printed in brownish-black 26 × 17 (10¼ × 6¾)
Monogram PB, below l.
Edition of one hundred, signed and numbered by the artist;
also twenty prints on Japanese paper
Reproduced in *L'Escarmouche*, No. 8, 31 December 1893

Bibliography: TF 7; CRM 26; UP

A preliminary drawing exists (reproduced in UP)

27
Young Woman in Black Stockings
Jeune femme aux bas noirs

1893

Lithograph printed in brownish-black 29 × 17
$(11\frac{3}{8} \times 6\frac{3}{4})$
Monogram PB, below r.
Edition of one hundred, signed and numbered by
the artist; also twenty prints on Japanese paper,
and a few proofs on a dark-blue paper
Reproduced in *L'Escarmouche*, No. 2, second year,
14 January 1894

Bibliography: TF 8; CRM 27 (*Femme en chemise*)

There exist a number of drawings of this subject

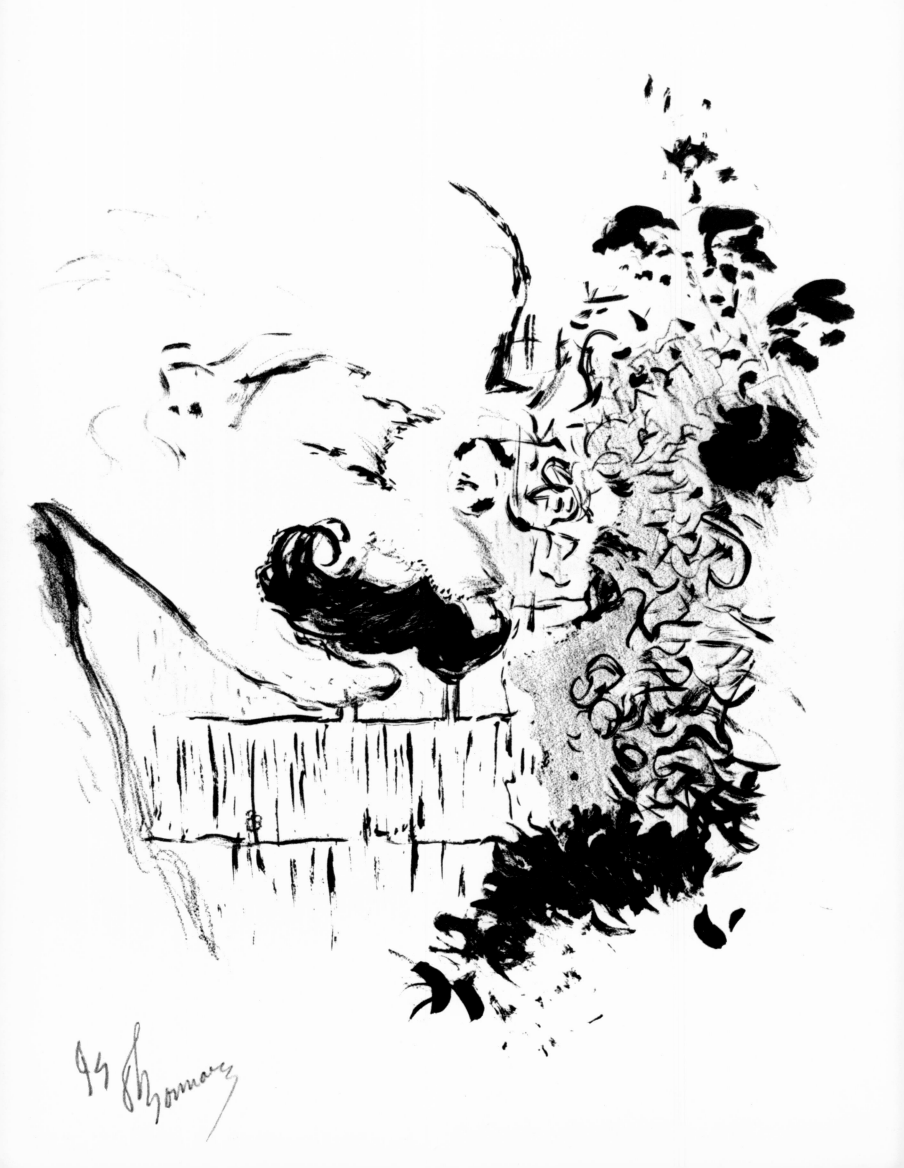

28
Conversation

1893

Lithograph printed in brownish-black 30 × 26 (11¾ × 10¼)
Small monogram PB, below l.
Edition of one hundred, signed and numbered by the artist; also twenty
prints on Japanese paper
Intended for *L'Escarmouche*, but never published in this short-lived weekly
magazine

Bibliography: TF 9; CRM 28

Contrary to the opinion of J. Floury and C. Roger-Marx, not a portrait as such, but
a figure in conversation with a woman, whose profile is visible as a fine tracery
emerging from her elaborately dressed hair

<div align="right">

29
The Tub
Le tub

1894

Lithograph printed in black 18 × 13 (7⅛ × 5⅛)
For the catalogue of the exhibition
'La Dépêche de Toulouse', May 1894

Bibliography: TF 20; CRM 31

</div>

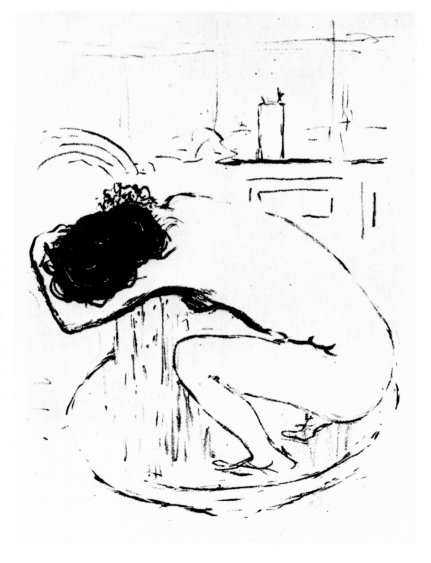

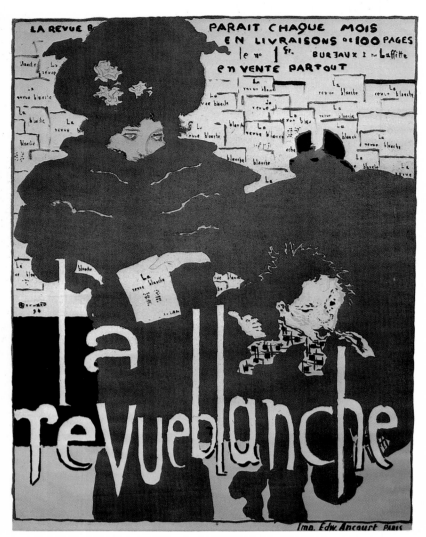

30
La Revue blanche

1894

Lithograph printed in four colours 80 × 62 (31½ × 24⅜)
Signed and dated c.l.
Printer: Edward Ancourt, Paris
Poster for the *Revue blanche*. The strange form r., apparently following the young woman, is in fact a man, seen from behind, an opera hat on his head and coat collar turned up, reading the poster for the *Revue* on the wall

Bibliography: TF 10; Th. Natanson, 1951; CRM 32

A small watercolour sketch exists, also a number of preliminary drawings. The Musée National d'Art Moderne in Paris has a wash-drawing (reproduced in A. Humbert, *Les Nabis et leur époque*, Cailler, 1954)
One very rare trial proof printed in grey – before overprinting in black, beige and pinkish-brown, and before letters (exhibited at Pully, 'Groupe des Nabis', 1963; no. 12 in the catalogue)

Detail at actual size

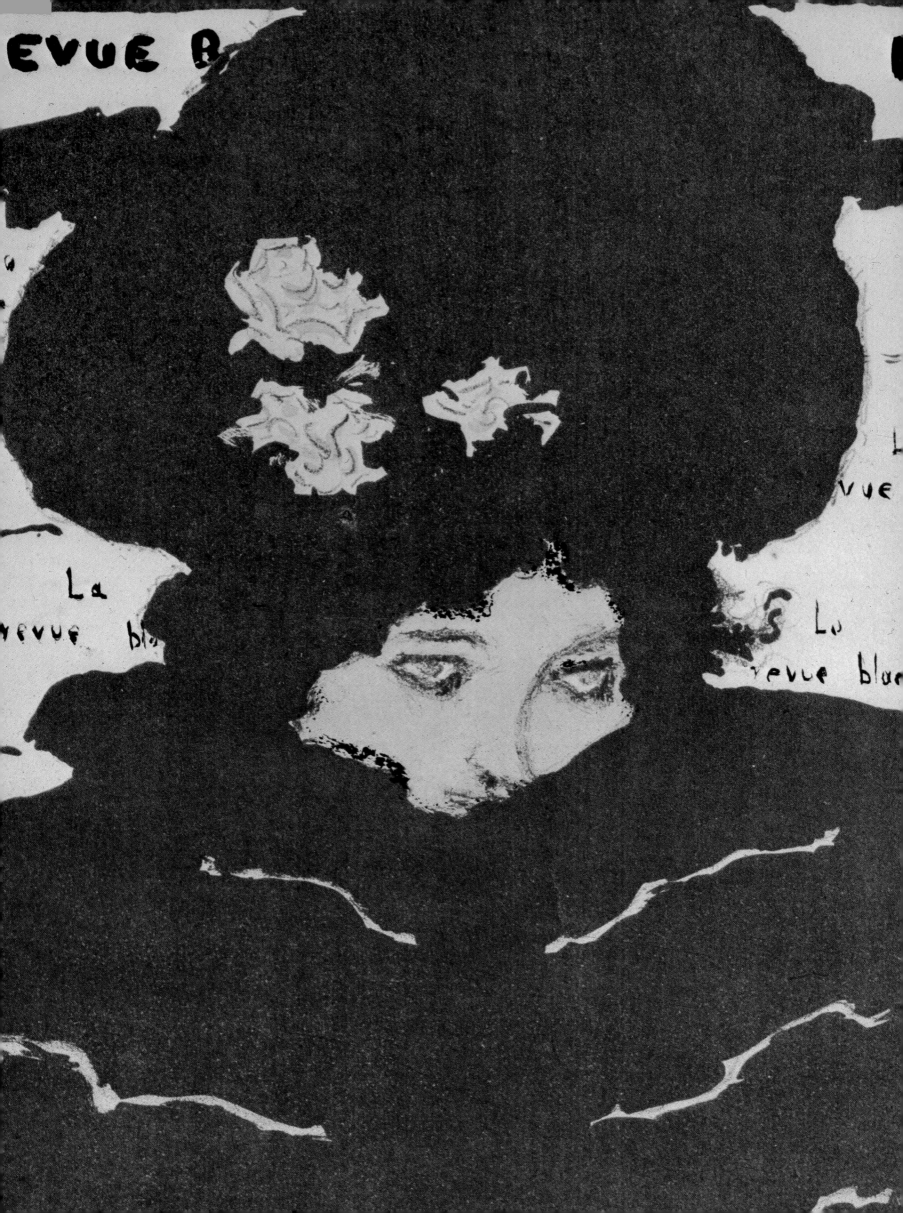

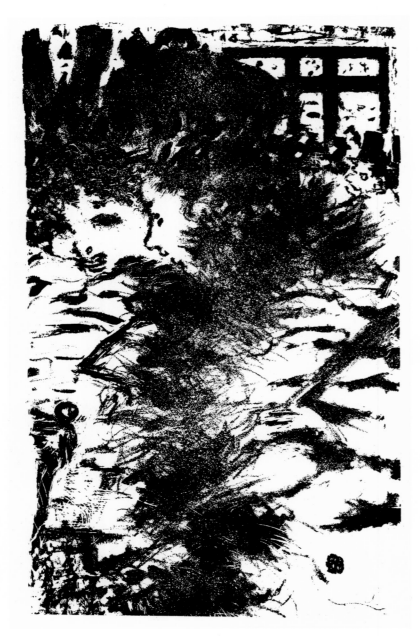

31
Parisian Women
Parisiennes

1895

Lithograph printed in black on buff background 20.6 × 12.5 ($8\frac{1}{8} × 4\frac{7}{8}$)
Monogram PB, below r.
Published in *La Revue blanche*, vol. VIII, no. 44, 1 April 1895
A small number of rare trial proofs is said to exist (CRM)

Bibliography: TF 11 (*Femmes dans la rue*); CRM 34

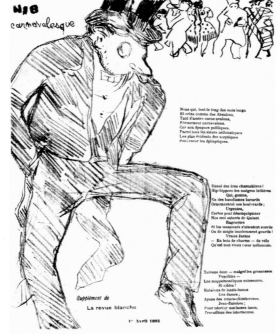

32
Nib carnavalesque

1895

Two lithographs printed in black, recto-verso, folded in two, thus making
four pages of illustration, and accompanying a text by Romain Coolus
Each page: 32.5 × 25 (12¾ × 9⅞)
Supplement to *La Revue blanche*, dated 1 April 1895
Monogram on final page, above r.

Bibliography: TF (listed under 'Quelques illustrations'; CRM 36

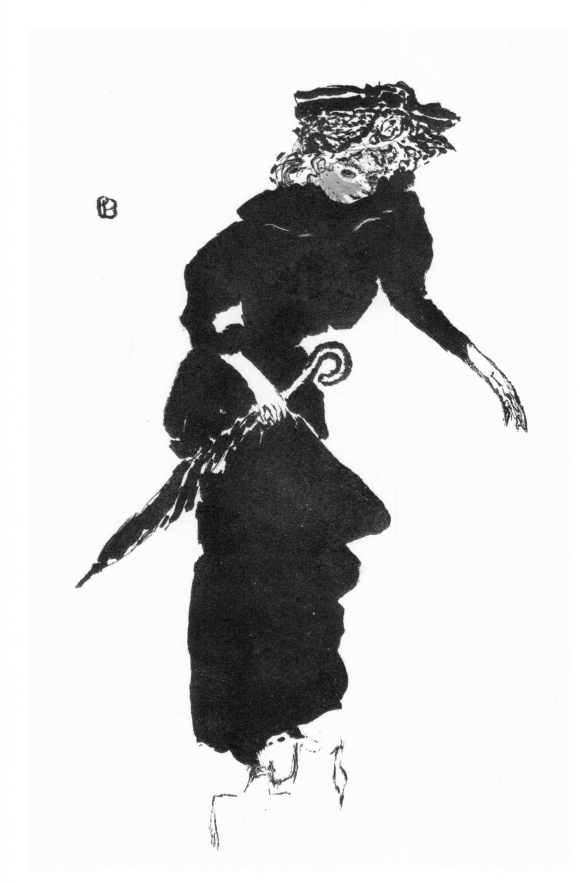

33
Woman with Umbrella
Femme au parapluie

1895

Lithograph printed in two colours
25 × 15.5 (9⅞ × 6⅛)
Monogram PB, above l.
Published in *La Revue blanche*, no. 46, and
reprinted the same year in *L'Album de la Revue
blanche* (see following pl.)
Printed in an edition of 110 for the *Album*

Bibliography: TF 12; CRM 35; UP

A number of preliminary studies exist, either pen and
ink or wash-drawings, some reproduced in UP

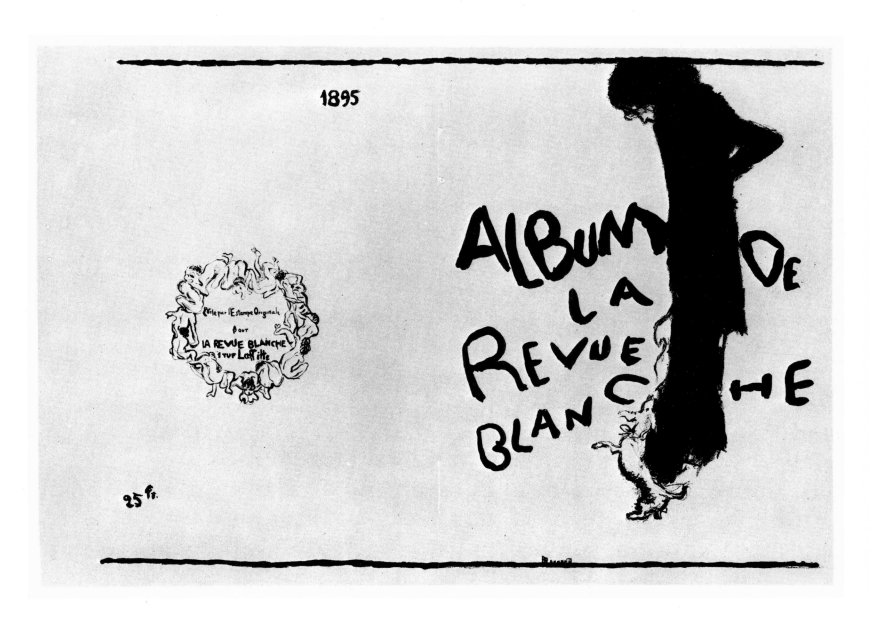

34
Cover for _L'Album de la Revue blanche_

1895

Lithograph printed in black on ochre background $40 \times 60 \left(15\frac{3}{4} \times 23\frac{5}{8}\right)$
Signed below, dated above
Album published by _L'Estampe originale_ for _La Revue blanche_
Edition of 110

Bibliography: TF 13; CRM 33

35, 36
Two lithographs for *L'Epreuve*

The first issue of *L'Epreuve* appeared in December 1894
Administrator and editor: Maurice Dumont (3 *bis* rue des Beaux-Arts, until
end July 1895)
Twelve issues, comprising 132 plates in all
Printer: Paul Lemaire, 14 rue Séguier
Printed in an edition of two hundred; plus a de luxe edition of fifteen; also
ten artist's proofs

35
The Card Game by Lamplight
La partie de cartes sous la lampe

1895

Lithograph printed in grey-green or
bistre 13.3 × 23.6 (5¼ × 9¼)
Signed below r.
For *L'Epreuve*, nos. 9–10, August–September
1895

Bibliography: TF 14 (*Etude*); CRM 29

Other artists contributing to *L'Epreuve*, nos.9–10:
P. Puvis de Chavannes; A. de la Gandara; H. Guérard;
M. Denis; G. Jeanniot; E. Béjot; Th. van
Rysselberghe; A. Maillol; C. Huard; M.Dumont;
H. Fantin-Latour; F. Rops; G. Rochegrosse;
G. d'Espagnat; P. Dillon; A Rassenfosse; E.
Berchmans; A. Donnay; A. Cazals

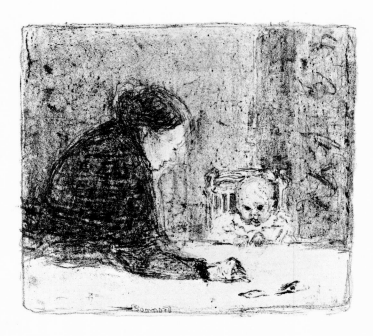

36
The Grandmother
La grand-mère

1895

Lithograph printed in grey-green or
bistre 20 × 23.5 (7⅞ × 9¼)
Signed below l.
For *L'Epreuve*, nos. 11–12, end 1895

Bibliography: TF 15 (*Intérieur*); CRM 29

There is a fine preliminary drawing in pencil (exhibited
by Huguette Berès in 1970; catalogue, no. 9)
Compare with various paintings on the same theme
(Dauberville, nos. 64, 01736, 01739, 01773)
Other artists contributing to *L'Epreuve*, nos. 11–12:
F. Rops; N. Goeneutte; H. Guérard; G Jeanniot;
E. Béjot; C. Huard; H. de Groux; M. Denis;
M. Dumont; F. Buhot; A. Charpentier; P. Puvis de
Chavannes; G. d'Espagnat; V. Koos; A. Maillol;
M. Delcourt; Neuburger; F. Launay; M. Mouclier

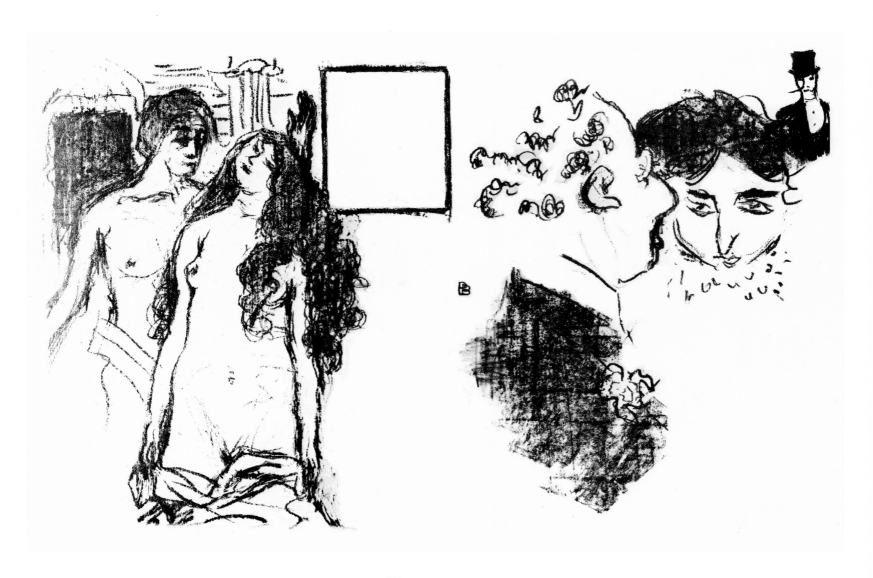

37
La dernière croisade

1896

Lithograph printed in grey, recto only 30 × 49 (11¾ × 19¼)
Monogram PB, c.
Double-spread illustration for the programme of *La dernière croisade* by
Maxime Gray, performed at the Théâtre de *l'Œuvre* in April 1896
There exist a number of proofs before letters, also a few proofs bearing the
words 'La Revue encyclopédique' but before the addition of programme
details

Bibliography: TF 22; CRM 39

A copy of the programme was presented by Suzanne Després to the Musée d'Art
Moderne in Paris

38
Les peintres graveurs

1896

Lithograph printed in three colours 64×47 ($25\frac{1}{2} \times 18\frac{1}{2}$)
Signed and dated below l.
Printed by A. Clot; poster for the exhibition held by Ambroise Vollard, 6
rue Laffitte, 15 June – 20 July 1896
A few proofs on hand-made Japanese paper bear a remarque (female nude,
half-length) below l.

Bibliography: TF 18; CRM 40; UJ 16

A small preliminary sketch in watercolours exists (reproduced in the catalogue for
the exhibition 'Nabis', Galerie Krugier, Geneva, 1969, no. 31; *Femme lisant*)

39
Le Salon des Cent

1896

Lithograph printed in three colours 63 × 45 (24¾ × 17¾)
Monogram PB, below r.; dated
Printed by Chaix (Ateliers Chéret), 20 rue Bergère, Paris; poster for the
23rd group exhibition of the Salon des Cent, 31 rue Bonaparte,
August–September 1896

Bibliography: TF 19; CRM 45

Some proofs before letters, on Japanese paper and signed
The poster by Toulouse-Lautrec, for the international poster exhibition organized
by the Salon des Cent, also dates from 1896

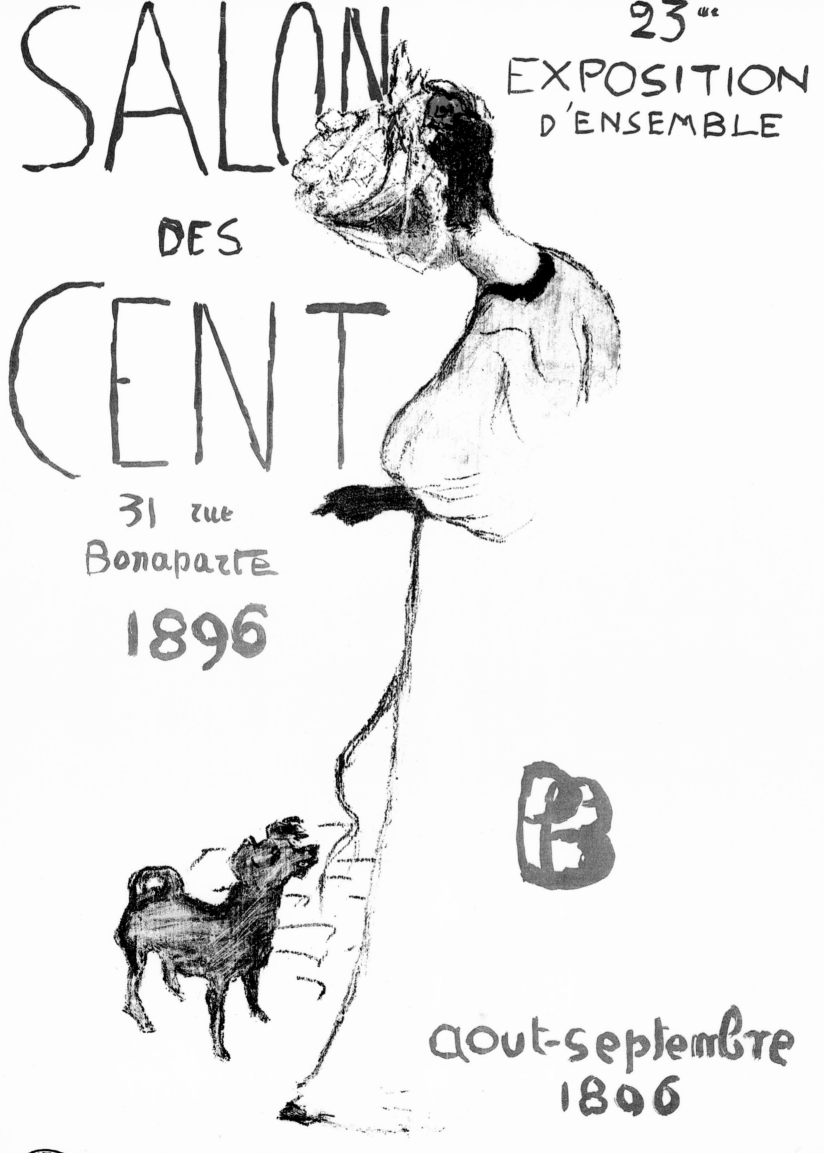

SALON
DES
CENT

23ᵐᵉ
EXPOSITION
D'ENSEMBLE

31 rue
Bonaparte
1896

aout-septembre
1896

40
The Laundry-Maid
La petite blanchisseuse

1896

Lithograph printed in five colours 30 × 19 (11¾ × 7½)
Signed above, and dated 96
Printed by A. Clot for the first *Album des peintres-graveurs*; published by
Ambroise Vollard in 1896
Printed in an edition of one hundred. Some very rare trial proofs exist of
various states, these printed in two or three colours on loose-leaf China
paper, and signed and annotated by hand of the artist: '2ᵉ état', '3ᵉ état'. Cf.
sale, Wednesday 3 December 1958, Hôtel Drouot (nos. 7 and 8 in the
catalogue)

Bibliography: TF 25; CRM 42; UJ 15

Many preliminary drawings, also a watercolour sketch exhibited by Huguette Berès
in 1970 (no. 13, reproduced in the catalogue of this exhibition)
The *Album* included twenty-two original prints, by: G. Auriol; A. Besnard, J. E.
Blanche; P. Bonnard (*The Laundry-Maid*); F. R. Carabin; M. Denis; H. Fantin-
Latour; A. Guillaumin; Hermann-Paul; G. Leheutre; A. Lunois; C. Maurin; E.
Munch; J. Pitcairn-Knowles; O. Redon; A. Renoir; J. Rippl-Ronaï; Th. van
Rysselberghe; J.-Th. Toorop; S. Valadon; F. Vallotton; E. Vuillard

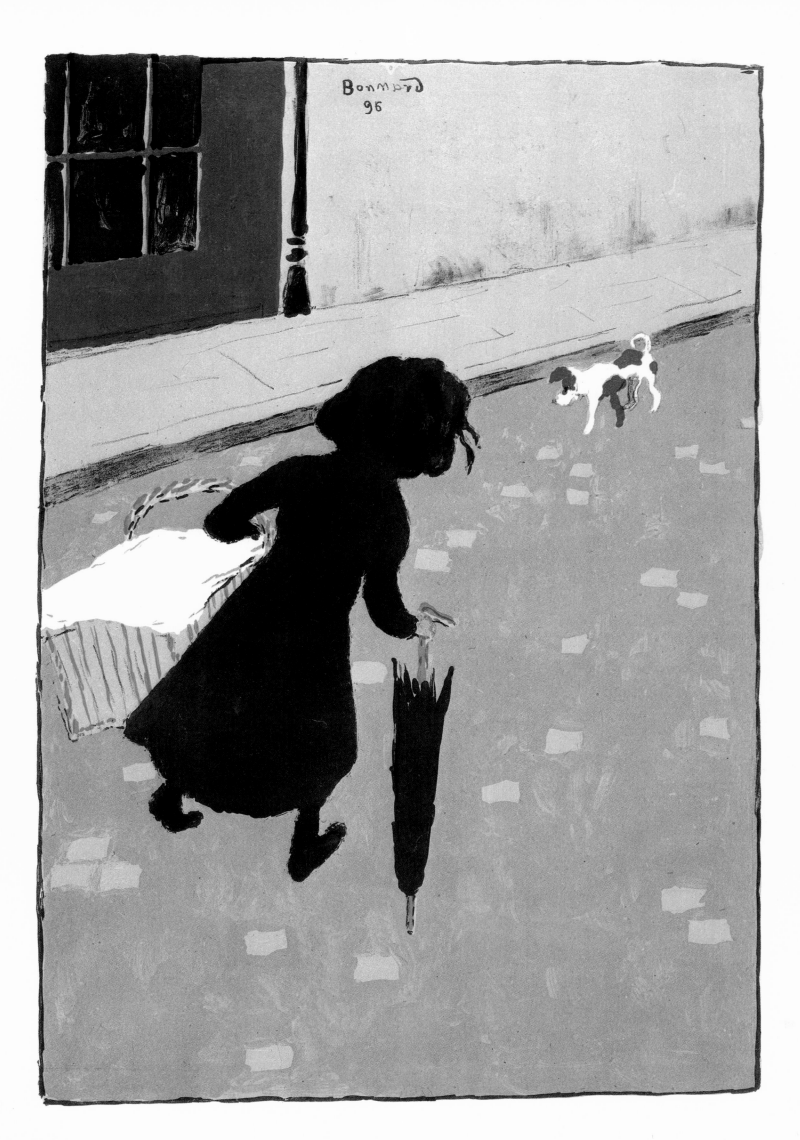

41
Cover for the second *Album d'estampes originales*,
published by the Galerie Vollard

1897

Lithograph printed in four colours 57 × 87 (22⅜ × 34¼)
Signed above c., and dated
Printed by A. Clot in an edition of one hundred
In a few rare trial proofs the eyes of the cat are yellow

Bibliography: TF 24; CRM 41; UJ 17

A large preliminary drawing, in lithographic crayon, was exhibited by Huguette
Berès in 1970 (reproduced as no. 16 in the catalogue)

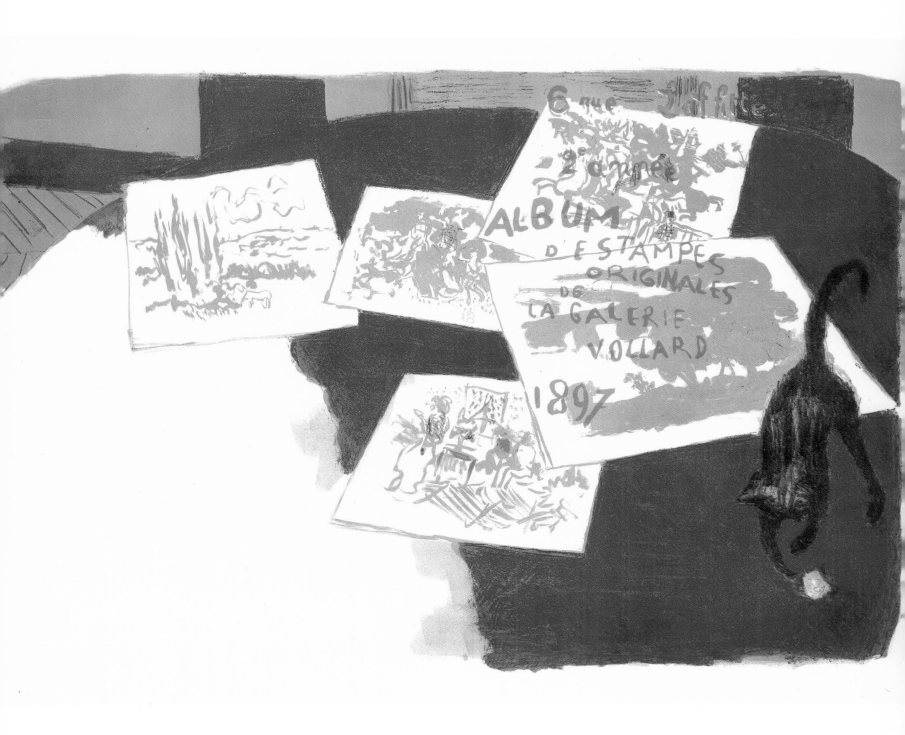

51

42
Boating
Le canotage

1897

Lithograph printed in four colours 26 × 47 (10¼ × 18½)
For the second *Album d'estampes originales*, published by the Galerie Vollard
Printed in an edition of one hundred; also a few rare trial proofs printed in
black

Bibliography: TF 27; CRM 44; UJ 18

Compare with a painting of the same subject, Dauberville, 01777
The *Album* included thirty-two original plates by: E. Aman-Jean; G. Auriol; P.
Bonnard (cover illustration and *Boating*); E. Carrière; P. Cézanne; C. Cottet; H.-E.
Cross; M. Denis; M. Eliot; H. Fantin-Latour; G. de Feure; J.-L. Forain;
E. Grasset; A. Guillaumin; G. Leheutre; R. Lewisohn; A. Lunois; H. Martin;
C. Maurin; L. Pissarro; P. Puvis de Chavannes; O. Redon; A. Rodin;
K.-X. Roussel; C.-H. Shannon; L. Simon; A. Sisley; Toulouse-Lautrec;
E. Vuillard; T.-P. Wagner; J. McNeill Whistler

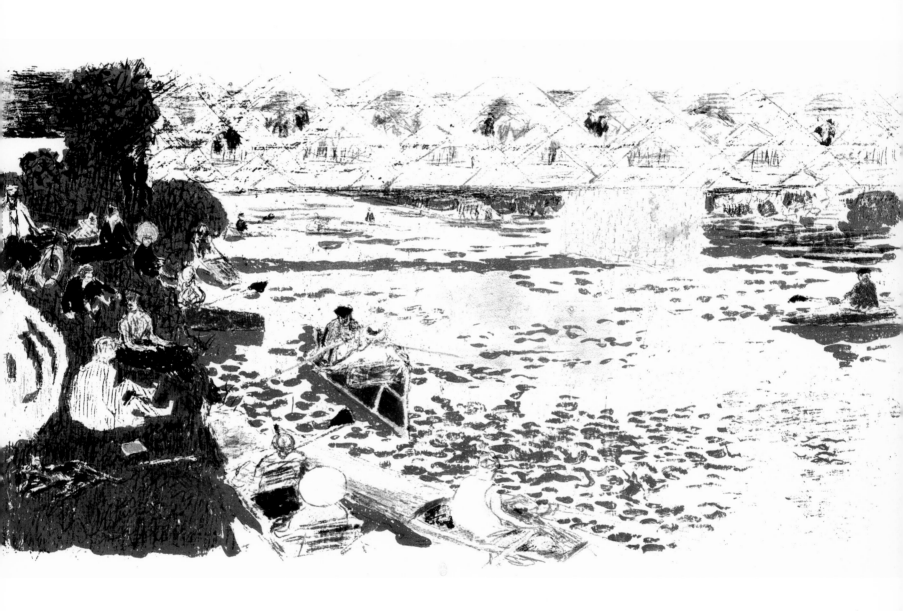

53

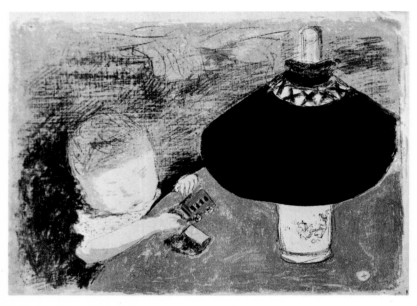

Trial proof with the base of the lamp lightly decorated

<div align="right">

43
Child with Lamp
L'enfant à la lampe

c. 1897

Lithograph printed in five colours 32×45 ($12\frac{5}{8} \times 17\frac{3}{4}$)
Printed in an edition of one hundred, apparently for a third *Album* planned
by Vollard
There exist a few, very rare, proofs of an earlier state, in which the base of
the lamp is white and bears very little decoration (CRM)

Bibliography: TF 26; CRM 43; UJ 19

Projected *Album* not published in the event
Original prints obtained from: P. Bonnard (*Child with Lamp*); P. Cézanne (2); J.-L.
Forain; A. Lunois (2); A. Renoir (2) P. Signac; F. Vallotton; E. Vuillard (cover)

</div>

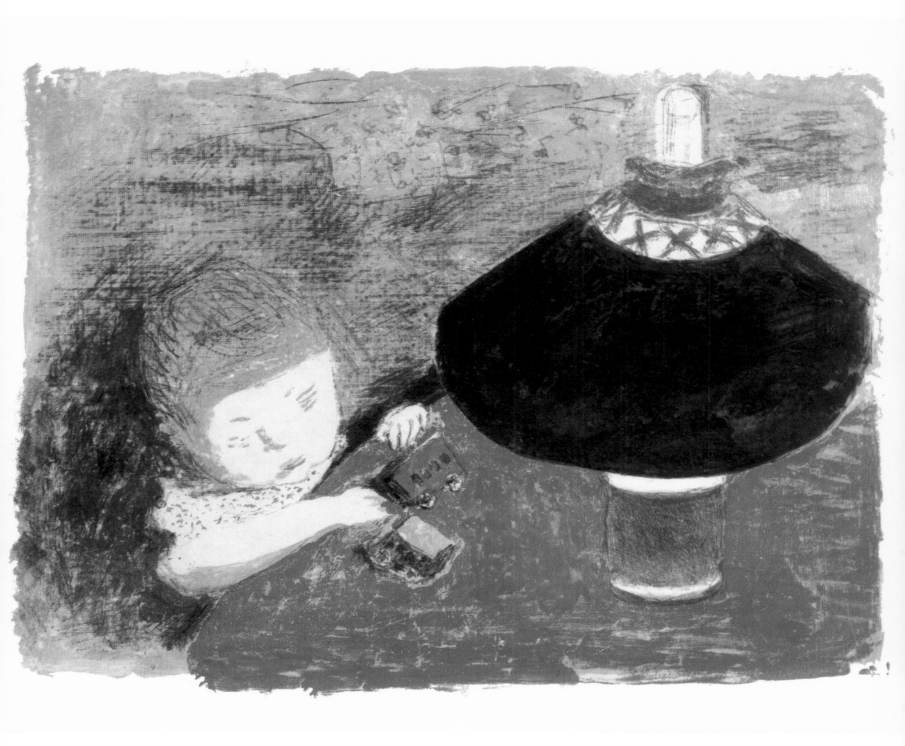

44
L'Estampe et l'affiche

1897

Lithograph printed in three colours 80 × 60 ($31\frac{1}{2}$ × $23\frac{5}{8}$)
Monogram PB, below l.
Poster advertising *L'Estampe et l'affiche*, an arts magazine edited by Clément
Janin and André Mellerio

Bibliography: TF 23; CRM 38

A small preliminary drawing, with heightening, was exhibited by Pierre Berès in
1944 ('L' Œuvre graphique de Bonnard'; catalogue no. 14)

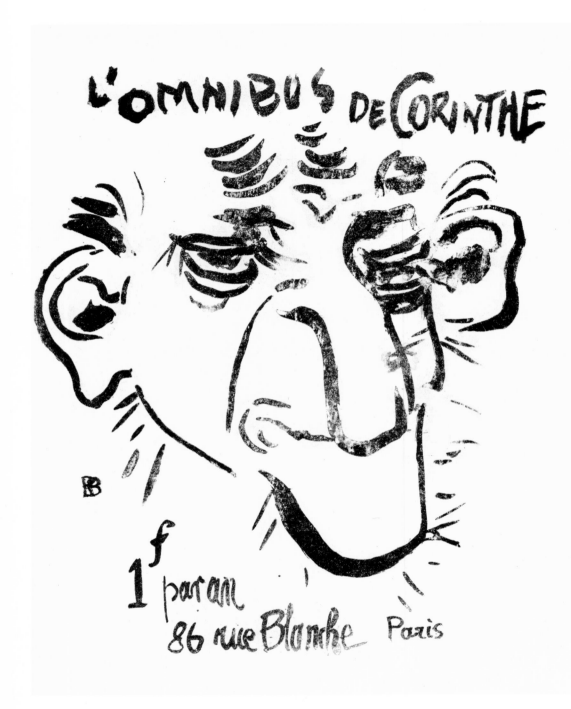

45
L'Omnibus de Corinthe

1897

Lithograph printed in black 32×25 ($12\frac{5}{8} \times 9\frac{7}{8}$)
Monogram PB, below 1.

Bibliography: CRM 37

Produced not, as CRM states, for *La Revue blanche*, but
by the publisher Fernand Clerget, 17 rue Guénégaud,
for a short-lived periodical *L'Omnibus de Corinthe*. Its
full title was: *L'Omnibus de Corinthe, véhicule illustré des
idées générales* (*The Corinth Omnibus, illustrated vehicle for
general ideas*). A quarterly, it announced: 'Departure
every three months'
Six issues of this humorous magazine were published,
from 15 October 1896 to 15 January 1898.
Subscriptions for the year could be taken out by
sending one franc in the form of a 'postal order or
stamp to the editor, 86 rue Blanche'
A 'de luxe-Japanese' edition included (for three francs
per year) 'a bonus or supplement' in the form of a
print. The first, announced in issue no. 3 (15 April
1897), was this lithograph by Bonnard. Later prints
were by Louis Valtat, Désiré Fortoul, Papyrus and
Marc Mouclier
Printed in an edition limited 'to the number of
subscribers'

46–51
Six covers for songs in the *Répertoire des Pantins*

The Théâtre des Pantins was a puppet theatre founded by Alfred Jarry, Franc-Nohain and Claude Terrasse. Bonnard worked with these three in making the marionettes.

The stage was set up in premises owned by Claude Terrasse at 6 rue Ballu. On 20 January 1898, the co-founders gave a performance of *Ubu Roi* (originally presented in 1896 at the Théâtre de l'Œuvre). The programme also included poems by Franc-Nohain, set to music by Terrasse. Other items were added to the repertoire, but the enterprise was short-lived.

The *Echo de Paris* of 1 April 1898 gave the following description of the theatre: 'Rue Ballu, at the back of a courtyard, on the first floor, a mini-theatre for a tiny audience. It is here that Alfred Jarry, with the aid of some ingenious marionettes, has recently staged a revival, lasting a few evenings, of his epic *Ubu*. The auditorium is cramped but is pleasantly decorated by Edouard Vuillard with pyrotechnics of dazzling colour, and by Bonnard with some quite beautifully executed silhouettes in black and grey.'

Alfred Jarry recalled Les Pantins during a conference held at *La libre esthétique* in Brussels in March 1902: 'The little wooden creatures lived in Paris with my friend Claude Terrasse, the well-known musician, and they seemed to enjoy listening to his music. For a year or two Terrasse and I were the Gullivers to these Lilliputians. We controlled them, as is usual, by means of strings, and Franc-Nohain, who had the task of inventing the motto for the Théâtre des Pantins, found nothing better than the obvious: "en avant, par fil" ("forward in single file" – *fil* meaning "file" or "string").'

One of the drawings for Bonnard's album *La vie du peintre* shows the painter in the theatre's auditorium with Claude Terrasse and his friends. In his book, published in 1927, Terrasse gives the following explanation of the scene: 'There is the young composer deep in conversation with Franc-Nohain, together with Jarry who, as usual, is dressed in his cycling clothes. Seated at the table is Bonnard, who is engaged in making one of the marionette figures for *Ubu*. Behind him appears his brother Charles. The Théâtre des Pantins did not survive for very long. Often the audience fell below a reasonable level. But it was a start. And it made everyone laugh . . .'

Bonnard produced the covers for the songs by Franc-Hohain. Alfred Jarry himself designed those for the pieces from *Ubu Roi*.

46
Monsieur Benoît's Lament
La complainte de M. Benoît

1898

Lithograph printed in black 31 × 23.5 (12¼ × 9¼)
Published by the *Mercure de France* for the
Répertoire des Pantins

Bibliography: TF 28; CRM 49

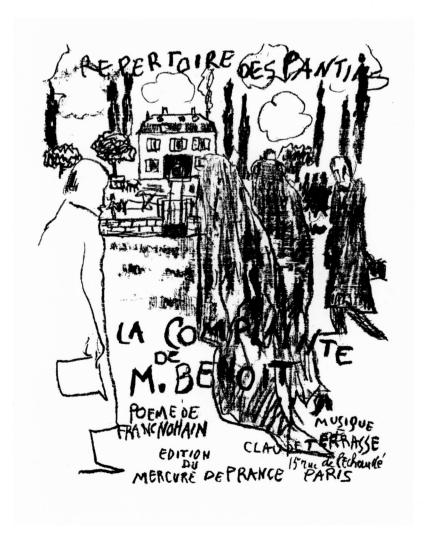

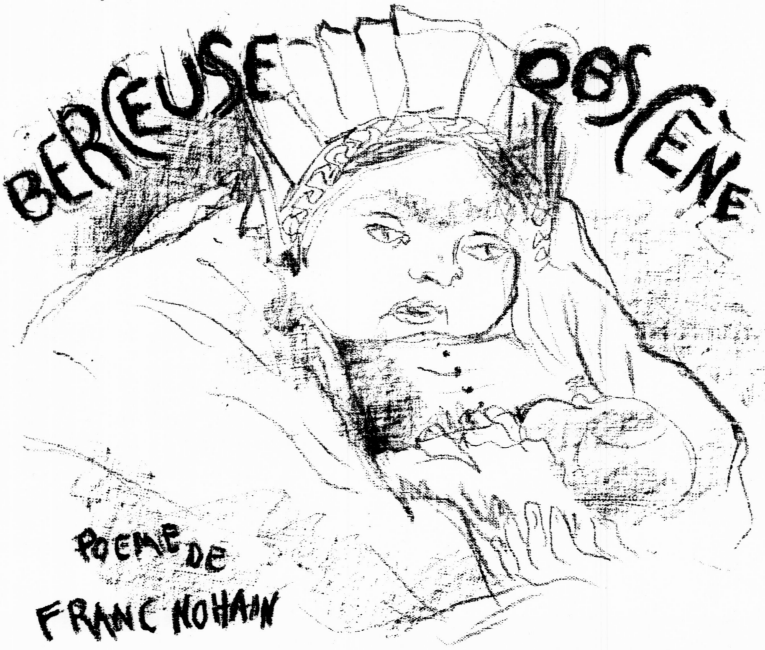

REPERTOIRE DES PANTINS

BERCEUSE OBSCÈNE

POEME DE
FRANC NOHAIN

MUSIQUE DE
CLAUDE TERRASSE

EDITION
DU MERCURE
DE FRANCE

PARIS 15 rue de l'ECHAUDÉ

60

47
Obscene Lullaby
Berceuse obscène

1898

Lithograph printed in black 31 × 25 (12¼ × 9⅞)
Published by the *Mercure de France*
for the *Répertoire des Pantins*

Bibliography: TF 29; CRM 50

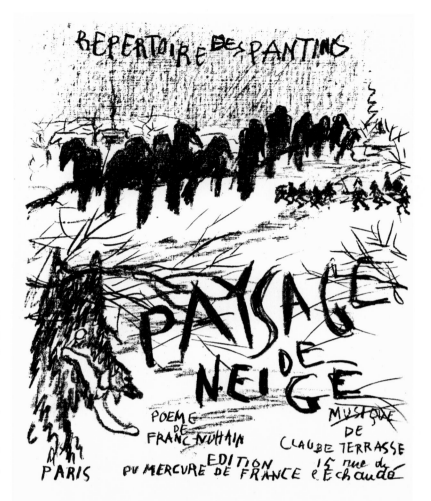

48
Snowscape
Paysage de neige

1898

Lithograph printed in black
32.5 × 26 (12¾ × 10¼)
Published by the *Mercure de France* for the
Répertoire des Pantins

Bibliography: TF 30; CRM 51; UP

49
Three songs 'à la charcutière':
1) The Land of Touraine
Du pays tourangeau

1898

Lithograph printed in black 31 × 25 (12¼ × 9⅞)
Published by the *Mercure de France* for the
Répertoire des Pantins

Bibliography: TF 31; CRM 52

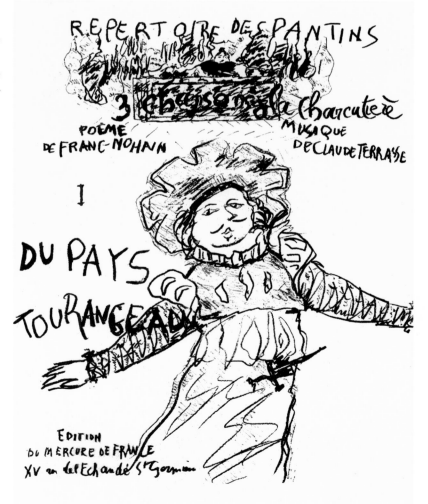

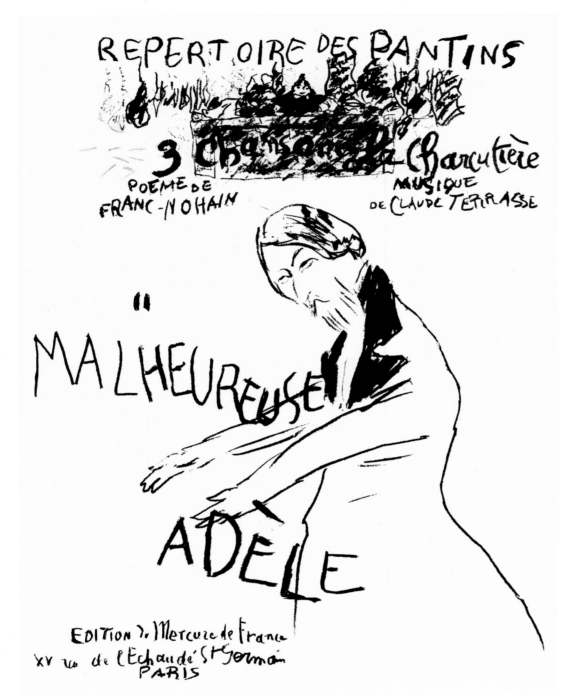

50
Three songs 'à la charcutière':
2) Poor Adèle
Malheureuse Adèle

1898

Lithograph printed in black 31×23 ($12\frac{1}{4} \times 9$)
Published by the *Mercure de France*
for the *Répertoire des Pantins*

Bibliography: TF 32; CRM 53

51
Three songs 'à la charcutière':
3) Velas or the Officer Risen from the
Ranks
Velas ou l'officier de fortune

1898

Lithograph printed in black 31×24 ($12\frac{1}{4} \times 9\frac{1}{2}$)
Published by the *Mercure de France*
for the *Répertoire des Pantins*

Bibliography: TF 33; CRM 54

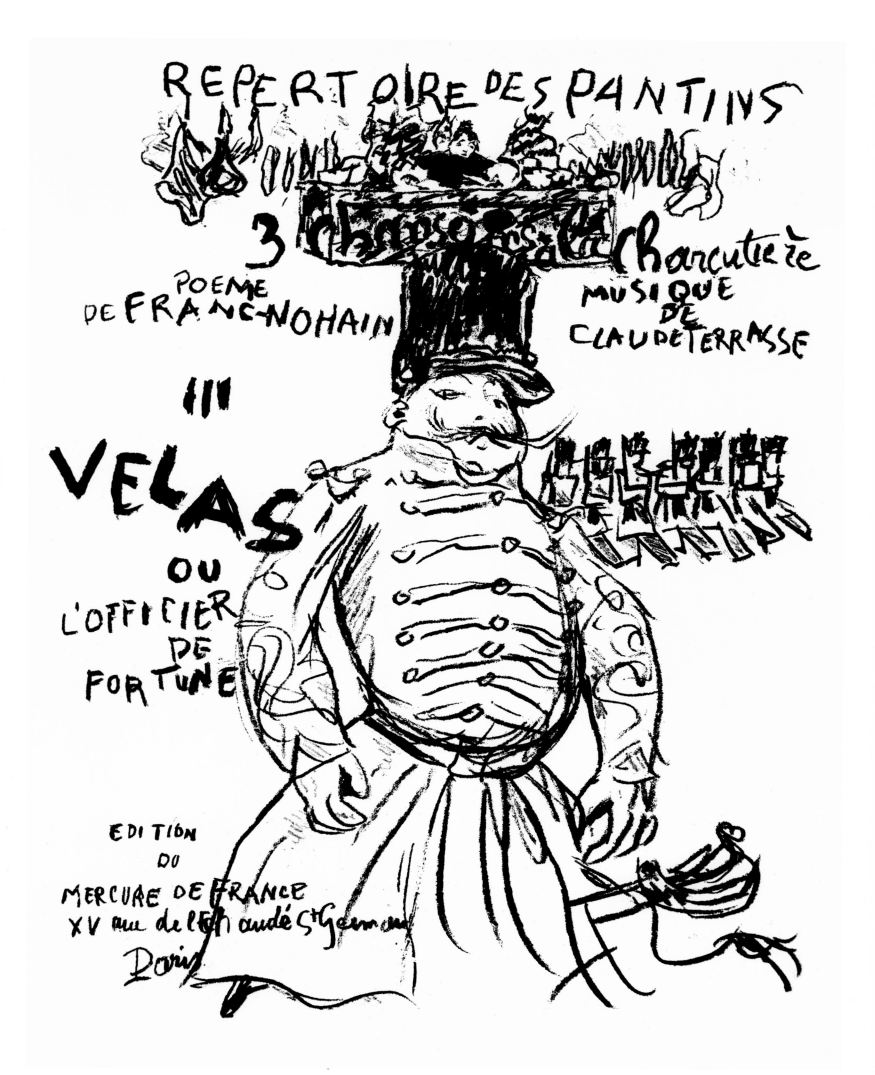

52, 53
La lithographie en couleurs by André Mellerio

Known principally as the biographer of Odilon Redon, to whom he devoted two major works published in 1913 and 1923, André Mellerio was an enthusiastic patron of print-making. From 1895 onwards he was regularly in the company of lithographic artists, and analysed their talents and recorded their experiments in two important studies: *Le mouvement idéaliste en peinture* (1896) and *La lithographie en couleurs* (1898). To further encourage the development of an art he admired, he founded and edited, in collaboration with Clément Janin, the periodical *L'Estampe et l'affiche* (1897 to 1899). 'We in fact concentrated, in 1897, in the periodical *L'Estampe et l'affiche*, on all aspects of lithography and colour engraving', he wrote in 1898.

52
Cover for *La lithographie en couleurs*

1898

Lithograph printed in three colours 21.5 × 19.5 ($8\frac{1}{2} \times 7\frac{5}{8}$)
Cover for the book by André Mellerio
Published by *L'Estampe et l'affiche*, 50 rue Sainte-Anne
Printed in an edition of one thousand, of which: two hundred, numbered, on Holland paper (cover on Japanese paper; frontispiece on China paper; eight hundred on tinted paper
A number of trial proofs of an earlier state exist, printed on antique Japanese paper with wide margins, and with brighter colours

Bibliography: TF 37; CRM 72

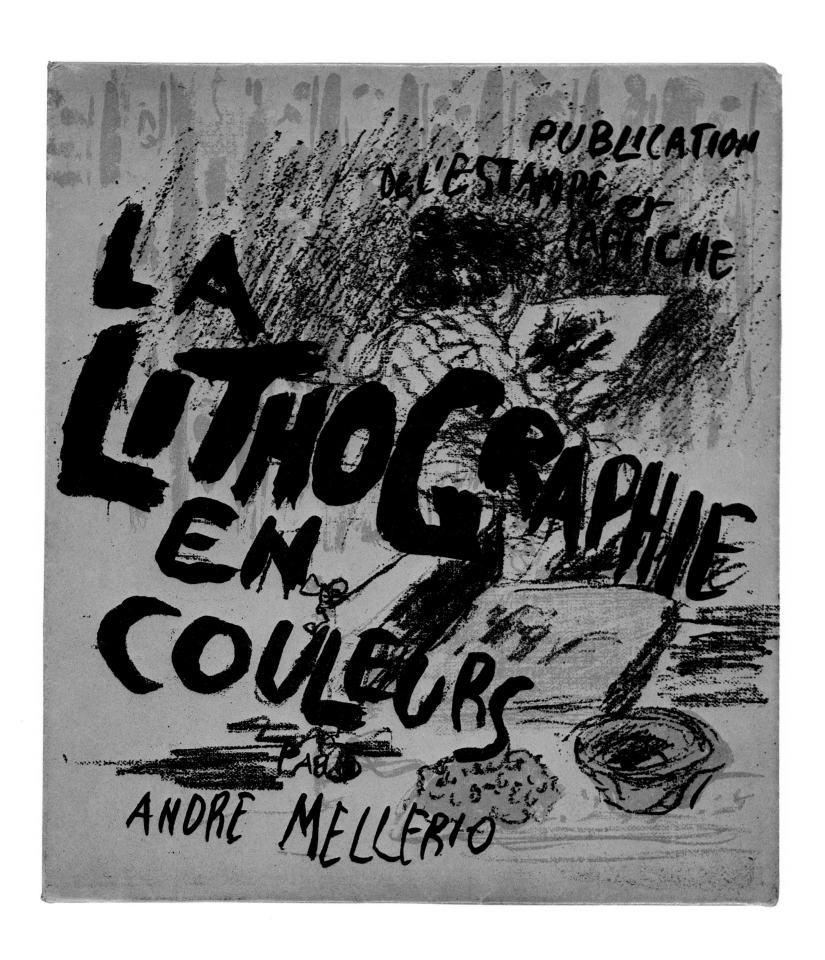

PUBLICATION DE L'ESTAMPE ET L'AFFICHE

LA LITHOGRAPHIE EN COULEURS PAR ANDRE MELLERIO

Frontispiece for *La lithographie en couleurs*

1898

Lithograph printed in four colours 21×19 $(8\frac{1}{4} \times 7\frac{1}{2})$
Frontispiece for the book by André Mellerio, cf. preceding entries
Printed in an edition of one thousand, of which: two hundred on China
paper; eight hundred on tinted paper
Some trial proofs on loose-leaf China paper with wide margins

Bibliography: TF 38; CRM 73

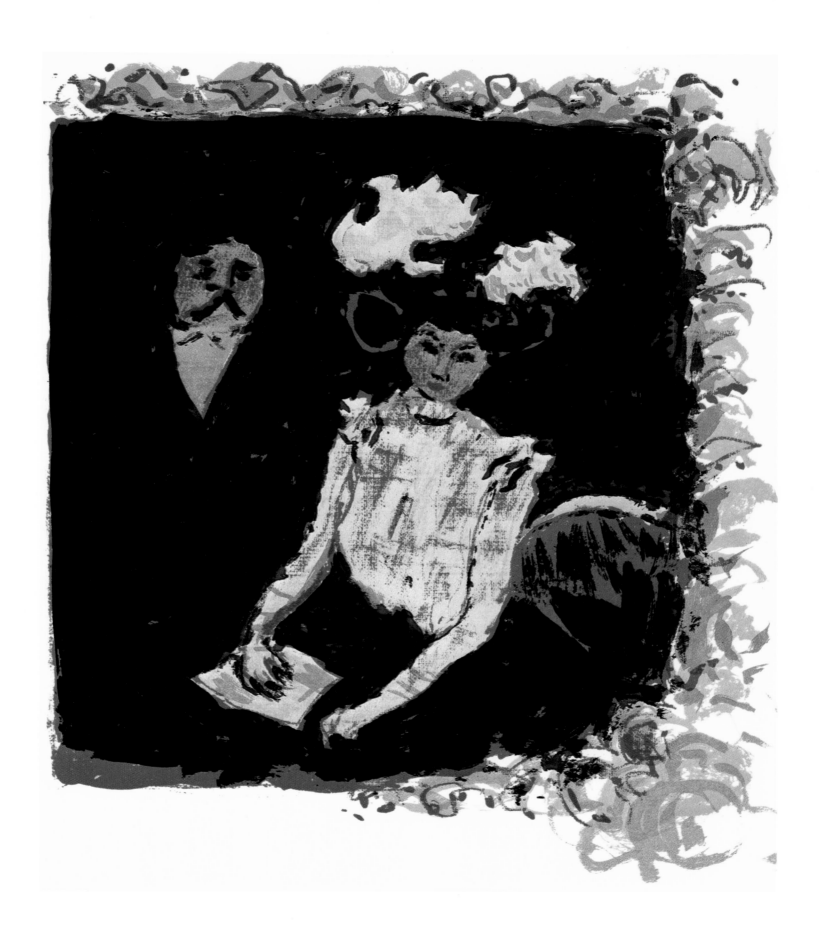

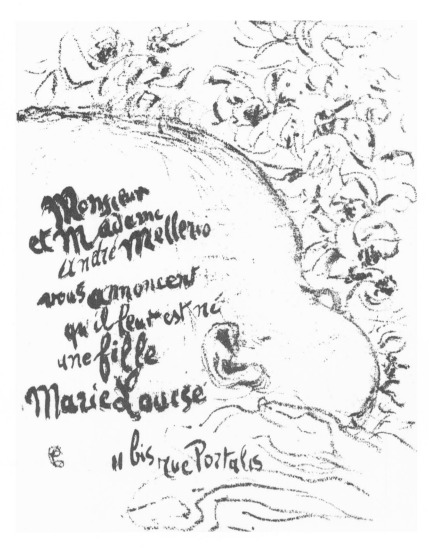

54
Announcement of a birth
Billet de naissance

1898

Lithograph printed in red 16 × 12 (6¼ × 4¾)
Monogram PB, below l.
Announcement of the birth of Marie-Louise Mellerio, daughter of André Mellerio
Printed in an edition of approximately two hundred

Bibliography: TF 36; CRM 36

55
Nannies' Promenade, frieze of carriages
La promenade des nourrices, frise de fiacres

1899

Lithograph printed in five colours 150 × 200 (59 × 79)
Monogram PB, below r. of third panel
Screen with four panels published in Paris in 1899 by Molines, 20 rue Laffitte
Printed in an edition of 110 (some examples mounted, some not)
Bonnard had the idea for this screen in 1894; the version he produced at that time was in size-colouring on canvas, and each panel had a narrow painted border. This earlier example is in an American collection (see the exhibition 'Bonnard et son environnement', New York, 1964; catalogue no. 3, reproduced) and is noted in Dauberville, vol 1, 60

Bibliography: TF 35; CRM 47

A letter from Bonnard to his mother indicates that the setting is the Tuileries, Place de la Concorde

See following pages

Detail at half size

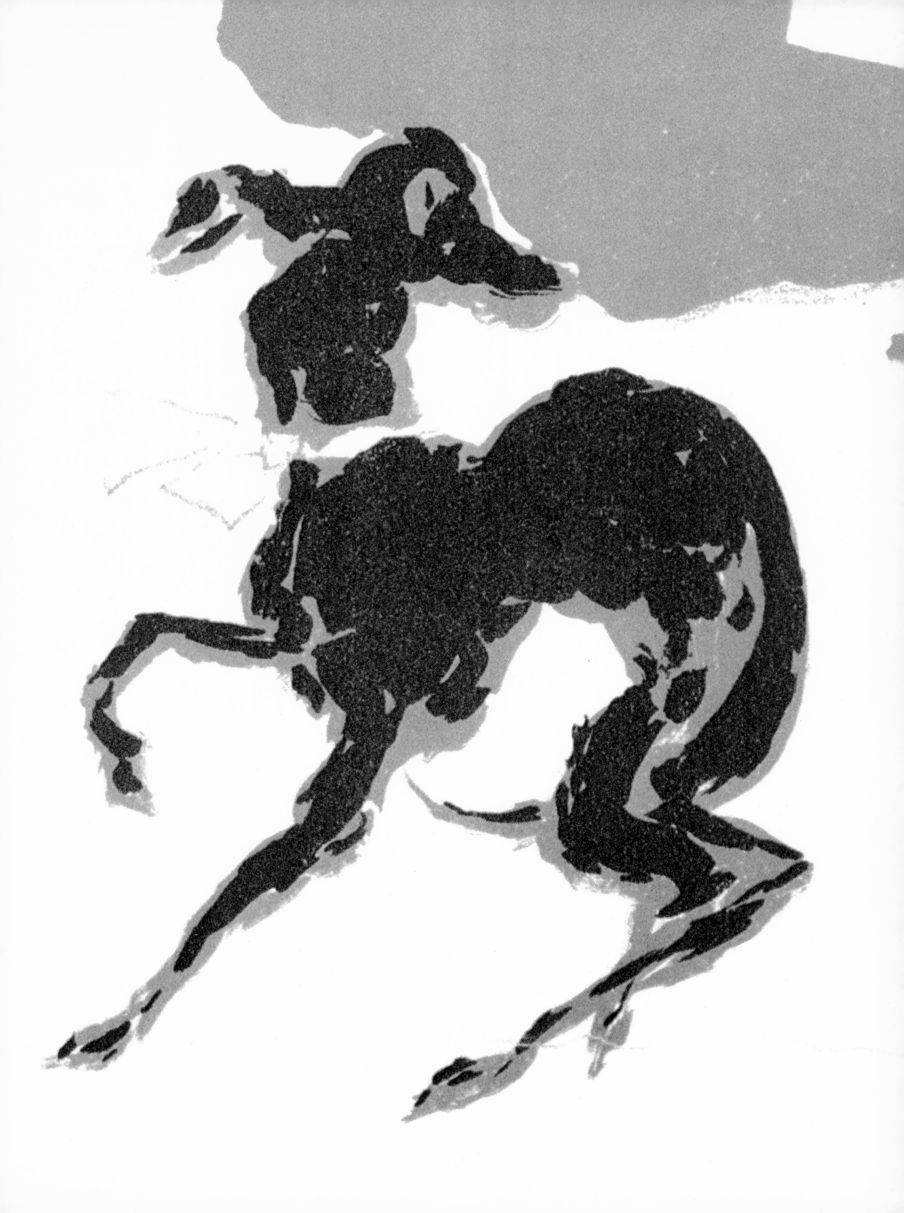

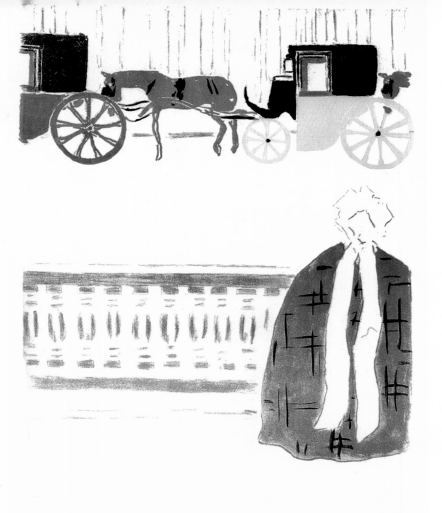
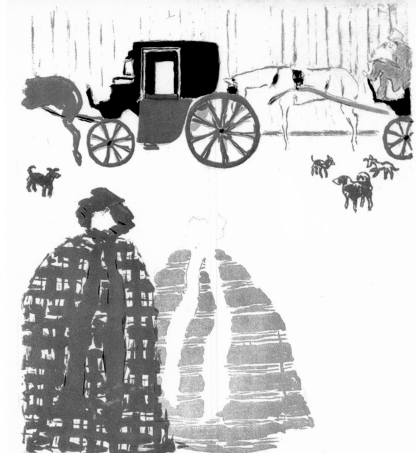

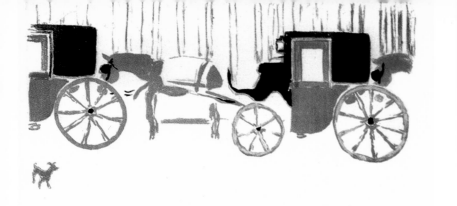
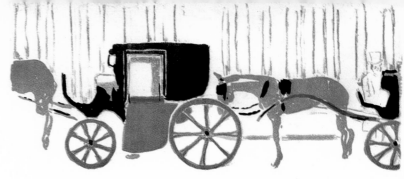
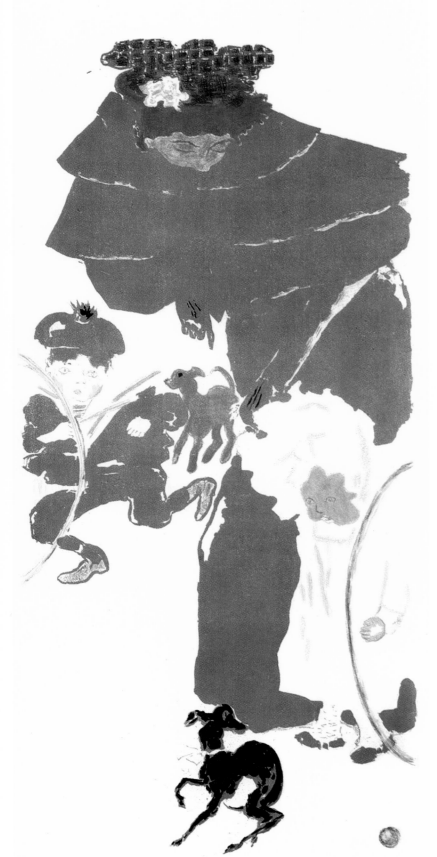
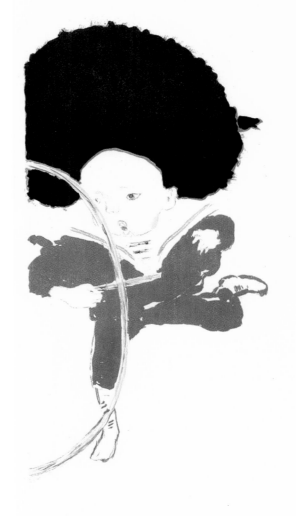

56
The Orchard
Le verger

1899

Lithograph printed in five colours 33 × 35 (13 × 13¾)
Printed in an edition of one hundred, signed and numbered, for the album
Germinal

Bibliography: TF 21; CRM 48

Compare with the painting *The Big Garden* (1898; Dauberville 01788), in which the same figure appears r., carrying a basket of washing. See too the painting *The Orchard* (1895; Dauberville 113)

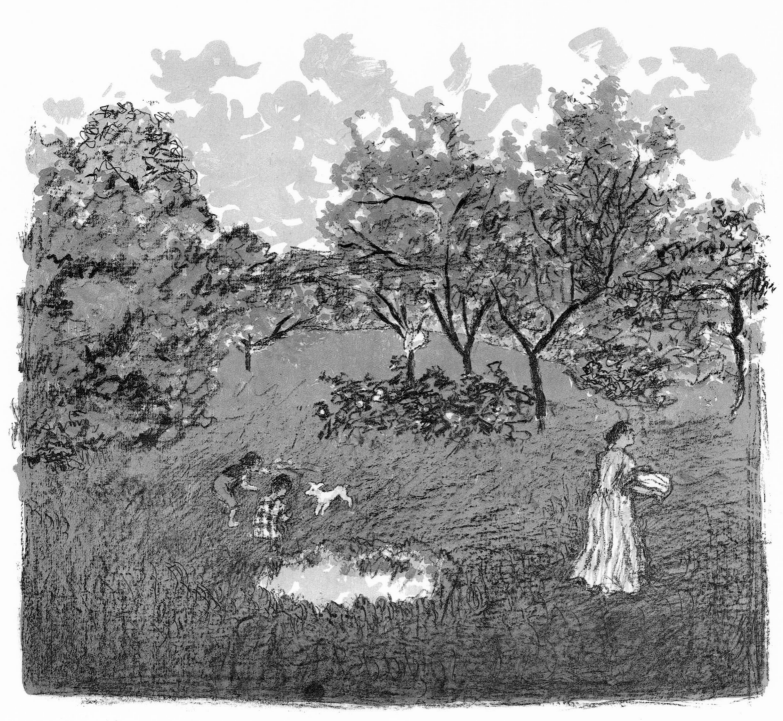

73

57
Panthéon-Courcelles

1899

Lithograph printed in sepia 24 × 18 (9½ × 7⅛)
Printed on an ochre background for the cover, and on a cream background
for the title-page, of a short comedy by Georges Courteline set to music by
Claude Terrasse
Printed by Paul Dupont, 4 rue de Bouloi

Bibliography: TF 39; CRM 55

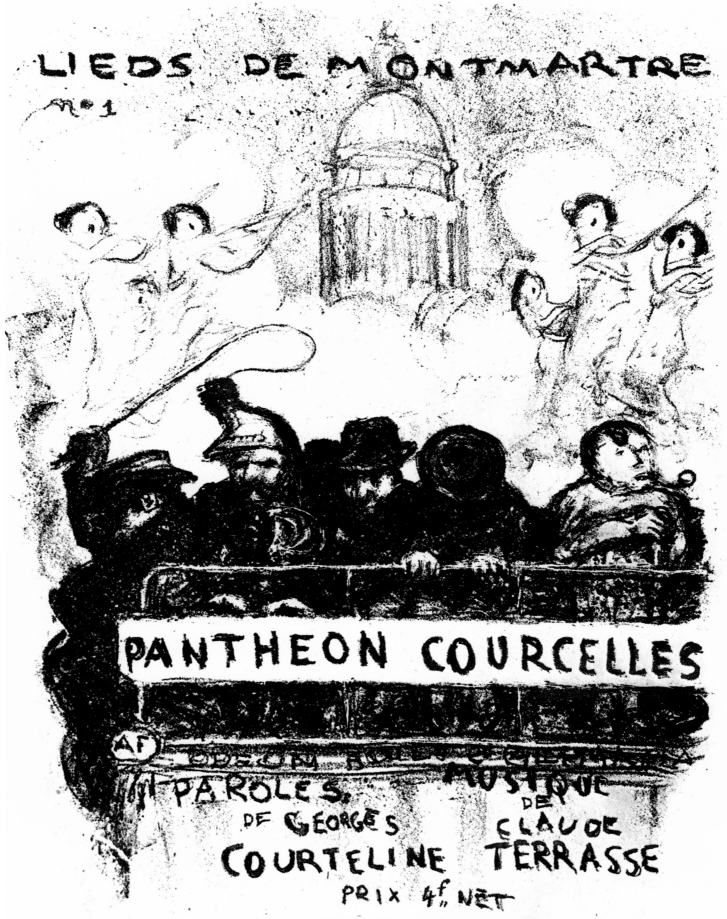

58–70
Some Scenes of Parisian Life
Quelques aspects de la vie de Paris

1899

Series of twelve plates, plus the cover, printed in colour, and of varying dimensions
Exhibited for the first time by Vollard, who published the series in 1899
Plans for the series were in train well before the date of publication – as we learn from the following passage taken from André Mellerio's book *La lithographie en couleurs* (1898): 'At the present time, the ever active Vollard, quite apart from two publications in black and white by Odilon Redon and Fantin-Latour, has in hand four series, each of twelve colour prints, by Bonnard, Vuillard, Denis and Roussel.' The series was not, however, completed until 1899. Again, we learn from the *Petit Almanach du Père Ubu* (January–February–March 1899): 'Vollard, 6, rue Laffitte, has in hand an album of twelve lithographs in colour, *Some Scenes of Parisian Life* by Pierre Bonnard. An album of twelve lithographs in colour by Vuillard. An album of twelve lithographs in colour by Maurice Denis . . .'
Printed by the artist, under the direction of Clot
Printed in an edition of one hundred, of which a few numbered and signed
Several states. Some trial proofs printed in black

Bibliography: TF 16 (1–13); CRM 56–68; UJ 14

Several of these lithographs make use of motifs that have already been used in the paintings. These comparisons are noted under the heading of each individual plate

58
Cover for the album
Couverture de l'album

1899

Lithograph printed in two colours 41 × 33 (16⅛ × 13)

Bibliography: TF 16(1); CRM 56; UJ 14(1)

Some preliminary drawings

59
Avenue du Bois

1899

Lithograph printed in five colours 31 × 46 (12¼ × 18⅛)

Bibliography: TF 16(2); CRM 57; UJ 14(2)

In the series *Some Scenes of Parisian Life*

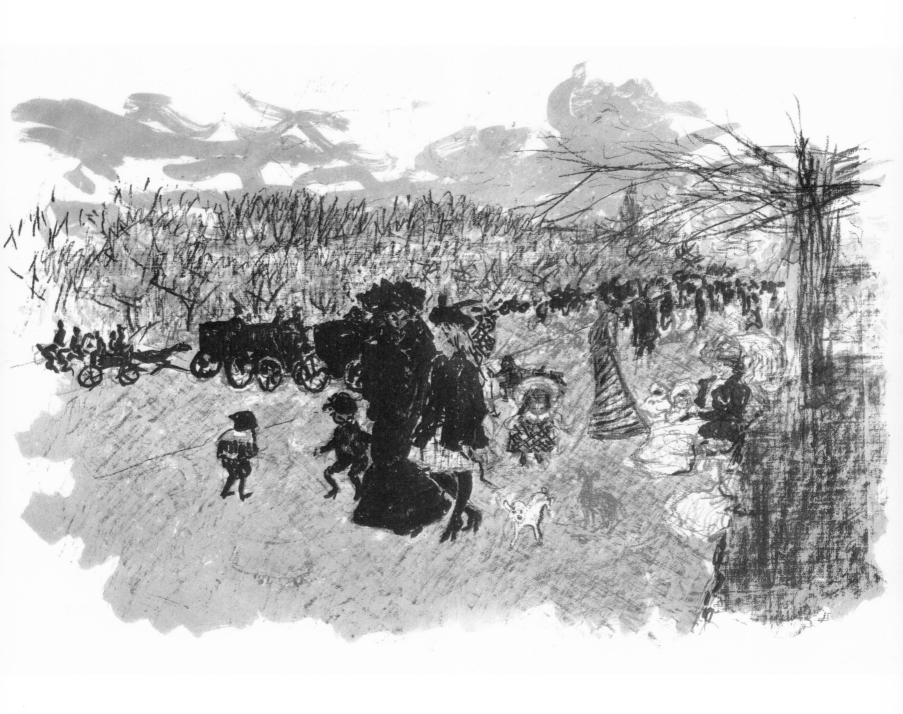

60
Street Corner
Coin de rue

1899

Lithograph printed in four colours 27×35 ($10\frac{5}{8} \times 13\frac{3}{4}$)

Bibliography: TF 16(3); CRM 58; UJ 14(3)

In the series *Some Scenes of Parisian Life*
One preliminary drawing
Compare with the rather similar scene, showing a workman carrying a plank, on the
first l. panel of the triptych *Views of Paris*, Dauberville, 136

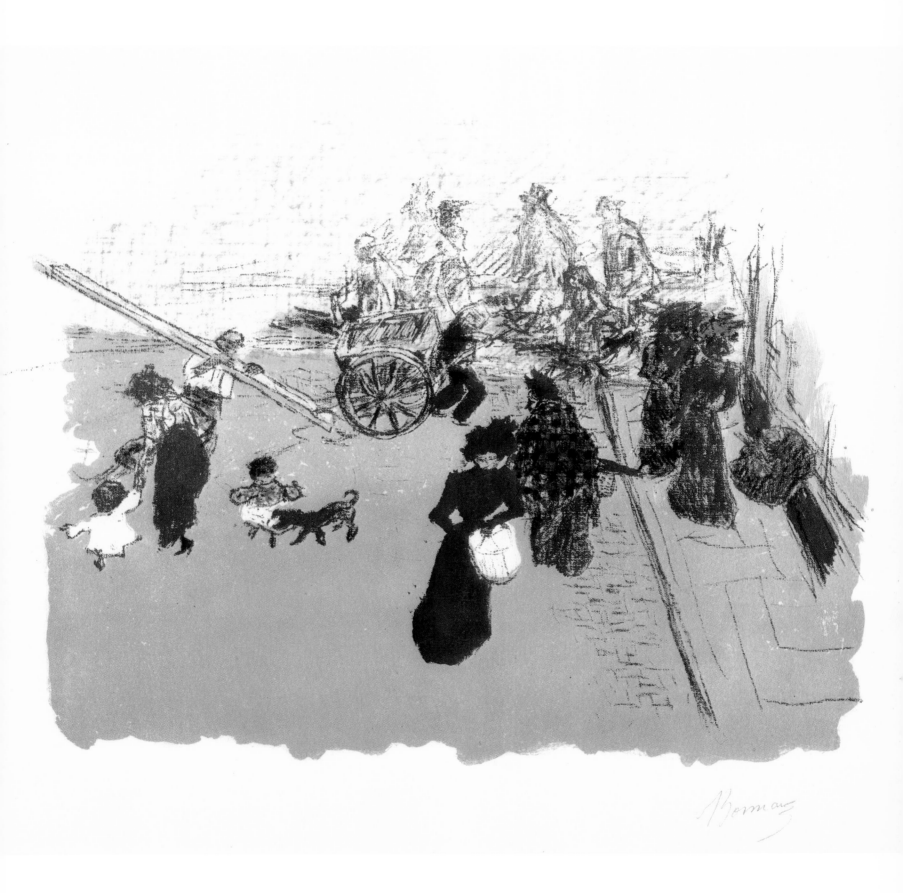

81

61
House in a Courtyard
Maison dans la cour

1899

Lithograph printed in four colours 35 × 26 (13¾ × 10¼)

Bibliography: TF 16(4); CRM 59; UJ 14(4)

In the series *Some Scenes of Parisian Life*
Some trial proofs of an earlier state with less detail on the roofs; a few rare proofs
printed in black
Compare with the paintings *Roofs*, Dauberville 154, and *Rue Tholozé*, Dauberville
155, in respect of certain details

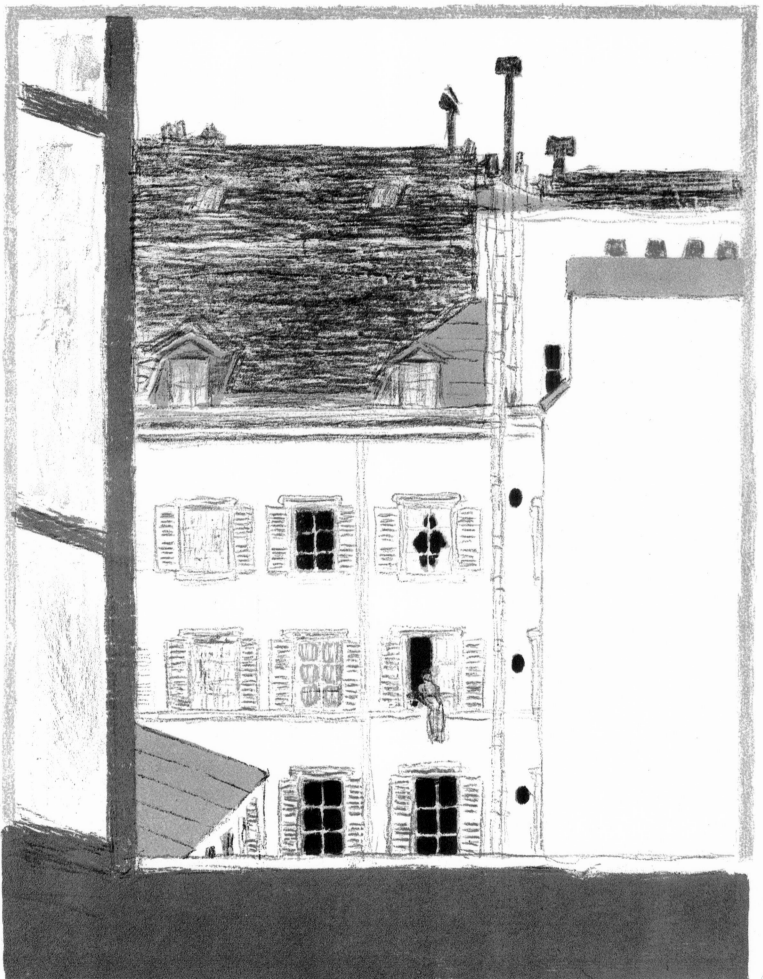

62
Street Scene from above
Rue vue d'en haut

1899
Lithograph printed in four colours 37 × 22 ($14\frac{1}{2}$ × $8\frac{5}{8}$)

Bibliography: TF 16(5); CRM 60; UJ 14(5)

In the series *Some Scenes of Parisian Life*

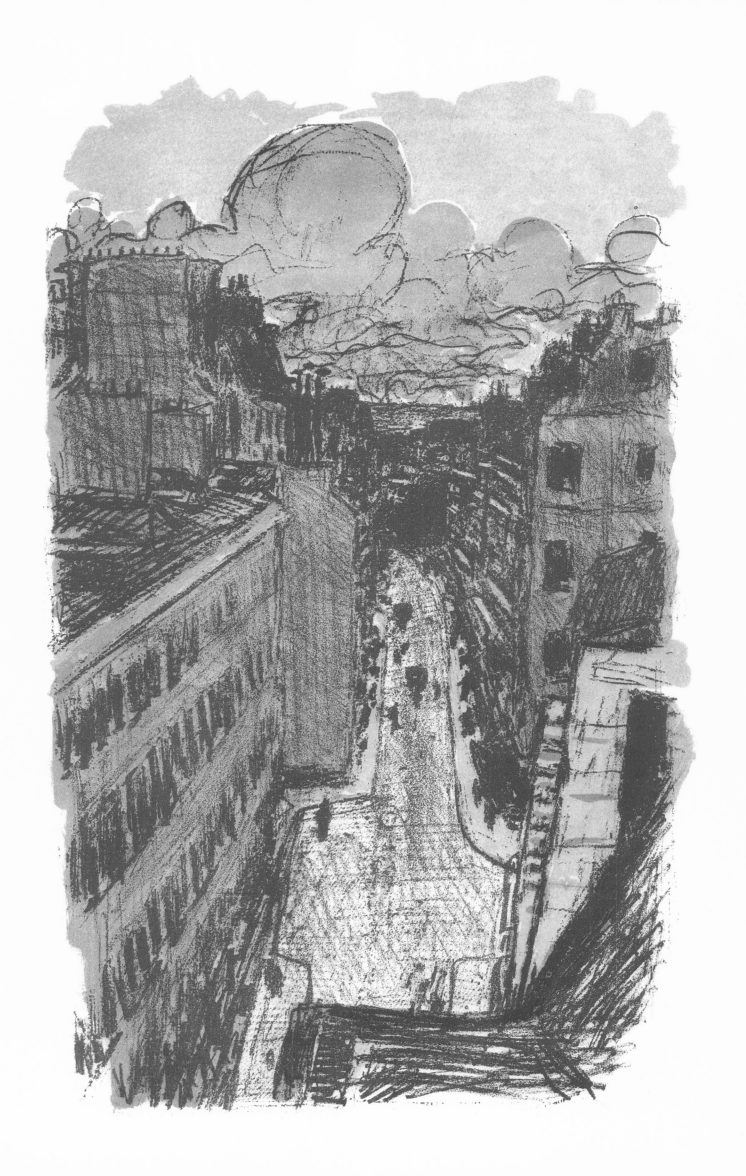

63
Boulevard

1899

Lithograph printed in four colours 17 × 43 ($6\frac{5}{8}$ × $16\frac{7}{8}$)

Bibliography: TF 16(6); CRM 61; UJ 14(6)

In the series *Some Scenes of Parisian Life*
Two or three trial proofs, before the addition of a passer-by
One preliminary drawing, in the Musée National d'Art Moderne, Paris

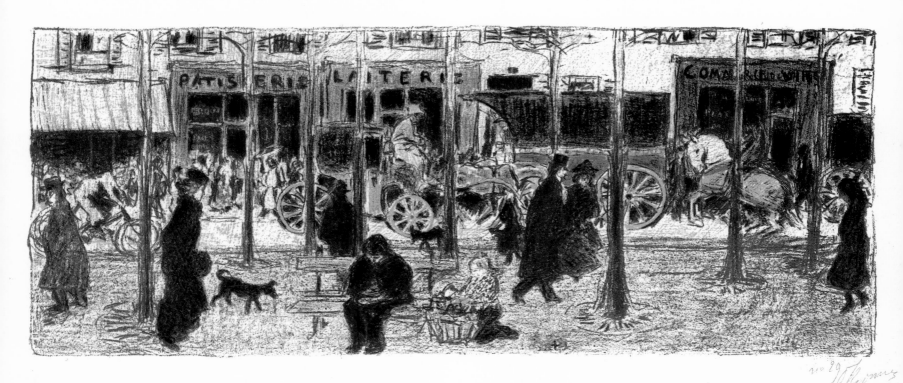

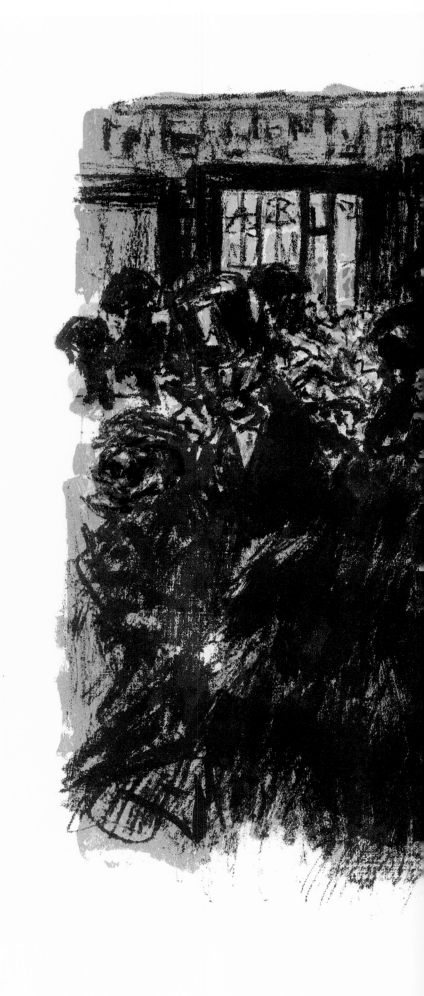

64
The Square at evening
Place le soir

1899

Lithograph printed in four colours 17×43 ($6\frac{5}{8} \times 16\frac{7}{8}$)

Bibliography: TF 16(7); CRM 62; UP; UJ 14(7)

In the series *Some Scenes of Parisian Life*
First state (very rare): mouldings on the shops, above carriage c., in flat tints, with fine horizontal detailing in scraper work extending r. beyond hat of coachman c.; before addition of vertical lines between and at sides of lighted windows c.; before modification of line of frame. Cross used as lay-mark, below c., enclosed within a square of pale colour
Second state (very rare): mouldings on the shops c. represented by broad horizontal lines in dark bistre against a background of pale bistre; vertical lines around lighted windows still absent; line of frame not yet modified. Cross used as lay-mark, below c., still enclosed within a small square of pale colour
Third and final state, printed in an edition of one hundred: four horizontal lines removed from tiling of shop l., above r. of umbrella; vertical lines representing shutters added to sides of lighted windows; further detailing added to cloak of woman in foreground. Cross below no longer appears against a pale ground. Line of frame slightly realigned outwards; minor detailing projecting beyond line now removed above r. and l., and below l.; corners meet at right angles, not rounded
Some trial proofs printed in black. Some preliminary drawings (notably those in the Musée National d'Art Moderne in Paris). One study in watercolour, pastel and Indian ink, dated 1899 (exhibited at the Galerie des Peintres-Graveurs in 1975)

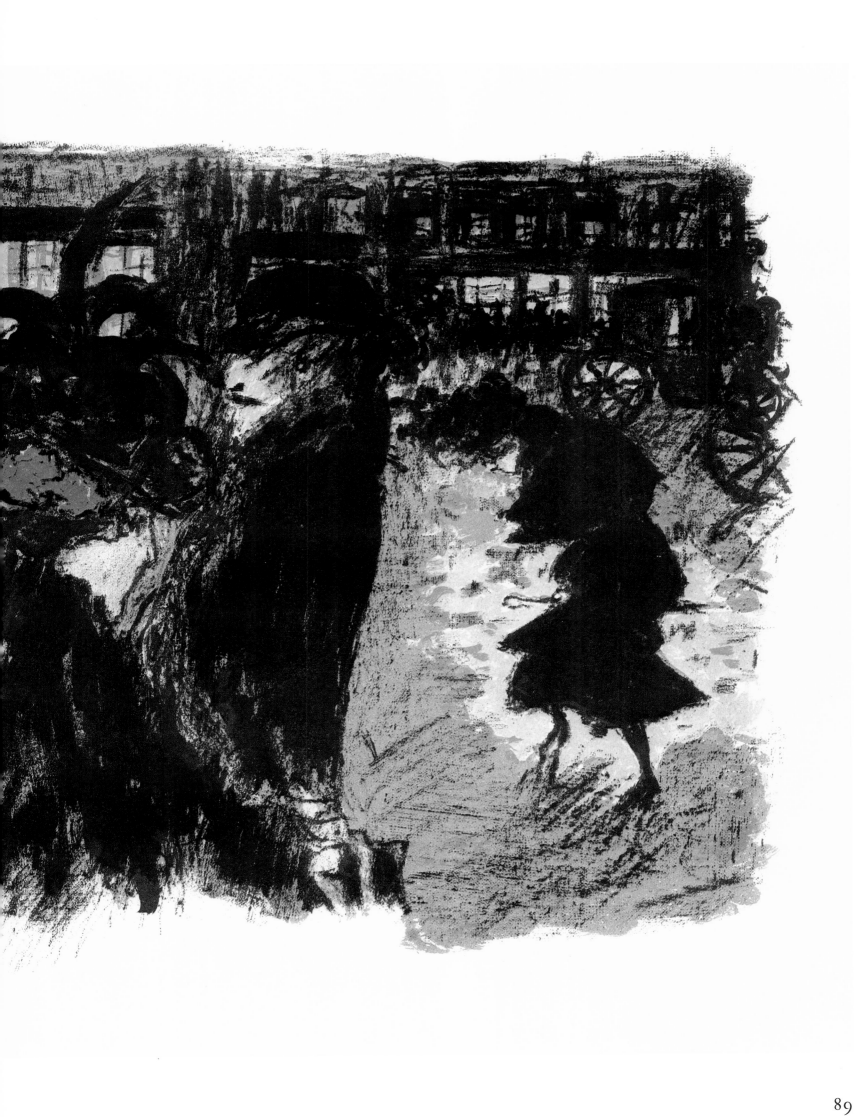

65
The Costermonger
Le marchand des quatre-saisons

1899

Lithograph printed in five colours 29×34 ($11\frac{3}{8} \times 13\frac{3}{8}$)

Bibliography: TF 16(8); CRM 63; UJ 14(8)

In the series *Some Scenes of Parisian Life*
A few rare trial proofs with remarques in margin r. and l.; some proofs printed in black

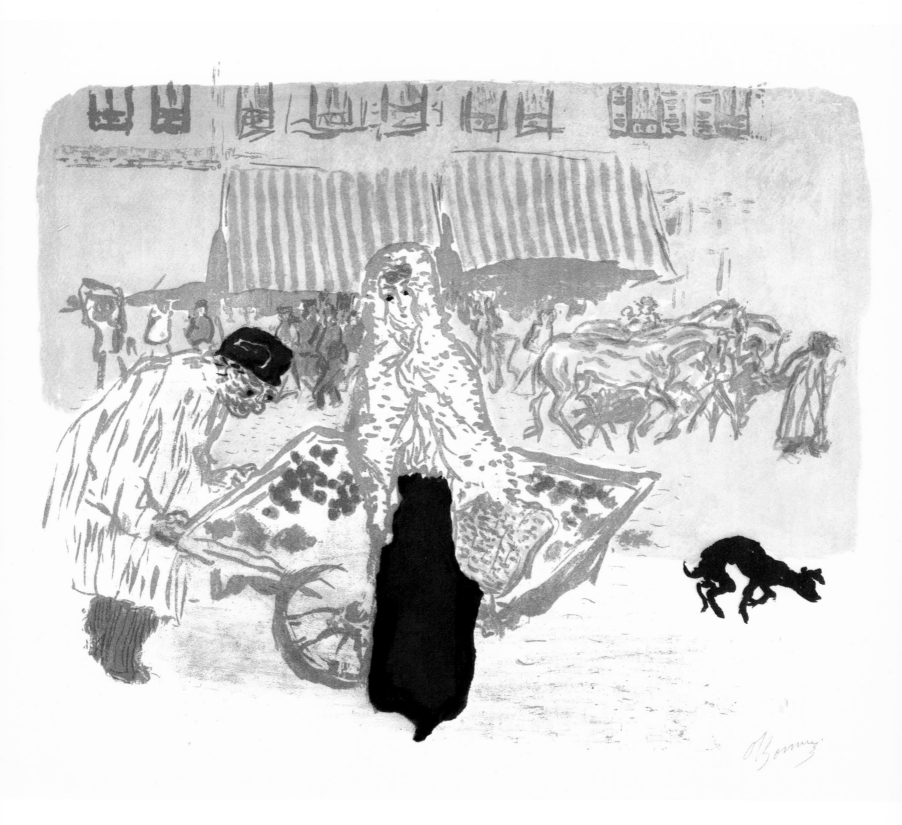

66
The Bridge
Le pont

1899

Lithograph printed in four colours 27 × 41 (10⅝ × 16⅛)

Bibliography: TF 16(9); CRM 64; UJ 14(9)

In the series *Some Scenes of Parisian Life*
Some trial proofs showing variation in the foreground; some trial proofs printed in
black; one preliminary drawing
The title assigned to this lithograph by CRM cannot be correct as the Pont des Arts
is a footbridge

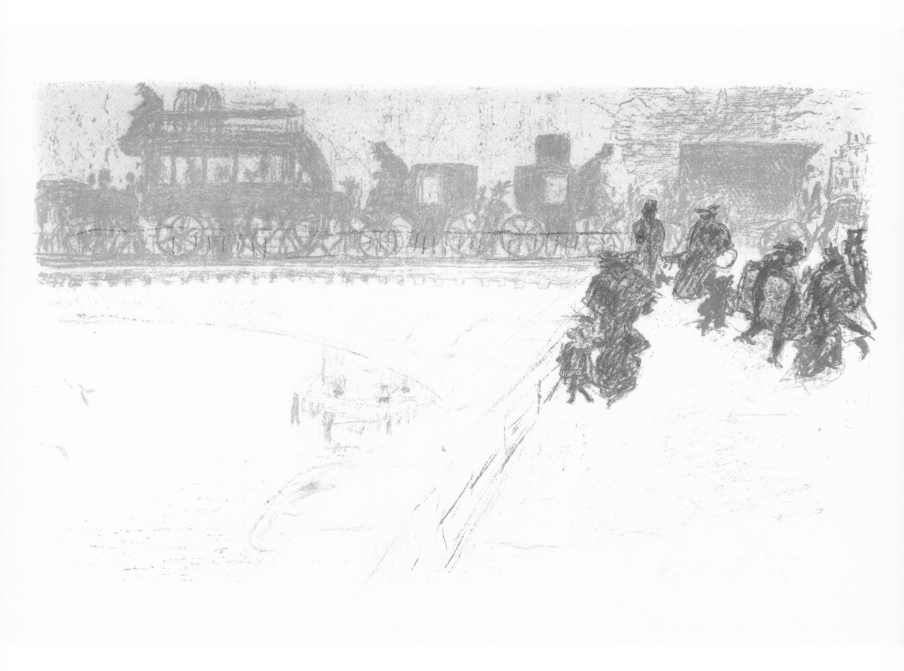

67
At the Theatre
Au théâtre

1899

Lithograph printed in four colours 20×40 ($7\frac{7}{8} \times 15\frac{3}{4}$)

Bibliography: TF 16(10); CRM 65; UJ 14(10)

In the series *Some Scenes of Parisian Life*

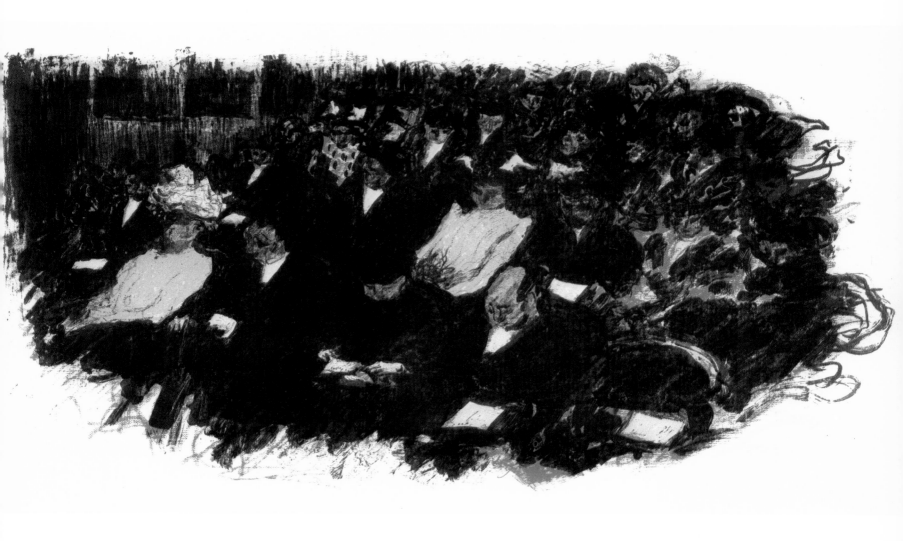

95

68
Rainy Street at evening
Rue, le soir, sous la pluie

1899

Lithograph printed in five colours 23 × 35 (9 × 13¾)

Bibliography: TF 16(11); CRM 66; UJ 14(11)

In the series *Some Scenes of Parisian Life*
Compare with the painting *Place Pigalle at night*, Dauberville 171

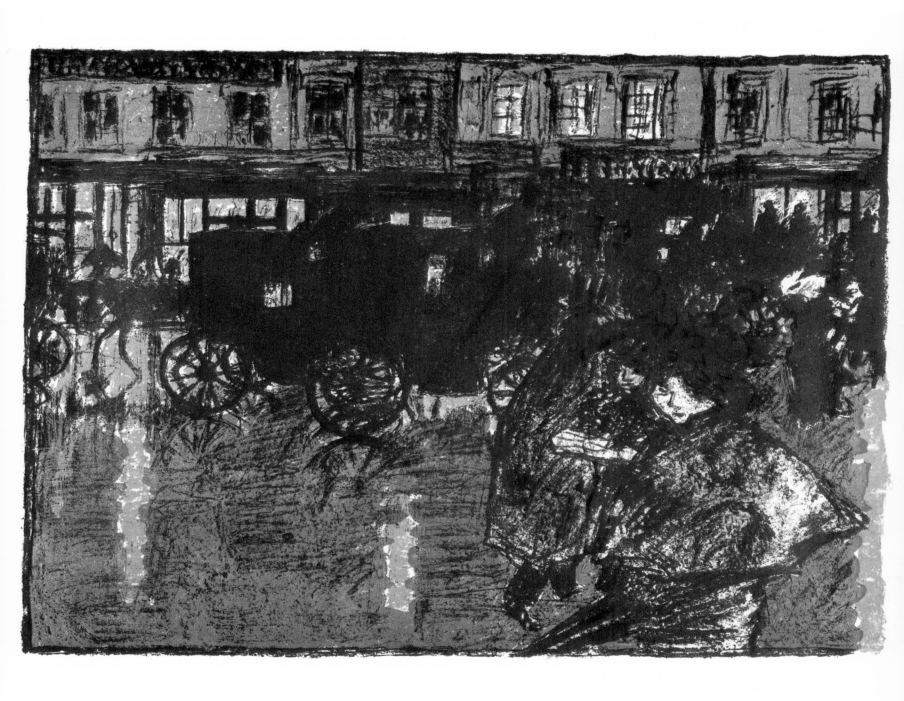

69
The Arc de Triomphe
L'Arc de Triomphe

1899

Lithograph printed in five colours 32×47 ($12\frac{5}{8} \times 18\frac{1}{2}$)

Bibliography: TF 16(12); CRM 67; UJ 14(12)

In the series *Some Scenes of Parisian Life*

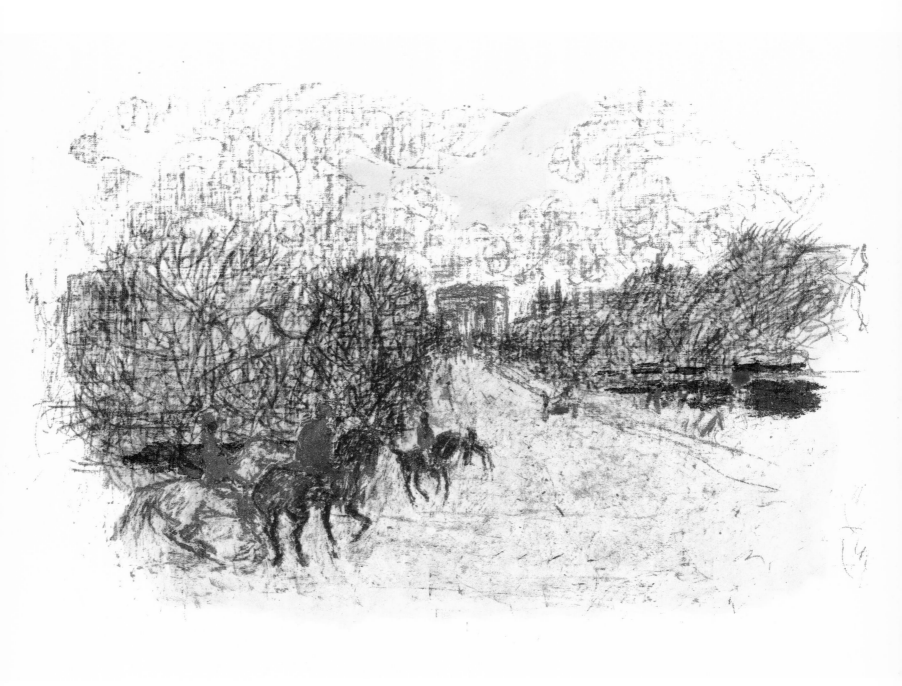

70
Street Corner seen from above
Coin de rue vue d'en haut

1899

Lithograph printed in four colours 36 × 21 (14⅛ × 8¼)

Bibliography: TF 16(13); CRM 69; UJ 14(13)

In the series *Some Scenes of Parisian Life*
Compare with the painting *Narrow Street in Paris* (or *Rue Tholozé*), Dauberville 156

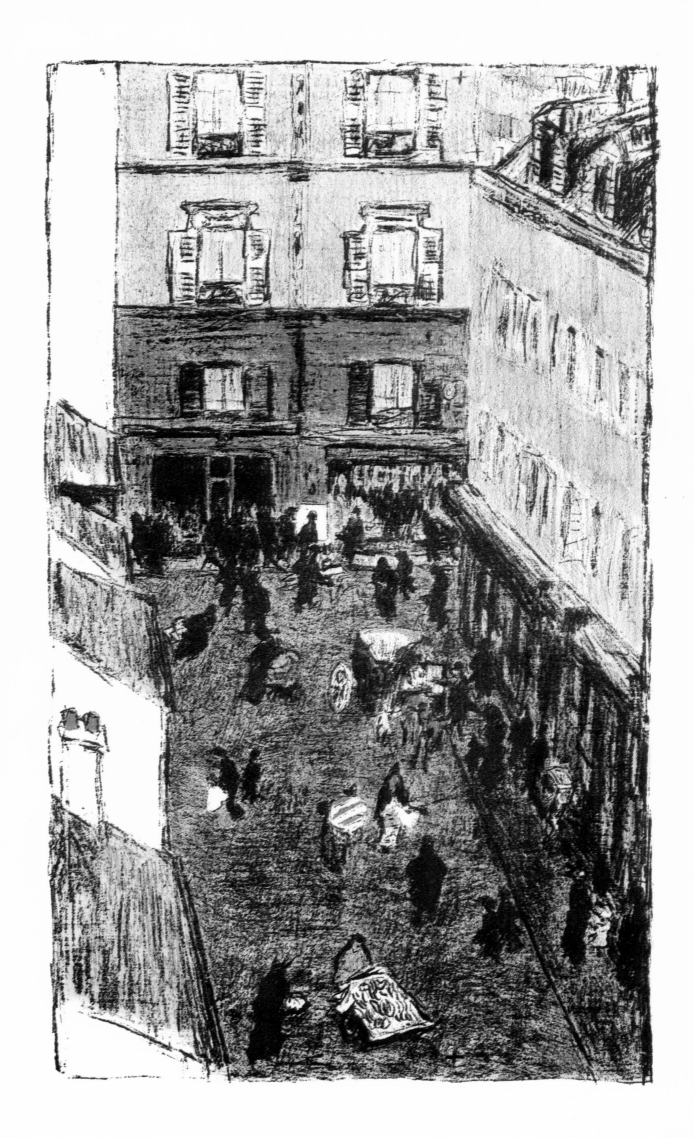

71
In the Street
Dans la rue

c. 1900

Lithograph printed in four colours 26 × 13 (10¼ × 5⅛)
Monogram PB, above l.
Printed in an edition of one hundred, signed and numbered by the artist

Bibliography: TF 17; CRM 46

CRM states, erroneously, that this lithograph was published in the Insel Verlag
album, in Leipzig, in 1900

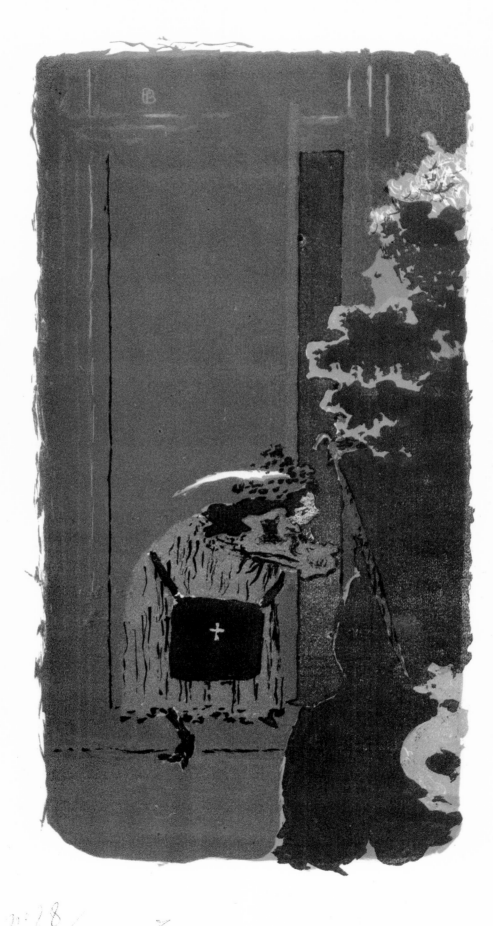

103

The Boulevards
Les boulevards

1900

Lithograph printed in four colours 26×33 ($10\frac{1}{4} \times 13$)
Published in an edition of one hundred for the Insel Verlag, in 1900
Some prints signed

Bibliography: TF 41; CRM 74

Published in *Das Mappenwerk der Insel*, Leipzig, Insel Verlag, 1900
This album was made up of twenty-four original plates by: P. Baum; P. Bonnard
(*The Boulevards*); F. Brangwyn; E. Delâtre; M. Denis; J. Ensor; W. Laage; W.
Nicholson; A. Rodin; H. Thoma; E. Vuillard; H. Vogeler; E. R. Weiss

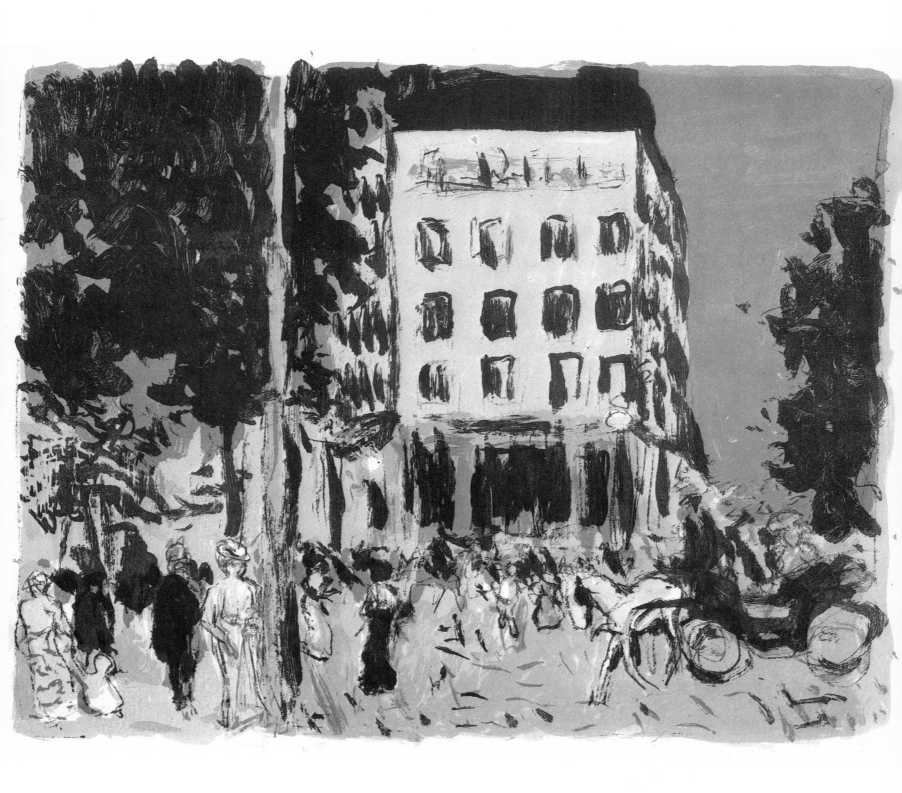

1900

109 lithographs and 9 wood-cuts (engraved by Tony Beltrand after drawings by Bonnard); illustrations for the poems of Paul Verlaine
Dimensions of book: 30.5 × 25 (12 × 9⅞)
Printed at the Imprimerie Nationale, Paris. Lithographs printed by Clot.
Editor: Ambroise Vollard
Book printed in an edition of 200, numbered, of which: ten on China paper with lithographic sequence (1–10); twenty on China paper without lithographic sequence (11–30); 170 on Holland wove paper (31–200)
The original stones have been cancelled
Lithographs printed in pink sanguine; some rare examples with a supplementary plate in bistre

Two covers: one, very rare, bearing the vignette of the Imprimerie Nationale; the other, a supplementary lithograph to replace the official stamp. 'As the Ministry of Justice judged it indecent for the official Minerva to lend patronage to such a free work, a new cover, with an illustration by Bonnard, was substituted for the earlier version . . .' (CRM)
'It is hardly surprising that Ambroise Vollard thought of Bonnard to illustrate Verlaine's *Parallèlement*. He knew already the artist's drawings for *Marie*; and he had seen the painting *Indolence*, a drawing of which is in fact included in this work, at the group exhibition organized by Durand-Ruel in May 1899. Bonnard invented a very free style of composition to complement Verlaine's poems; the lithographs stray into and around the verses themselves and curve out again into the margins, voluptuous and tender images whose powers of suggestion miraculously enhance the poet's art. "I wanted the lithographs to be in pink," the painter was to say, "because it allowed me to convey more of the poetic atmosphere of Verlaine." Unfortunately the book was a total disaster when it appeared in September 1900. It was criticized for its freedom of composition and its unconventional layout, and even for its use of lithographs at a time when wood engraving was still preferred. Vollard, however, was delighted and, far from

discouraged, commissioned a second book.' (See *Pierre Bonnard*, Editions Gallimard, pp. 61 and 63)
'Vollard, who was the friend of all the best painters of his day, spared nothing in his efforts to publish Verlaine's *Parallèlement* in a magnificent edition: an imposing format, impressive lithographs, the large and elegant Garamond italic type, recently recast by the Imprimerie Nationale; and finally, the prominent role played by the illustrations. On each page, the tender and sensual lithographs, which prompted Cézanne to remark that they were "the work of a draughtsman", overflow their boundaries and pour into the margins, pink as the early light of morning, marking indelibly the dawn of the twentieth century in the history of the printed book.' (Jacques Guignard, *Le Livre*, Editions de Chêne, 1942)
For these drawings Pierre Bonnard drew heavily on certain of his paintings, notably for some of the nudes – the face of Marthe de Méligny (Marie Boursin), the model who became his life's companion, is often recognizable. See *Indolence* (Dauberville 219; 01802; 01803); *Nude with Black Stockings* (Dauberville 01829); *Man and Women* (Dauberville 224)
As part of his preparation for this work Bonnard took a number of photographs of Marthe. For the scenes set in the eighteenth century, he used ideas derived from the characters of Watteau, as he had seen them in *Gilles, Assembly in a Park*, the *Embarkation for the Island of Cythera* and the *Enseigne de Gersaint*
Some editions of the book included an original drawing
There are two quite exceptional editions, one belonging to Ambroise Vollard and the other the property formerly of Dr A. Roudinesco, each of which comprises the series of lithographs only, together with nine rejected lithographs, printed in sanguine; also a series of seventy-seven lithographs specially printed on black China paper. (See the catalogue for the Vente Roudinesco, Hôtel Drouot, 30 May 1967, catalogue no. 178)

Bibliography: TF 40; Marguette Bouvier, *Comœdia*, 23 January 1943; AS 21; CRM 94

PAUL VERLAINE

—

PARALLÈLEMENT

—

LITHOGRAPHIES ORIGINALES
DE PIERRE BONNARD

PARIS
IMPRIMERIE NATIONALE
—
AMBROISE VOLLARD, ÉDITEUR
RUE LAFFITTE, 6

MDCCCC

IMPRIMÉ PAR DÉCISION SPÉCIALE
DE M. LE GARDE DES SCEAUX, MINISTRE DE LA JUSTICE

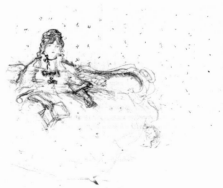

PARALLÈLEMENT

JUSTIFICATION DU TIRAGE.
———

DEUX CENTS EXEMPLAIRES NUMÉROTÉS.

Nᵒˢ 1 à 10 sur chine chine, avec une suite de toutes les planches sans le texte.
Nᵒˢ 11 à 30 sur chine chine.
Nᵒˢ 31 à 200 sur vélin de Hollande.

Toutes les planches ont été détruites.

———

Nᵒ 128

DÉDICACE.

Vous souvient-il, cocodette un peu mûre,
Qui gobergez vos flemmes de bourgeoise,
Du temps joli quand, gamine un peu sure,
Tu m'écoutais, blanc-bec fou qui dégoise?

Gardâtes-vous fidèle la mémoire,
O grasse en des jerseys de poult-de-soie,
De t'être plu jadis à mon grimoire,
Cour par écrit, postale petite oye?

Avez-vous oublié, Madame Mère,
Non, n'est-ce pas, même en vos bêtes fêtes,
Mes fautes de goût, mais non de grammaire,
Au rebours de tes chères lettres bêtes?

Et quand sonna l'heure des justes noces,
Sorte d'Ariane qu'on me dit lourde,
Mes yeux gourmands & mes baisers féroces,
A tes nennis faisant l'oreille sourde?

Rappelez-vous aussi, s'il est loisible
A votre cœur de verve mal morose,
Ce moi toujours tout prêt, terrible, horrible,
Ce toi mignon prenant goût à la chose,

Et tout le train, tout l'entrain d'un manège
Qui par malheur devint notre ménage,
Que n'avez-vous, en ces jours-là, que n'ai-je
Compris les torts de votre & de mon âge!

C'est bien fâcheux: me voici, lamentable
Épave éparse à tous les flots du vice,
Vous voici, toi, coquine détestable,
Et ceci fallait que je l'écrivisse!

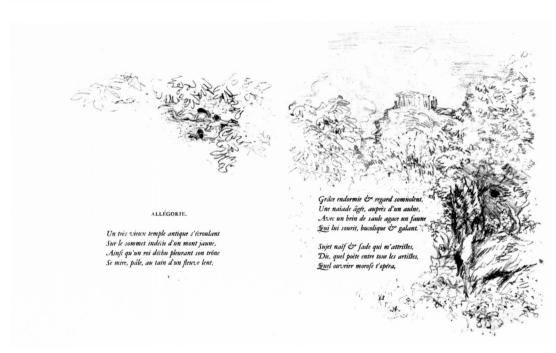

ALLÉGORIE.

Un très vieux temple antique s'écroulant
Sur le sommet indécis d'un mont jaune,
Ainsi qu'un roi déchu pleurant son trône
Se mire, pâle, au tain d'un fleuve lent;

Grâce endormie & regard somnolent,
Une naïade âgée, auprès d'un aulne,
Avec un brin de saule agace un faune
Qui lui sourit, bucolique & galant.

Sujet naïf & fade qui m'attristes,
Dis, quel poète entre tous les artistes,
Quel ouvrier morose t'opéra,

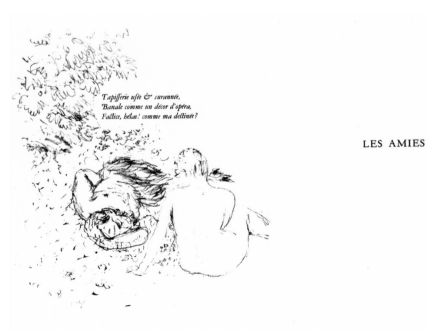

Tapisserie usée & surannée,
Banale comme un décor d'opéra,
Factice, hélas! comme ma destinée?

LES AMIES

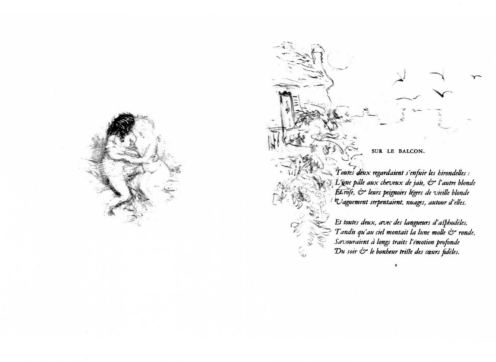

SUR LE BALCON.

Toutes deux regardaient s'enfuir les hirondelles :
L'une pâle aux cheveux de jais, & l'autre blonde
Et rose, & leurs peignoirs légers de vieille blonde
Vaguement serpentaient, nuages, autour d'elles.

Et toutes deux, avec des langueurs d'asphodèles,
Tandis qu'au ciel montait la lune molle & ronde,
Savouraient à longs traits l'émotion profonde
Du soir & le bonheur triste des cœurs fidèles.

Telles, leurs bras pressant, moites, leurs tailles souples,
Couple étrange qui prend pitié des autres couples,
Telles, sur le balcon, rêvaient les jeunes femmes.

Derrière elles, au fond du retrait riche & sombre,
Emphatique comme un trône de mélodrame
Et plein d'odeurs, le Lit, défait, s'ouvrait dans l'ombre.

PENSIONNAIRES.

L'une avait quinze ans, l'autre en avait seize;
Toutes deux dormaient dans la même chambre.
C'était par un soir très lourd de septembre :
Frêles, des yeux bleus, des rougeurs de fraise;

Chacune a quitté, pour se mettre à l'aise,
La fine chemise au frais parfum d'ambre.
La plus jeune étend les bras, & se cambre,
Et sa sœur, les mains sur ses seins, la baise.

Puis tombe à genoux, puis devient farouche
Et tumultueuse & folle, & sa bouche
Plonge sous l'or blond, dans les ombres grises;

Et l'enfant, pendant ce temps-là, recense
Sur ses doigts mignons des valses promises,
Et, rose, sourit avec innocence.

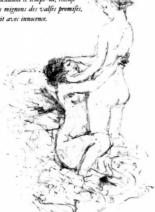

PER AMICA SILENTIA.

Les longs rideaux de blanche mousseline
Que la lueur pâle de la veilleuse
Fait fluer comme une vague opaline
Dans l'ombre mollement mystérieuse,

Les grands rideaux du grand lit d'Adeline
Ont entendu, Claire, ta voix rieuse,
Ta douce voix argentine et câline
Qu'une autre voix enlace, furieuse.

«Aimons, aimons!» difaient vos voix mêlées,
Claire, Adeline, adorables victimes
Du noble vœu de vos âmes sublimes.

Aimez, aimez! ô chères Effeulées,
Puifqu'en ces jours de malheur, vous encore,
Le glorieux Stigmate vous décore.

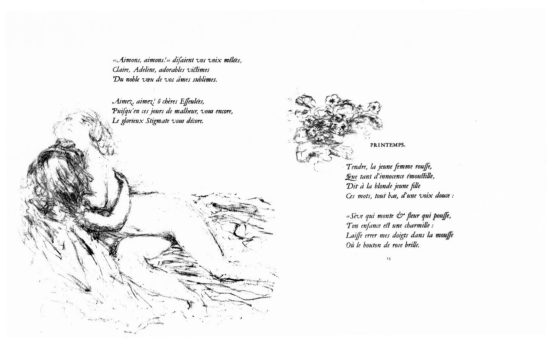

PRINTEMPS.

Tendre, la jeune femme roufse,
Que tant d'innocence émoustille,
Dit à la blonde jeune fille
Ces mots, tout bas, d'une voix douce :

«Sève qui monte & fleur qui poufse,
Ton enfance eft une charmille :
Laifse errer mes doigts dans la moufse
Où le bouton de rose brille.

13

«Laifse-moi, parmi l'herbe claire,
Boire les gouttes de rofée
Dont la fleur tendre eft arrofée,

«Afin que le plaifir, ma chère,
Illumine ton front candide
Comme l'aube l'azur timide.»

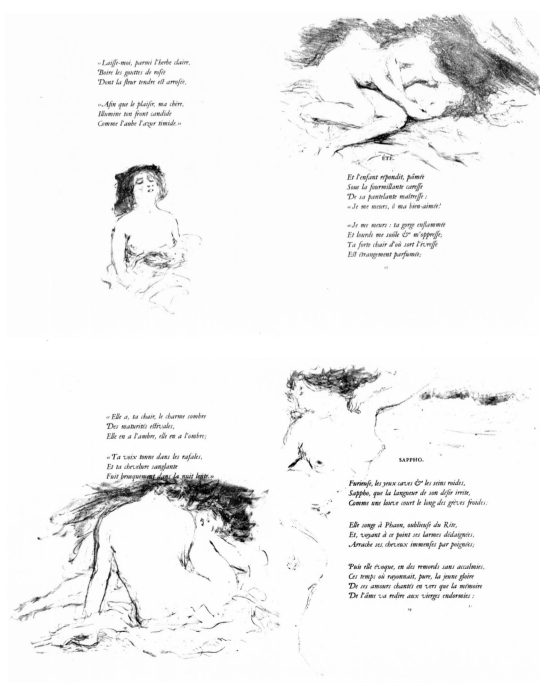

ÉTÉ.

Et l'enfant répondit, pâmée
Sous la fourmillante careffe
De sa pantelante maîtreffe :
« Je me meurs, ô ma bien-aimée!

«Je me meurs : ta gorge enflammée
Et lourde me foûle & m'oppreffe,
Ta forte chair d'où sort l'ivreffe
Eft étrangement parfumée;

17

« Elle a, ta chair, le charme sombre
Des maturités eftivales,
Elle en a l'ambre, elle en a l'ombre;

«Ta voix tonne dans les rafales,
Et ta chevelure sanglante
Fuit bruquement dans la nuit lente.»

SAPPHO.

Furieufe, les yeux caves & les seins roides,
Sappho, que la langueur de son défir irrite,
Comme une louve court le long des grèves froides;

Elle songe à Phaon, oublieufe du Rite,
Et, voyant à ce point ses larmes dédaignées,
Arrache ses cheveux immenfes par poignées;

Puis elle évoque, en des remords sans accalmies,
Ces temps où rayonnait, pure, la jeune gloire
De ses amours chantés en vers que la mémoire
De l'âme va redire aux vierges endormies :

19

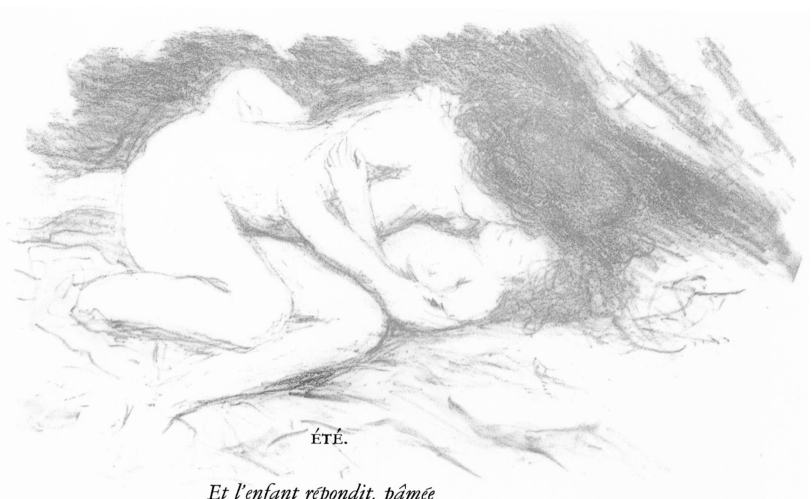

ÉTÉ.

Et l'enfant répondit, pâmée
Sous la fourmillante caresse
De sa pantelante maîtresse :
« Je me meurs, ô ma bien-aimée!

« Je me meurs : ta gorge enflammée
Et lourde me soûle & m'oppresse;
Ta forte chair d'où sort l'ivresse
Est étrangement parfumée;

17

Et voilà qu'elle abat ses paupières blémies
Et saute dans la mer où l'appelle la Moire
Tandis qu'au ciel éclate, incendiant l'eau noire,
La pâle Séléné qui venge les Amies.

10

FILLES

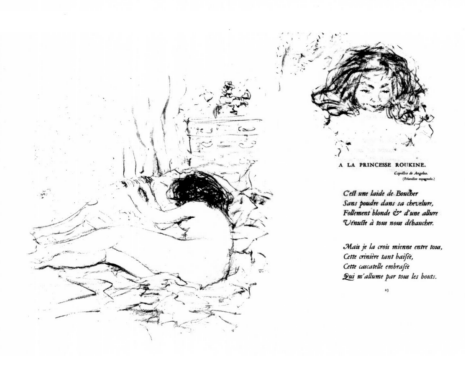

A LA PRINCESSE ROUKINE.
Copillos de Angelos.
(Friandise espagnole.)

C'est une laide de Boucher
Sans poudre dans sa chevelure,
Follement blonde & d'une allure
Vénuste à tous nous débaucher.

Mais je la crois mienne entre tous,
Cette crinière tant baisée,
Cette cascatelle embrasée
Qui m'allume par tous les bouts.

23

Elle est à moi bien plus encor
Comme une flamboyante enceinte
Aux entours de la porte sainte,
L'aime, la dive toison d'or!

Et qui pourrait dire ce corps
Sinon moi, son chantre & son prêtre,
Et son esclave humble & son maître
Qui s'en damnerait sans remords?

Son cher corps rare, harmonieux,
Suave, blanc comme une rose
Blanche, blanc de lait pur, & rose
Comme un lis sous de pourpres cieux?

Cuisses belles, seins redressants,
Le dos, les reins, le ventre, fête
Pour les yeux et les mains en quête
Et pour la bouche & tous les sens?

24

Mignonne, allons voir si ton lit
A toujours sous le rideau rouge
L'oreiller sorcier qui tant bouge
Et les draps fous. O vers ton lit!

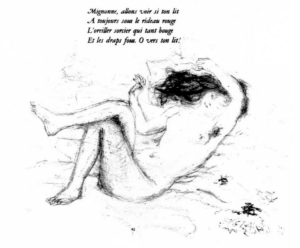

25

112

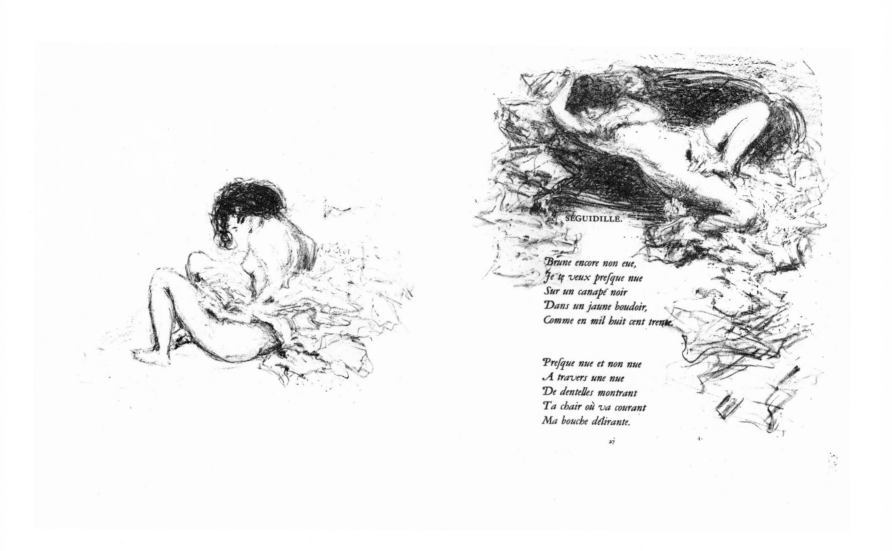

SÉGUIDILLE.

Brune encore non eue,
Je te veux presque nue
Sur un canapé noir
Dans un jaune boudoir,
Comme en mil huit cent trente.

Presque nue et non nue
A travers une nue
De dentelles montrant
Ta chair où va courant
Ma bouche délirante.

27 4

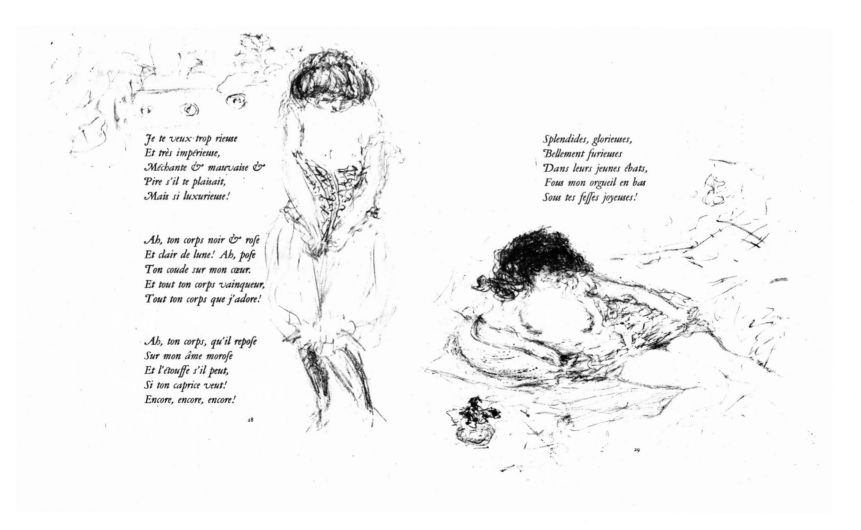

Je te veux trop rieuse
Et très impérieuse,
Méchante & mauvaise &
Pire s'il te plaisait,
Mais si luxurieuse!

Ah, ton corps noir & rose
Et clair de lune! Ah, posé
Ton coude sur mon cœur.
Et tout ton corps vainqueur,
Tout ton corps que j'adore!

Ah, ton corps, qu'il repose
Sur mon âme morose
Et l'étouffe s'il peut,
Si ton caprice veut!
Encore, encore, encore!

28

Splendides, glorieuses,
Bellement furieuses
Dans leurs jeunes ébats,
Fous mon orgueil en bas
Sous tes fesses joyeuses!

29

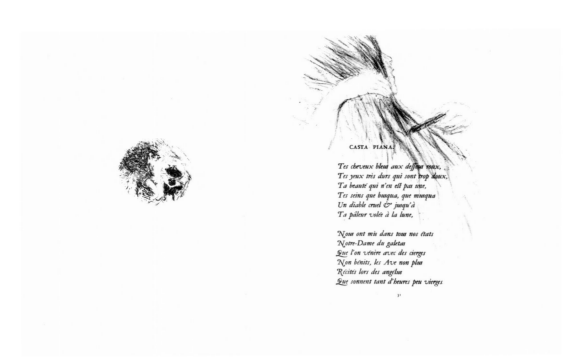

CASTA PIANA.

Tes cheveux bleus aux dessous roux,
Tes yeux très durs qui sont trop doux,
Ta beauté qui n'en est pas une,
Tes seins que busqua, que musqua
Un diable cruel & jusqu'à
Ta pâleur volée à la lune,

Nous ont mis dans tous nos états
Notre-Dame du galetas
Que l'on vénère avec des cierges
Non bénits, les Ave non plus
Récités lors des angélus
Que sonnent tant d'heures peu vierges.

Et vraiment tu sens le fagot :
Tu tournes un homme en nigaud,
En chiffe, en symbole, en un souffle,
Le temps de dire ou de faire oui,
Le temps d'un bonjour ébloui,
Le temps de baiser ta pantoufle.

Terrible lieu, ton galetas!
On t'y prend toujours sur le tas
A démolir quelque maroufle,
Et, décanillés, ces amants,
Munis de tous les sacrements,
T'y penses moins qu'à ta pantoufle!

T'as raison! Aime-moi donc mieux
Que tous ces jeunes & ces vieux
Qui ne savent pas la manière,
Moi qui suis dans ton mouvement,
Moi qui connais le boniment
Et te voue une cour plénière!

Ne fronce plus ces sourcils-ci,
Casta, ni cette bouche-ci,
Laisse-moi puiser tous tes baumes,
Piana, sucrés, salés, poivrés,
Et laisse-moi boire, poivrés,
Salés, sucrés, tes sacrés baumes.

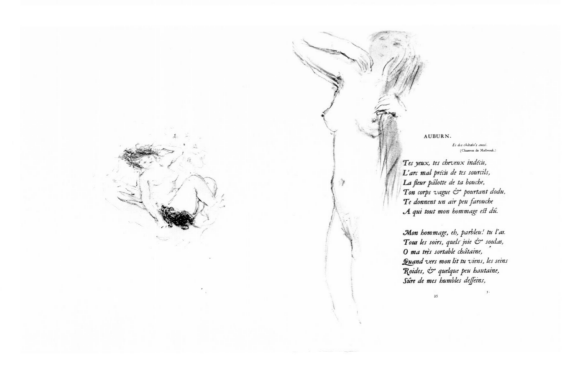

AUBURN.

Et des châtain's aussi.
(Chanson de Malbrouck.)

Tes yeux, tes cheveux indécis,
L'arc mal précis de tes sourcils,
La fleur pâlotte de ta bouche,
Ton corps vague & pourtant dodu,
Te donnent un air peu farouche
A qui tout mon hommage est dû.

Mon hommage, eh, parbleu! tu l'as.
Tous les soirs, quels joie & soulas,
O ma très sortable châtaine,
Quand vers mon lit tu viens, les seins
Roides, & quelque peu hautaine,
Sûre de mes humbles desseins,

Les seins roides sous la chemise,
Fière de la fête promise
A tes sens partout & longtemps,
Heureuse de savoir ma lèvre,
Ma main, mon tout, impénitents
De ces péchés qu'un fol s'en sèvre!

Sûre de baisers savoureux
Dans le coin des yeux, dans le creux
Des bras & sur le bout des mammes,
Sûre de l'agenouillement
Vers ce buisson ardent des femmes
Follement, fanatiquement!

Et hautaine puisque tu sais
Que ma chair adore à l'excès
Ta chair & que tel est ce culte
Qu'après chaque mort, — quelle mort! —
Elle renaît, dans quel tumulte!
Pour mourir encore & plus fort.

36

Oui, ma vague, sois orgueilleuse,
Car radieuse ou sourcilleuse,
Je suis ton vaincu, tu m'as tien :
Tu me roules comme la vague
Dans un délice bien païen,
Et tu n'es pas déjà si vague!

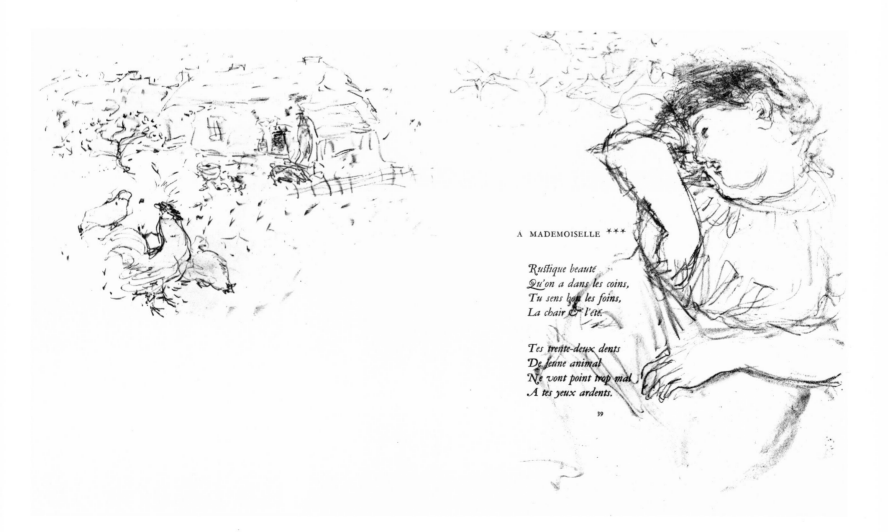

A MADEMOISELLE ***

Rustique beauté
Qu'on a dans les coins,
Tu sens bon les foins,
La chair & l'été.

Tes trente-deux dents
De jeune animal
Ne vont point trop mal
A tes yeux ardents.

39

115

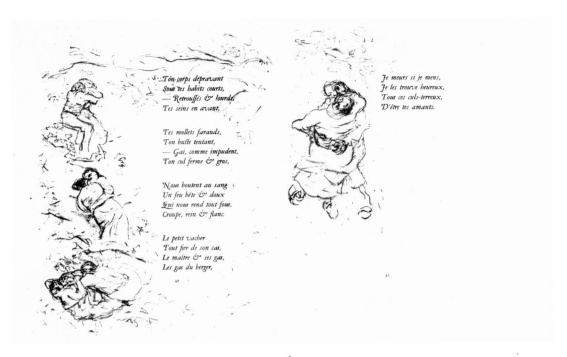

Ton corps depravant
Sous tes habits courts,
— Retroussés & lourds,
Tes seins en avant.

Tes mollets farauds,
Ton buste tentant,
— Gai, comme impudent,
Ton cul ferme & gros,

Nous boutent au sang
Un feu bête & doux
Qui nous rend tout fous,
Croupe, rein & flanc.

Le petit vacher
Tout fier de son cas,
Le maître & ses gas,
Les gas du berger,

Je meurs si je mens,
Je les trouve heureux,
Tous ces culs-terreux,
D'être tes amants.

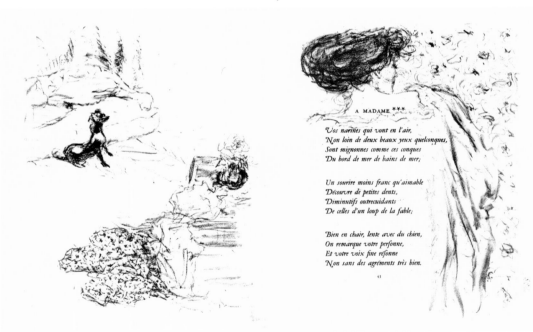

A MADAME ***

Vos narines qui vont en l'air,
Non loin de deux beaux yeux quelconques,
Sont mignonnes comme ces conques
Du bord de mer de bains de mer;

Un sourire moins franc qu'aimable
Découvre de petites dents,
Diminutifs outrecuidants
De celles d'un loup de la fable;

Bien en chair, lente avec du chien,
On remarque votre personne,
Et votre voix fine résonne
Non sans des agréments très bien.

De la grâce externe & légère
Et qui me laissait plutôt coi
Font de vous un morceau de roi,
O constitutionnel, chère!

Toujours est-il, regret ou non,
Que je ne sais pourquoi mon âme
Par ces froids pense à vous, Madame
De qui je ne sais plus le nom.

RÉVÉRENCE PARLER

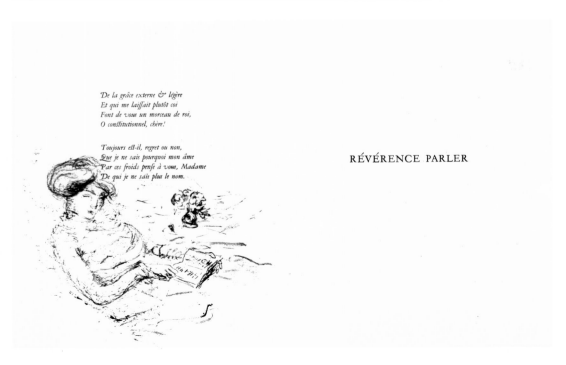

PROLOGUE D'UN LIVRE
DONT.IL NE PARAÎTRA QUE LES EXTRAITS.CI-APRÈS.

Ce n'est pas de ces dieux foudroyés,
Ce n'est pas encore une infortune
Poétique autant qu'inopportune,
O lecteur de bon sens, ne fuyez!

On sait trop tout le prix du malheur
Pour le perdre en disert gaspillage.
Vous n'aurez ni mes traits ni mon âge,
Ni le vrai mal secret de mon cœur.

Et de ce que ces vers maladifs
Furent faits en prison, pour tout dire,
On ne va pas crier au martyre.
Que Dieu vous garde des expansifs!

On vous donne un livre fait ainsi.
Prenez-le pour ce qu'il vaut en somme.
C'est l'ægri somnium d'un brave homme
Étonné de se trouver ici.

On y met, avec la «bonne foy»,
L'orthographe à peu près qu'on possède
Regrettant de n'avoir à son aide
Que ce prestige d'être bien soi.

Vous lirez ce libelle tel quel,
Tout ainsi que vous feriez d'un autre.
Ce vœu bien modeste est le seul nôtre,
N'étant guère après tout criminel.

Un mot encore, car je vous dois
Quelque lueur en définitive
Concernant la chose qui m'arrive :
Je compte parmi les maladroits.

J'ai perdu ma vie & je sais bien
Que tout blâme sur moi s'en va fondre :
A cela je ne puis que répondre
Que je suis vraiment né Saturnien.

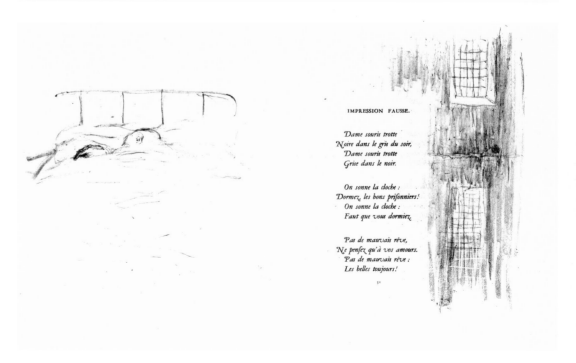

IMPRESSION FAUSSE.

Dame souris trotte
Noire dans le gris du soir,
Dame souris trotte
Grise dans le noir.

On sonne la cloche :
Dormez, les bons prisonniers!
On sonne la cloche :
Faut que vous dormiez.

Pas de mauvais rêve,
Ne pensez qu'à vos amours.
Pas de mauvais rêve :
Les belles toujours!

Le grand clair de lune!
On ronfle ferme à côté.
Le grand clair de lune
En réalité!

Un nuage passe,
Il fait noir comme en un four.
Un nuage passe.
Tiens, le petit jour!

Dame souris trotte,
Rose dans les rayons bleus.
Dame souris trotte :
Debout, paresseux!

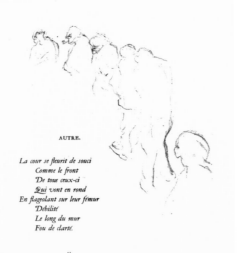

AUTRE.

La cour se fleurit de souci
Comme le front
De tous ceux-ci
Qui vont en rond
En flageolant sur leur fémur
Débilité
Le long du mur
Fou de clarté.

Tournez, Samsons sans Dalila,
Sans Philistin,
Tournez bien la
Meule au destin.
Vaincu risible de la loi,
Mouds tour à tour
Ton cœur, ta foi
Et ton amour!

Ils vont! & leurs pauvres souliers
Font un bruit sec,
Humiliés,
La pipe au bec.
Pas un mot ou bien le cachot,
Pas un soupir.
Il fait si chaud
Qu'on croit mourir.

J'en suis de ce cirque effaré,
Soumis d'ailleurs
Et préparé
A tous malheurs.
Et pourquoi si j'ai contristé
Ton vœu têtu,
Société,
Me choierain-tu?

Allons, frères, bons vieux voleurs,
Doux vagabonds,
Filous en fleurs,
Mes chers, mes bons,
Fumons philosophiquement,
Promenons-nous
Paisiblement :
Rien faire est doux.

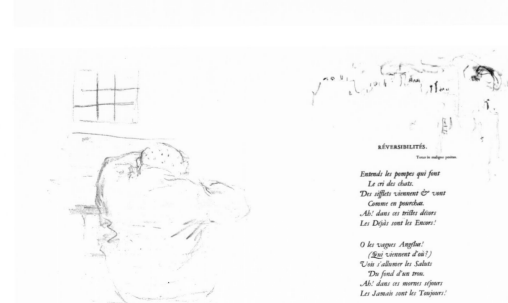

RÉVERSIBILITÉS.

Totus in maligno positus.

Entends les pompes qui font
Le cri des chats.
Des sifflets viennent & vont
Comme en pourchas.
Ah! dans ces tristes décors
Les Déjàs sont les Encors!

O les vagues Angélus!
(Qui viennent d'où?)
Vois s'allumer les Saluts
Du fond d'un trou.
Ah! dans ces mornes séjours
Les Jamais sont les Toujours!

Quels rêves épouvantés,
 Vous grands murs blancs!
Que de sanglots répétés,
 Fous ou dolents!
Ah! dans ces piteux retraits
Les Toujours sont les Jamais!

Tu meurs doucereusement,
 Obscurément,
Sans qu'on veille, ô cœur aimant.
 Sans testament!
Ah! dans ces deuils sans rachats
Les Encors sont les Déjàs!

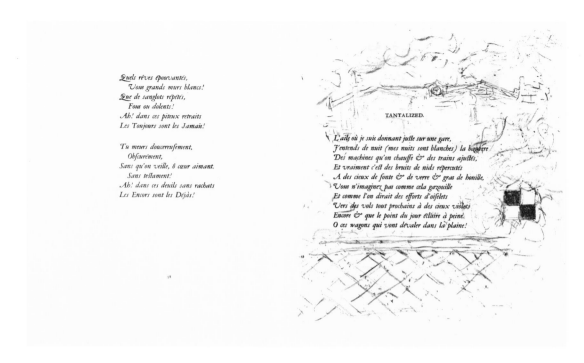

TANTALIZED.

L'aile où je suis donnant juste sur une gare,
J'entends de nuit (mes nuits sont blanches) la bagarre
Des machines qu'on chauffe & des trains ajustés,
Et vraiment c'est des bruits de nids répercutés
A des cieux de fonte & de verre & gras de houille,
Vous n'imaginez pas comme cela gazouille
Et comme on dirait des efforts d'oiselets
Vers des vols tout prochains à des cieux violets
Encore & que le point du jour éclaire à peine!
O ces wagons qui vont dévaler dans la plaine!

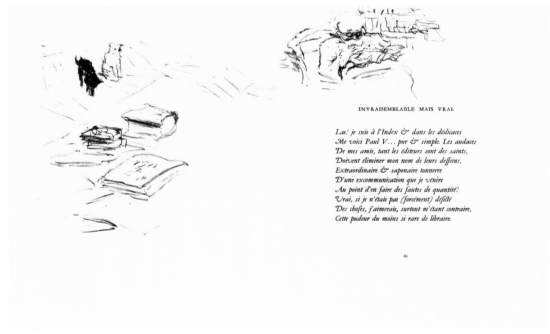

INVRAISEMBLABLE MAIS VRAI

Las! je suis à l'Index & dans les dédicaces
Me voici Paul V... pur & simple. Les audaces
De mes amis, tant les éditeurs sont des saints,
Doivent éliminer mon nom de leurs desseins,
Extraordinaire & saponaire tonnerre
D'une excommunication que je vénère
Au point d'en faire des fautes de quantité!
Vrai, si je n'étais pas (forcément) défilé
Des choses, j'aimerais, surtout m'étant contraire,
Cette pudeur du moins si rare de libraire.

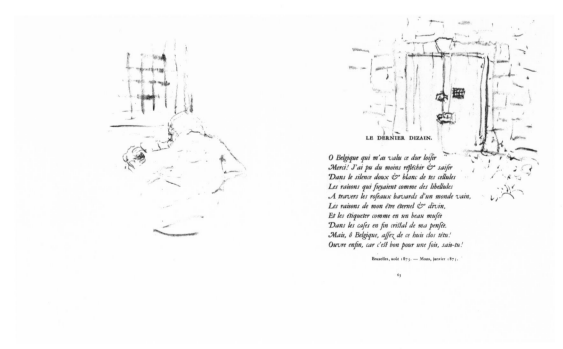

LE DERNIER DIZAIN.

O Belgique qui m'as valu ce dur loisir
Merci! J'ai pu du moins réfléchir & saisir
Dans le silence doux & blanc de tes cellules
Les raisons qui fuyaient comme des libellules
A travers les roseaux bavards d'un monde vain,
Les raisons de mon être éternel & divin,
Et les étiqueter comme en un beau musée
Dans les cases en fin cristal de ma pensée.
Mais, ô Belgique, assez de ce huis clos têtu!
Ouvre enfin, car c'est bon pour une fois, sais-tu!

Bruxelles, août 1873. — Mons, janvier 1875.

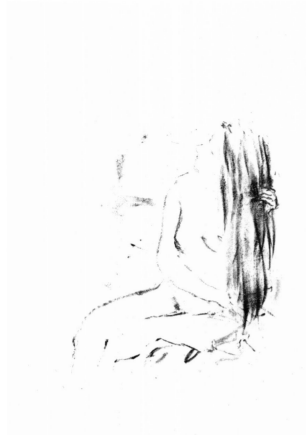

LUNES

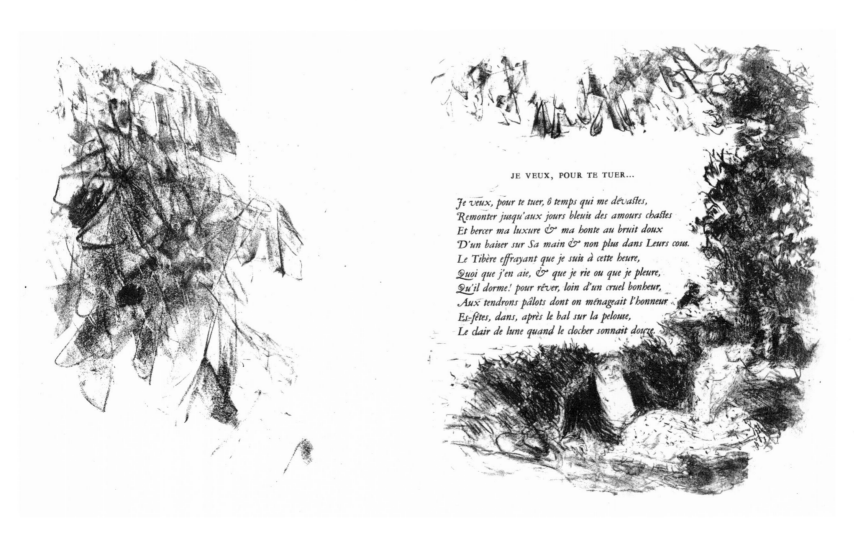

JE VEUX, POUR TE TUER...

Je veux, pour te tuer, ô temps qui me dévastes,
Remonter jusqu'aux jours bleus des amours chastes
Et bercer ma luxure & ma honte au bruit doux
D'un baiser sur Sa main & non plus dans Leurs cous.
Le Tibère effrayant que je suis à cette heure,
Quoi que j'en aie, & que je rie ou que je pleure,
Qu'il dorme! pour rêver, loin d'un cruel bonheur,
Aux tendrons pâlots dont on ménageait l'honneur
Es-fêtes, dans, après le bal sur la pelouse,
Le clair de lune quand le clocher sonnait douze.

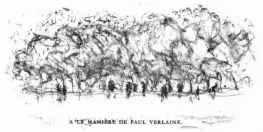

A LA MANIÈRE DE PAUL VERLAINE.

C'eſt à cauſe du clair de la lune
Que j'aſſume ce maſque nocturne
Et de Saturne penchant ſon urne
Et de ces lunes l'une après l'une.

Des romances ſans paroles ont,
D'un accord discord enſemble & frais,
Agacé ce cœur fadaſſe exprès,
O le ſon, le friſſon qu'elles ont!

69

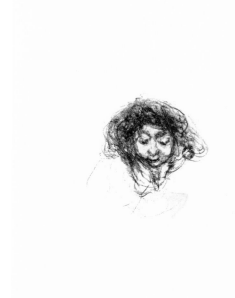

Il n'eſt pas que vous n'ayez fait grâce
A quelqu'un qui vous jetait l'offenſe :
Or, moi, je pardonne à mon enfance
Revenant fardée & non ſans grâce.

Je pardonne à ce menſonge-là
En faveur en ſomme du plaiſir
Très banal drôlement qu'un loiſir
Douloureux un peu m'inocula.

EXPLICATION.

Je vous dis que ce n'eſt pas ce que l'on penſe.
P. V.

Le bonheur de ſaigner ſur le cœur d'un ami,
Le beſoin de pleurer bien longtemps ſur ſon ſein,
Le déſir de parler à lui, bas à demi,
Le rêve de reſter enſemble ſans deſſein!

Le malheur d'avoir tant de belles ennemies,
La ſatiété d'être une machine obſcène,
L'horreur des cris impurs de toutes ces lamies,
Le cauchemar d'une inceſſante miſe en ſcène!

Mourir pour ſa Patrie ou pour ſon Dieu, gaîment,
Ou pour l'autre, en ſes bras, & baiſant chaſtement
La main qui ne trahit, la bouche qui ne ment!

71

Vivre loin des devoirs & des ſaintes tourmentes
Pour les ſeins clairs & pour les yeux luiſants d'amantes,
Et pour le . . . reſte! vers telles morts infamantes!

AUTRE EXPLICATION.

Amour qui ruiſſelais de flammes & de lait,
Qu'eſt devenu ce temps, & comme eſt-ce qu'elle eſt,
La conſiance ſacrée au chrême des promeſſes?
Elle reſſemble une putain dont les proueſſes
Empliraient cent bidets de futurs fœtus froids;
Et le temps a crû mais pire, tels les effrois
D'un polype groſſi d'heure en heure & qui pète.
Lâches, nous! de nous être ainſi lâchés!
«Arrête!»
Dit quelqu'un de dedans le ſein. C'eſt bien la loi.
On peut mourir pour telle ou tel, on vit pour ſoi,
Même quand on voudrait vivre pour tel ou telle!

73

Et puis l'heure sévère, ombre de la mortelle,
S'en vient déjà couvrir les trois quarts du cadran.
Il faut, dès ce jourd'hui, renier le tyran
Plaisir, & se complaire aux prudents hyménées,
Quittant le souvenir des heures entraînées
Et des gens. Et voilà la norme & le flambeau.
Ce sera bien.»

 L'Amour :

 «Ce ne serait pas beau.»

74

LIMBES.

L'imagination, reine,
Tient ses ailes étendues,
Mais la robe qu'elle traîne
A des lourdeurs éperdues.

Cependant que la Pensée,
Papillon, s'envole & vole,
Rose & noir clair, élancée
Hors de la tête frivole.

L'imagination, sise
En son trône, ce fier siège!
Assise, comme indécise,
A tout ce preste manège,

75

Et le papillon fait rage,
Monte & descend, plane & vire :
On dirait dans un naufrage
Des culbutes du navire.

La reine pleure de joie
Et de peine encore, à cause
De son cœur qu'un chaud pleur noie,
Et n'entend goutte à la chose.

Psyché Deux pourtant se lasse.
Son vol est la main plus lente
Que cent tours de passe-passe
Ont faite toute tremblante.

Hélas, voici l'agonie!
Qui s'en fût formé l'idée?
Et tandis que, bon génie
Plein d'une douceur lactée,

76

La bestiole céleste
S'en vient palpiter à terre,
La Folle-du-Logis reste
Dans sa gloire solitaire!

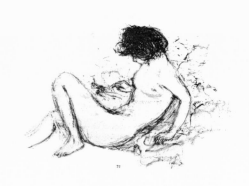

77

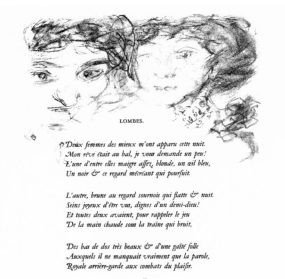

LOMBES.

Deux femmes des mieux m'ont apparu cette nuit.
Mon rêve était au bal, je vous demande un peu!
L'une d'entre elles maigre assez, blonde, un œil bleu,
Un noir & ce regard mécréant qui poursuit.

L'autre, brune au regard sournois qui flatte & nuit.
Seins joyeux d'être vus, dignes d'un demi-dieu!
Et toutes deux avaient, pour rappeler le jeu
De la main chaude sous la traîne qui bruit,

Des bas de dos très beaux & d'une gaîté folle
Auxquels il ne manquait vraiment que la parole,
Royale arrière-garde aux combats du plaisir.

79

Et ces dames — scrutez l'armorial de France —
S'efforçaient d'entamer l'orgueil de mon désir.
Et n'en revenaient pas de mon indifférence.

Vouziers (Ardennes), 13 avril — 13 mai 1885.

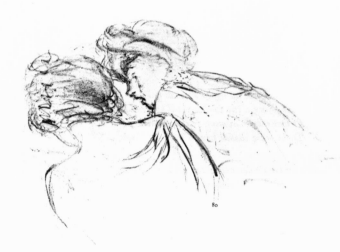

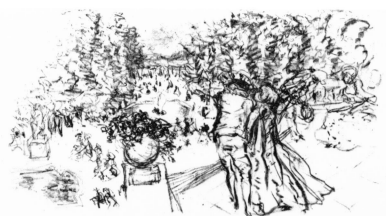

LA DERNIÈRE FÊTE GALANTE.

Pour une bonne fois séparons-nous,
Très chèrs messieurs & si belles mesdames,
Assez comme cela d'épithalames,
Et puis là, nos plaisirs furent trop doux.

Nul remords, nul regret vrai, nul désastre!
C'est effrayant ce que nous nous sentons
D'affinités avecque les moutons
Enrubannés du pire poétastre.

81

Nous fûmes trop ridicules un peu
Avec nos airs de n'y toucher qu'à peine.
Le Dieu d'amour veut qu'on ait de l'haleine,
Il a raison! Et c'est un jeune Dieu.

Séparons-nous, je vous le dis encore.
O que nos cœurs qui furent trop bêlants,
Dès ce jourd'hui réclament trop hurlants,
L'embarquement pour Sodome & Gomorrhe!

82

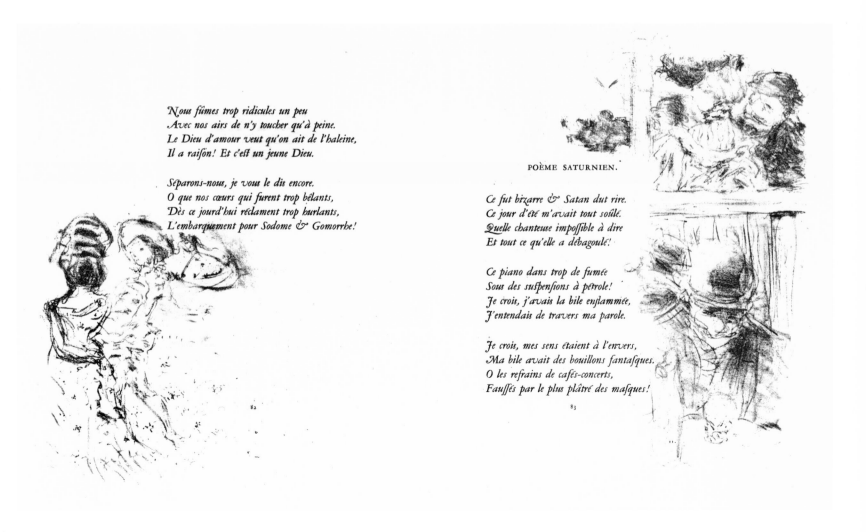

POÈME SATURNIEN.

Ce fut bizarre & Satan dut rire.
Ce jour d'été m'avait tout soûlé.
Quelle chanteuse impossible à dire
Et tout ce qu'elle a débagoulé!

Ce piano dans trop de fumée
Sous des suspensions à pétrole!
Je crois, j'avais la bile enflammée,
J'entendais de travers ma parole.

Je crois, mes sens étaient à l'envers,
Ma bile avait des bouillons fantasques.
O les refrains de cafés-concerts,
Faussés par le plus plâtré des masques!

83

Dans des troquets comme en ces bourgades,
J'avais rôdé, suçant peu de glace.
Trois galopins aux yeux de tribades
Dévisageaient sans fin ma grimace.

Je fus hué manifestement
Par ces voyous, non loin de la gare,
Et les engueulai si goulûment
Que j'en faillis gober mon cigare.

Je rentre : une voix à mon oreille,
Un pas fantôme. Aucun ou personne ?
On m'a frôlé. — La nuit sans pareille !
Ah! l'heure d'un réveil drôle sonne.

Attigny (Ardennes), 31 mai — 1ᵉʳ juin 1885.

84

L'IMPUDENT.

La misère & le mauvais œil,
Soit dit sans le calomnier,
Ont fait à ce monstre d'orgueil
Une âme de vieux prisonnier.

Oui, jettatore, oui, le dernier
Et le premier des gueux en deuil
De l'ombre même d'un denier
Qu'ils poursuivront jusqu'au cercueil.

Son regard mûrit les enfants.
Il a des refus triomphants.
Même il est bête à sa façon.

85

Beautés passant, au lieu de sous,
Faites à ce mauvais garçon
L'aumône seulement... de vous.

86

L'IMPÉNITENT.

Rôdeur vanné, ton œil fané
Tout plein d'un désir satané,
Mais qui n'est pas l'œil d'un bélître,
Quand passe quelqu'un de gentil,
Lance un éclair comme une vitre.

Ton blaire flaire, âpre & subtil,
Et l'étamine & le pistil,
Toute fleur, tout fruit, toute viande,
Et ta langue d'homme entendu
Pourlèche ta lèvre friande.

87

124

Vieux faune en l'air'guettant ton dû,
As-tu vraiment bandé, tendu
L'arme affez de tes paillardifes?
L'as-tu, drôle, braquée affez?
Ce n'eft rien que tu nous le dies.

Quoi, malgré ces reins fricaffés,
Ce cœur éreinté, tu ne fais
Que dévouer à la luxure
Ton cœur, tes reins, ta poche à fiel,
Ta rate & toute ta freffure!

Sucrés & doux comme le miel,
Damnants comme le feu du ciel,
Bleu comme fleur, noirs comme poudre,
Tu raffoles beaucoup des yeux
De tout genre en dépit du Foudre.

Les nez te plaifent, gracieux
Ou fimplement malicieux

88

Étant la force des vifages,
Étant auffi, fuivant des gens,
Des indices & des préfages.

Longs baifers plus clairs que des chants,
Tout petits baifers aftringents
Qu'on dirait qui vous fucent l'âme,
Bons gros baifers d'enfants, légers
Baifers danfeurs, telle une flamme.

Baifers mangeurs, baifers mangés,
Baifers buveurs, bus, enragés,
Baifers languides & farouches,
Ce que t'aimes bien, c'eft furtout,
N'eft-ce pas? les belles bouhouches.

Les corps enfin font de ton goût,
Mieux pourtant couchés que debout,
Se mouvant fur place qu'en marche,
Mais de n'importe quel climat,
Pont-Saint-Efprit ou Pont-de-l'Arche.

89

Pour que ce goût les acclamât
Minces, grands d'afpect plutôt mat,
Faudrait pourtant du jeune en somme.
Pieds fins & forts, tout légers bras
Mufculeux & des cheveux comme

Ça tombe, longs, bouclés ou ras, —
Sinon pervers & fcélérats
Tout à fait, un peu d'innocence
En moins, pour toi fauver, du moins,
Quelque ombre encore de décence?

Nenni dà! Vous, foyez témoins,
Dieux la connaiffant dans les coins,
Que ces manières de parts telles,
Sont pour s'amufer mieux au fond
Sans trop mufer aux bagatelles.

C'eft ainfi que les chofes vont
Et que les raillards fieffés font.

90

Mais tu te ris de ces morales, —
Tel un quelqu'un plus que preffé
Paffe outre aux défenfes murales!

Et tu réponds, un peu laffé
De te voir ainfi relancé,
De ta voix que la foif dégrade
Mais qui n'eft pas d'un marmiteux :
«Qu'y peux-tu faire, camarade,

Si nous fommes cet amiteux?»

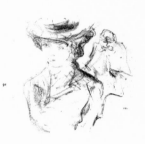

91

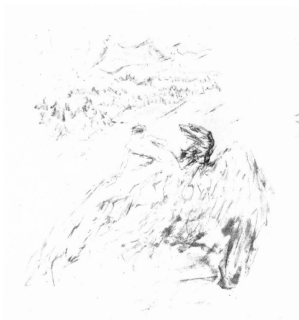

SUR UNE STATUE DE GANYMÈDE.

Eh quoi! Dans cette ville d'eaux,
Trêve, repos, paix, intermède,
Encore toi de face & de dos,
Beau petit ami Ganymède.

L'aigle t'emporte, on dirait comme
Amoureux de parmi les fleurs.
Son aile, d'élans économe,
Semble te vouloir par ailleurs

Que chez ce Jupin tyrannique,
Comme qui dirait-au Revard[*]
Et son œil qui nous fait la nique
Te coule un drôle de regard.

[*] Montagne aux environs d'Aix-les-Bains.

93

'Bah! reste avec nous, bon garçon,
Notre ennui, viens donc le distraire
Un peu de la bonne façon.
N'es-tu pas notre petit frère?

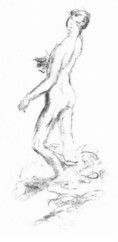

PROLOGUE SUPPRIMÉ
'A UN LIVRE D'«INVECTIVES».

Mes femmes, toutes! & ce n'est pas effrayant :
A peu près, en trente ans! neuf, ainsi que les Muses,
Je vous évoque & vous invoque, chœur riant,
Au seuil de ce recueil où, mon fiel, tu t'amuses.

Neuf environ! Sans m'occuper du casuel,
Des amours de raccroc, des baisers de rencontre,
Neuf que j'aimais & qui m'aimaient, ceci c'est réel,
Ou que non pas, qu'importe à ce Fiel qui se montre?

Je vous évoque, corps si choyés, chères chairs,
Seins adorés, regards où les miens vinrent vivre
Et mourir, & tous les trésors encor plus chers,
Je vous invoque au seuil, mesdames, de mon livre :

Toi qui fus blondinette & mignarde aux yeux bleus,
Vous mes deux brunes, l'une grasse & grande, & l'autre
Imperceptible avec, toutes deux, de doux yeux
De velours sombre, d'où coulait cette âme vôtre;

Et ô rouquine en fleur qui mis ton rose & blanc
Incendie ès-mon cœur, plutôt noir, qua s'embrase
A ton étreinte, bras très frais, souple & dur flanc,
Et l'or mystérieux du vase pour l'extase.

Et vous autres, Parisiennes à l'excès,
Toutes de mise abandonné sur ma prière
(Car je déteste les parfums & je ne sais
Rien de meilleur à respirer que l'odeur fière

Et saine de la femme seule que l'on eut
Pour le moment sur le moment) & vous, le reste
Qu'on, sinon très gentil, très moralement, eut
D'un geste franc, bon, & leste, sinon céleste.

Je vous atteste, sœurs aimables de mon corps,
Qu'on fut injuste à mon endroit, & que je souffre
A cause de cette faiblesse, fleur du corps,
Perte de l'âme, qui, paraît-il, mène au gouffre,

Au gouffre où les malins, les matois, les «peinards»
Comme autant de démons d'enfer, un enfer bête
Et d'autant plus méchant dans ses ennuis traînards,
Accueillent d'escroquerie âpre le poète. . .

O mes chères, soyez mes muses, en ce nid
Encore bienséant d'un pamphlet qui s'essore.
Soyez à ce pauvres que la haine bénit
Le rire du soleil & les pleurs de l'aurore.

Donnez force & virilité, par le bonheur
Que vous donniez jadis à ma longue jeunesse,
Pour que je parle bien, & comme à votre honneur
Et comme en votre honneur, & pour que je renaisse

En quelque sorte à la Vigueur, non celle-là
Que nous déployions en des ères plus propices,
Mais à celle qu'il faut, au temps où nous voilà,
Contre les scélérats, les sots & les complices.

O mes femmes, soyez mes muses, voulez-vous?
Soyez même un petit comme un lot d'Erynnies
Pour rendre plus méchants mes vers encor trop doux
A l'adresse de ce vil tas d'ignominies :

Telle contemporaine & tel contemporain
Dont j'ai trop éprouvé la haine & la rancune,
Martial & non Juvénal, & non d'airain,
Mais de poivre & de sel, la mienne de rancune.

Mes vers seront méchants, du moins je m'en prévaux,
Comme la gale & comme un hallier de vermine,
Et comme tout. . . Et sus aux griefs vrais ou faux
Qui m'agacent. . . Muses, or, sus à la vermine!

24 septembre 1891.

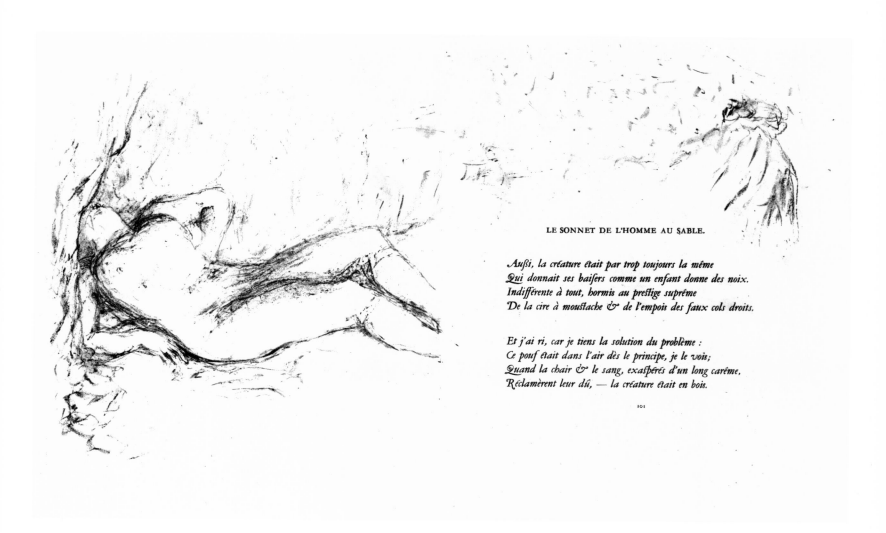

LE SONNET DE L'HOMME AU SABLE.

Auſſi, la créature était par trop toujours la même
Qui donnait ſes baiſers comme un enfant donne des noix.
Indifférente à tout, hormis au preſtige suprême
De la cire à mouſtache & de l'empois des faux cols droits.

Et j'ai ri, car je tiens la solution du problême :
Ce pouf était dans l'air dès le principe, je le vois;
Quand la chair & le ſang, exaſpérés d'un long carême,
Réclamèrent leur dû, — la créature était en bois.

101

C'eſt le conte d'Hoffmann avec de la bêtiſe en marge,
Amis qui m'écoutez faites votre entendement large,
Car c'eſt la vérité que ma morale, & la voici :

Si, par malheur (puiſſe d'ailleurs l'augure aller au diable!),
Quelqu'un de vous devait s'emberlificoter auſſi,
Qu'il réclame un conſeil de reviſion préalable.

GUITARE.

Le pauvre du chemin creux chante & parle.
Il dit : «Mon nom eſt Pierre & non pas Charle
Et je m'appelle auſſi Duchatelet[]).*
Une fois je vis, moi qu'on croit très laid,
Paſſer vraiment une femme très belle.
(Si je la voyais telle, elle était telle.)
Nous nous mariâmes au vieux curé.
On eut tout ce qu'on avait eſpéré,
Juſqu'à l'enfant qu'on m'a dit vivre encore.
Mais elle devint la pire pécore
Même pas digne de cette chanſon,
Et certain beau ſoir quitta la maiſon
En emportant tout l'argent du ménage
Dont les trois quarts étaient mon apanage.

(*) *Voir* Louise Leclercq, *nouvelles par l'auteur.*

103

C'était une voleuse, une sans-cœur,
Et puis, par des fois, je lui faisais peur.
Elle n'avait pas l'ombre d'une excuse,
Pas un amant ou par rage ou par ruse.
Il paraît qu'elle couche depuis peu
Avec un individu qui tient lieu
D'époux à cette femme de querelle.
Faut-il la tuer ou prier pour elle ? »

Et le pauvre sait très bien qu'il priera,
Mais le diable parierait qu'il tuera.

BALLADE DE LA VIE EN ROUGE.

L'un toujours vit la vie en rose,
Jeunesse qui n'en finit plus,
Seconde enfance moins morose,
Ni vœux, ni regrets superflus.
Ignorant tout flux & reflux,
Ce sage pour qui rien ne bouge
Règne instinctif : tel un phallus.
Mais moi je vois la vie en rouge.

L'autre ratiocine & glose
Sur des modes irrésolus,
Soupesant, pesant chaque chose
De mains gourdes aux lourds calus.

105 14

Lui faudrait du temps tant & plus
Pour se risquer hors de son bouge.
Le monde est gris à ce reclus.
Mais moi je vois la vie en rouge.

Lui, cet autre alentour il ose
Jeter des regards bien voulus,
Mais, sur quoi que son œil se pose,
Il s'exaspère où tu te plus,
Œil des philanthropes joufflus ;
Tout lui semble noir, vierge ou gouge,
Les hommes, vins bus, livres lus.
Mais moi je vois la vie en rouge.

ENVOI

Prince & princesse, allez, élus,
En triomphe par la route où je
Trime d'ornières en talus.
Mais moi je vois la vie en rouge.

106

MAINS.

Ce ne sont pas des mains d'altesse,
De beau prélat quelque peu saint.
Pourtant une délicatesse
Y laisse son galbe succinct.

Ce ne sont pas des mains d'artiste,
De poète proprement dit,
Mais quelque chose comme triste
En fait comme un groupe en petit ;

107

Car les mains ont leur caractère,
C'est tout un monde en mouvement
Où le pouce & l'auriculaire
Donnent les pôles de l'aimant.

Les météores de la tête
Comme les tempêtes du cœur,
Tout s'y répète & s'y reflète
Par un don logique & vainqueur.

Ce ne sont pas non plus les palmes
D'un rural ou d'un faubourien ;
Encor leurs grandes lignes calmes
Disent : « Travail qui ne doit rien. »

Elles sont maigres, longues, grises,
Phalange large, ongle carré,
Tels en ont aux vitraux d'églises
Les saints sous le rinceau doré,

108

Ou tels quelques vieux militaires
Déshabitués des combats
Se rappellent leurs longues guerres
Qu'ils narrent entre haut & bas.

Ce soir elles ont, ces mains sèches,
Sous leurs rares poils hérissés,
Des airs spécialement rêches,
Comme en proie à d'âpres pensers.

Le noir souci qui les agace,
Leur quasi-songe aigre les font
Faire une sinistre grimace
A leur façon, mains qu'elles sont.

J'ai peur à les voir sur la table
Préméditer là, sous mes yeux,
Quelque chose de redoutable,
D'inflexible & de furieux.

109

La main droite est bien à ma droite,
L'autre à ma gauche, je suis seul.
Les linges dans la chambre étroite
Prennent des aspects de linceul,

Dehors le vent hurle sans trêve,
Le soir descend insidieux . . .
Ah! si ce sont des mains de rêve,
Tant mieux, — ou tant pis, — ou tant mieux!

LES MORTS QUE.....

Les morts que l'on fait saigner dans leur tombe
Se vengent toujours.
Ils ont leur manière, & plaignez qui tombe
Sous leurs grands coups sourds.
Mieux vaut n'avoir jamais connu la vie,
Mieux vaut la mort lente d'autres suivie,
Tant le temps est long, tant les coups sont lourds.

Les vivants qu'on fait pleurer comme on saigne
Se vengent parfois.
Ceux-là qu'ils ont pris, qu'un chacun les plaigne,
Pris entre leurs doigts.
Mieux vaut un ours & les jeux de sa patte,
Mieux vaut cent fois le chanvre & sa cravate,
Mieux vaut l'édredon d'Othello cent fois.

111

110

O toi, persécuteur, crains le vampire
Et crains l'étrangleur :
Leur jour de colère apparaîtra pire
Que toute douleur.
Tiens ton âme prête à ce jour ultime
Qui surprendra l'assassin comme un crime
Et fondra sur le vol comme un voleur.

NOUVELLES VARIATIONS
SUR LE POINT-DU-JOUR.

Le Point-du-Jour, le point blanc de Paris,
Le seul point blanc, grâce à tant de bâtisse
Et neuve & laide & que je t'en ratisse,
Le Point-du-Jour, aurore des paris!

Le bonneteau fleurit «dessur» la berge,
La bonne tôt s'y déprave, tant pis
Pour elle & tant mieux pour le birbe gris
Qui lui du moins la croit encore vierge.

Il a raison, le vieux, car voyez donc
Comme est joli toujours le paysage :
Paris au loin, triste & gai, fol & sage.
Et le Trocadéro, ce cas, au fond.

113

Puis la verdure & le ciel & les types
Et la rivière obscène & molle, avec.
Des gens trop beaux, leur cigare à leur bec :
Épatants ces metteurs-au-vent de tripes!

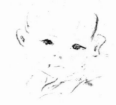

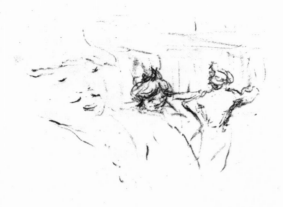

PIERROT GAMIN.

Ce n'est pas Pierrot en herbe
Non plus que Pierrot en gerbe.
C'est Pierrot, Pierrot, Pierrot.
Pierrot gamin, Pierrot gosse,
Le cerneau hors de la cosse,
C'est Pierrot, Pierrot, Pierrot.

Bien qu'un rien plus haut qu'un mètre,
Le mignon drôle sait mettre
Dans ses yeux l'éclair d'acier
Qui sied au subtil génie
De sa malice infinie
De poète-grimacier.

Lèvres rouge-de-blessure
Où sommeille la luxure,
Face pâle aux rictus fins,
Longue, très accentuée,
Qu'on dirait habituée
A contempler toutes fins;

Corps fluet & non pas maigre,
Voix de fille & non pas aigre,
Corps d'éphèbe en tout petit,
Voix de tête, corps en fête,
Créature toujours prête
A soûler chaque appétit.

Va, frère, va, camarade,
Fais le diable, bats l'estrade
Dans ton rêve & sur Paris
Et par le monde, & sois l'âme
Vile, haute, noble, infâme
De nos innocents esprits!

Grandis, car c'est la coutume,
Cube ta riche amertume,
Exagère ta gaieté,
Caricature, auréole,
La grimace & le symbole
De notre simplicité!

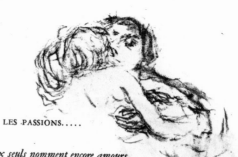

LES ·PASSIONS.....

Ces paſſions qu'eux seuls nomment encore amours
Sont des amours auſſi, tendres & furieuses,
Avec des particularités curieuses
Que n'ont pas les amours certes de tous les jours.

Même plus qu'elles & mieux qu'elles héroïques,
Elles se parent de ſplendeurs d'âme & de sang
Telles qu'au prix d'elles les amours dans le rang
Ne sont que Ris & Jeux ou beſoins érotiques.

Que vains proverbes, que riens d'enfants trop gâtés,
— «Ah! les pauvres amours banales, animales,
Normales! Gros goûts lourds ou frugales fringales,
Sans compter la ſottiſe & des fécondités!»

119

— Peuvent dire ceux-là que sacre le haut Rite,
Ayant conquis la plénitude du plaiſir,
Et l'inſatiabilité de leur déſir
Béniſſant la fidélité de leur mérite.

La plénitude! Ils l'ont superlativement :
Baiſers repus, gorgés, mains privilégiées
Dans la richeſſe des careſſes repayées,
Et ce divin final anéantiſſement!

Comme ce sont les forts & les forts, l'habitude
De la force les rend invaincus au déduit.
Plantureux, savoureux, débordant, le déduit!
Je le crois bien qu'ils l'ont la pleine plénitude!

Et pour combler leurs vœux, chacun d'eux tour à tour
Fait l'action suprême, a la parfaite extase,
— Tantôt la coupe ou la bouche & tantôt le vase —
Pâmé comme la nuit, fervent comme le jour.

120

Leurs beaux ébats sont grands & gais. Pas de ces criſes :
Vapeurs, nerfs. Non, des jeux courageux, puis d'heureux
Bras las autour du cou, pour de moins langoureux
Qu'étroits sommeils à deux, tout coupés de repriſes.

Dormez, les amoureux! Tandis qu'autour de vous
Le monde inattentif aux choſes délicates,
Bruit ou gît en somnolences scélérates,
Sans même, il eſt si bête! être de vous jaloux.

Et ces réveils·francs, clairs, riants, vers l'aventure
De fiers damnés d'un plus magnifique sabbat?
Et salut, témoins purs de l'âme en ce combat
Pour l'affranchiſſement de la lourde nature!

121

16

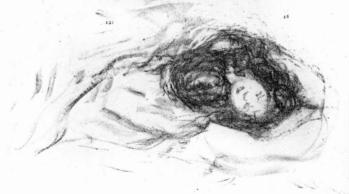

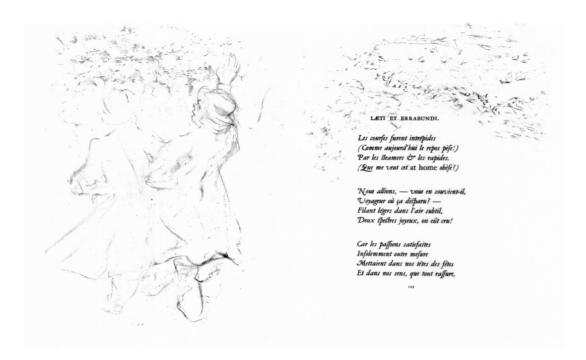

LÆTI ET ERRABUNDI.

Les courfes furent intrépides
(Comme aujourd'hui le repos pèfe!)
Par les fteamers & les rapides.
(Que me veut cet at home obèfe?)

Nous allions, — vous en fouvient-il,
Voyageur où ça difparu? —
Filant légers dans l'air fubtil,
Deux fpectres joyeux, on eût cru!

Car les paffions fatisfaites
Infolemment outre mefure
Mettaient dans nos têtes des fêtes
Et dans nos fens, que tout raffure,

123

Tout, la jeuneffe, l'amitié,
Et nos cœurs, ah! que dégagés
Des femmes prifes en pitié
Et du dernier des préjugés,

Laiffant la crainte de l'orgie
Et le fcrupule au bon ermite,
Puifque quand la borne eft franchie
Ponfard ne veut plus de limite.

Entre autres blâmables excès
Je crois que nous bûmes de tout,
Depuis les plus grands vins français
Jufqu'à ce faro, jufqu'au ftout,

En paffant par les eaux-de-vie
Qu'on cite comme redoutables,
L'âme au feptième ciel ravie,
Le corps, plus humble, fous les tables.

124

Des payfages, des cités
Pofaient pour nos yeux jamais las;
Nos belles curiofités
Euffent mangé tous les atlas.

Fleuves & monts, bronzes & marbres,
Les couchants d'or, l'aube magique,
L'Angleterre, mère des arbres,
Fille des beffrois, la Belgique,

La mer, terrible & douce au point, —
Brochaient fur le roman très cher
Que ne difcontinuait point
Notre âme, — & quid de notre chair?... —

Le roman de vivre à deux hommes
Mieux que non pas d'époux modèles,
Chacun au tas verfant des fommes
De fentiments forts & fidèles.

125

L'envie aux yeux de bafilic
Cenfurait ce mode d'écot :
Nous dînions du blâme public
Et foupions du même fricot.

La mifère auffi faifait rage
Par des fois dans le phalanftère :
On ripoftait par le courage,
La joie & les pommes de terre.

Scandaleux fans favoir pourquoi,
(Peut-être que c'était trop beau)
Mais notre couple reftait coi
Comme deux bons porte-drapeau,

Cois dans l'orgueil d'être plus libres
Que les plus libres de ce monde,
Sourd aux gros mots de tous calibres,
Inacceffible au rire immonde.

126

Nous avions laiffé fans émoi
Tous impédiments dans Paris,
Lui quelques fots bernés, & moi
Certaine princeffe Souris,

Une fotte qui tourna pire...
Puis foudain tomba notre gloire,
Tels, nous, des maréchaux d'empire
Déchus en brigands de la Loire.

Mais déchus volontairement!
C'était une permiffion,
Pour parler militairement,
Que notre féparation,

Permiffion fous nos femelles,
Et depuis combien de campagnes!
Pardonnâtes-vous aux femelles?
Moi j'ai peu revu ces compagnes,

127

Assez toutefois pour souffrir.
Ah! quel cœur faible que mon cœur!
Mais mieux vaut souffrir que mourir
Et surtout mourir de langueur.

On vous dit mort, vous. Que le Diable
Emporte avec qui la colporte
La nouvelle irrémédiable
Qui vient ainsi battre ma porte!

Je n'y veux rien croire. Mort, vous,
Toi, dieu parmi les demi-dieux!
Ceux qui le disent sont des fous.
Mort, mon grand péché radieux,

Tout ce passé brûlant encore
Dans mes veines & ma cervelle
Et qui rayonne & qui fulgore
Sur ma ferveur toujours nouvelle!

128

Mort tout ce triomphe inouï
Retentissant sans frein ni fin
Sur l'air jamais évanoui
Que bat mon cœur qui fut divin!

Quoi, le miraculeux poème
Et la toute-philosophie,
Et ma patrie & ma bohême
Morts? Allons donc! tu vis ma vie!

129

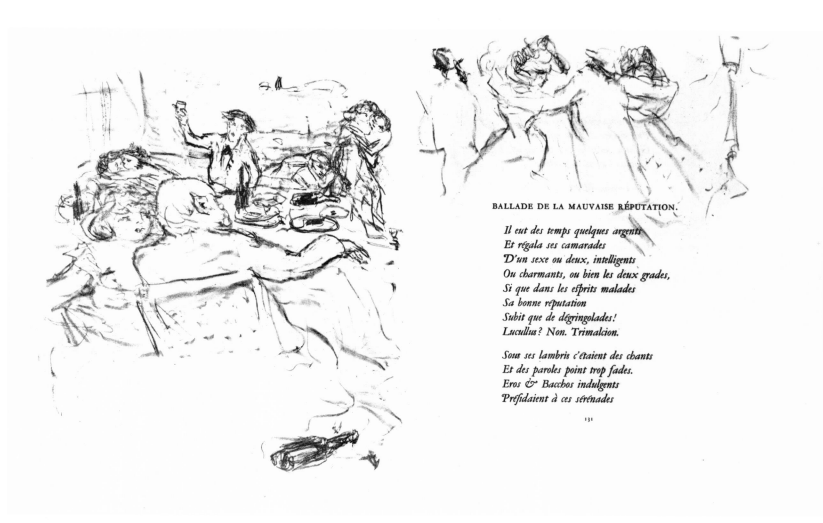

BALLADE DE LA MAUVAISE RÉPUTATION.

Il eut des temps quelques argents
Et régala ses camarades
D'un sexe ou deux, intelligents
Ou charmants, ou bien les deux grades,
Si que dans les esprits malades
Sa bonne réputation
Subit que de dégringolades!
Lucullus? Non. Trimalcion.

Sous ses lambris c'étaient des chants
Et des paroles point trop fades.
Eros & Bacchos indulgents
Présidaient à ces sérénades

131

Qu'accompagnaient des embraffades.
Puis chœurs & converfation
Ceffaient pour des fins peu mauffades.
Lucullus? Non. Trimalcion.

L'aube pointait & ces méchants
La faluaient par cent aubades
Qui réveillaient au loin les gens
De bien, & par mille rafades.
Cependant de vagues brigades
— Zèle ou dénonciation —
Verbalifaient chez des alcades.
Lucullus? Non. Trimalcion.

ENVOI.

Prince, ô très haut marquis de Sade.
Un fouris pour votre fcion.
Fier derrière fa paliffade.
— Lucullus? Non. Trimalcion.

CAPRICE.

O poète, faux pauvre & faux riche, homme vrai,
Jufqu'en l'extérieur riche & pauvre pas vrai,
(Dès lors, comment veux-tu qu'on foit fûr de ton cœur?)
Tour à tour fouple drôle & monfieur fomptueux,
Du vert clair plein d'«efpère» au noir componctueux,
Ton habit a toujours quelque détail blagueur.

Un bouton manque. Un fil dépaffe. D'où venue
Cette tache — ah çà, malvenue ou bienvenue? —
Qui rit & pleure fur le cheviot & la toile?
Nœud noué bien & mal, foulier luifant & terne.
'Bref, un type à fe pendre à la Vieille-Lanterne
Comme à marcher, gai proverbe, à la belle étoile.

Gueux, mais pas comme çà, l'homme vrai, le feul vrai,
Poète, va, fi ton langage n'eft pas vrai,
Toi l'es, & ton langage, alors! Tant pis pour ceux
Qui n'auront pas aimé, fou comme autant de tois,
La lune pour chauffer les fans femmes ni toits,
La mort, ah! pour bercer les cœurs malchanceux.

Pauvres cœurs mal tombés, trop bons & très fiers, certes!
Car l'ironie éclate aux lèvres belles, certes,
De vos bleffures, cœurs plus bleffés qu'une cible,
Petits facrés-cœurs de Jéfus plus lamentables!
Va, poète, le feul des hommes véritables,
Meurs fauvé, meurs de faim pourtant le moins poffible.

BALLADE SAPPHO.

Ma douce main de maîtreffe & d'amant
Paffe & rit fur ta chère chair en fête,
Rit & jouit de ton jouiffement.
Pour la fervir tu fais bien qu'elle eft faite,
Et ton beau corps faut que je le dévête
Pour l'enivrer fans fin d'un art nouveau
Toujours dans la careffe toujours prête.
Je fuis pareil à la grande Sappho.

Laiffe ma tête errant & s'abîmant
A l'aventure, un peu farouche, en quête
D'ombre & d'odeur & d'un travail charmant
Vers les faveurs de ta gloire fecrète.

Laiffe rôder l'âme de ton poète
Partout par là, champ ou bois, mont ou vau,
Comme tu veux & fi je le fouhaite.
Je fuis pareil à la grande Sappho.

Je preffe alors tout ton corps goulûment,
Toute ta chair contre mon corps d'athlète
Qui fe bande & s'amollit par moment,
Heureux du triomphe & de la défaite
En ce conflit du cœur & de la tête.
Pour la ftérile étreinte où le cerveau
Vient faire enfin la nature complète,
Je fuis pareil à la grande Sappho.

ENVOI.

Prince ou princeffe, honnête ou malhonnête,
Qui qu'en grogne & quel que foit fon niveau,
Trop fu poète ou drain proxénète,
Je fuis pareil à la grande Sappho.

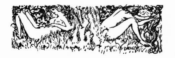

TABLE DES MATIÈRES.

ACHEVÉ D'IMPRIMER LE 29 SEPTEMBRE 1900, SUR LES PRESSES À BRAS DE L'IMPRIMERIE NATIO-NALE, AVEC UNE FONTE NOUVELLE DE CARACTÈRES GRAVÉS EN 1540 PAR GARAMOND, SUR L'ORDRE DE FRANÇOIS I^{er}.

LE VÉLIN DE HOLLANDE A ÉTÉ FABRIQUÉ SPÉ-CIALEMENT PAR LA MAISON VAN GELDER, D'AMS-TERDAM, AVEC LE FILIGRANE *PARALLÈLEMENT*. LES LITHOGRAPHIES ONT ÉTÉ IMPRIMÉES À LA PRESSE À BRAS PAR AUGUSTE CLOT.

LES ORNEMENTS DU LIVRE ONT ÉTÉ DESSINÉS PAR PIERRE BONNARD ET GRAVÉS SUR BOIS PAR T. BELTRAND.

135

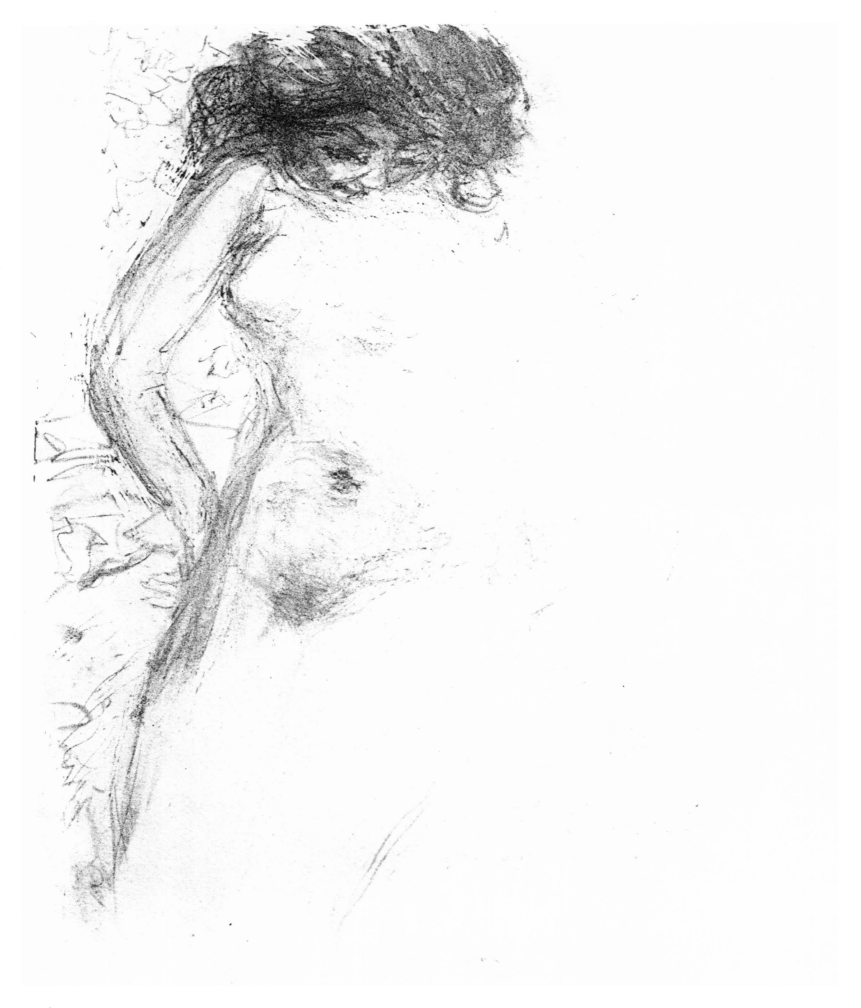

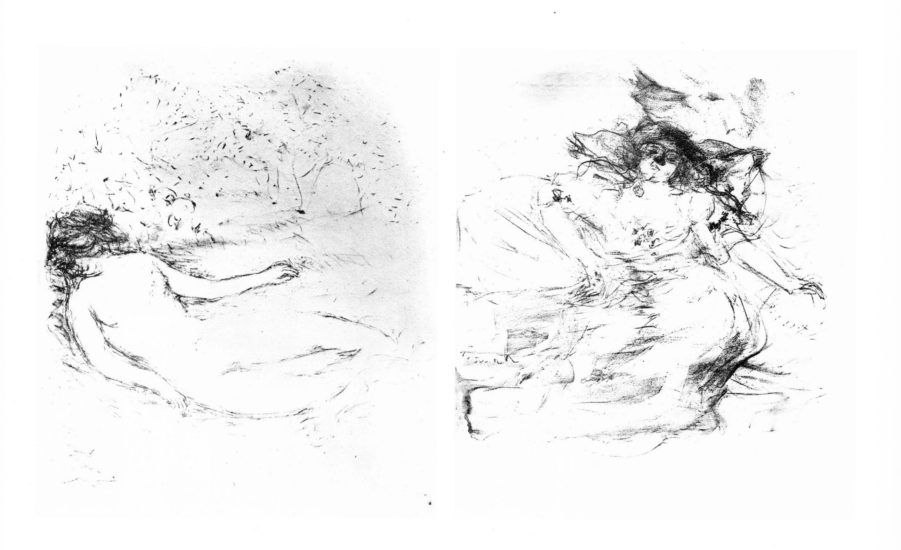

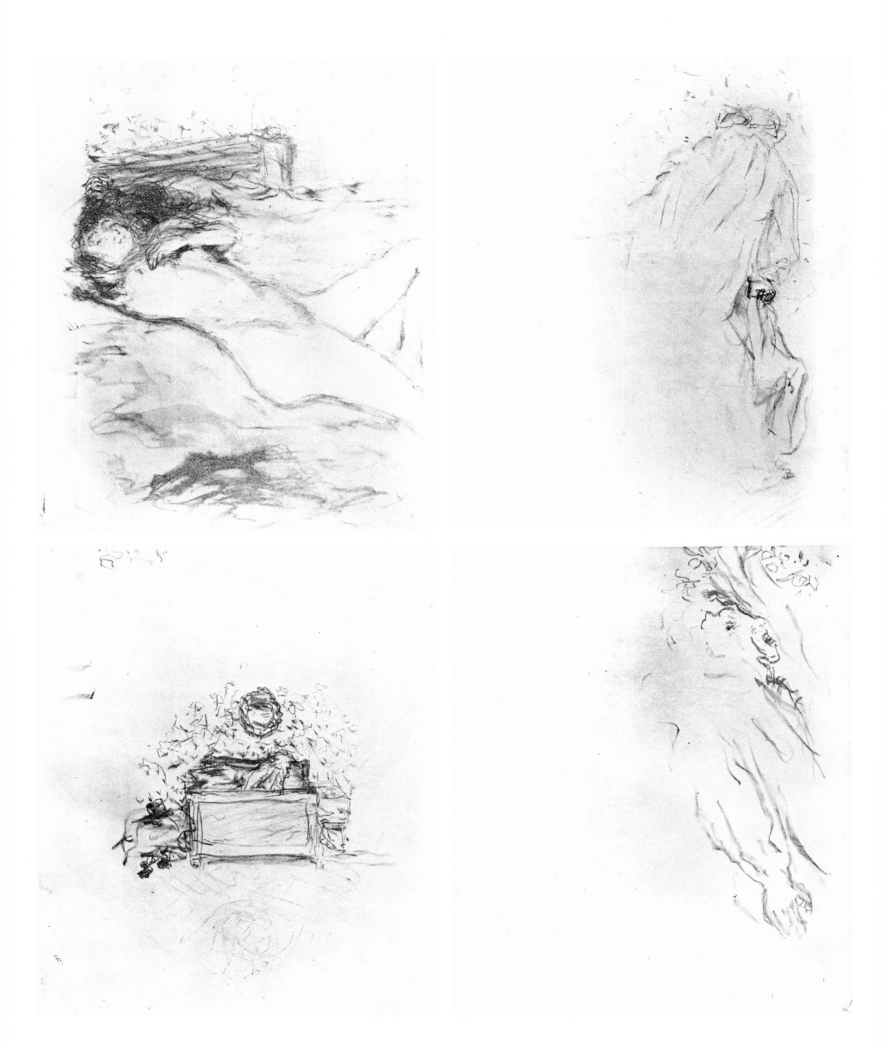

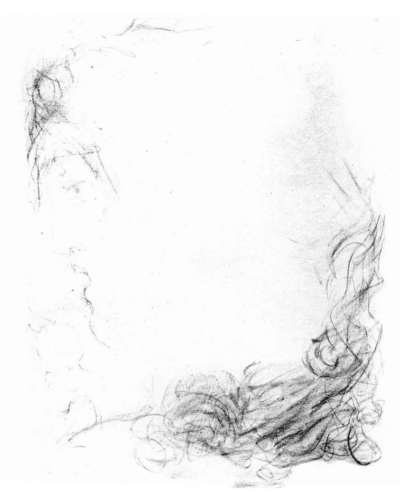

75
Daphnis and Chloë
Daphnis et Chloé

1902

156 lithographs printed in black for the pastoral poem by Longus
Dimensions of book: 30.5 × 25 (12 × 9⅞)
Printed at the Imprimerie Nationale, Paris. Lithographs printed by Clot.
Publisher: Ambroise Vollard
The book printed in an edition of 250, numbered, of which : ten on Japanese paper, with double sequence of lithographs minus the text, and printed in a different colour (sanguine) (1–10); forty on China paper, with double sequence of all the lithographs minus the text, and printed in a different colour (blue) (11–50); two hundred on Van Gelden Holland wove paper bearing the watermark 'Daphnis et Chloé' (51–250)

Some very rare proofs from an earlier state, of which some modified by hand. The original stones have been cancelled. After the book of *Parallèlement*, Vollard 'immediately wanted another, and I started the lithographs for *Daphnis and Chloë*, of a more classical inspiration. I worked rapidly and with enjoyment; *Daphnis* was able to appear in 1902. On each page I evoked the shepherd of Lesbos with a sort of happy intoxication that quite carried me away . . .', said Bonnard to Marguette Bouvier (*Comœdia*, 23 January 1943)

The illustrations have a standard format; yet this strict form was chosen by the painter himself and is not in the least monotonous, so varied are the subjects and their interpretation. 'The lithographs, of an unprecedented lightness of touch, have been printed with such subtlety and skill that you seem to see the original crayon, and they, like the text, have that marvellous spontaneity that will remain for ever one of Bonnard's greatest gifts.' (Jacques Guignard, *Le Livre*, Editions du Chêne, 1942)

Bibliography: TF 42; Marguette Bouvier, *Comœdia*, 23 January 1943; AS 22; CRM 95; Günter Busch, 1961; UJ 23

There still exist some preliminary drawings for these lithographs, done in lithographic crayon, highly elaborated, and already in the dimensions required for the illustrations. These make it possible to follow the creative process of the artist and see the steps leading up to the definitive lithograph. Few states or trial proofs, but instead a systematic process of experimentation contained in a sequence of drawings. As well as following the text, the painter has recalled the peasants of the Île-de-France and of Marly and Montval, where he had bought a small house. Also the peasants of his native Dauphiné. In this instance he was not inspired by his paintings. On the contrary. After illustrating *Daphnis*, he continually returned in his canvases to the characters of this book, the nymphs, fauns and satyrs
Compare with *The Fauns*, Dauberville 329; *Faun and Nymph*, Dauberville 471; *The little Fauns*, Dauberville 540. Bonnard even introduced these same elements into a sculpture, *Centre-piece for a table*, cast in bronze (Musée National d'Art Moderne, Paris)

LES PASTORALES DE LONGUS
OU
DAPHNIS ET CHLOÉ
TRADUCTION
DE MÉSSIRE J. AMYOT
EN SON VIVANT ÉVÊQUE D'AUXERRE ET GRAND AUMÔNIER DE FRANCE

REVUE, CORRIGÉE, COMPLÉTÉE DE NOUVEAU
REFAITE EN GRANDE PARTIE
PAR
PAUL-LOUIS COURIER
VIGNERON, MEMBRE DE LA LÉGION D'HONNEUR
CI-DEVANT CANONNIER À CHEVAL

LITHOGRAPHIES ORIGINALES
DE P. BONNARD

PARIS
AMBROISE VOLLARD, ÉDITEUR
6, RUE LAFFITTE, 6

1902

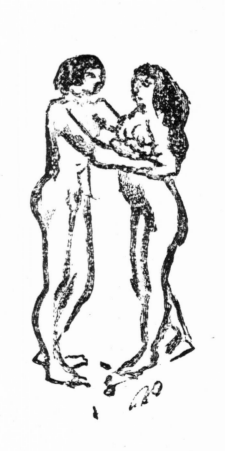

Enlarged detail

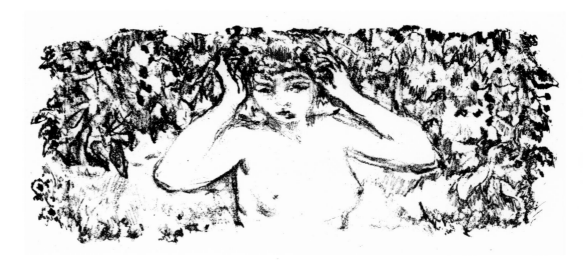

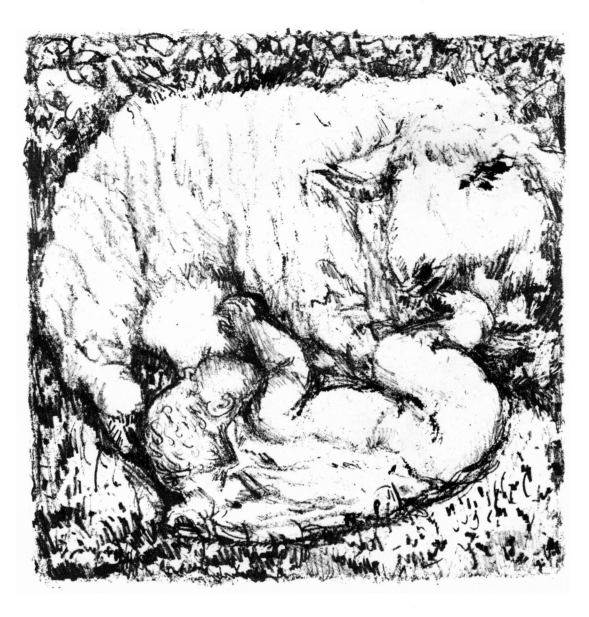

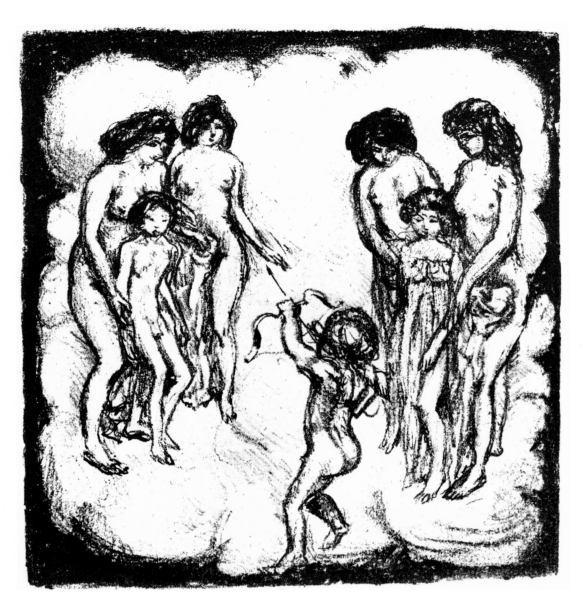

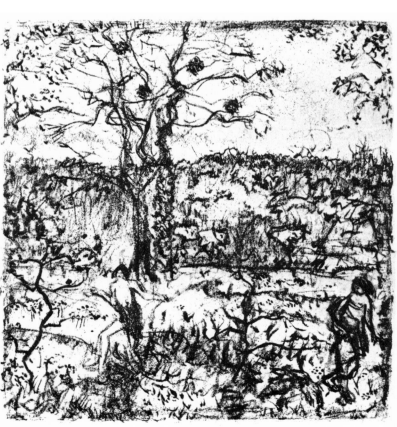

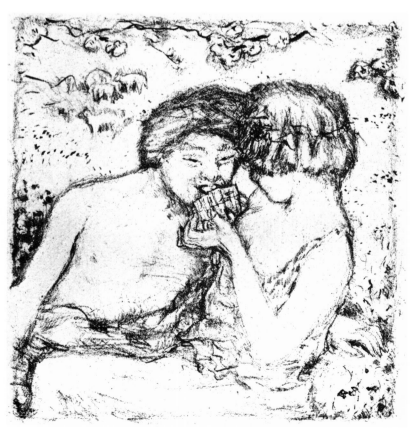

144

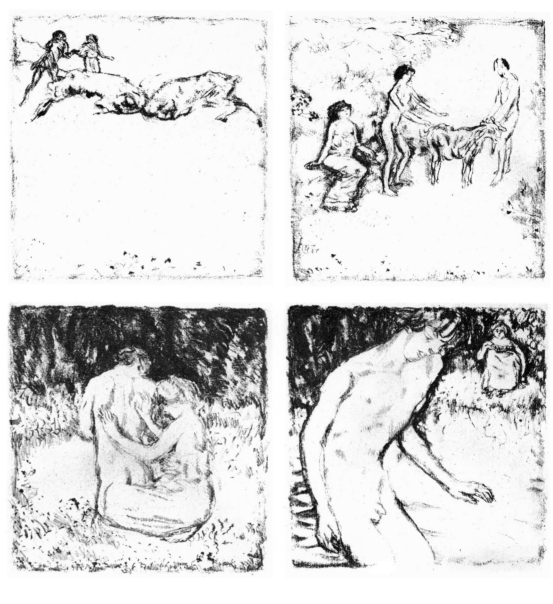

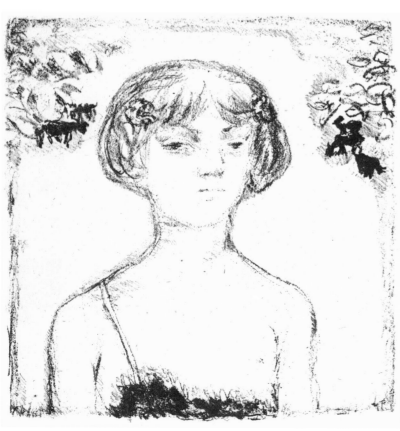

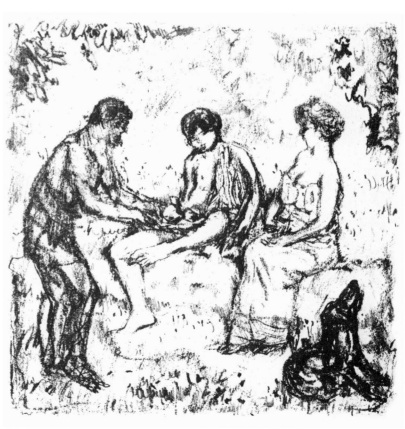

145

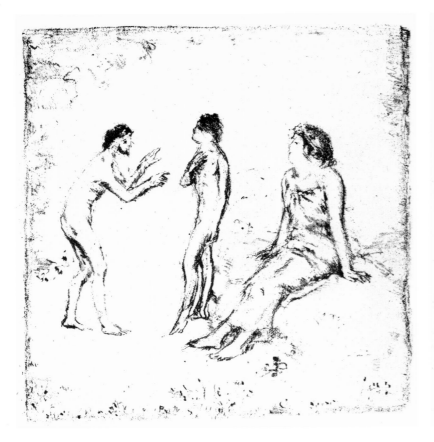

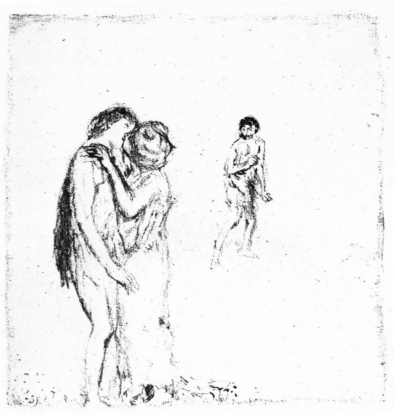

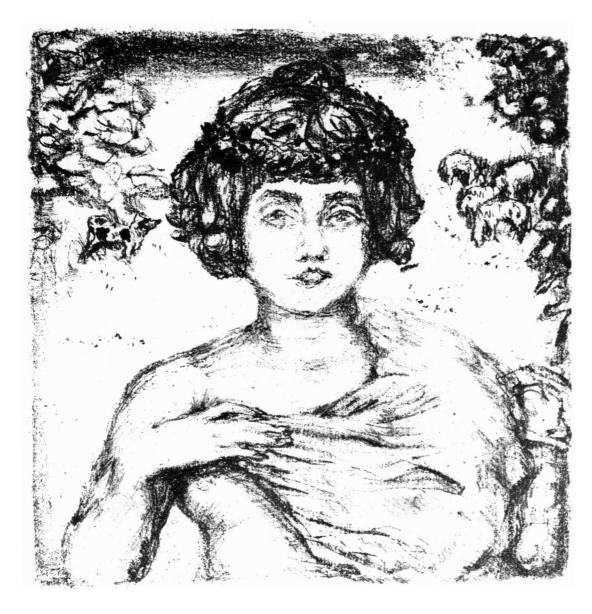

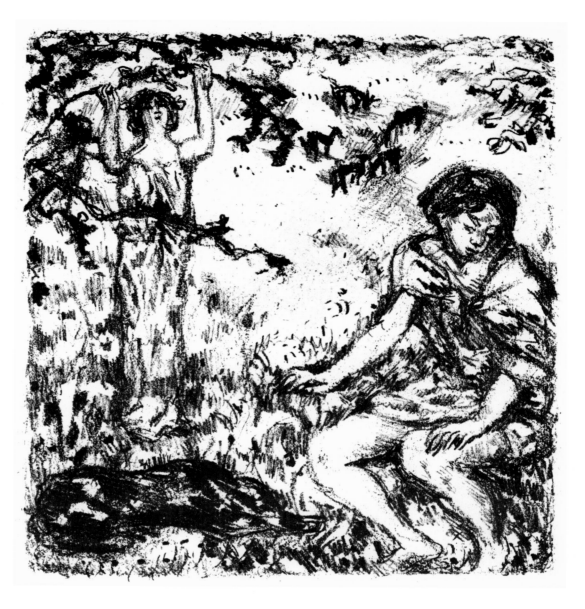

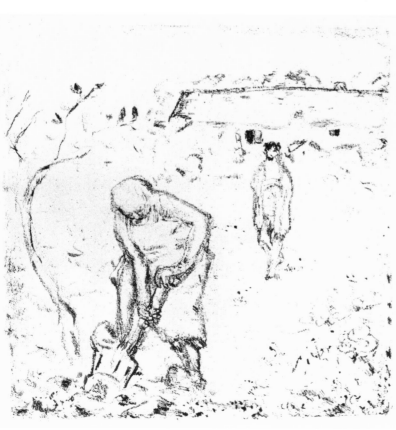

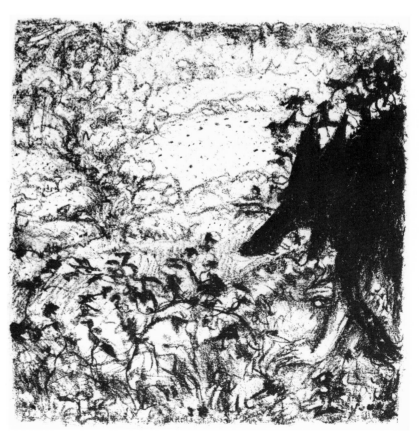

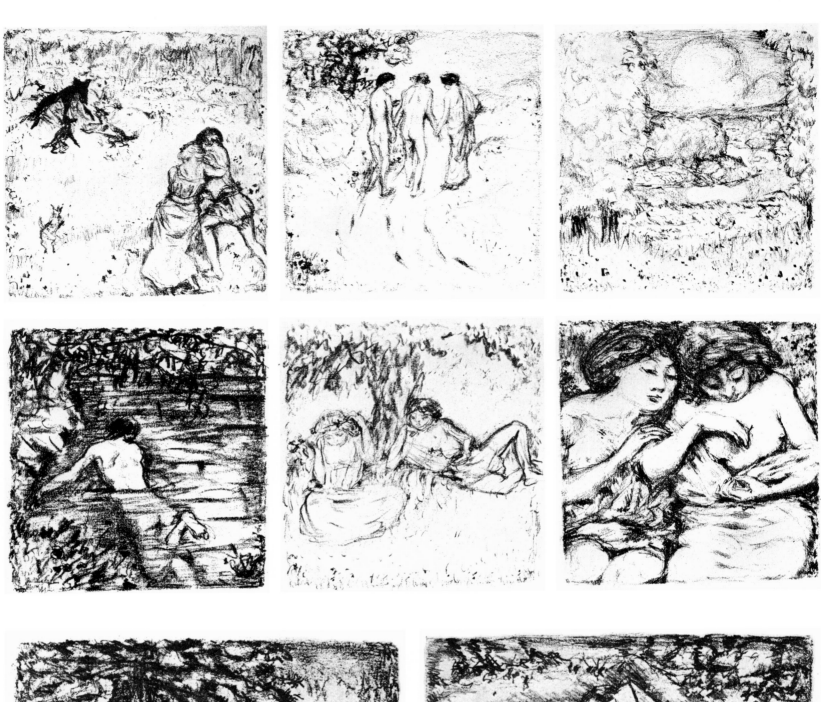
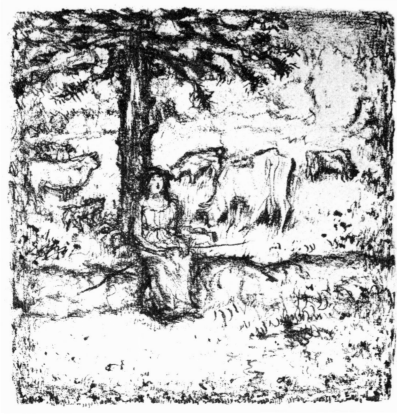
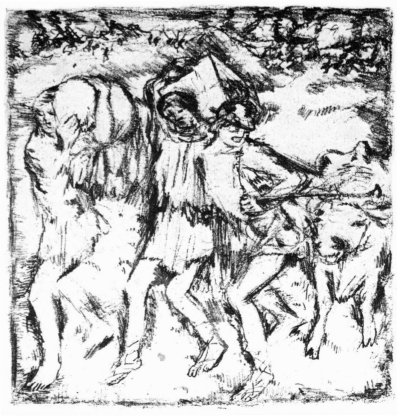

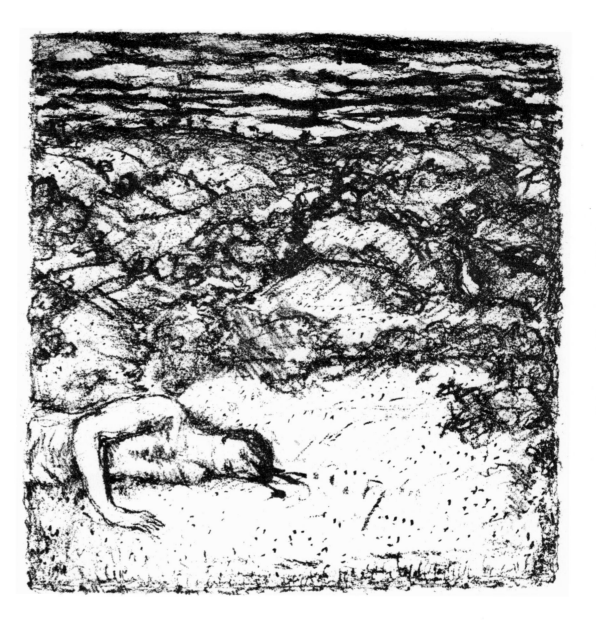

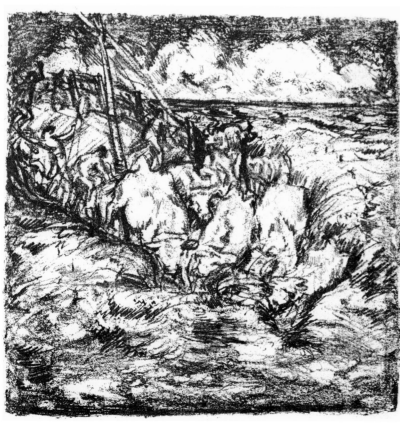

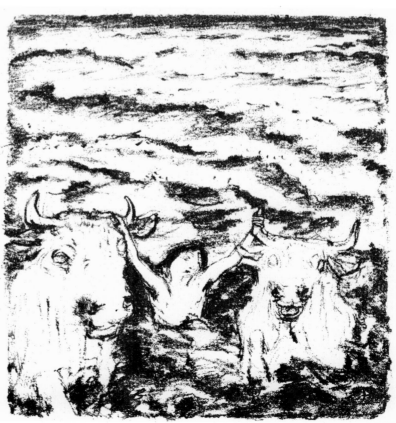

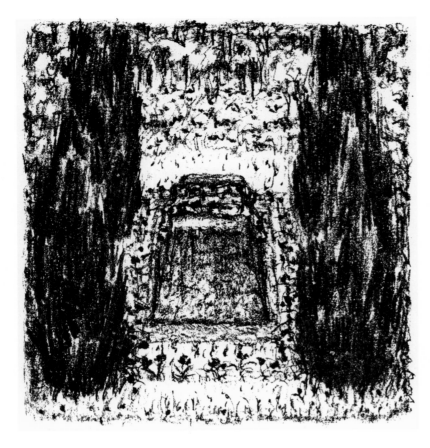

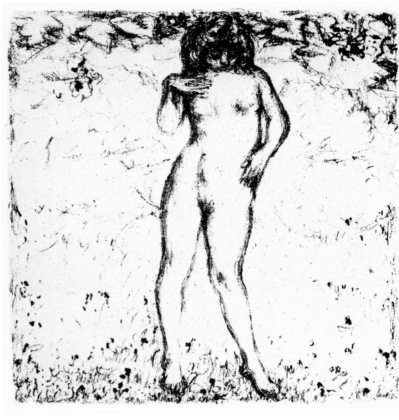

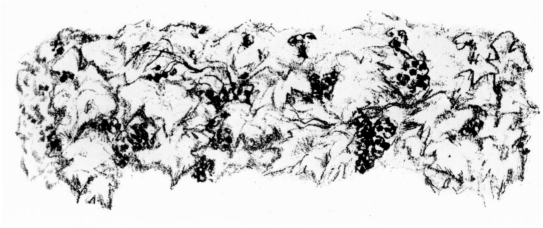

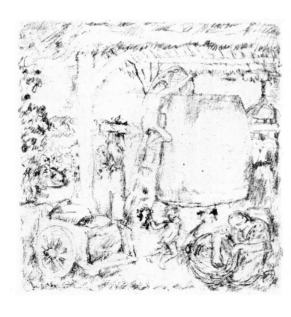

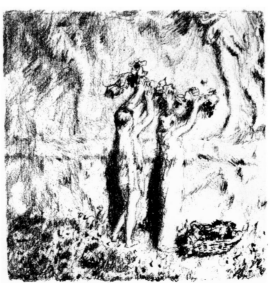

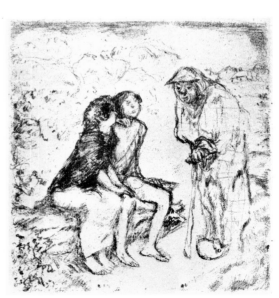

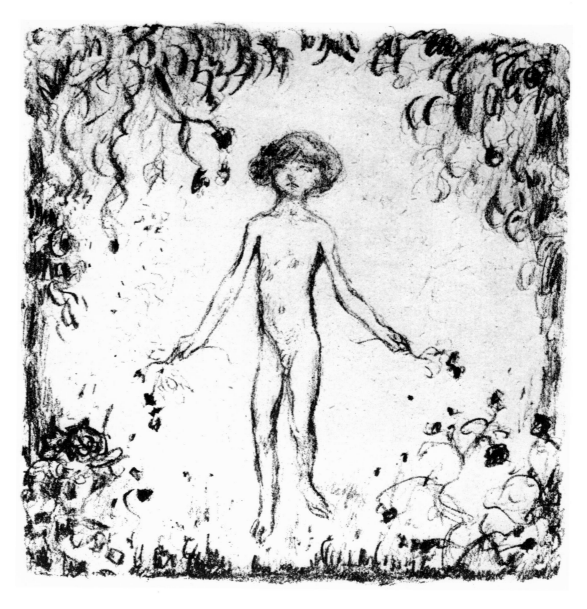

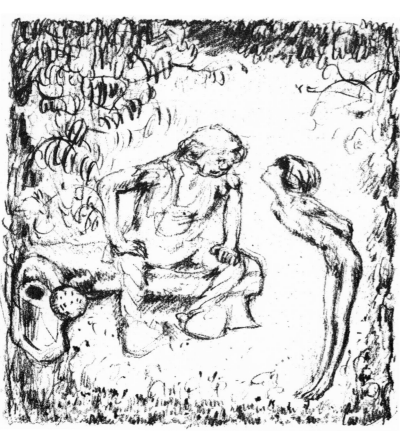

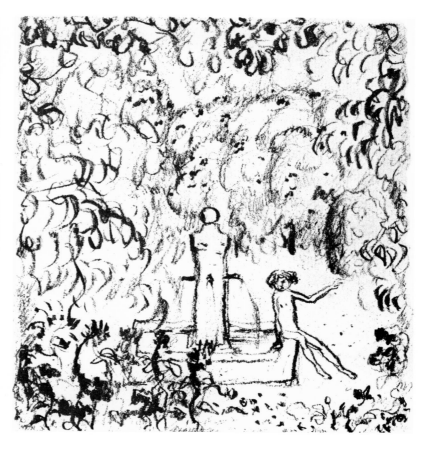

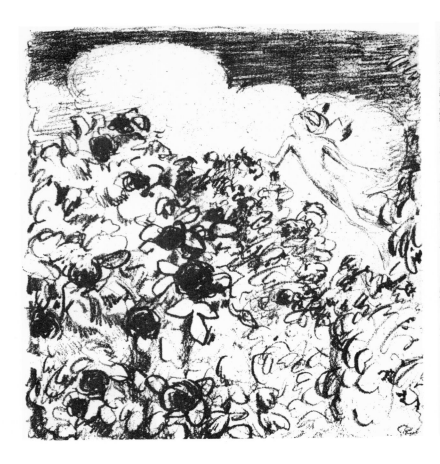 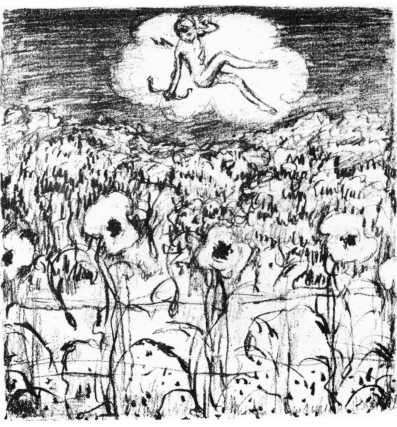

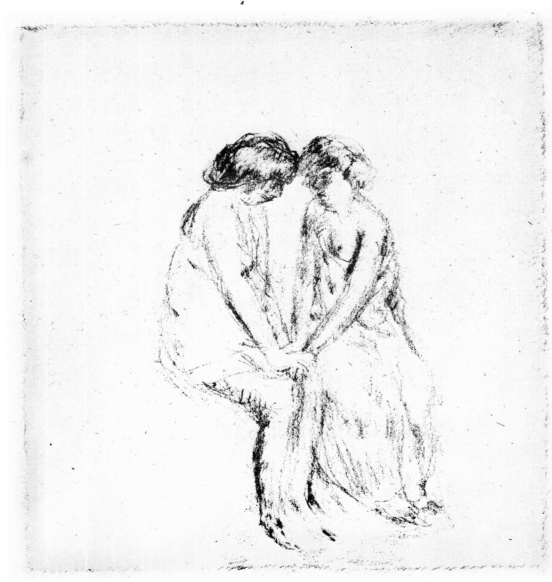

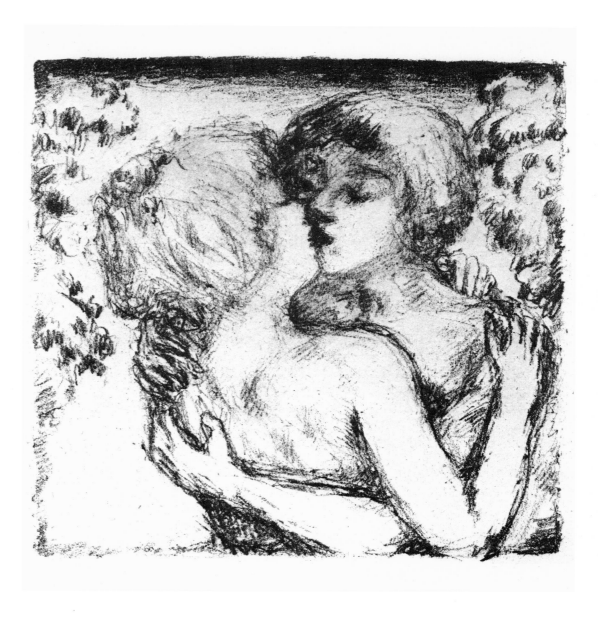

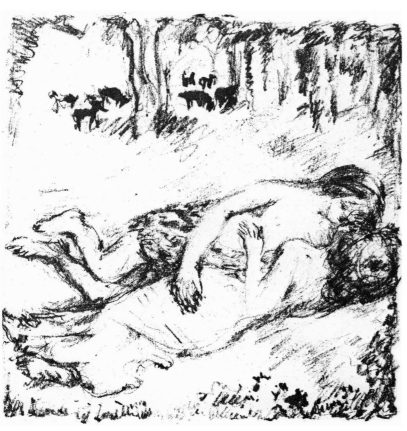

153

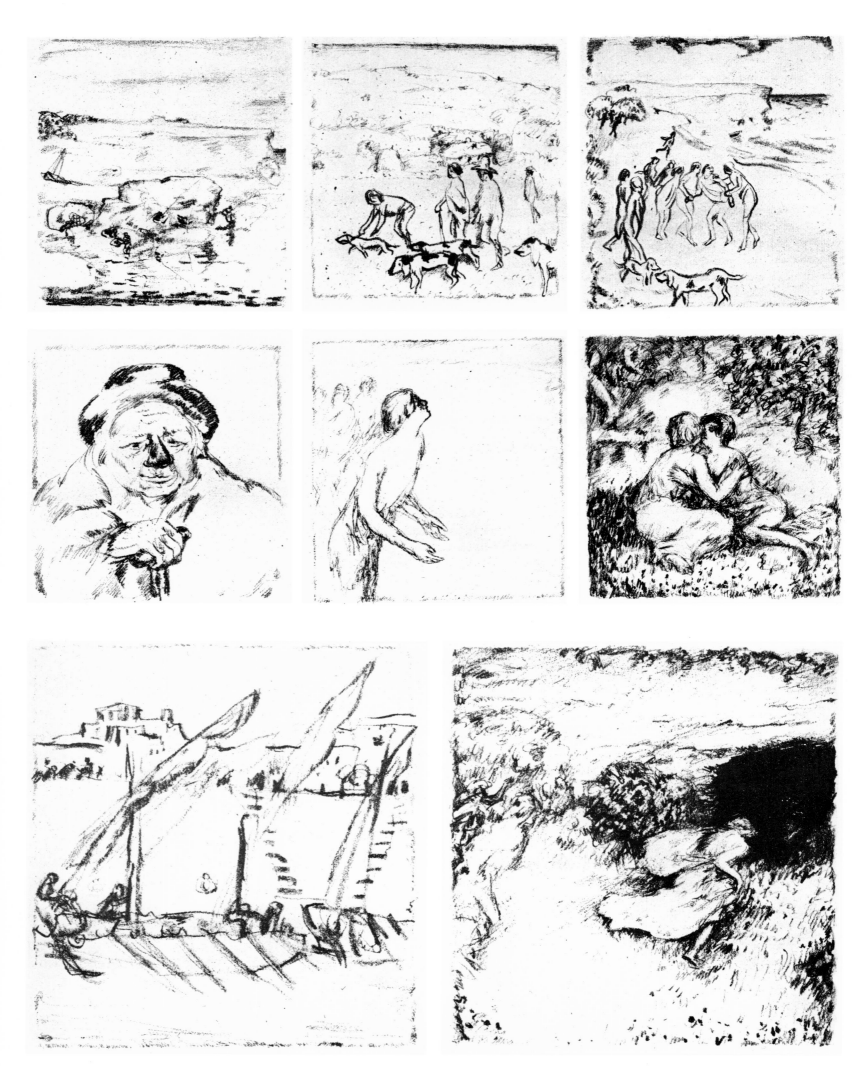

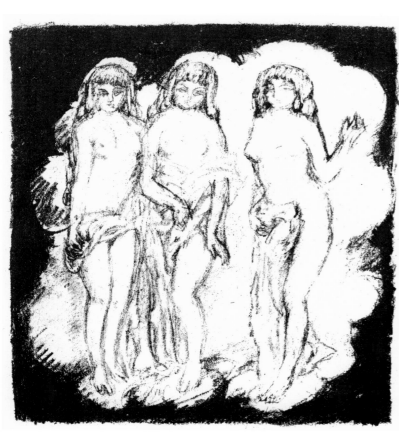

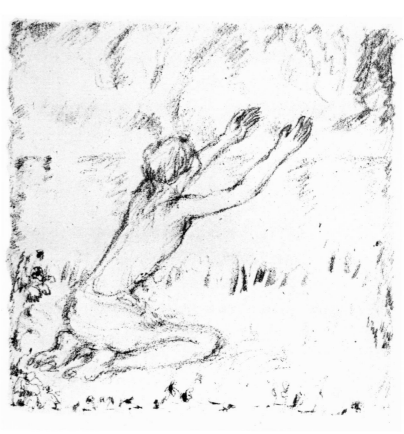

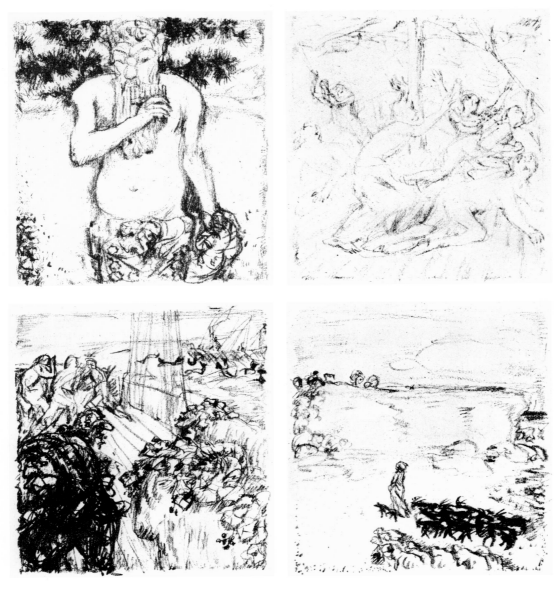

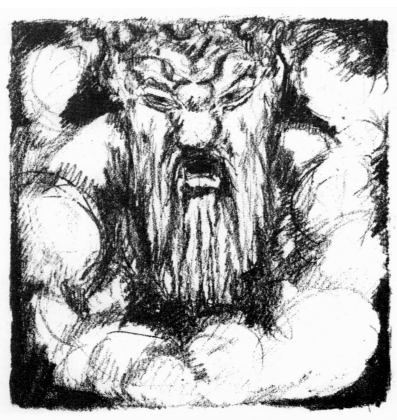

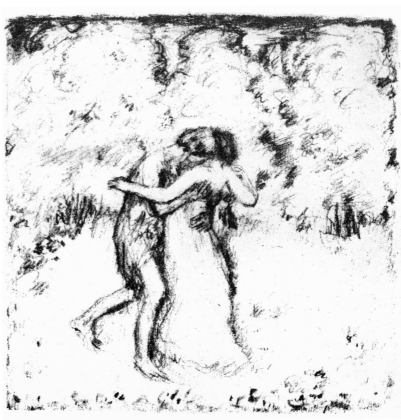

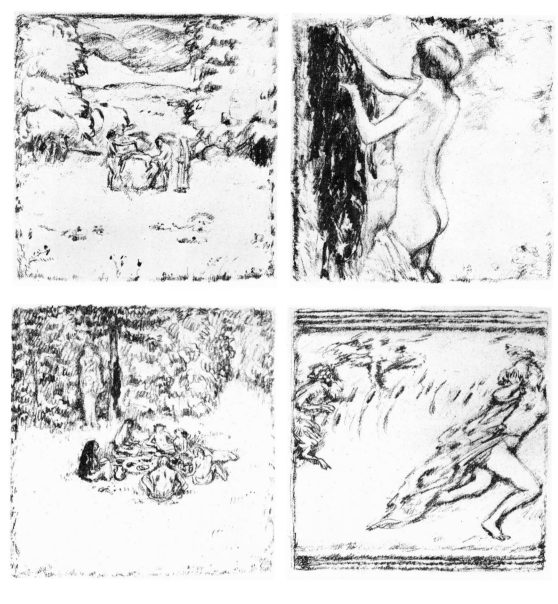

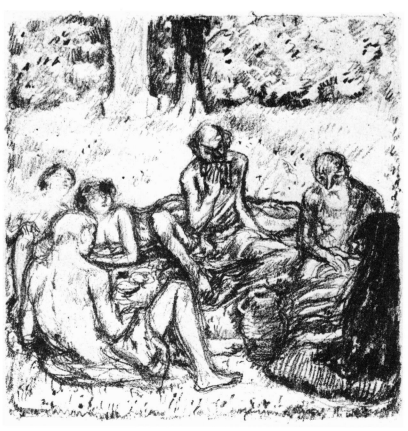

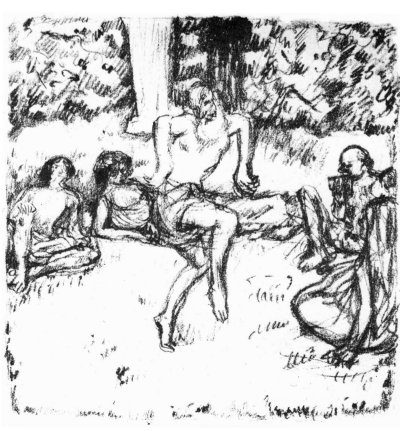

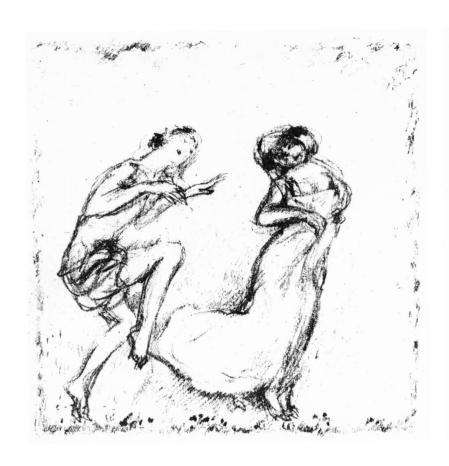
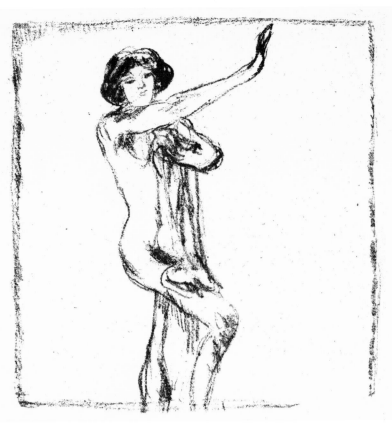

159

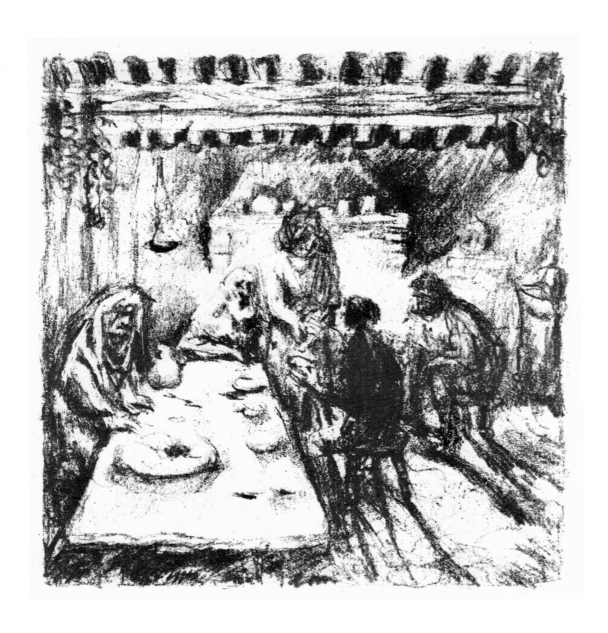

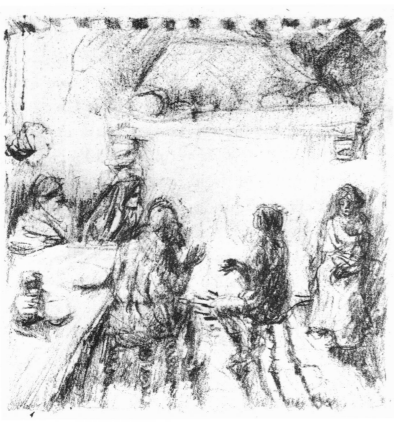

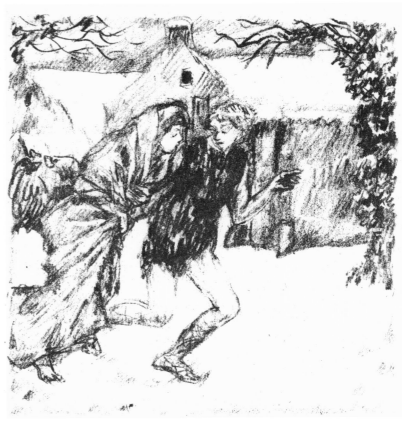

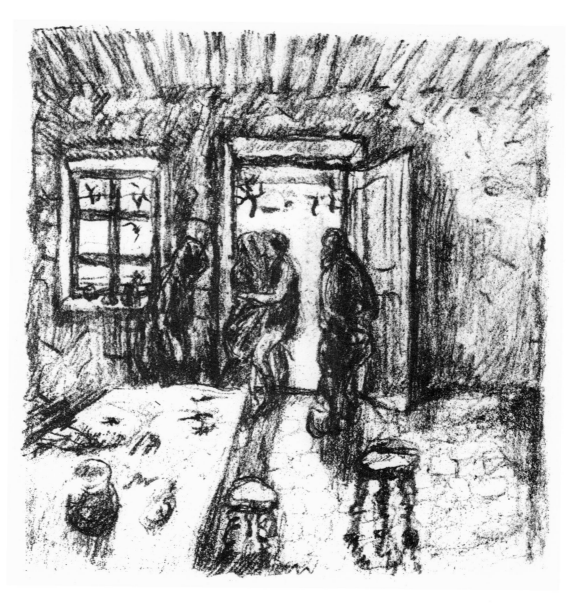

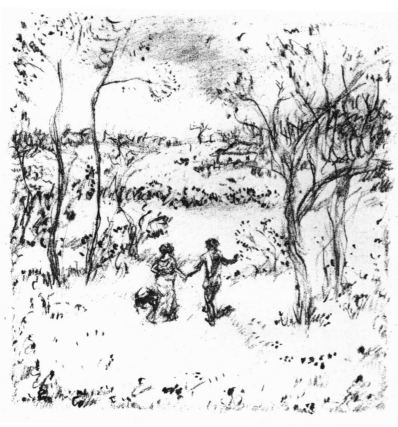

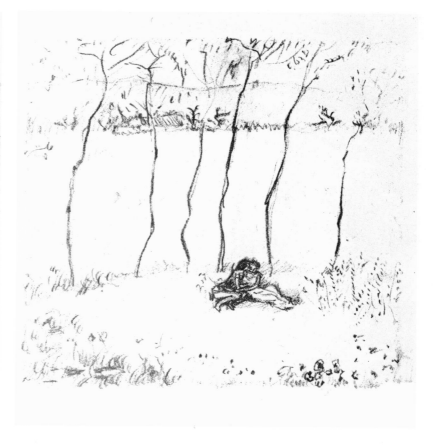

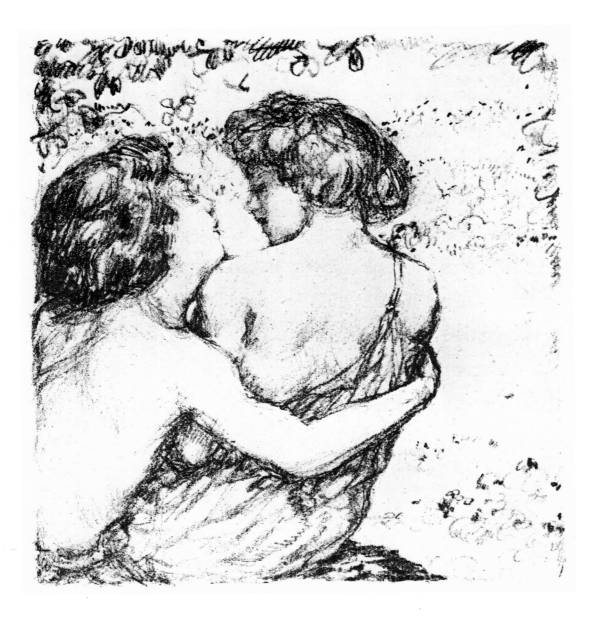

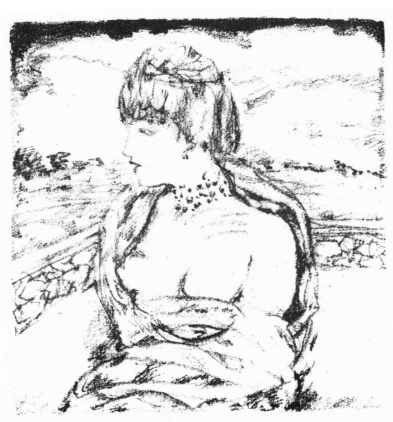

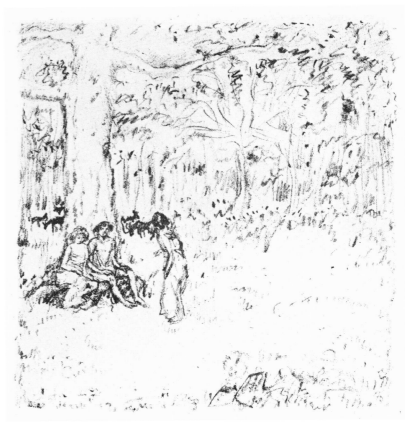

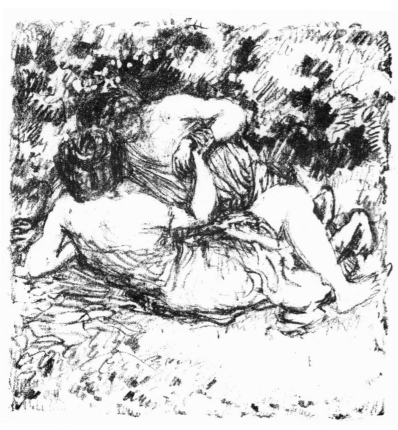

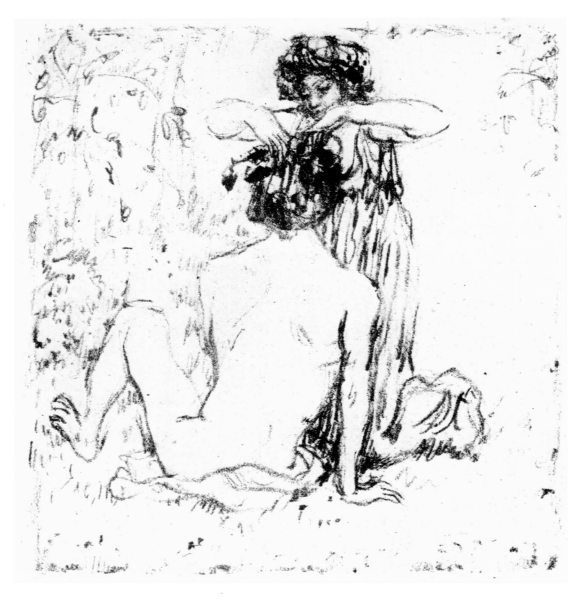

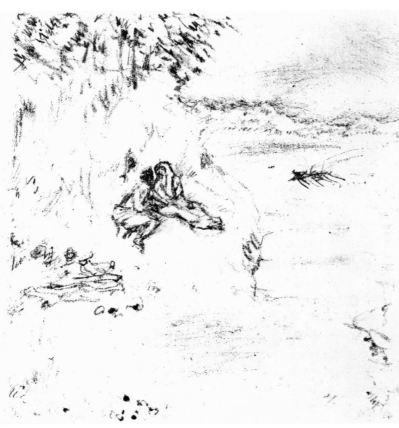

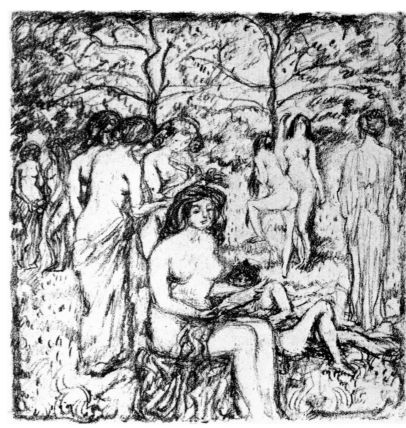

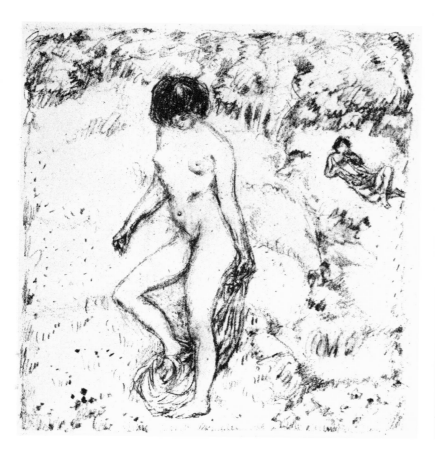

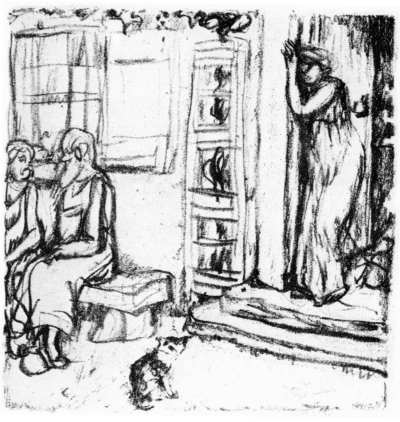

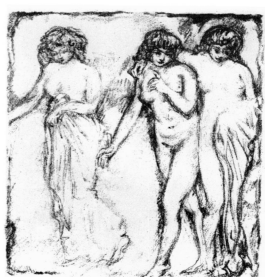

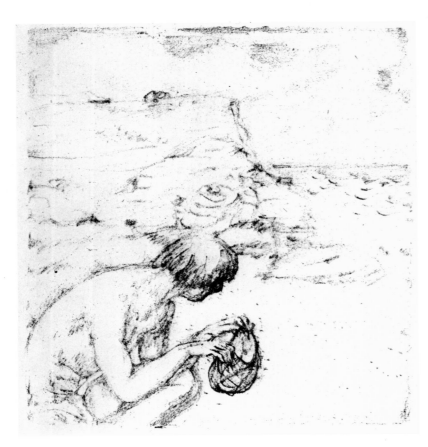

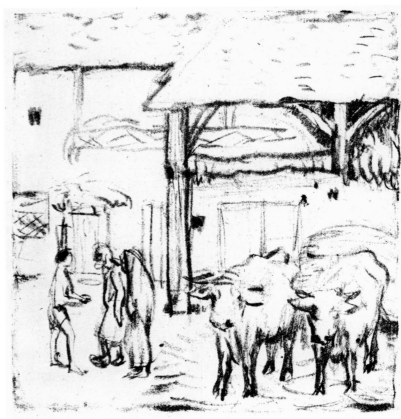

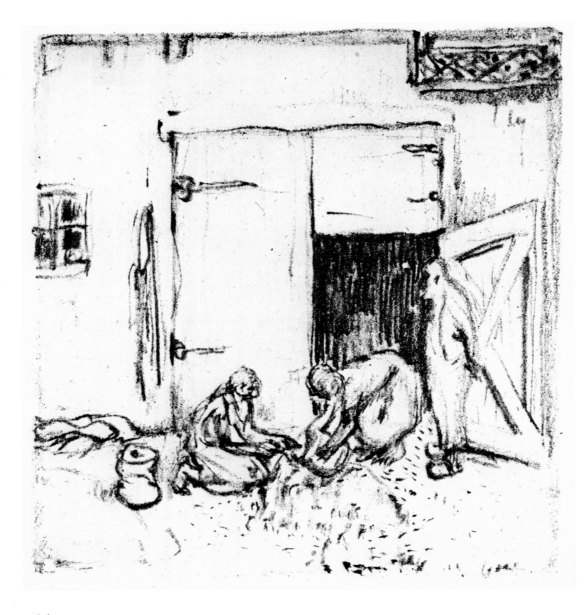

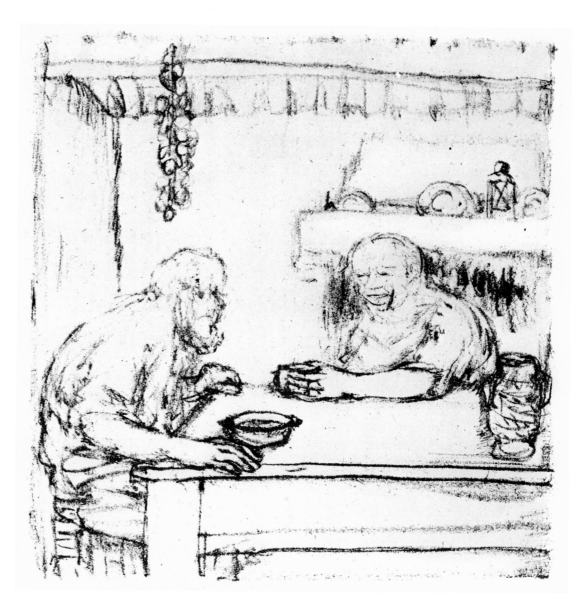

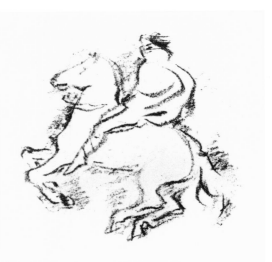

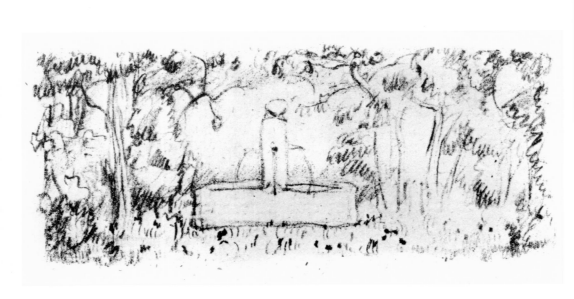

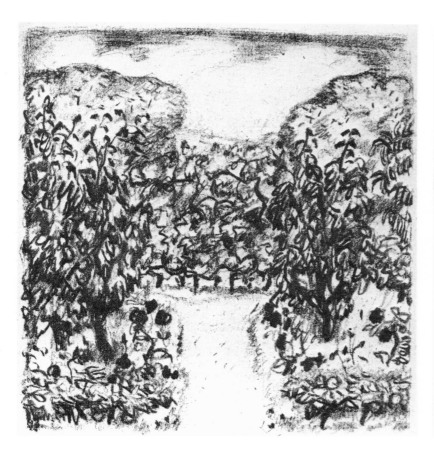

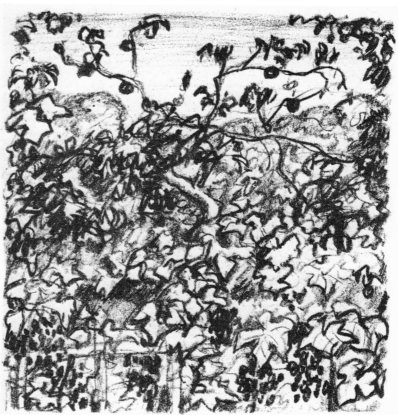

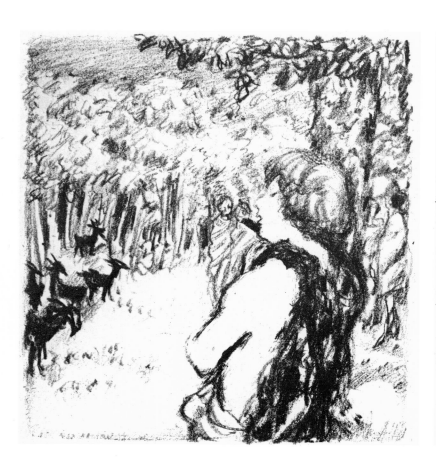

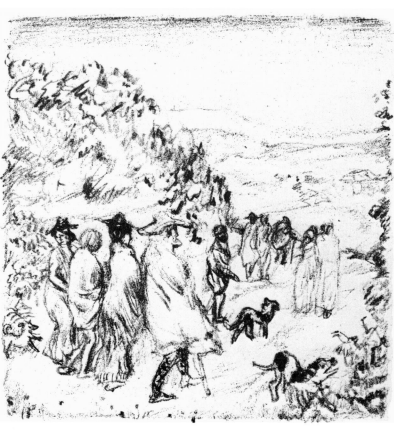

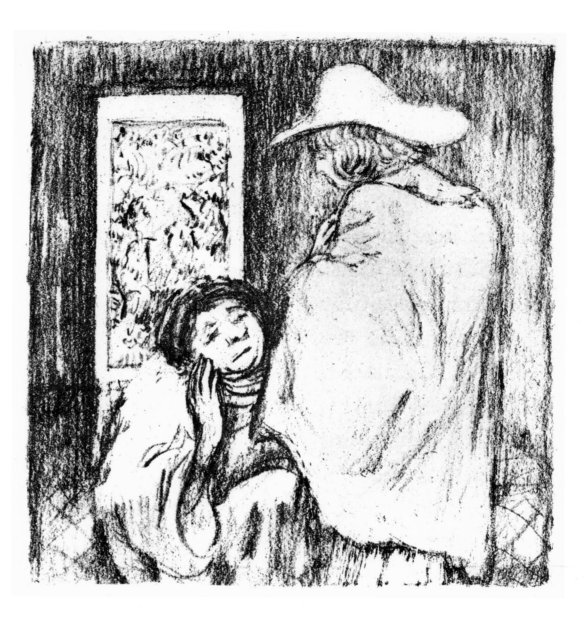

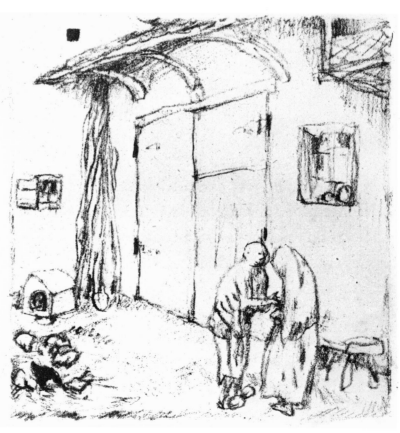

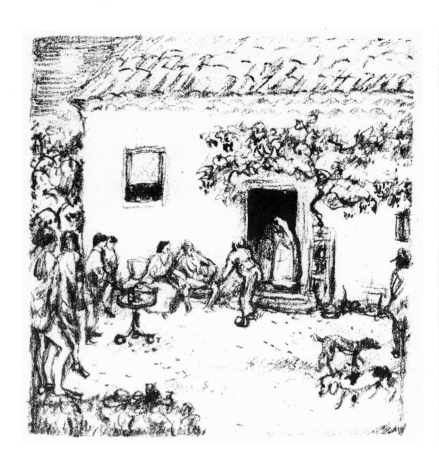

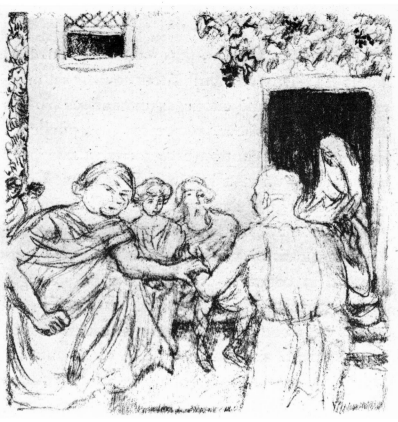

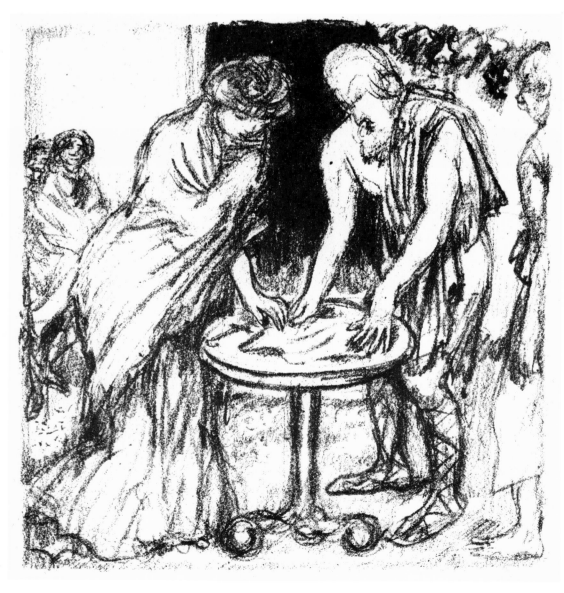

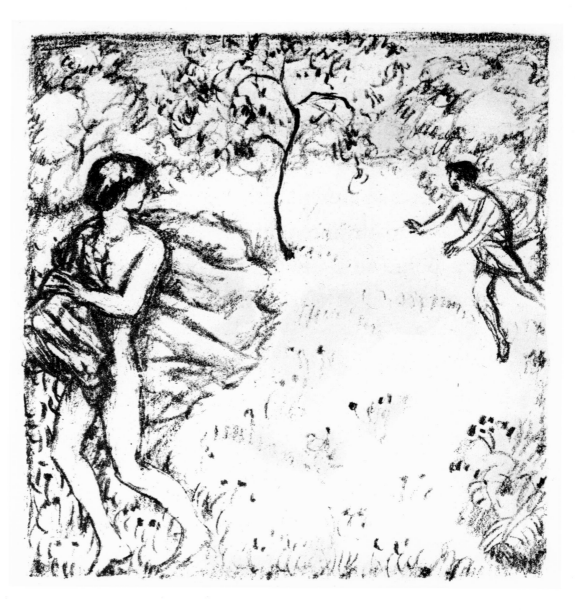

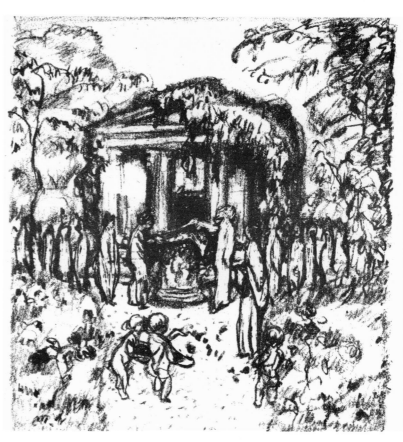

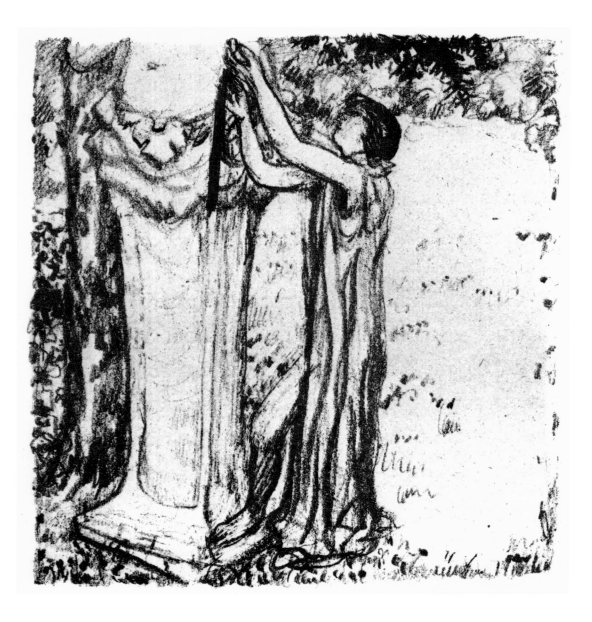

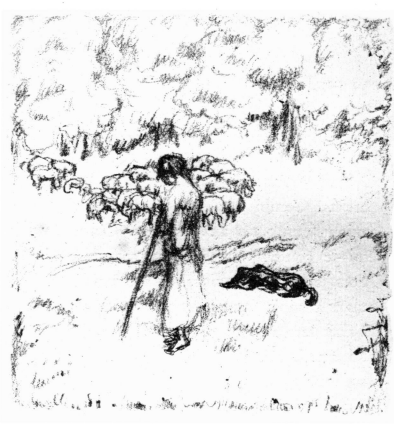

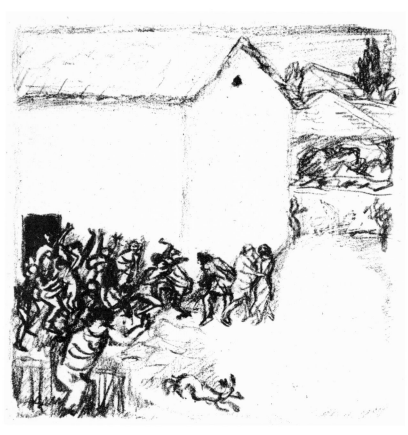

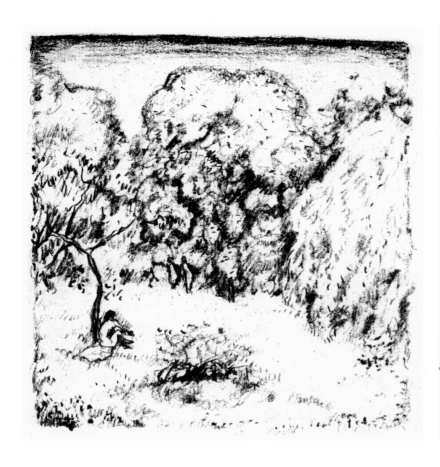

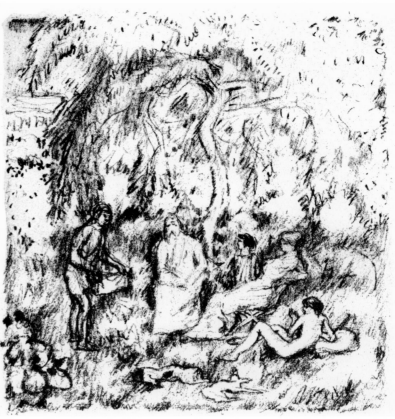

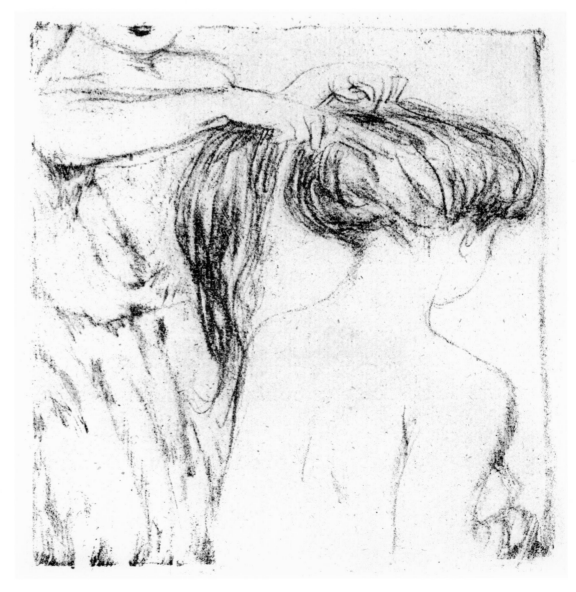

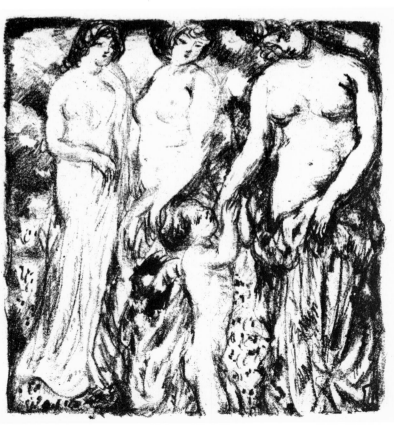

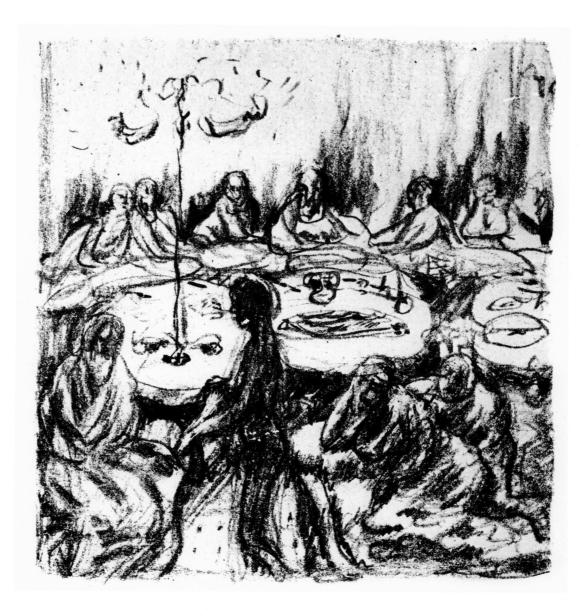

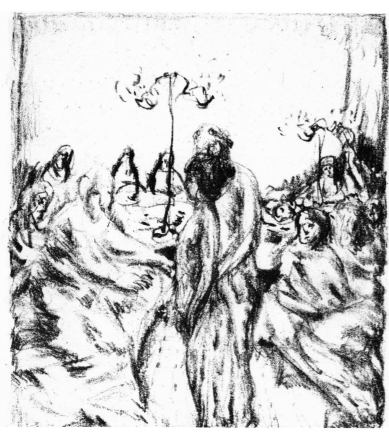

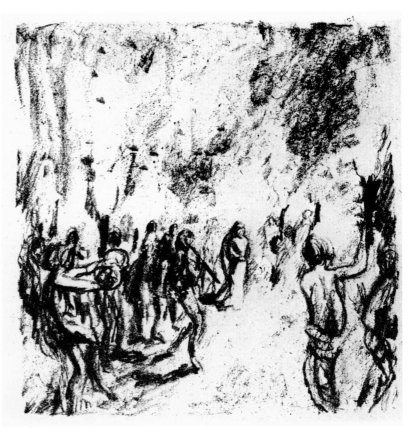

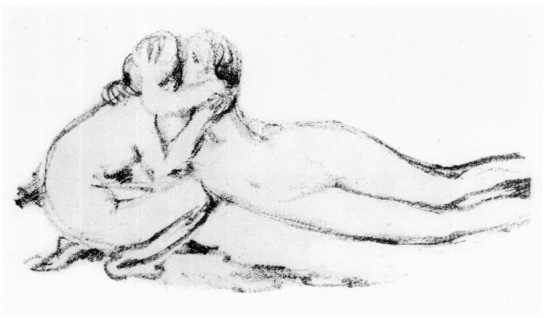

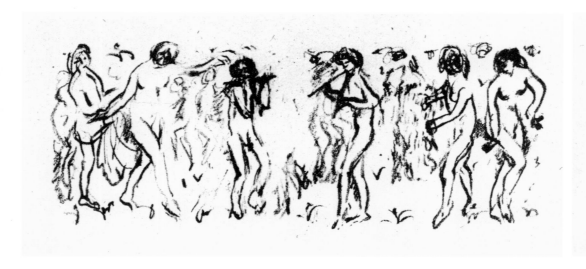

76
Six lithographs, variants for *Daphnis and Chloë*

1902

a)	**Landscape with rock**	
	Paysage au rocher	15×13.8 ($5\frac{7}{8} \times 5\frac{1}{2}$)
b)	**Unleashing of the dogs**	
	Le lâcher des chiens	15.1×13.6 ($5\frac{7}{8} \times 5\frac{3}{8}$)
c)	**The capture**	
	La capture	15.2×13.8 ($6 \times 5\frac{1}{2}$)
d)	**Male figure, head and shoulders**	
	Personnage masculin en buste	15.4×14 ($6\frac{1}{8} \times 5\frac{1}{2}$)
e)	**Lovers with poplar trees**	
	Les amoureux aux peupliers	13.5×13.8 ($5\frac{3}{8} \times 5\frac{1}{2}$)
f)	**Female figure, head and shoulders**	
	Personnage féminin en buste	15.5×13.8 ($6\frac{1}{8} \times 5\frac{1}{2}$)

Printed in an edition of fifty on loose-leaf China or Japanese antique paper, in blue, black or bistre. Also a few proofs with wide margins on loose-leaf China paper, of which some signed in pencil

a) see p. 154, top left

b) see p. 154, top centre

c) see p. 154, top right

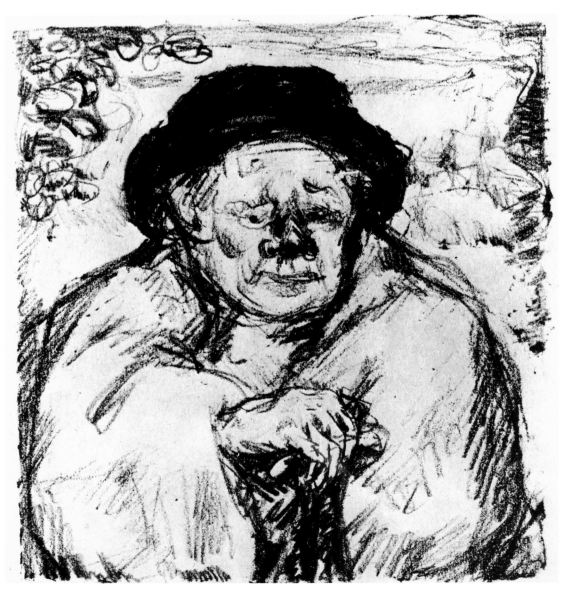

d) see p. 154, top left

e) see p. 161, bottom right

f) see p. 162, bottom left

183

77
Le Figaro

1903

Lithograph printed in three colours 127×83 $(50 \times 32\frac{5}{8})$
Signed below r.
Poster, printed by Chaix, 20 rue Bergère

Bibliography: TF 34; CRM 71

One trial proof of an earlier state, modified by hand of the artist (Collection
Sagot–Le Garrec); this has been exhibited on several occasions, most notably at the
Orangerie (1967, cataologue no. 260) and by Huguette Berès (1970, catalogue
no. 65); in this state, the blue colouring consists of no more than a few lines in
crayon

LE PLUS IMPORTANT
DES JOURNAUX PARISIENS
LE FIGARO
EST MIS EN VENTE à

LE FIGARO

EST DISTRIBUÉ À TOUS SES ABONNÉS
AVANT

IMP. CHAIX, Rue Bergere, 20. Paris. 6 03. (Encre Lorilleux)

78
Le Figaro

1903

Lithograph printed in two colours 56 × 38 (22 × 15)
Signed above r., on the chair-back
Small poster, printed by Chaix, and announcing the
publication in *Le Figaro* of a new novel by Abel Hermant,
Confession d'un homme d'aujourd'hui

Bibliography: CRM 70

LIRE DANS
LE FIGARO

le nouveau roman

d'Abel HERMANT

Confession d'un Homme d'aujourd'hui

79
Le Salon d'Automne

1912

Lithograph printed in two colours 147 × 106 (57⅞ × 41¾)
Signed below r.
Poster, printed by the Imprimerie C. Verneau
The poster advertises the Salon d'Automne of 1912; Bonnard also designed
the cover for the catalogue
This catalogue contains the following announcement, p. 258: 'One hundred
prints of the poster of 1912 are on sale, price 5 francs per print . . .'

The print reproduced here belongs to the Museum of Modern Art, New York (gift
of Peter H. Deitsch)
Some preliminary drawings

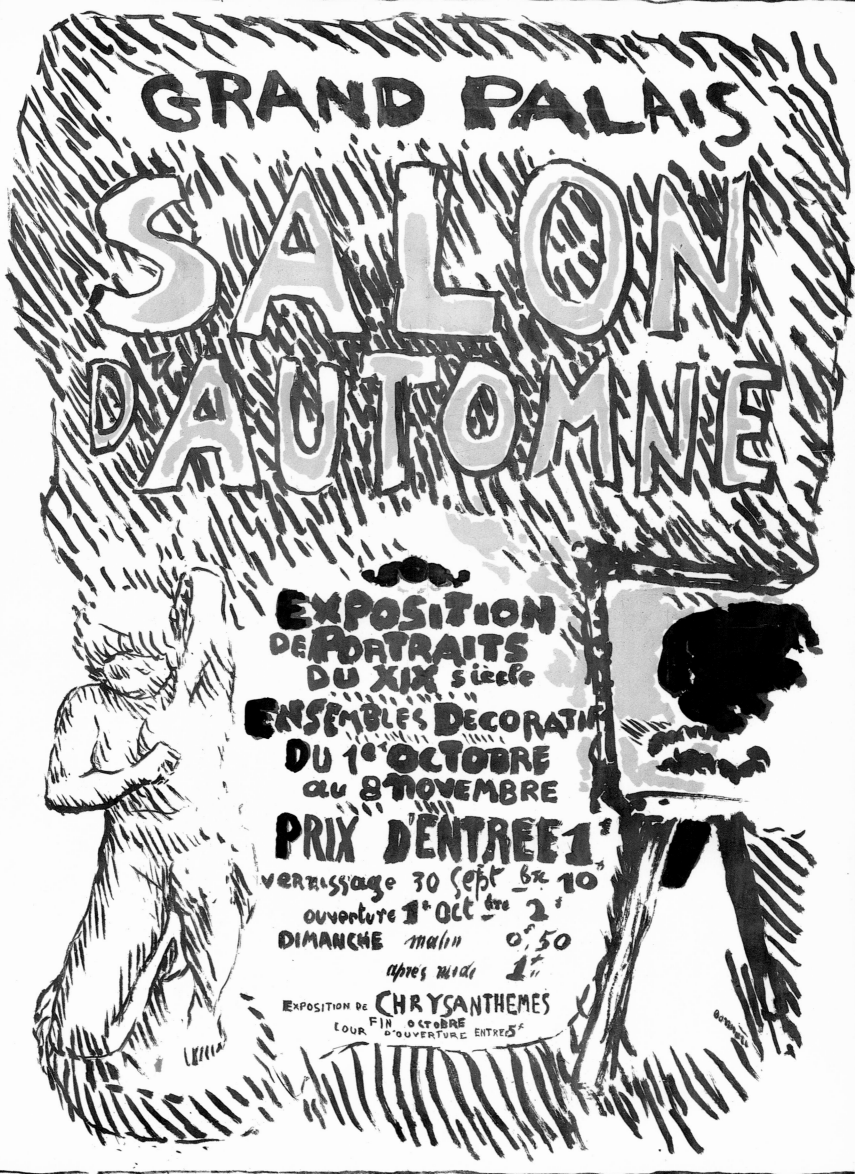

GRAND PALAIS

SALON D'AUTOMNE

EXPOSITION
DE PORTRAITS
DU XIX siècle
ENSEMBLES DECORATIFS
DU 1er OCTOBRE
au 8 NOVEMBRE
PRIX D'ENTREE 1f

vernissage 30 sept bre 10h

ouverture 1er Oct bre 2s

DIMANCHE matin 0f,50

après midi 1fr

EXPOSITION DE CHRYSANTHEMES
FIN OCTOBRE
jour D'OUVERTURE ENTREE 5f

IMP CH. VERNEAU 25. Rue DUCOUÉDIC

80
Nude at her toilet
Nu à la toilette

c. 1912

Lithograph printed in two colours 14×9 ($5\frac{1}{2} \times 3\frac{1}{2}$)
Signed below c., on the stone, also in the margin, by the artist
Printed in an edition of thirty, by Bernheim-Juene

81
Woman standing
Femme debout

1913

Lithograph printed in two colours 16.2×13.5 ($6\frac{3}{8} \times 5\frac{3}{8}$)
Signed below c.
This lithograph was used on the cover of a Bernheim-Jeune prospectus, 1913

One proof before letters, printed in black on China paper with wide margins; exhibited by Pierre Berès in 1944; see the catalogue of this exhibition, nos. 114 and 115. No trace of this proof has been found at the present moment

82
Bather
Baigneur

1914

Lithograph printed in black 14×8 ($5\frac{1}{2} \times 3\frac{1}{8}$)
After Cézanne (*Venturi* 262), for the book on Cézanne published by
Bernheim-Jeune in 1914
Printed in an edition of six hundred, of which: one hundred on Japanese
paper; one hundred on Arches laid paper; four hundred on textured paper

Bibliography: CRM 91

The book on Cézanne includes, apart from the lithograph by Bonnard, original
lithographs by Vuillard, Maurice Denis, Maillol, Matisse and K.-X. Roussel; also
an original etching by Cézanne (*Venturi* 1161)

83
La légende de Joseph

1914

Lithograph printed in four colours 160 × 120 (63 × 47¼)
Poster for the Ballets Russes
Editions 'Succès', 18 rue Royale, Paris
The *Bulletin* No. 7 issued by the Bernheim-Jeune Gallery (14 May 1914)
includes the following short note by Félix Fénéon: 'The walls of Paris
would have been looking decidedly grimmer than in the days when the
images of Chéret and Lautrec blossomed profusely against them, but now a
poster by Bonnard proclaims in yellow, red and black on quadruple
columbier *La légende de Joseph* as told by Strauss, Kessler and Hofmannsthal,
and shows the dancer Léonide Massine in all his youthful agility . . .'

Bibliography: TF 43; CRM 75

The poster reproduced here was presented to the Bibliothèque Nationale de Paris
by Maître Guy Loudmer
CRM includes a reproduction of a pastel sketch for this poster. A few other
preliminary drawings exist, studies of the dancer Massine; also a small sketch,
presented by Boris Kochno to the library of the Opéra de Paris
Another copy of the poster, described as the property of Monsieur Serge Lifar, was
exhibited in 1939 at the Musée des Arts Décoratifs (exhibition of 'Les ballets de
Diaghilev', catalogue no. 404)

Bonnard and Renoir

Bonnard always had a great admiration for Renoir and noted down some of his recollections of him:

'It was when I had not long finished painting the illustrations for a little book published by *La Revue blanche** that I first heard from Renoir. I didn't know him and I'd never even seen him. Renoir wrote saying he liked my drawings. You have a distinct quality of charm – do not neglect it. You will encounter better painters than yourself, but yours is a precious gift . . . That, roughly, was what Renoir wrote so spontaneously to an unknown beginner.

'The Renoir I met was still a fit man. He came to lunch with our group, as a friend, in a restaurant in place Clichy. A lean figure in his grey suit and little hat, he was in high spirits and was full of good humour. I think he found us all rather too serious.

'Later I visited him in his studio at rue Caulaincourt. Gabrielle was his regular model at that time, and, alas, already something of a sick-nurse, for Renoir's hands were seizing up. Around midday, the friends who were there began to take their leave. Renoir had to go out as well but lingered to chat. Up piped Gabrielle: "Come on, time for a piss . . ."

'After he had moved to the South of France, where I was staying for a few months, I went to visit him, late in the day so as not to interrupt his work. There he was, smoking a cigarette and squinting at the canvas in progress. He didn't talk painting but was extolling the days of craftsmanship and the reign of Francis I[er].

'One day, in the last few years of his life, he said to me, quite brusquely: "It's true, isn't it Bonnard, we must make things look more beautiful?"

'A statement like that might worry a lot of people, who think it implies introducing alien aesthetic formulae into the interpretation of his vision. But Renoir created a magnificent universe for himself. He worked from nature, and had the ability to project onto a model, or lighting, that somewhat lacked lustre his recollections of more joyous times.

'A famous painter told me one day: "I saw Renoir painting. He was using a model against a blue background – a moment later the background was red." He was incensed . . .

'I regarded Renoir like a rather strict father.'

*These were the drawings for *Marie* by Peter Nansen, published in 1898.

84
Portrait of Renoir
Portrait de Renoir

c. 1916

Etching 27 × 20 ($10\frac{5}{8}$ × $7\frac{7}{8}$)
There is a photograph of Renoir with his son Jean, the film director, who was at that time, *c.* 1916, on sick-leave. Evidently Bonnard made substantial use of this photograph for his etching; there also exists a very fine preliminary drawing.

Bibliography: TF 63; UJ 20

The photograph in question was discovered in Bonnard's archives Daniel Wildenstein discovered the matching plate in the archives of Claude Monet. The possibility therefore exists that the photograph was taken by Monet, who gave a print to Bonnard

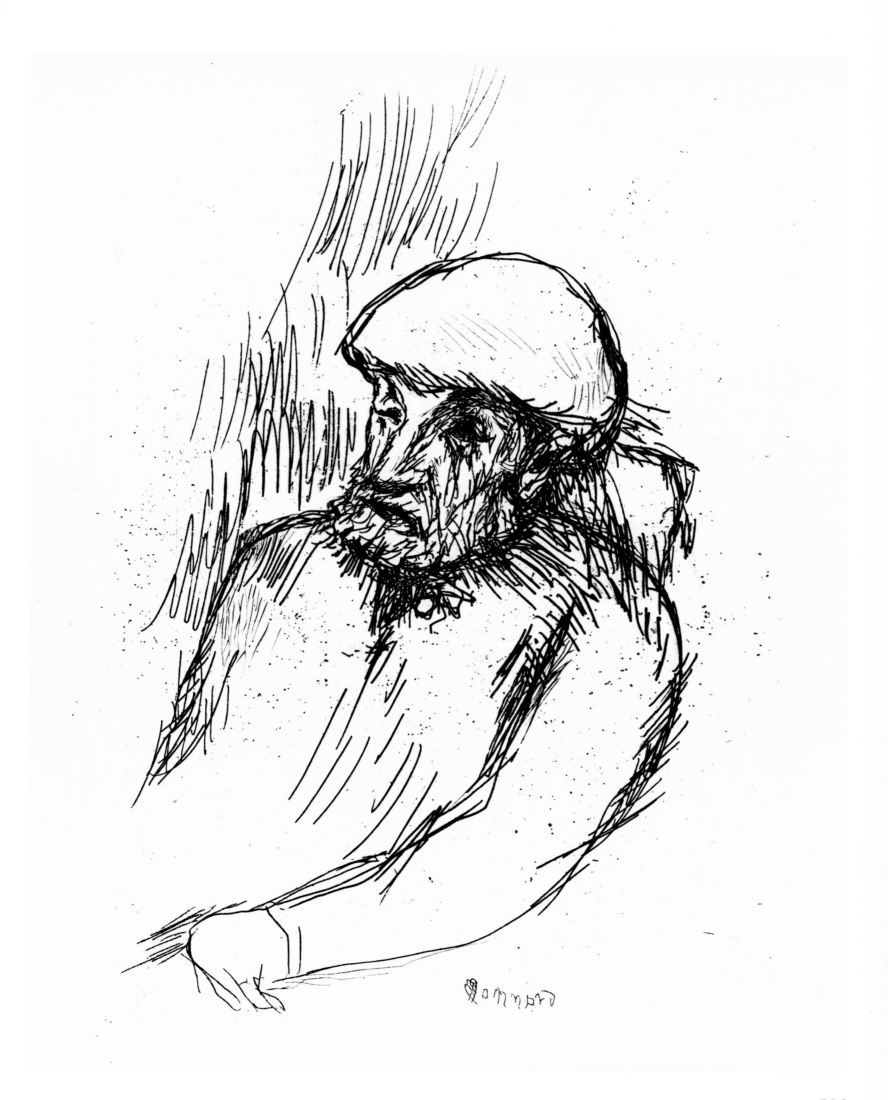

Bulletin de la vie artistique

1919

Lithograph printed in black 71.5 × 52 (28⅛ × 20½)
Signed below l.
Poster for the *Bulletin de la vie artistique*, published by Editions Bernheim-
Jeune
Several proofs before letters on white paper, of which one modified by
hand of the artist

Bibliography: TF 45; CRM 76

A number of preliminary drawings exist
The Galerie Bernheim-Jeune published its news of art and artists in a *Bulletin* which
was initially incorporated in certain of its exhibition catalogues. Later the *Bulletin de
la vie artistique* became a magazine in its own right; as such it appeared from
1 December 1919 to 15 December 1926. Its guiding spirit, Félix Fénéon, wrote:
'Collected together in fourteen short volumes, exactly spanning the period from the
death of Renoir to the death of Monet, the *Bulletin* will be an easily accessible
reference work on the book-shelves of anyone interested in art . . .'

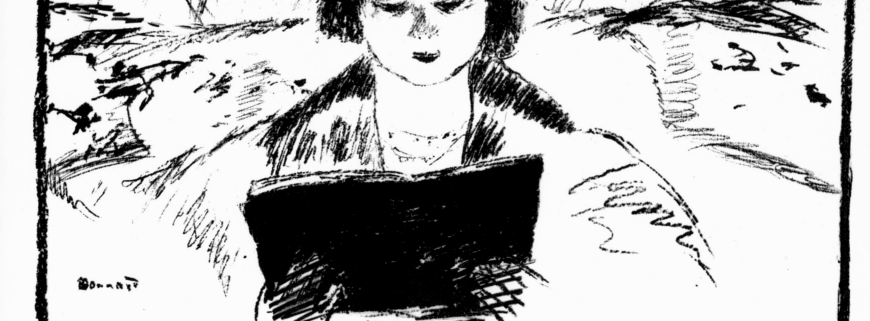

86
Preliminary design of book-plates for
Misia
Projet d'ex-libris pour Misia

c. 1920
Dry-point 23 × 16.5 (9 × 6½)

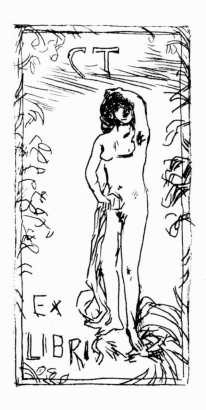

87, 87a
Female nude
Femme nue

c. 1920

Dry-point 11.9 × 5.3 (4⅝ × 2⅛)
Book-plate for Monsieur Charles Terrasse
Printed by Fort
The copper plate has been lost

Bibliography: TF 46

(87a is a variant)

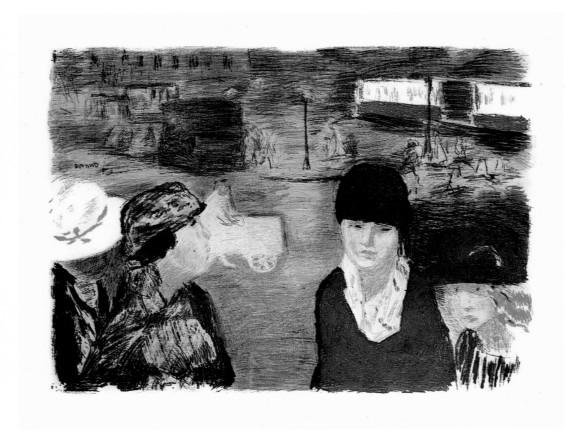

88
Place Clichy

1922

Lithograph printed in five colours 50×65 ($19\frac{5}{8} \times 25\frac{5}{8}$)
Published by Bernheim-Jeune and printed in an edition of one hundred
In a letter to Claude Roger-Marx of 7 January 1923, Bonnard wrote: 'I have recently done a colour lithograph which is being handled by the firm of Bernheim . . .

Bibliography: CRM 77

Some rare proofs of a first state before extensive modification of figures and background; also a detailed sketch in pastel, exhibited by Huguette Berès in 1970 (catalogue no. 23, described erroneously as 'for the *Album des peintres-graveurs*'); a second sketch in pastel is in the possession of the Bibliothèque Nationale, Paris

Detail at actual size

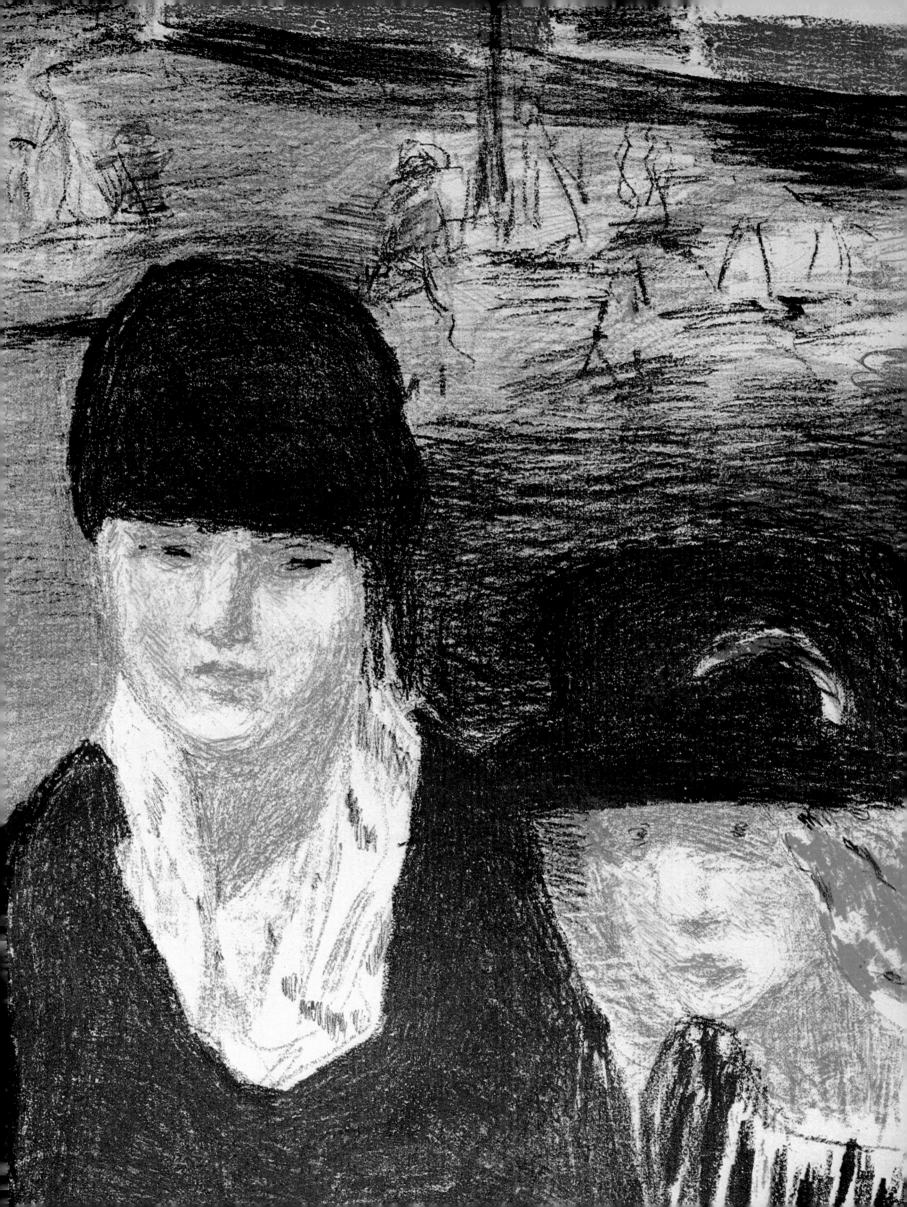

Portrait of Ambroise Vollard
Portrait d' Ambroise Vollard

c. 1924

Etching 35.5 × 24 (14 × 9½)
Printed by Fort, for Ambroise Vollard

Bibliography: TF 62; UJ 21

Compare with a painting of the same period, Dauberville 1260; it is not clear
whether the painting, which exactly resembles the etching, pre-dates it or not
Bonnard recorded some of his impressions of the great publisher:

'I first met Monsieur Vollard when I was a young man. He quickly became
the friend of artists, who were won over by his constructive criticism and
frankness. My relationship with him was at its closest when I was working
with him on book illustrations. As a publisher he worked inordinately
hard, taking no heed of time or money expended, to make sure that
everything was perfect. He occupies a certain position too, as a writer who
could make any topic interesting.'

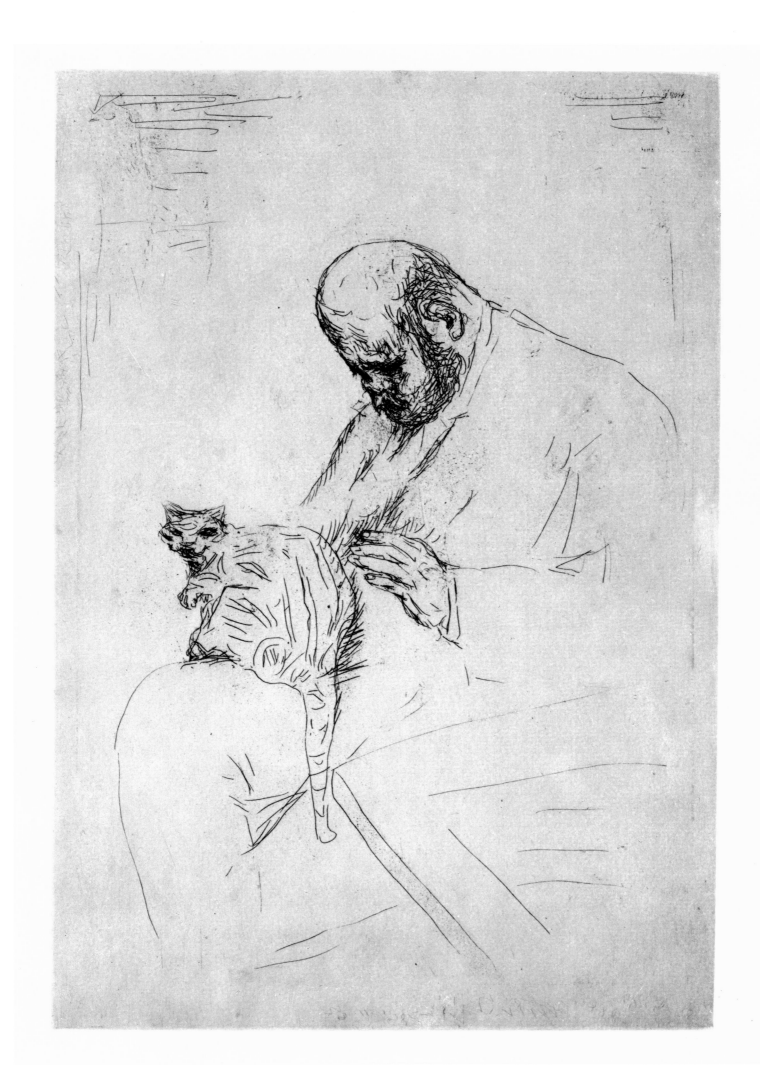

203

Bonnard and Octave Mirbeau
Illustrations for *Dingo*

Bonnard met Octave Mirbeau at the *Revue blanche*; he included a sketch of him in his series *The painter's life*, which shows him in conversation with Henri de Régnier at the *Revue*'s offices. The writer's rough looks and love of excess intrigued Bonnard, who became greatly attached to him. 'Bonnard', wrote Thadée Natanson, 'admired Mirbeau but he also held him in considerable affection. He took enormous pleasure in doing the illustrations for *La 628 E 8*, less in adding pictures to recollections of Holland and Belgium than in giving visible form to the ideas of the authors, who actually had less experience of this part of the world than he did himself. He took no less pleasure in trying his hand at the etchings he did for *Dingo*. Here we have the observer and friend of animals, and dogs in particular, in easy converse with a man who loved them and understood them no less well . . .' (*Le Bonnard que je propose*, p. 58)

In 1908, in the 'Préface au catalogue de la vente Thadée Natanson', Mirbeau gave a very accurate description and thoughtful analysis of Bonnard's art: 'His spontaneous drawing, profoundly original, sharp and unforgettable, is particularly evocative. It is also delightfully wicked, of surpassing grace, and bold to a fault. But his singularly discriminating taste, and an exquisite sense of what is right, give him that relaxed skill that brings forms to life and creates the most unexpected harmonies. The sense of purpose that is evident in the faintest line and palest hint of colour makes even a minor sketch a complete and autonomous whole.'

In reply to questions from Marguette Bouvier, Bonnard recalled Mirbeau as he knew him: 'I liked Mirbeau, though our characters were quite different, in fact totally opposed, I'd say. First I worked on his account of a tour through the Netherlands. He'd just bought his first car, 628 E 8, and used its registration number as the title. I drew a whole series of marginal illustrations. I really enjoyed doing it as I greatly enjoy Mirbeau's humour. The whole book is full of it. For me *Dingo* was a more major piece of work. A good number of the fifty-five etchings in it are full plates, separate from the text . . .' (Marguette Bouvier, 'Pierre Bonnard revient à la lithographie', *Comœdia*, 23 January 1943)

Title page

OCTAVE MIRBEAU

DINGO

PARIS
AMBROISE VOLLARD, ÉDITEUR
28, rue de Martignac, 28
MCMXXIV

90
Dingo

1924

Fifty-five original etchings, of which fourteen are inset plates, illustrating the book by Octave Mirbeau
Dimensions of book: 38.5 × 28.5 (15⅛ × 11¼)
Editor: Ambroise Vollard, 28 rue de Martignac, Paris
Printed in an edition of 350, numbered, of which: thirty on Japanese antique paper, with illustrations (1–30; these copies signed on the title-page by the artist); forty on Shidzuoka Japanese paper (31–70); 280 on Arches laid paper (71–350); and twenty, not for sale, on Arches laid paper, marked A to T.
Text printed on a hand-press by the craftsman Emile Féquet; etchings printed on the presses of Louis Fort
The copper plates were destroyed after printing
In his 'Essai de catalogue de l'œuvre gravé et lithographié de Bonnard', Jean Floury notes that 'fifty sets of the inset plates were printed in a separate edition on Japanese antique paper, with a title-page signed by the artist, and rather larger than the book in format'
In *Ambroise Vollard, Editor*, Una E. Johnson makes the same point

Bibliography: TF 56; UJ 24; AS 26

Some motifs in photogravure modified by hand of the artist

Right: cover

OCTAVE MIRBEAU

DINGO

PARIS
AMBROISE VOLLARD, ÉDITEUR
28, rue de Martignac, 28
MCMXXIV

p. 5

p. 5

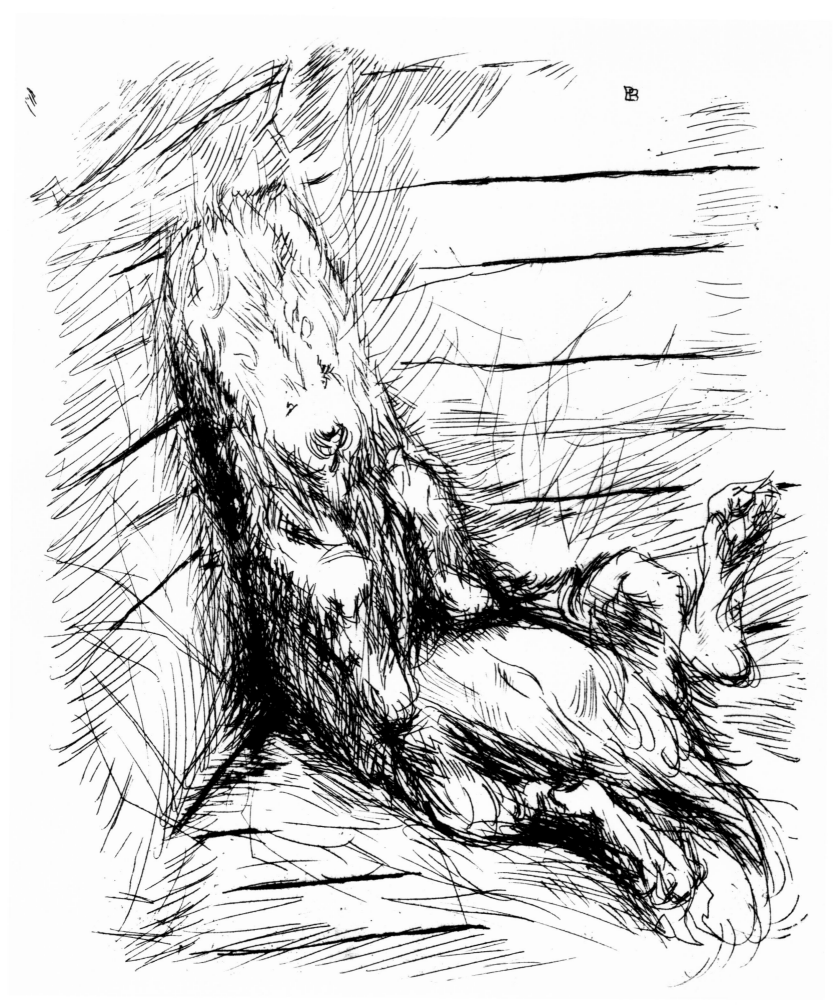

p. 8

p. 15

p. 17

p. 17

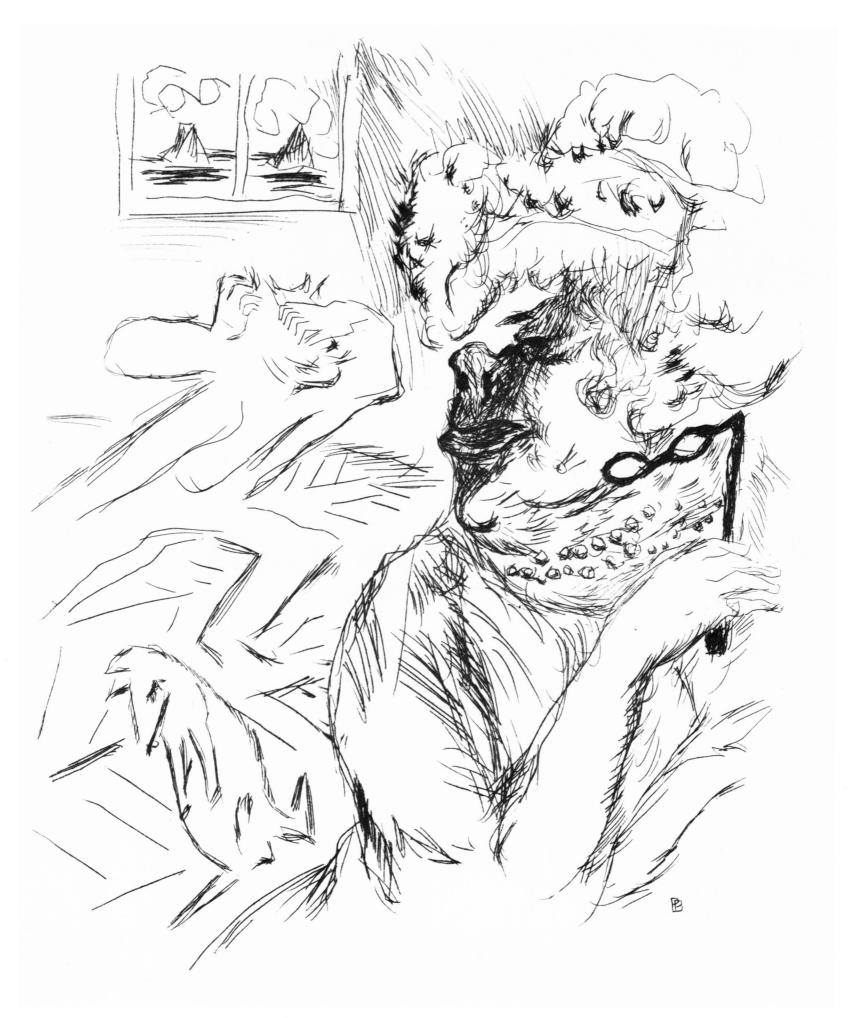

p. 24

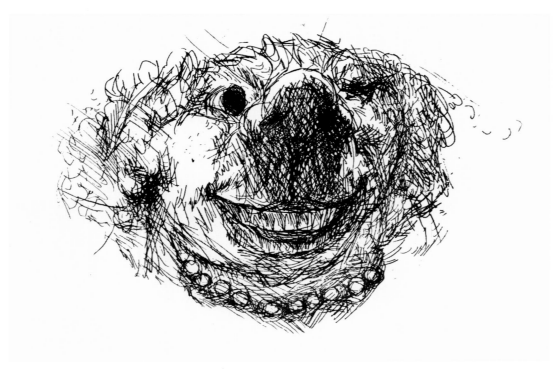

p. 27

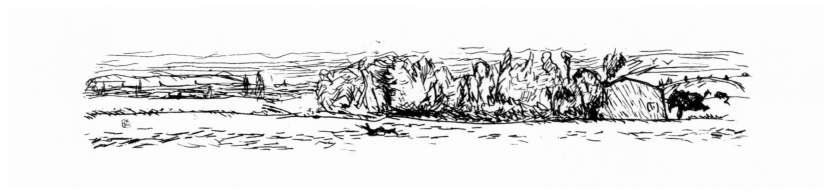

p. 29

p. 29

p. 32

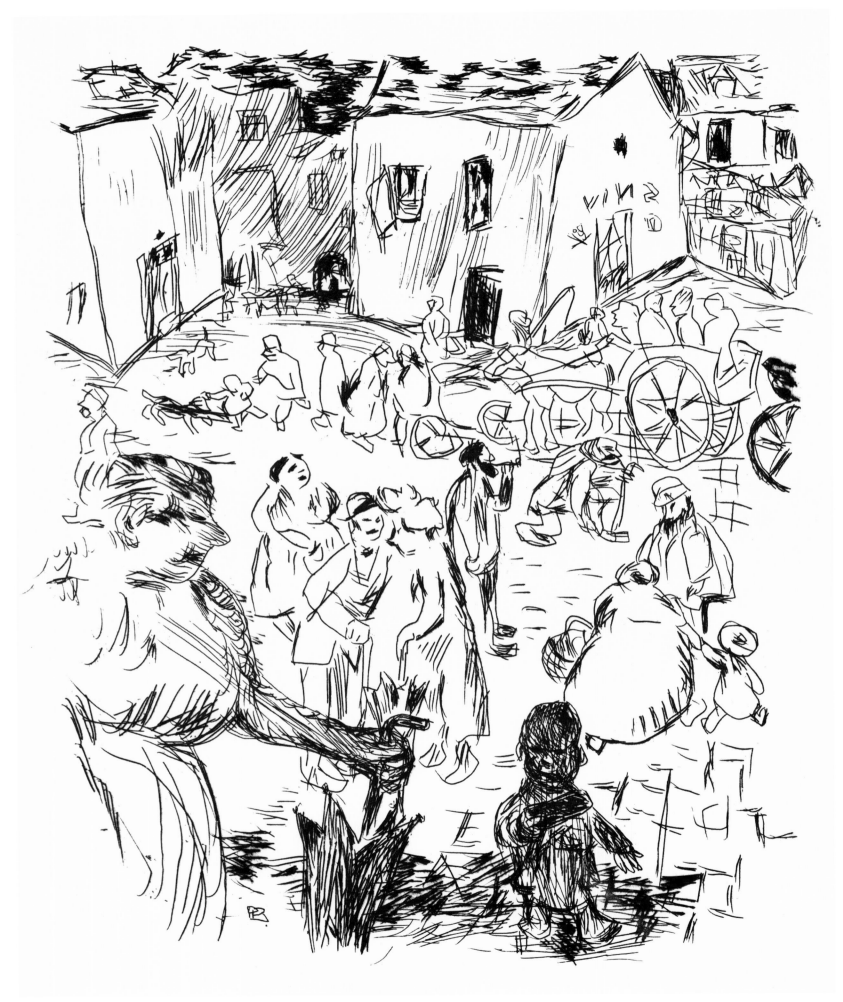

p. 38

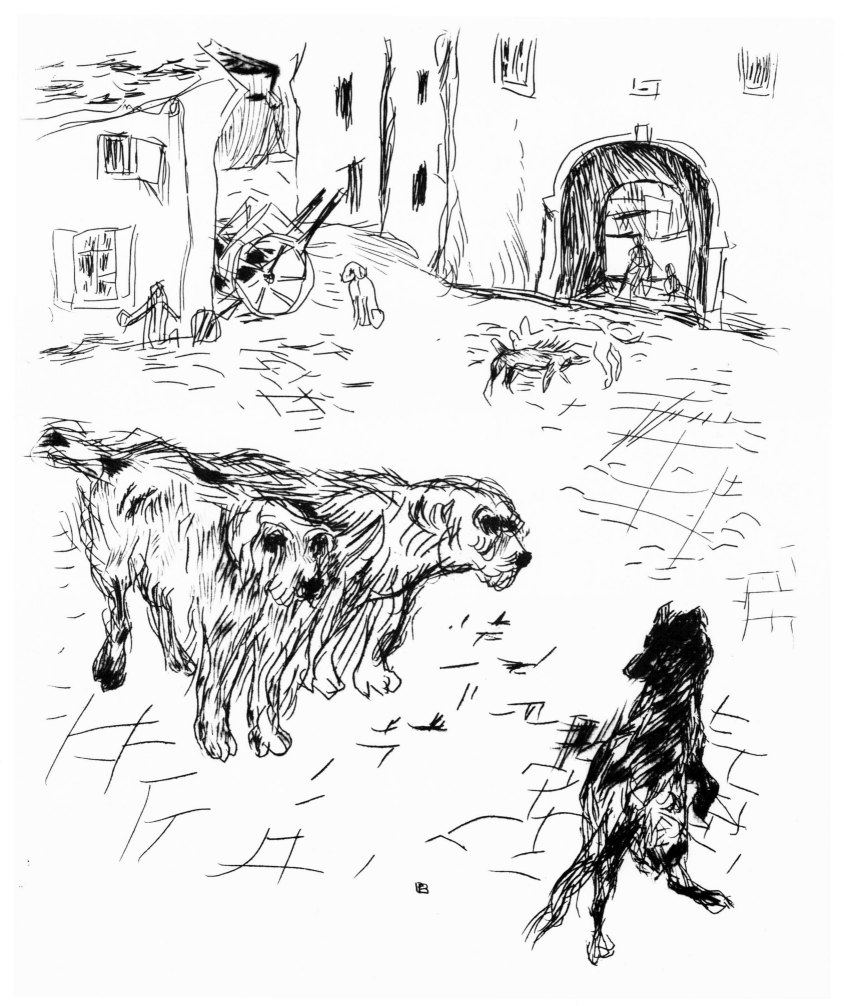

p. 46

p. 49

p. 51

p. 51

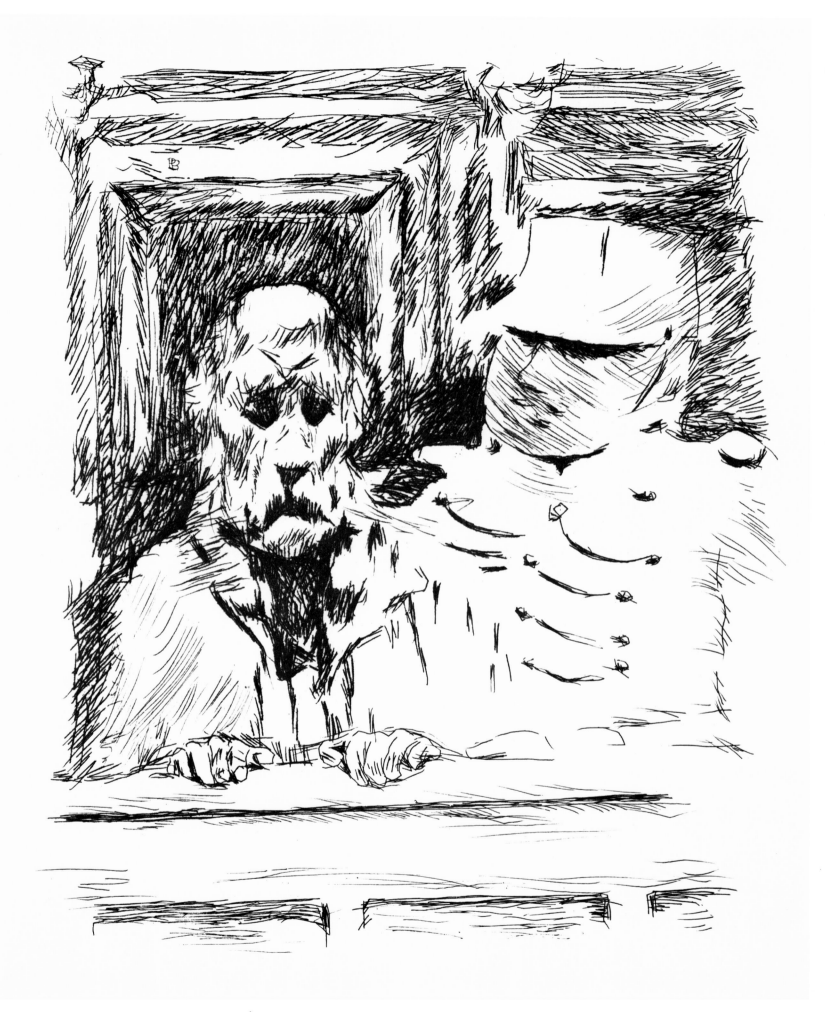

p. 60

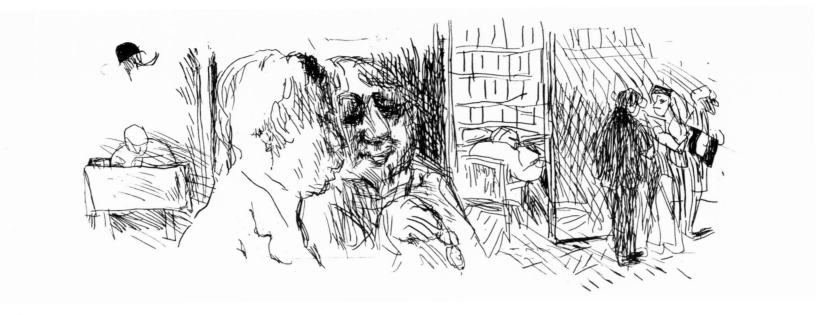

p. 69

p. 71

p. 71

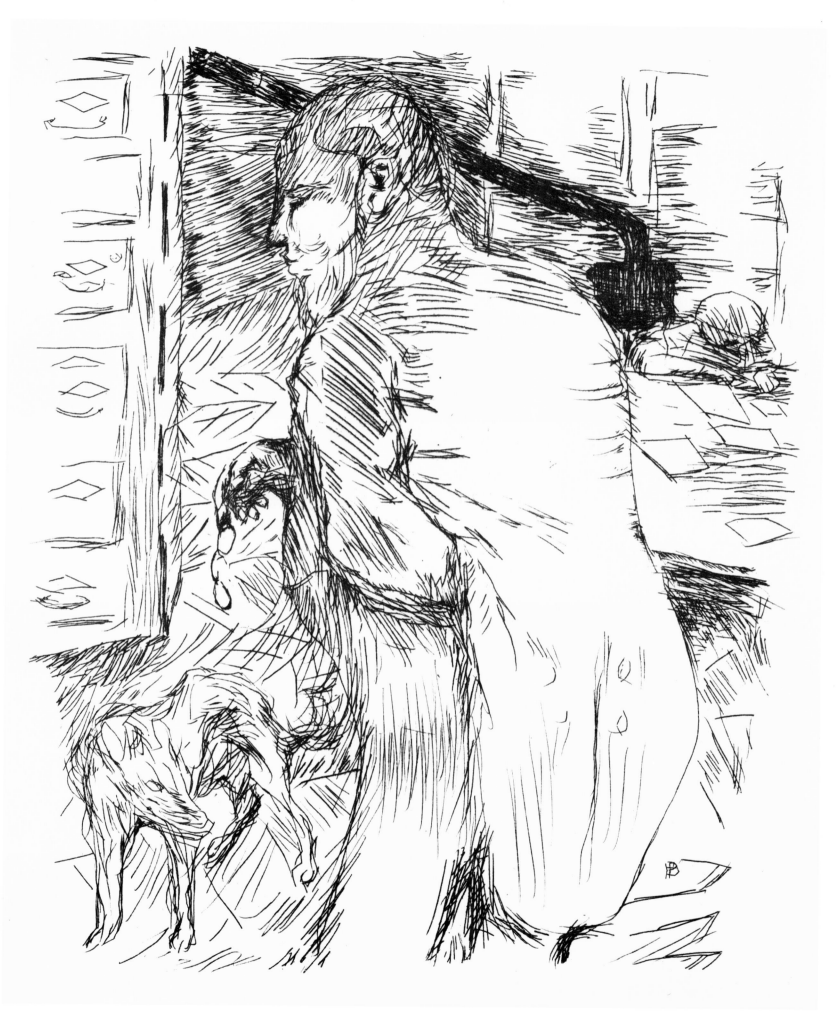

p. 76

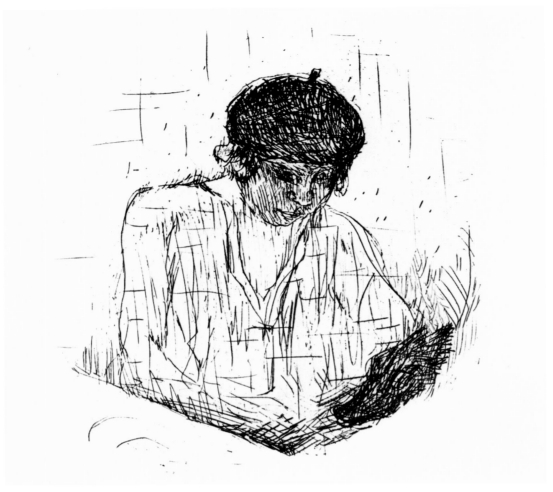

p. 79

p. 81

p. 81

218

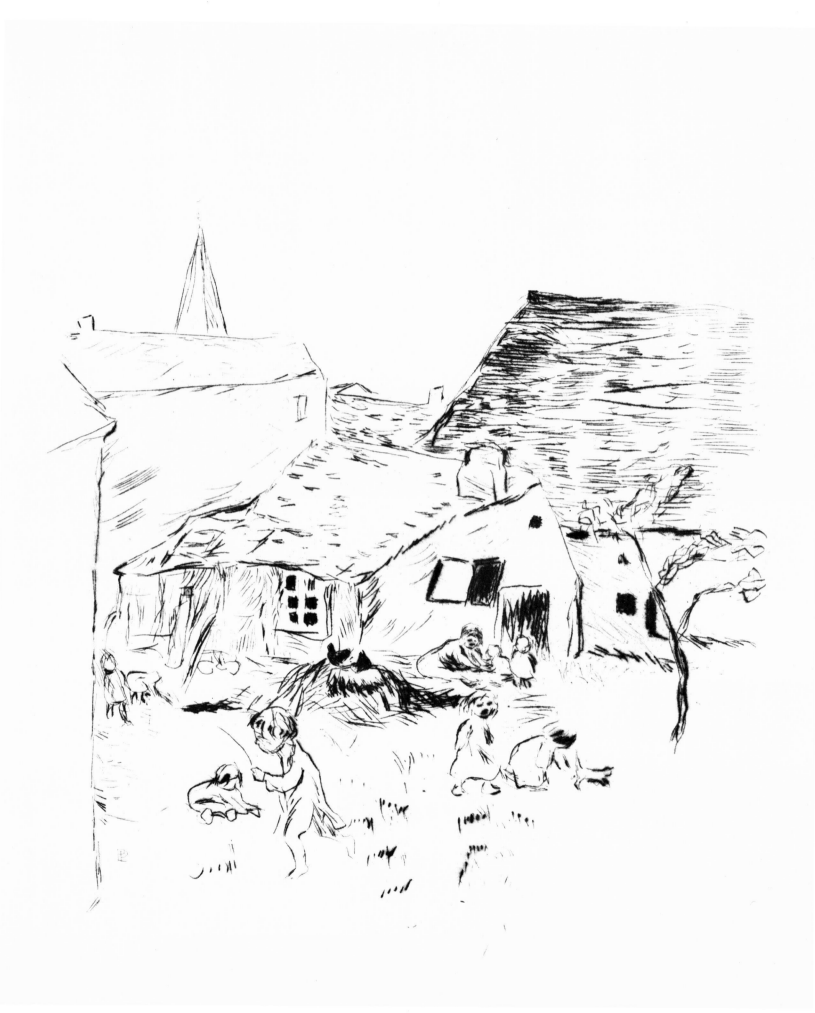

p. 92

p. 99

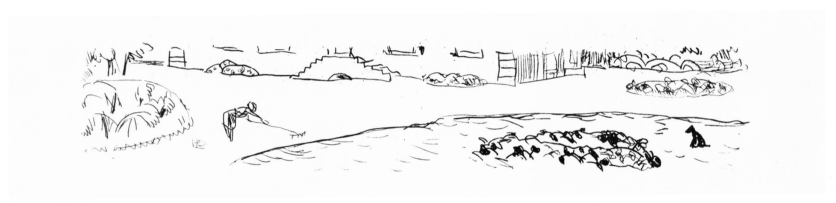

p. 101

p. 101

p. 118

221

p. 121

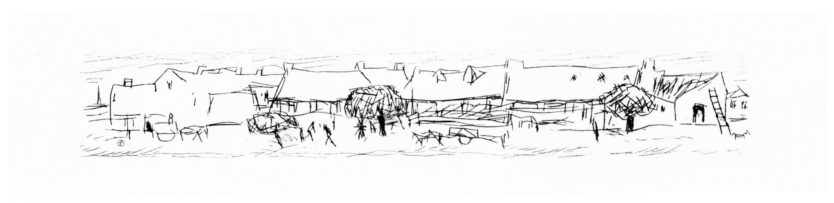

p. 123

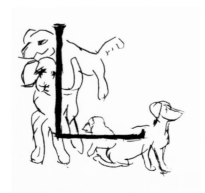

p. 123

p. 130

p. 135

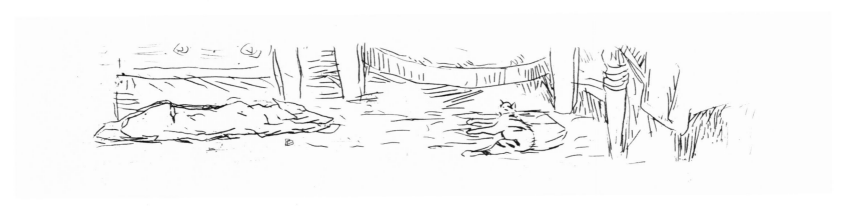

p. 137

p. 137

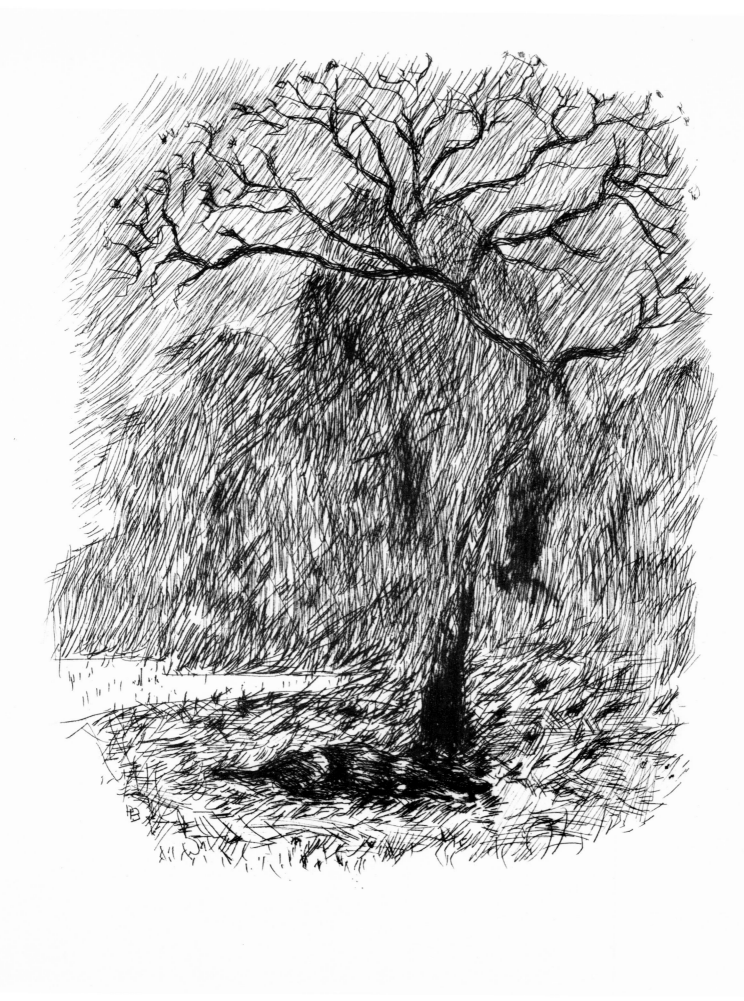

p. 140

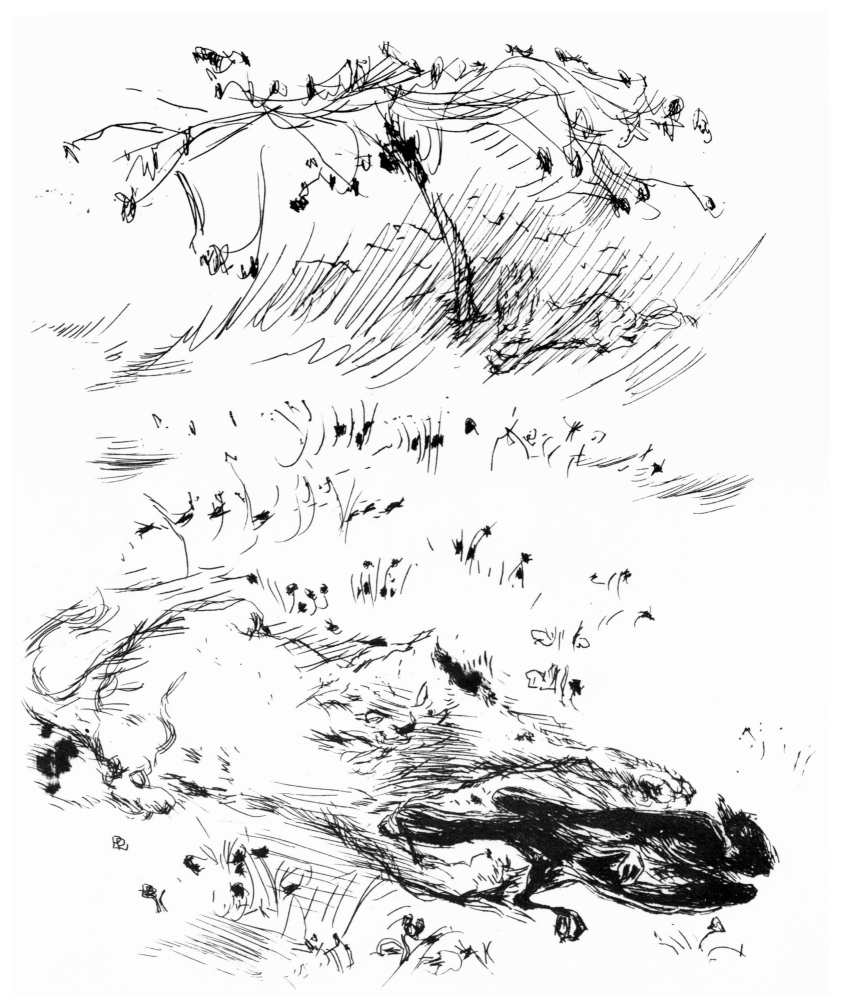

p. 142

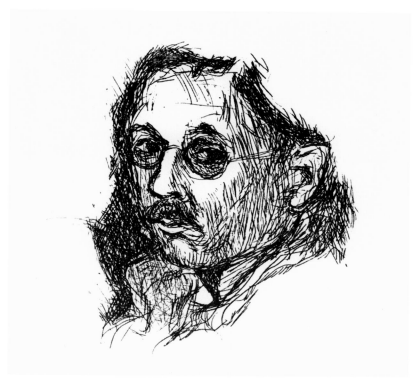

p. 149

p. 151

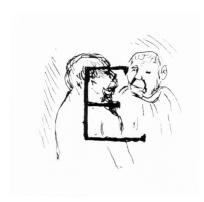

p. 151

p. 157

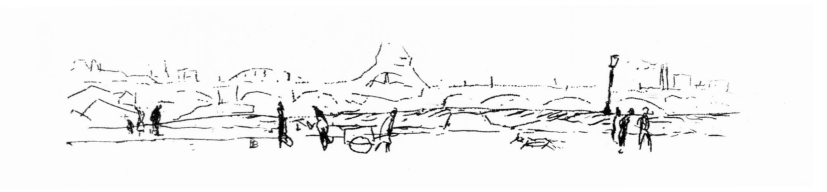

p. 159

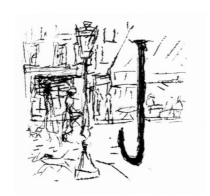

p. 159

228

p. 162

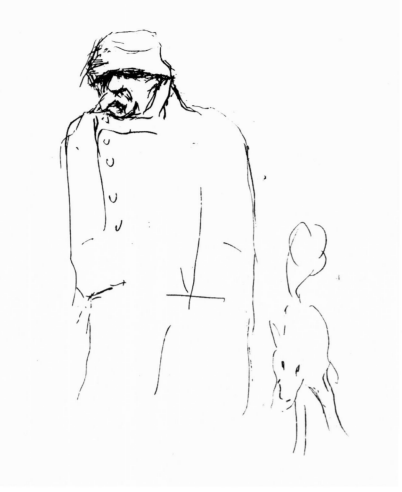

p. 173

p. 175

p. 175

230

p. 187

p. 189

p. 189

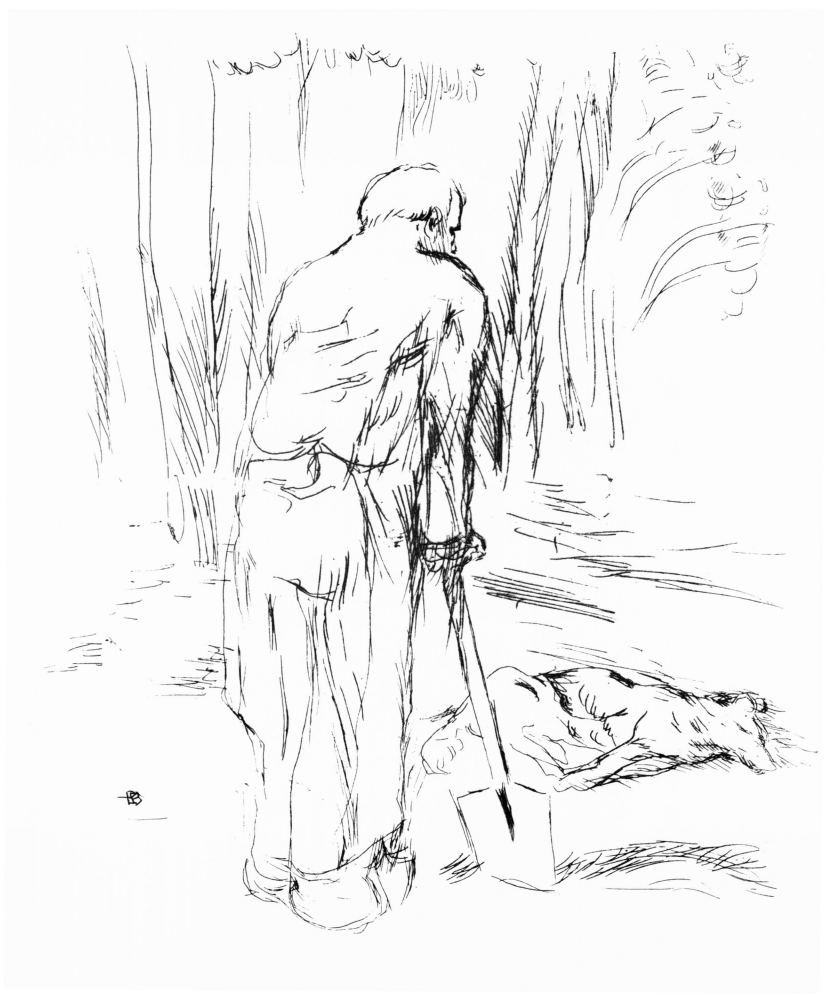

p. 192

p. 193

INDICATION POUR LE PLACEMENT, DANS LE VOLUME, DES EAUX-FORTES HORS-TEXTE.

page 8 page 24 page 32

page 38 page 46 page 60 page 76

page 92 page 118 page 130 page 140

page 142 page 162 page 192

Dingo. Unpublished illustrations and
trial versions

1924

Unpublished frontispiece for *Dingo*
(trial version)

On the verso of the half-title:
Landscape (village street), reworked as an inset
plate in the final edition
Plate impression: 26.7 × 20 (10½ × 7⅞)
See p. 211 of catalogue

Unpublished title-page for *Dingo*
(trial version)

Portrait of Bonnard, reworked as an illustration
in text in the final edition
Etching. No plate-mark (plate larger than page).
Size of page: 37.5 × 27.5 (14¾ × 10¾); subject:
8.5 × 8.1 (3⅜ × 3¼)

OCTAVE MIRBEAU

DINGO

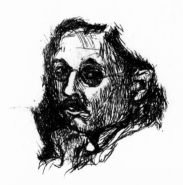

PARIS
AMBROISE VOLLARD, ÉDITEUR
28, rue de Martignac, 28
MCMXXIV

Photogravure with some modification,
remarques and signature in dry-point

a) Cat and Dog

Plate impression: 27.3×21 ($10\frac{3}{4} \times 8\frac{1}{4}$)
Signed on the copper plate below r.

b) Woman with Dog

La femme au chien

Plate impression: 28.5 × 22.7 (11¼ × 9)
Signed on the copper plate below r.
Proof on Japanese paper
Remarque (self-portrait of Bonnard) below l.

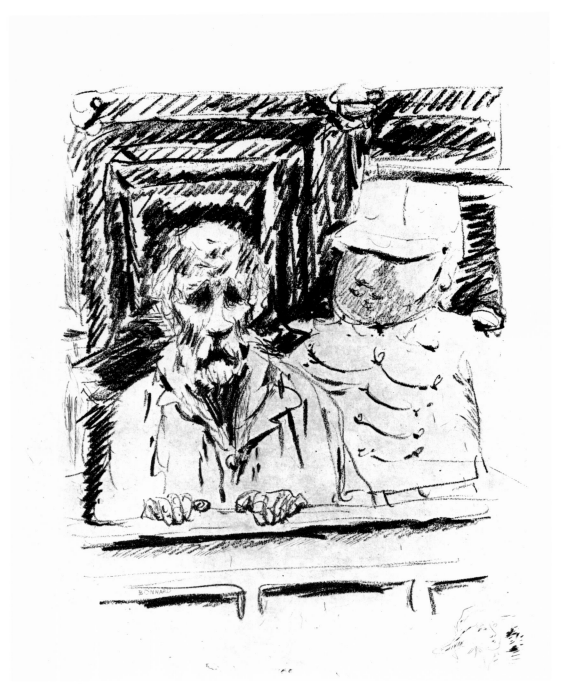

c) Policeman and accused man
Gendarme et accusé

Plate impression: 31.2×24.5 $(12\frac{1}{4} \times 9\frac{5}{8})$
Proof on Japanese paper
Remarque (head of young woman) below r.

d) Man in frock-coat
L'homme à la redingote

Plate impression: 28.7×22.6 $(11\frac{1}{4} \times 8\frac{7}{8})$
Signed on the copper plate below r.
Remarque (bouquet of flowers) below l.
Handwritten inscription in pencil, below the
plate: 'Bon pour 200 Ambroise Vollard' ('OK for
200, Ambroise Vollard'). On the verso,
handwritten inscription in pencil: '57 japons fait
avec remarque coupage et effaçage de
remarque/215 blancs 215/fini à 57 japons/215
blancs' ('57 Japanese with remarque cut and
delete remarque/215 white 215/total 57
Japanese/215 white')
It is not known if the edition was in fact printed
as specified

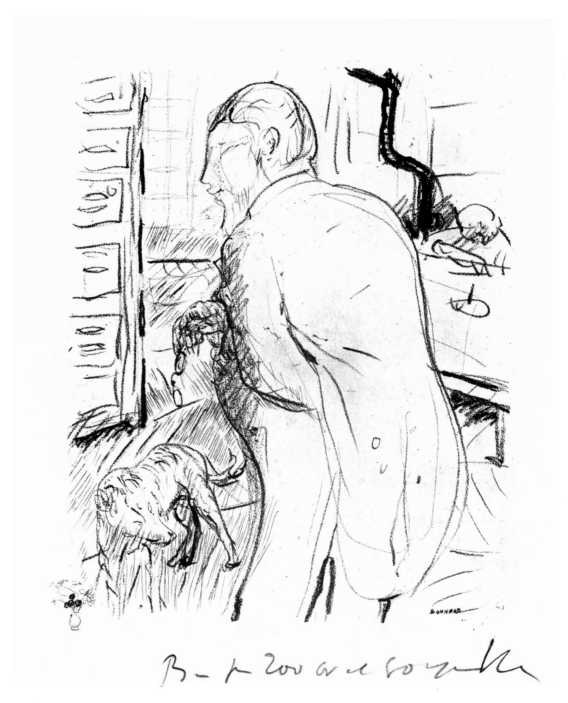

The publisher Edmond Frapier (Galerie des Peintres-Graveurs) was anxious to reawaken interest in lithography and had the idea, *c*. 1923, of publishing an 'Essai sur l'historie de la lithographie en France' as an introduction to an album of lithographs showing all the different approaches to the art 'from Manet to Matisse'.

He also published a number of individual albums of original lithographs in the series *Maîtres et petits maîtres d'aujourd'hui*. The series covered, among others, Maurice Denis, Rouault and Vlaminck. Each short album contained four original prints, and was printed in a de luxe edition of twenty-five copies (with two states of each plate, signed and numbered), plus an ordinary edition of one hundred copies (numbered, comprising the four plates in their last state, numbered and signed). The stones were cancelled after printing.

In addition, Frapier published a number of individual plates.

The lithograph *The Bath* was published in the *Album des peintres-lithographes de Manet à Matisse*.

The following four lithographs – *Fruit Bowl and Dish*; *Woman standing in her bath*; *Landscape in the South of France*; and *Woman dressing, seated* – appear in the *Album Bonnard des Maîtres et petits maîtres d'aujourd'hui*, published in 1925 with a preface by Claude Roger-Marx.

The remaining seven lithographs reproduced here were published as individual prints.

In these lithographs Bonnard frequently reworked themes he was employing in his paintings at this time (the points of comparison are listed under the heading of each individual plate). The descriptions of the plates are taken from the notes of Claude Roger-Marx, and from M. E. Rouir ('Quelques remarques sur les lithographies de Pierre Bonnard', *Le Livre et L'Estampe*, nos. 53–54, 1968), both of whom obtained their information from source by talking directly to Edmond and Jacques Frapier.

92
The Bath (first version)
Le bain (première planche)

c. 1925

Lithograph 33 × 22.5 (13 × 8⅞)
Monogram PB, below r.
The stone was accidentally destroyed, and only five trial proofs remain of this first version

Bibliography: TF 51; CRM 79; ER

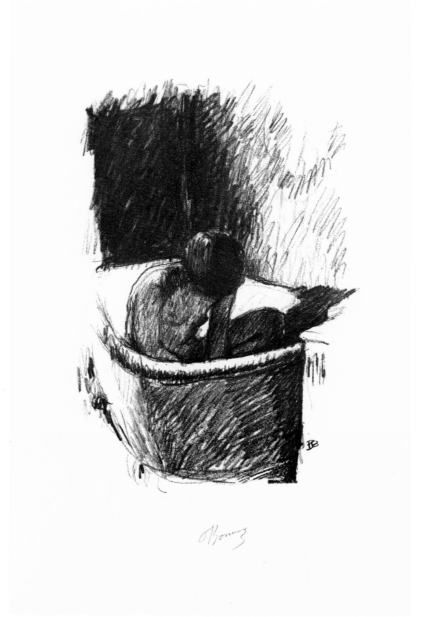

93
Fruit Bowl and Dish
La coupe et le compotier

1925
Lithograph printed in black or in
sanguine $26 \times 18 \ (10\frac{1}{4} \times 7\frac{1}{8})$
For the album *Maîtres et petits maîtres d'aujourd'hui*
First state:
large monogram; five signed trial proofs on
different papers $19 \times 28.5 \ (7\frac{1}{2} \times 11\frac{1}{4})$
Second state:
motif reduced in size l. $19 \times 28.5 \ (7\frac{1}{2} \times 11\frac{1}{4})$;
monogram deleted; twenty-five signed prints in
sanguine for de luxe edition of album
Third state:
close-set monogram, below r.; one hundred
signed prints for ordinary edition

Bibliography: TF 55; CRM 80; ER

Some preliminary drawings

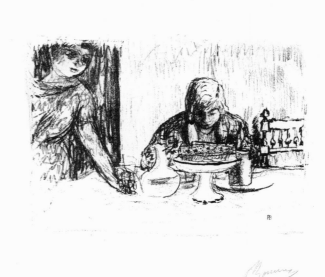

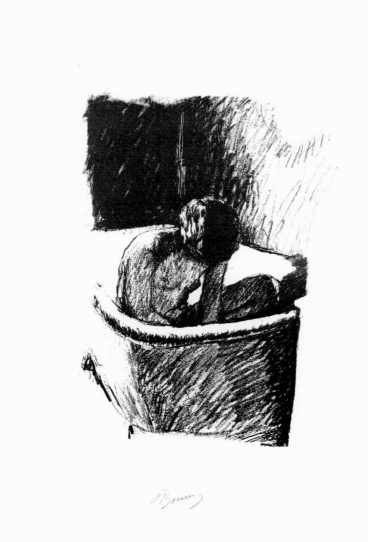

92a
The Bath (second version)
Le bain (deuxième planche)

c. 1925

Lithograph printed in black or in sanguine $33 \times 22.5 \ (13 \times 8\frac{7}{8})$
For the *Album des peintres-lithographes de Manet à Matisse*, published by
Frapier
The composition is very nearly identical with the first version
First state: no lithographed monogram; thirty-five impressions printed in
black, ten printed in sanguine, signed by the artist; wide margins; fifty
prints on Imperial Japanese paper for de luxe edition of *Album*
Second state: lithographed signature below l.; fifty prints on loose-leaf
China paper, making up double set for de luxe edition; 525 prints for
ordinary edition
It is the first state reproduced here

Bibliography: TF 51; CRM 79; ER

Many of the prints were destroyed when Royan was bombed in 1945
All prints bore the impress of the Galerie des Peintres-Graveurs, below r.
The stone was cancelled after printing. Certificate of cancellation may be seen at the
Galerie de Peintres-Graveurs
(The above information, which applies equally to all the lithographs published by
E. Frapier, was supplied by Monsieur Jacques Frapier)

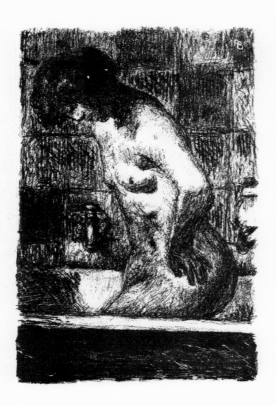

94
Woman standing in her bath
Femme debout dans sa baignoire

1925

Lithograph printed in black 33.5 × 22.4 (13¼ × 8⅞)
For the album *Maîtres et petits maîtres d'aujourd'hui*
First state: vertical line in r. margin; remarques in margin below; five signed trial proofs on different papers
Second state: no remarques; monogram above r.; five signed trial proofs on different papers
Third state: some areas scraped clean; vertical line in r. margin deleted; twenty-five signed prints for de luxe edition of album
Fourth state: signed with scraper above r., next to first monogram; one hundred signed prints for ordinary edition

Bibliography: TF 52; CRM 81; ER

Compare with the painting *Woman in her bath*, Dauberville 1.275

95
Landscape in the South of France
Paysage du Midi

1925

Lithograph printed in black 22 × 33 (8⅝ × 13)
For the album *Maîtres et petits maîtres d'aujourd'hui*
First state: shadow below l. entirely in grey; monogram below r.; five signed trial proofs
Second state: shadow has several lines added; five signed trial proofs
Third state: monogram deleted; twenty-five signed prints for de luxe edition
Fourth state: monogram reinstated; twenty-five signed prints for de luxe edition; one hundred signed prints for ordinary edition
It is the fifth state that is reproduced here

Bibliography: TF 53; CRM 82; ER

Some proofs printed in bistre, signed by the artist; also a preliminary drawing

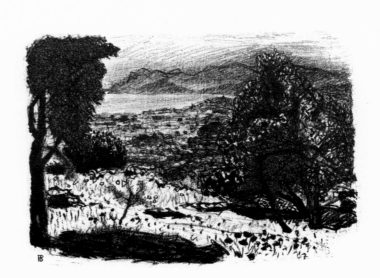

96
Woman dressing, seated
La toilette assise

1925

Lithograph printed in black 33 × 23.5 (13 × 9¼)
For the album *Maîtres et petits maîtres d'aujourd'hui*
First state: before monogram; dimensions of stone: 35 × 23.5 (13¾ × 9¼);
twenty-five signed prints
Second state: stone cut to dimensions: 33 × 23.5 (13 × 9¼); monogram r.;
twenty-five signed prints for de luxe edition
Third state: some areas scraped clean, below, and on arm; twenty-five
signed prints for de luxe edition; one hundred signed prints for ordinary
edition

Bibliography: TF 54; CRM 83; ER

An almost identical pencil drawing is reproduced in Thadée Natanson, *Le Bonnard
que je propose*, no. 57

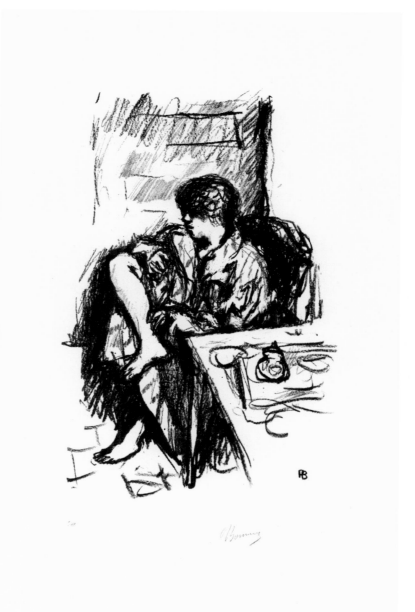

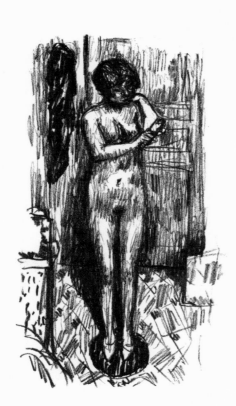

97
Nude study
Etude de nu

c. 1925

Lithograph printed in black or in sanguine 29.5 × 19.5 (11⅝ × 7⅝)
For the publisher Frapier; individual plate
First state: vertical line r. indicating side of doorway; five signed trial
proofs on different papers
Second state: vertical line r., deleted; twenty-five signed prints in black;
ten signed prints in sanguine

Bibliography: TF 50; CRM 84; ER

Compare with the painting *Nude raising left arm*, Dauberville 1480

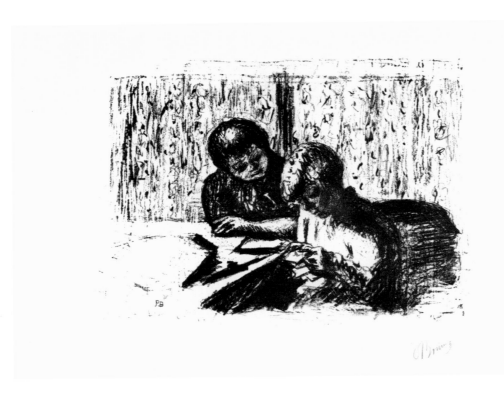

98
The Letter
La lettre

c. 1925

Lithograph printed in black or in
sanguine 24.5 × 32 (9⅝ × 12⅝)
For the publisher Frapier; individual plate
First state: no monogram; five signed trial proofs
Second state: monogram below l.; thirty-five
signed prints

Bibliography: TF 47; CRM 85; ER

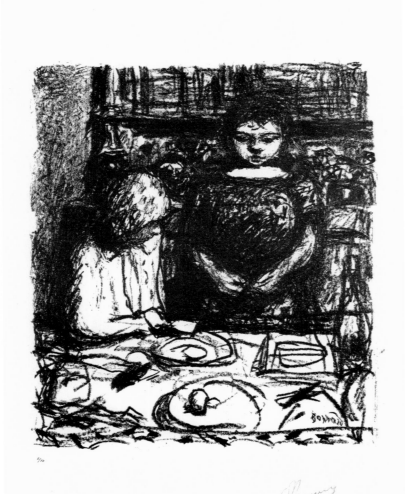

99
The Menu
Le menu

c. 1925

Lithograph printed in black 37.5 × 27.3 (14⅜ × 10¾)
For the publisher Frapier, individual plate
First state: vertical line r. of composition; five signed trial proofs on
different papers
Second state: Vertical line r. deleted; ten signed trial proofs on different
papers
Third state: lapels of seated woman's dress extended; twenty-five signed
prints
It is the second state reproduced here

Bibliography: TF 49; CRM 86; ER

Compare with the painting *Before dinner*, Dauberville 1266; a very similar drawing
also exists

100
La rue Molitor

c. 1925

Lithograph printed in black
37.5 × 24.5 (14¾ × 9⅝)
For the publisher Frapier, individual plate
First state: detailing in crayon between the two
trees; five signed trial proofs
Second state: detailing between two trees
deleted; tree-trunk l. extended very precisely;
fifty signed prints

Bibliography: TF 48 CRM 87; ER

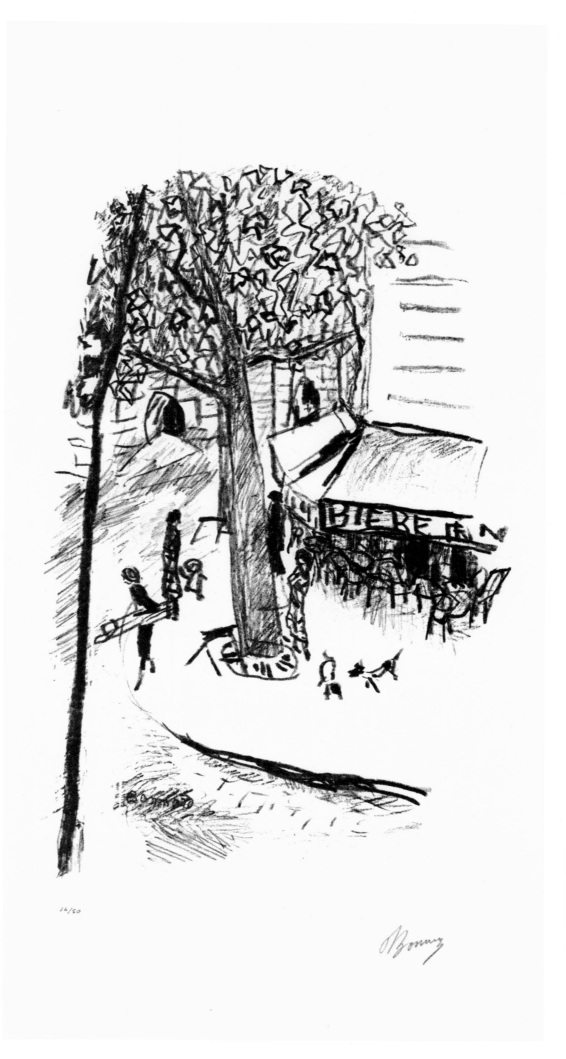

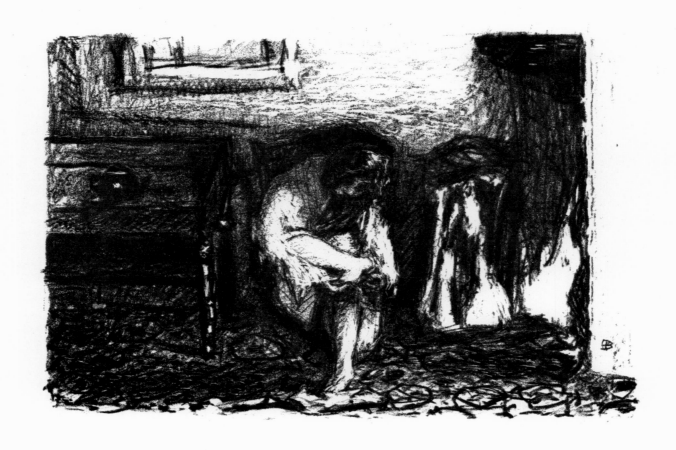

101
Stockings
Les bas

c. 1927–28

Lithograph printed in black 24.6 × 31.5 (9⅝ × 12⅜)
For the publisher Frapier, individual plate
Claude Roger-Marx believes there were three states
First state: six proofs
Second state: retouching of right arm and scraper work on l. sleeve:
nine proofs
Third state: shadows softened; thirteen proofs
Monsieur Rouir has been unable to discover these different states.
The stone was destroyed in the bombing of Royan in 1945

Bibliography: no reference in TF; CRM 88; ER

Several drawings of this subject exist
Compare with the painting *Woman at her toilet*, Dauberville 1218

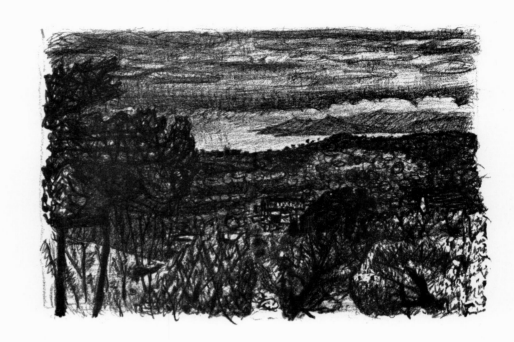

102
Nightfall
La nuit tombe

c. 1927–28

Lithograph printed in black
23.6 × 31.3 (9¼ × 12⅜)
For the publisher Frapier, individual plate
One state, of which several trial proofs
The stone, having been moved to Monsieur
Frapier's home in Royan, was destroyed in the
bombing of 1945

Bibliography: no reference in TF; CRM 89; ER

Compare with the painting *Landscape at Le Cannet*,
Dauberville 1294

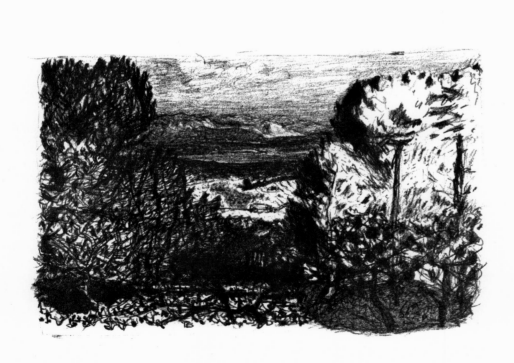

103
Last Light
Dernier reflet

c. 1927–28

Lithograph printed in black 24 × 32 (9½ × 12⅝)
For the publisher Frapier, individual plate
One state, of which several trial proofs
The stone, having been moved to Monsieur
Frapier's house in Royan, was destroyed in the
bombing of 1945

Bibliography: no reference in TF; CRM 90; ER

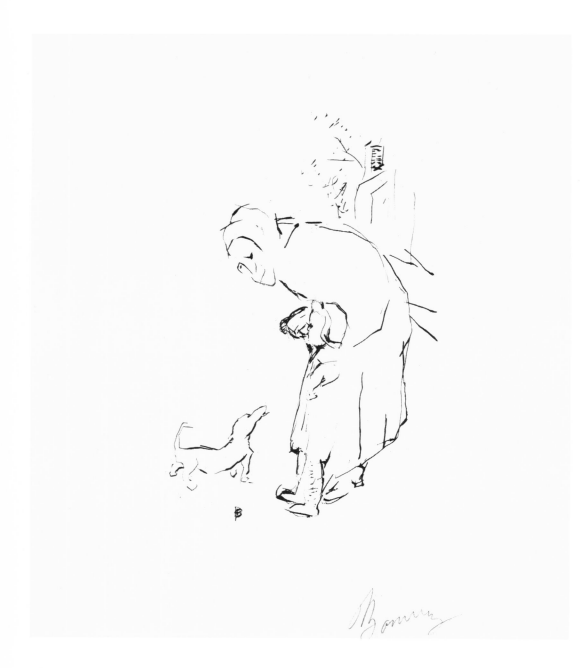

104
The old woman, the child and the basset hound
La vieille femme, l'enfant et le basset

1927

Dry-point 18 × 15 ($7\frac{1}{8}$ × $5\frac{7}{8}$)
Dry-point for de luxe edition of *Art d'aujourd'hui*
Printed in an edition of one hundred

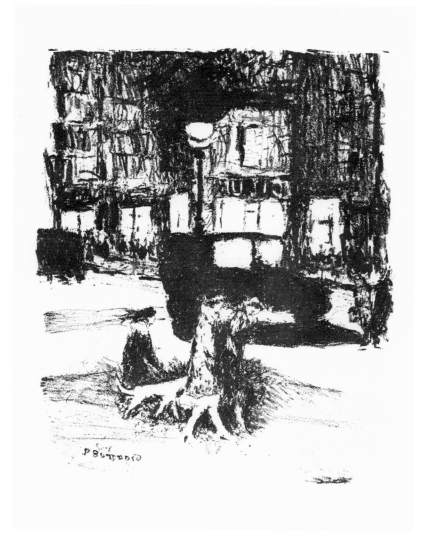

105
The Street
La rue

1927

Lithograph printed in black 24×18 ($9\frac{1}{2} \times 7\frac{1}{8}$)
Signed below l.
Printed in an edition of 225, of which twenty-five on Japanese paper, for
Tableaux de Paris (frontispiece), published by Emile-Paul in 1927
Some prints on loose-leaf China paper

Bibliography: TF 57; AS 365; CRM 92

Original texts by: P. Valéry; R. Allard; F. Carco; Colette; J. Cocteau; T. Derême;
R. Escholier; G. Duhamel; J. Giraudoux; M. Jacob; E. Jaloux; J. de Lacretelle; V.
Larbaud; P. Morand; P. Mac-Orlan; A. Salmon; C. Vildrac; J.-L. Vaudoyer; A.
Warnod; A. Suares

Original lithographs and copper engravings: P. Bonnard; E. Ceria; H. David; A.
Dunoyer de Segonzac; P. Falké; Foujita; C. Laborde; M. Laurencin; P.-A.
Marquet; C. Martin; Matisse; L.-A. Moreau; J. Oberlé; J. Pascin; G. Rouault; M.
Utrillo; K. van Dongen; M. Vlaminck; H. de Waroquier
Ed. Emile-Paul Frères, Paris, 1927. First impression 19 June 1927. Colophon:
edition of 225: 25 printed on Imperial Japanese paper with sequence of engravings
on Arches paper, numbered 1–25; 200 printed on Rives wove paper, numbered
26–225; some prints for contributors on all these papers

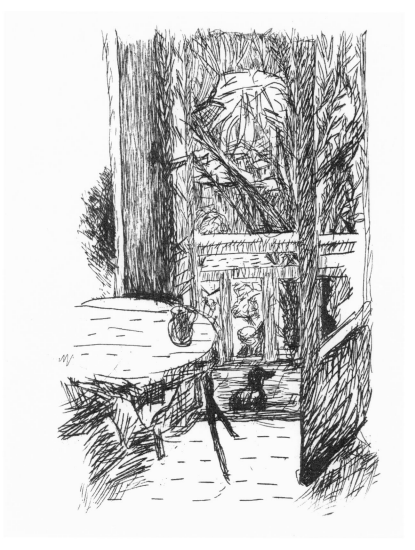

106
French Windows
La porte-fenêtre

1927

Etching 18×12 ($7\frac{1}{8} \times 4\frac{3}{4}$)
Three proofs on white wove paper, three proofs on Japanese paper
Plate cancelled
This plate was to be included in the de luxe edition of Charles Terrasse's
book on Bonnard (1927). It was rejected by the painter and was replaced by
the engraving *Errand-girls*; for this reason no more than a few trial proofs
were printed

Bibliography: TF 58

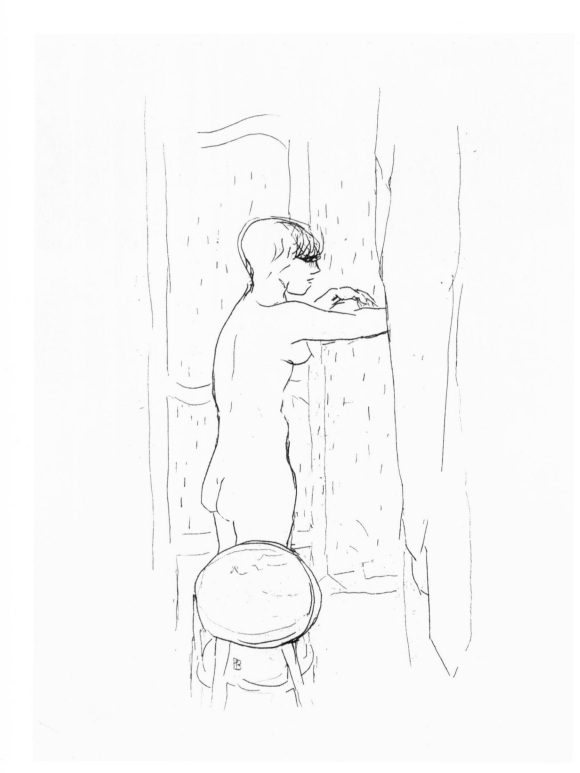

107
Toilette

1927

Dry-point $22 \times 16 \left(5\frac{5}{8} \times 6\frac{1}{4}\right)$
For the book by Charles Terrasse on Bonnard,
published by Floury
Printed in an edition of 2,420 on fine wove paper:
and 220, printed in bistre on hand-made Japanese
antique paper, for de luxe edition of the book

Bibliography: TF 59

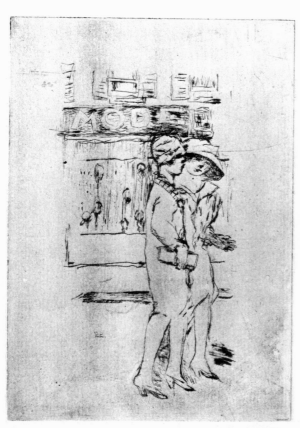

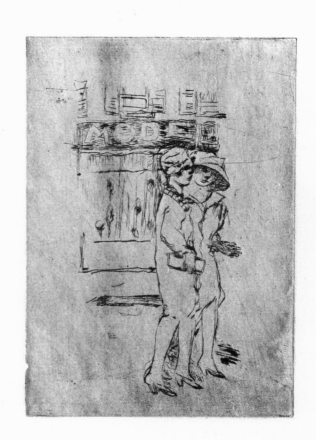

108
Errand-girls
Trottins

1927

Dry-point 18×12 $(7\frac{1}{8} \times 4\frac{3}{4})$
Five proofs on wove paper

Bibliography: TF 60

<div align="right">

108a
Errand-girls
Trottins

1927

Dry-point 18×12 $(7\frac{1}{8} \times 4\frac{3}{4})$

</div>

The same subject as the preceding plate, but with differences in detail: here the sign 'Modes' is only partially visible, and a tree r. appears in silhouette 220 prints on hand-made Japanese paper for de luxe edition of the book by Charles Terrasse on Bonnard

<div align="right">

Bibliography: TF 61

</div>

One or two proofs on grained paper before removal of black marks; also some preliminary drawings

(At the top, right hand corner: a variant)

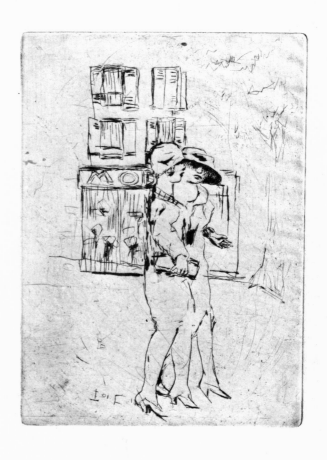

110
The Massage
La friction au gant de crin

c. 1930

Dry-point 31×17 ($12\frac{1}{2} \times 6\frac{5}{8}$)
Monogram PB, on the copper plate, below l.
According to the catalogue of the sale of the
Collection D. David-Weill (Hôtel Drouot, 25 and
26 May 1971) where a print of this dry-point was
put up for sale (catalogue no. 19), an edition of
only twelve prints was produced, in *c.* 1930.

109
Two Nudes (Women bathing)
Deux nus (les baigneuses)

c. 1927–29

Dry-point and roulette on copper plate 16.6×23.3 ($6\frac{1}{2} \times 9\frac{1}{8}$)
Signed with monogram PB on the plate, below r.
Printed in an edition of approximately fifty on Japanese and thin Japanese
paper
Probably engraved for Vollard, who was planning an *Album de nus* with
prints by, among others, Dufy, Maillol, Forain, Picasso and Rouault
The copper plate has been preserved

Bibliography: UJ

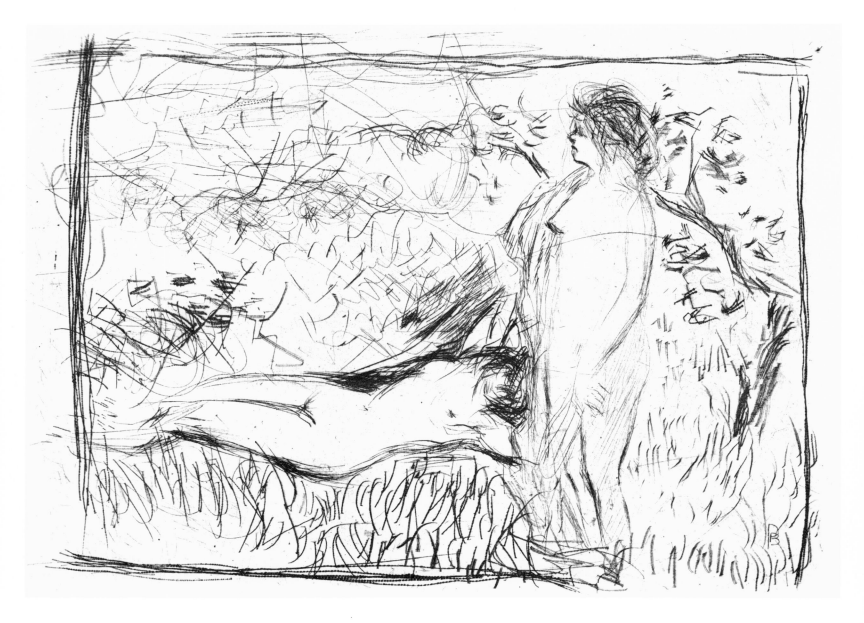

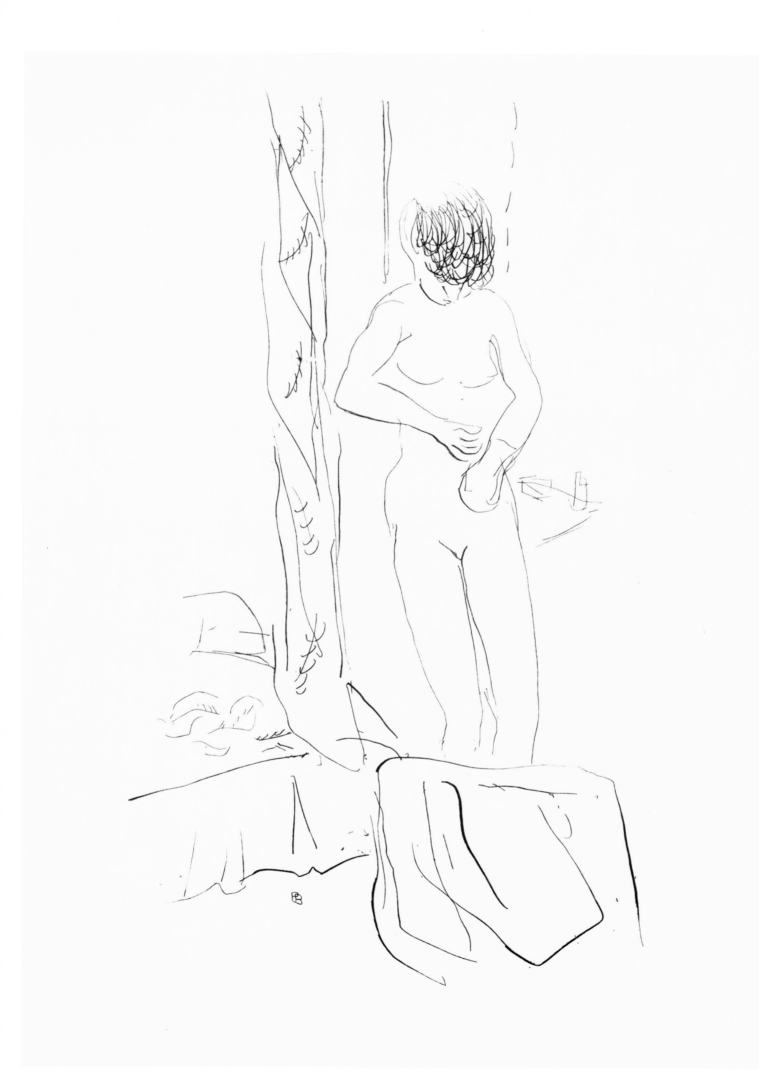

Bonnard and Ambroise Vollard

In his *Souvenirs d'un marchand de tableaux*, Ambroise Vollard tells the story of how Bonnard came to provide the illustrations for the book of *Saint Monique*, of which he was the author:

'You wouldn't feel like illustrating my book?'

'God! If it's only a few drawings you want . . .'

'In fact I fared a great deal better than that at Bonnard's hands. He produced forty-two inset plates and 178 head- and tail-pieces.

'In the circumstances I renewed my frequent but unsuccessful attempts to combine, in one volume, wood engravings, lithos and etchings. To give the illustrations a unity, I had to restrict the inset plates to lithographs only and give up the idea of alternating them with etchings in the body of the book. As I didn't want to deprive the admirers of Bonnard of such a fine series of plates, I put all the etchings at the end of the volume . . .'

Vollard describes later how Bonnard agreed to make an illustrated table of contents of the engravings, to assist the binders in placing the plates in the correct order: 'Why not ask Bonnard himself to engrave, on copper, miniature versions of his inset plates? Even though every time I asked him for another plate I swore it was the last time I would "pester" him, I wrote and told him what I wanted. A while later, to my great delight, he brought me the plates, on which he had engraved the forty-two little motifs . . .' (In fact there were in the end forty-six inset plates – twenty-nine lithographs and seventeen etchings.)

It is not entirely clear whether it was Vollard or Bonnard who first had the idea of combining different print-making techniques. 'I illustrated *Sainte Monique*. Vollard had conceived it in the form of dialogues, like a play. To follow the rhythm of the text and break the monotony of a uniform technique throughout the volume, I introduced etchings and wood engravings. It's a book that was a long time in the making. I started it in 1920, and it wasn't published until ten years later.' (Bonnard to Marguette Bouvier, *Comœdia*, 23 January 1943)

AMBROISE VOLLARD

SAINTE MONIQUE

PARIS
AMBROISE VOLLARD, ÉDITEUR
28, RUE DE MARTIGNAC, 28
MCMXXX

III
La vie de sainte Monique

1930

Twenty-nine drawings transferred onto stone; seventeen original etchings, of which three contain the table of inset plates; and 178 compositions drawn on wood blocks by the artist; illustrations for a book written and published by Ambroise Vollard
Format of book: 33×26 ($13 \times 10\frac{1}{4}$)
Book printed in an edition of 340, of which: eight on Japanese antique paper (1–8); twenty-five on Imperial Japanese paper (9–33); fifty on hand-made wove paper from the Papeteries d'Arches (34–83)
The copies numbered 1–83 contain the sequence of lithographs and etchings printed on Arches wove paper, and are signed with the monograms of the illustrator and author
257 copies of the book printed on Arches wove paper (84–340). In addition: thirty-five copies, not for sale, numbered in Roman numerals; fifteen exhibition copies marked A to O
Plates cancelled after printing
Printer: Aimé Jourde (wood engravings and lithographs)
There are first-state proofs of several of the etchings

Bibliography: TF 64; UJ 25; AS 28; CRM 96

On 15 December 1978, a collection of trial proofs was sold at the Hôtel Drouot-Rive gauche, in Paris ('Livres illustrés et œuvres originales'). The catalogue entry (no. 56) reads as follows:
Pierre Bonnard
Collection of trial proofs for the illustration of *Sainte Monique* by Ambroise Vollard, 1930
Three original etchings and twenty-five trial proofs
The collection is contained in a portfolio bearing in Bonnard's hand the words *Saint Augustin*, the original title (?) of *Sainte Monique*
It contains: three original etchings from the book, proofs on laid paper, of which two are first-state proofs, before signature of artist on plate; four trial proofs, printed together on a single large sheet of Holland paper, for the compositions on pages 26, 48, 126 and 136; nineteen proofs on laid paper for the compositions on pages 10, 14, 20, 26, 52, 80, 100, 106, 122, 126, 130, 154, 156, 164, 168, 170, 176, 180 and 192; four trial proofs, with some modification in pen and ink by the artist, of two illustrations apparently never published; these, being somewhat smaller, are undoubtedly very early versions of the illustrations

255

256

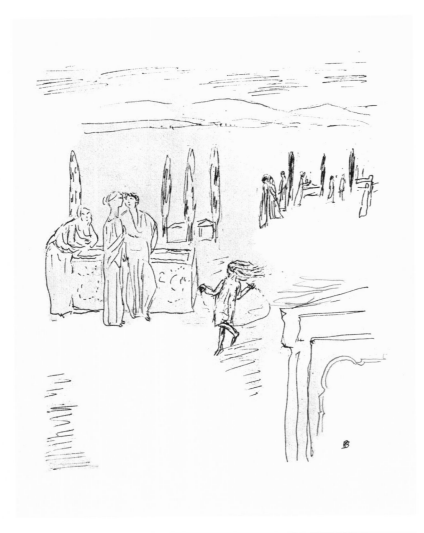

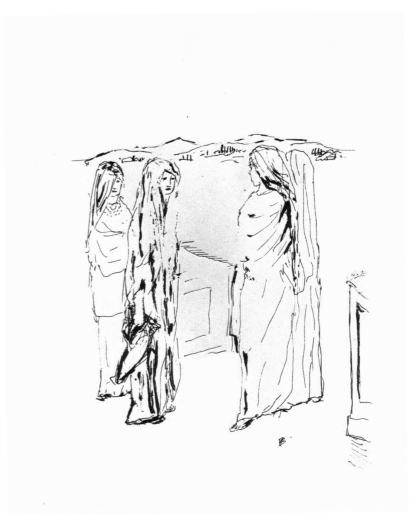

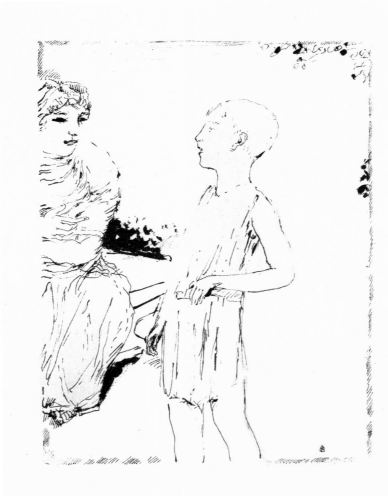

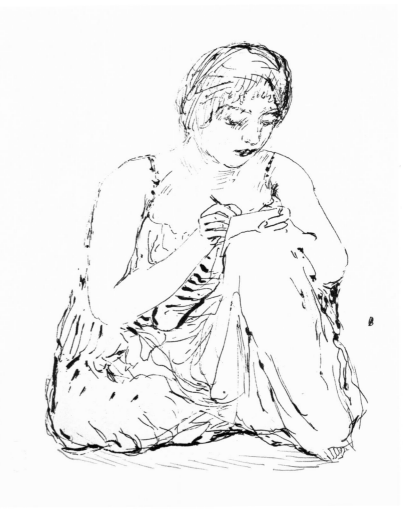

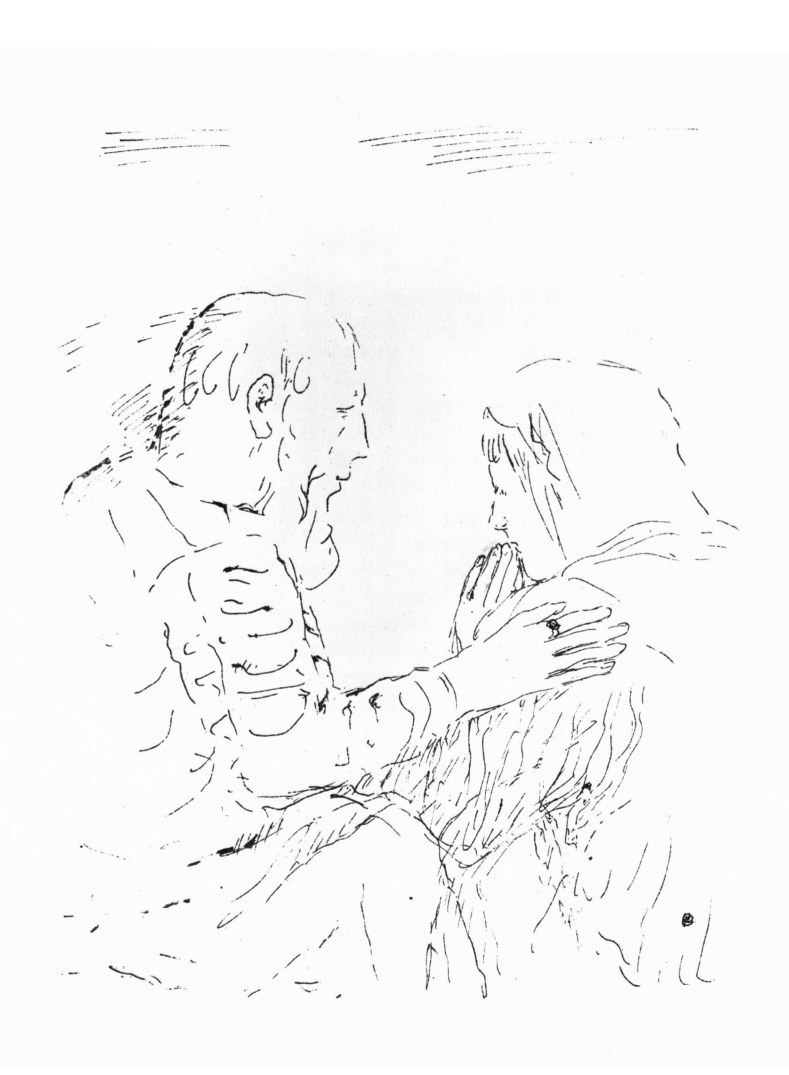

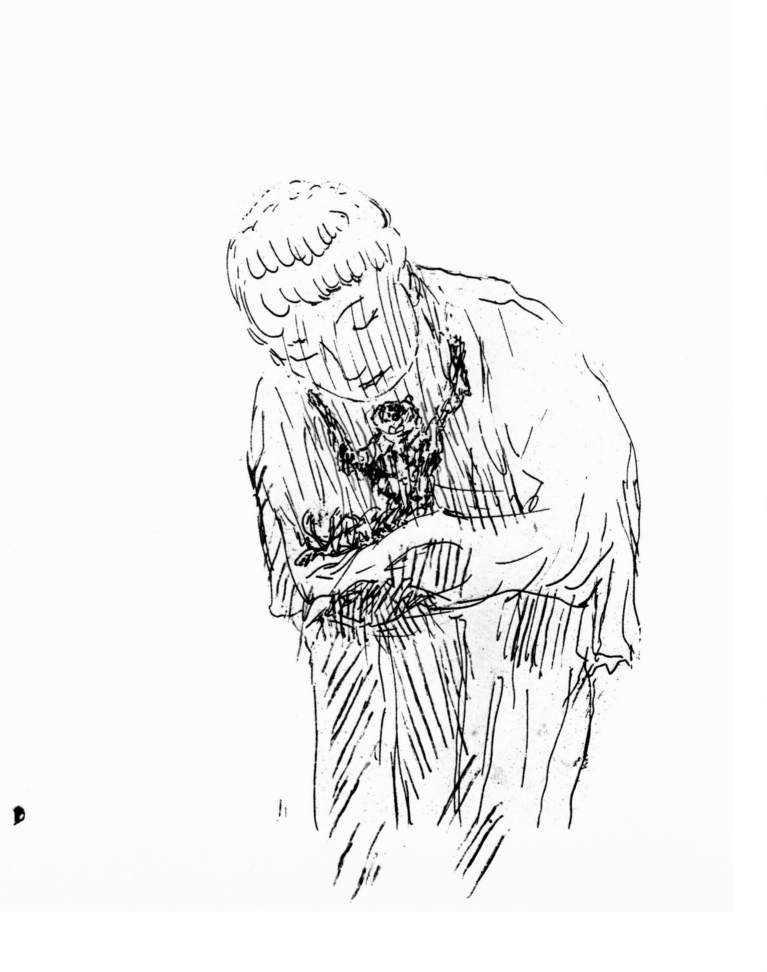

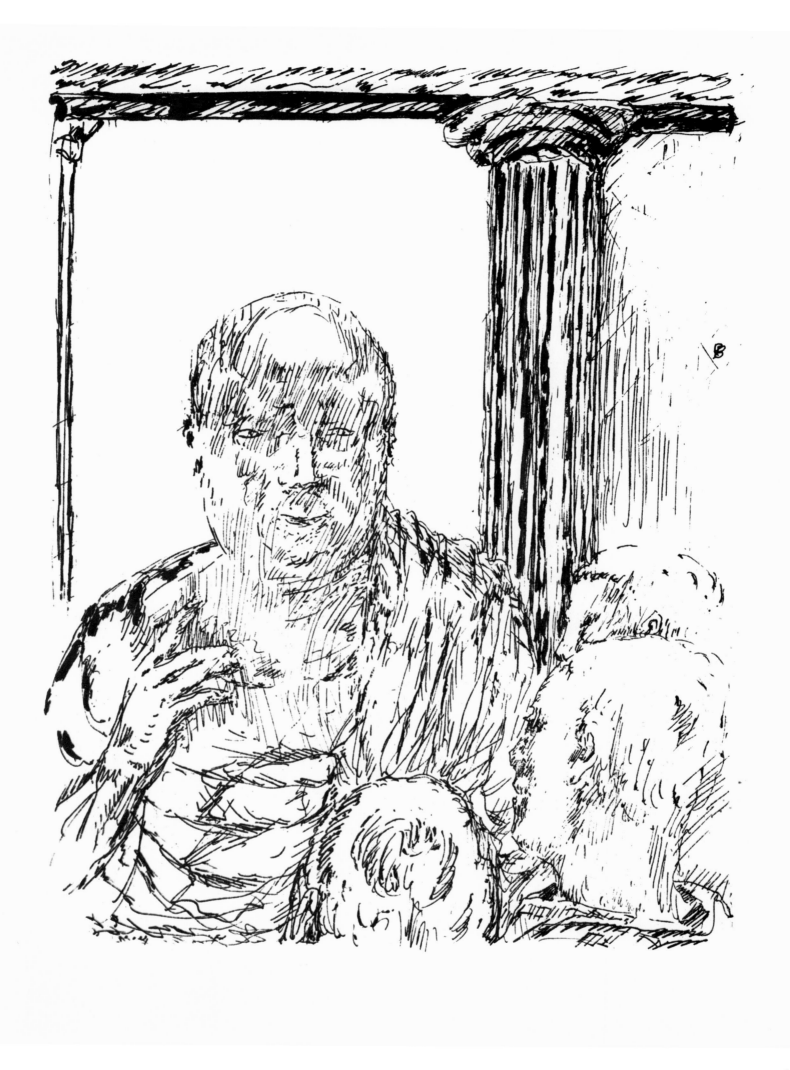

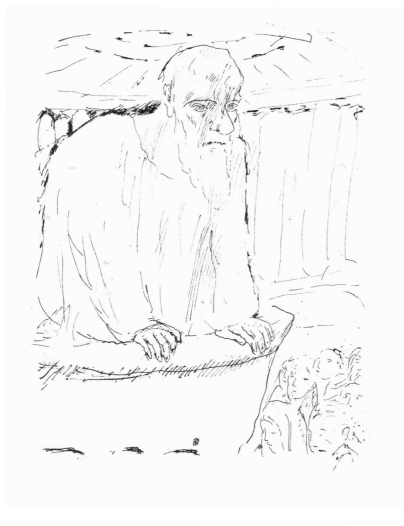

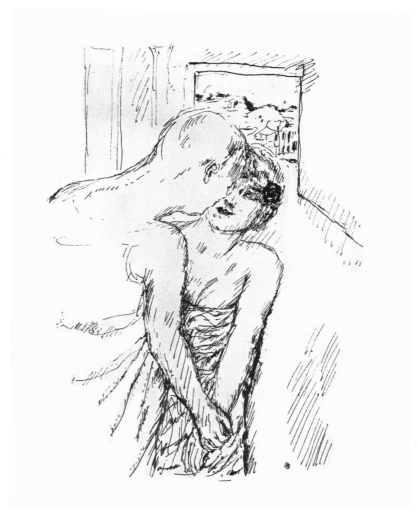

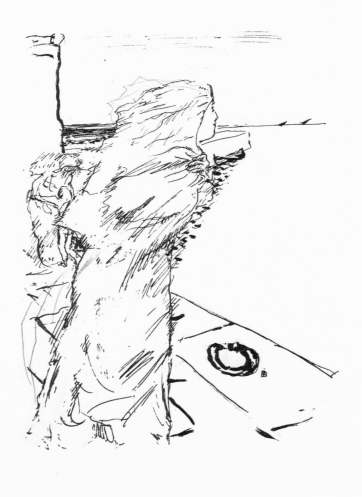

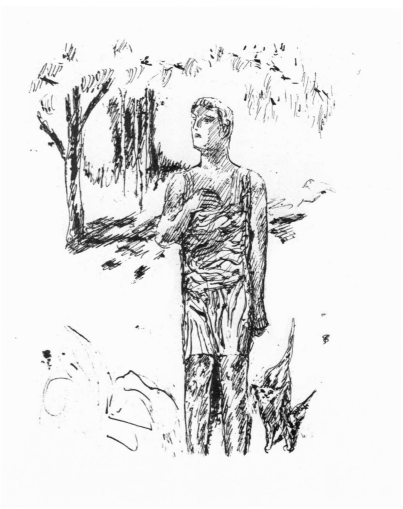

263

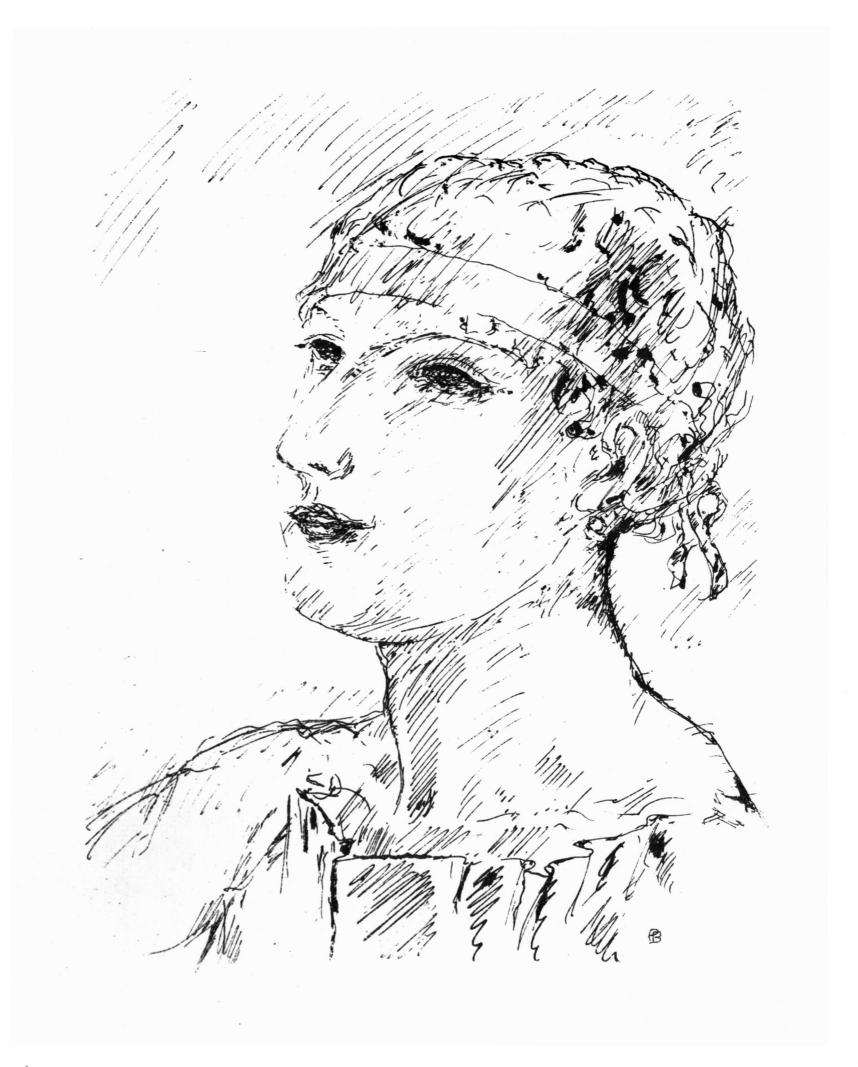

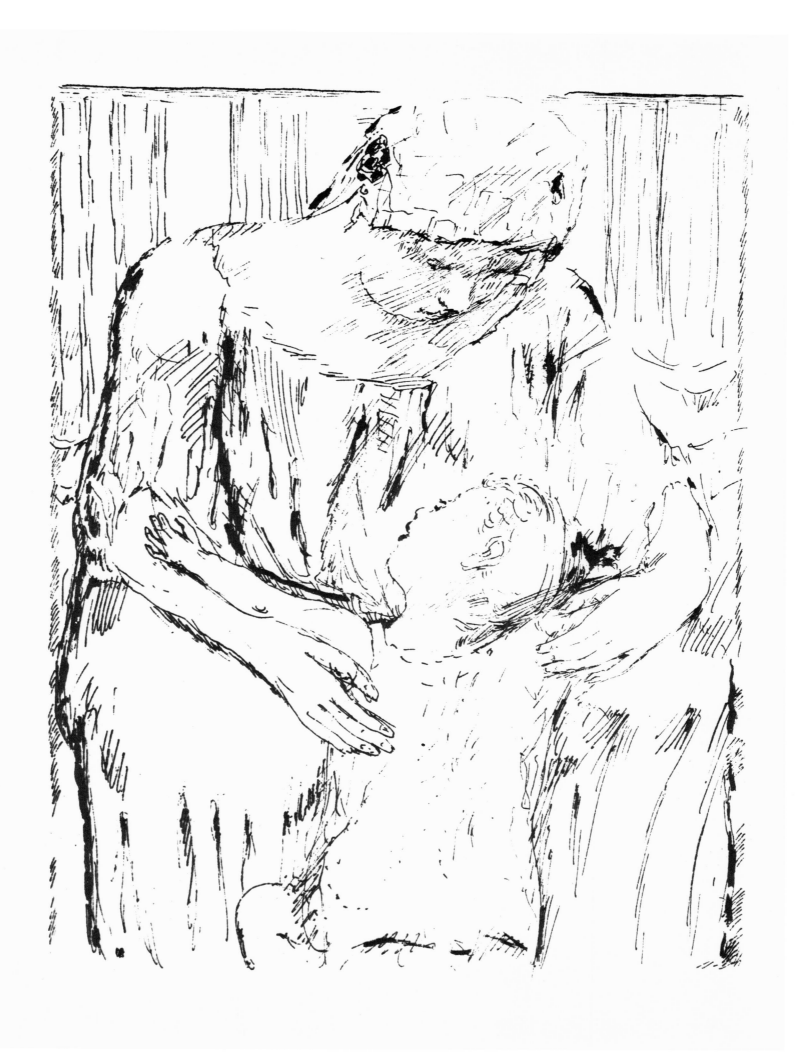

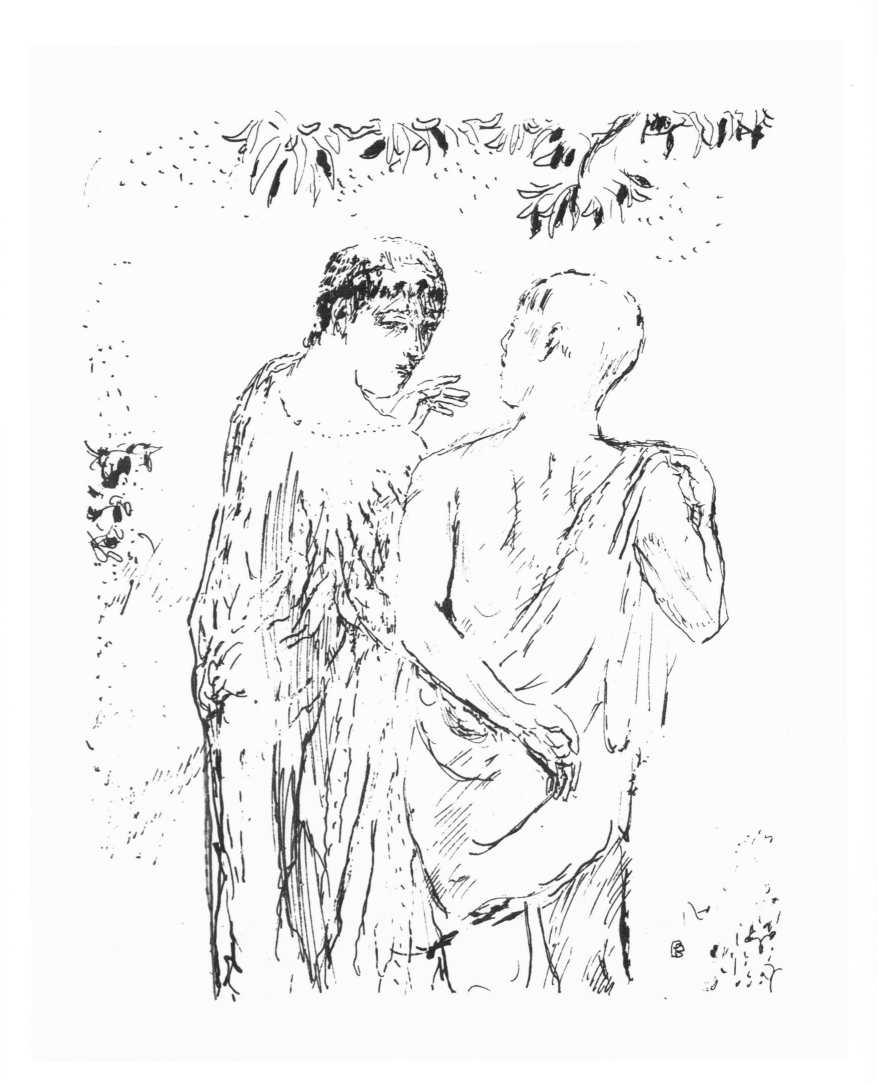

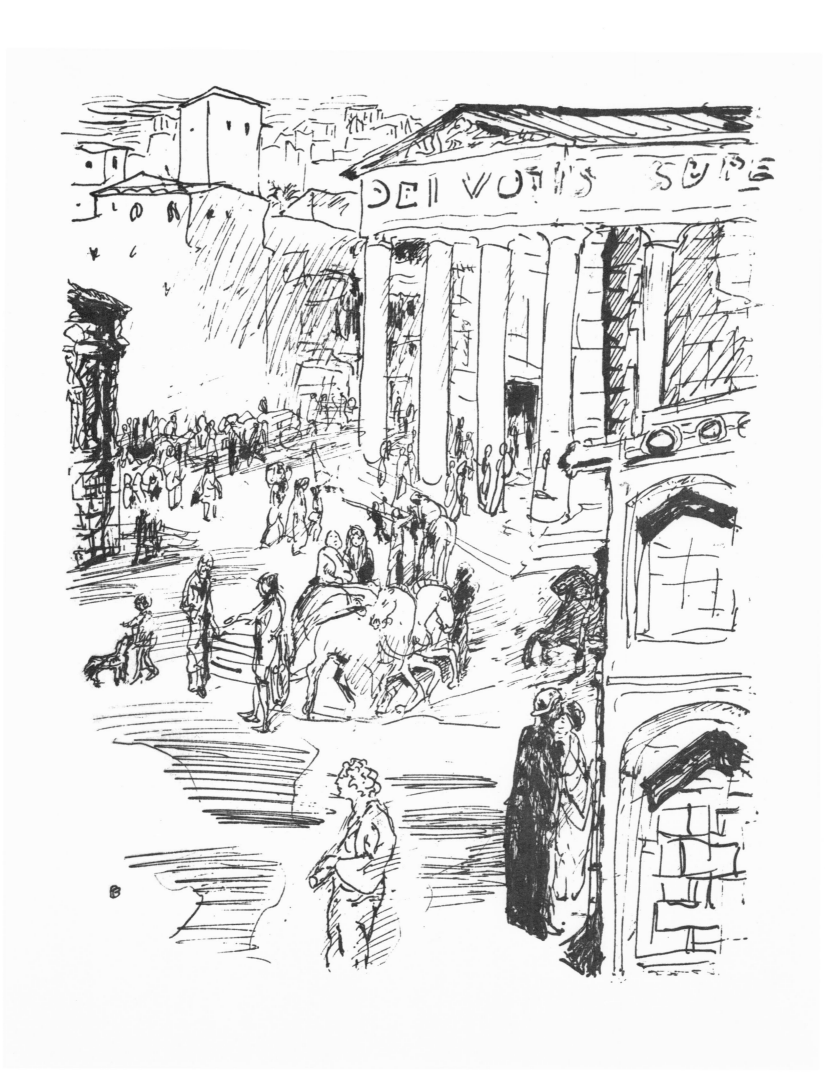

267

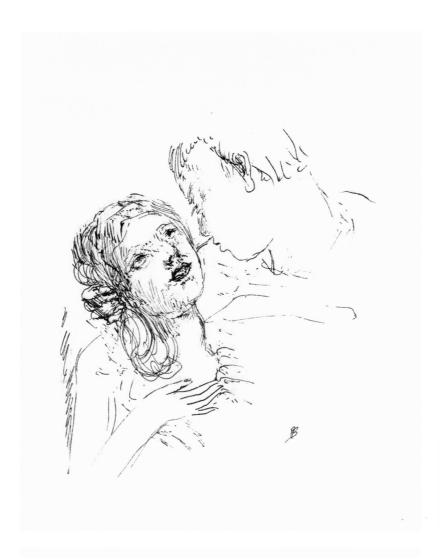

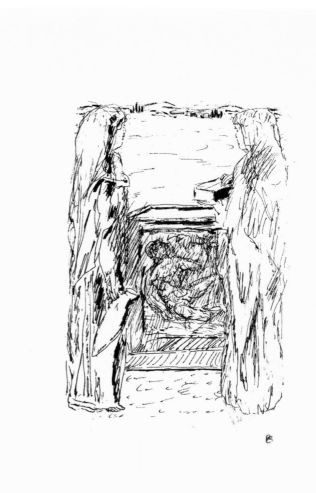

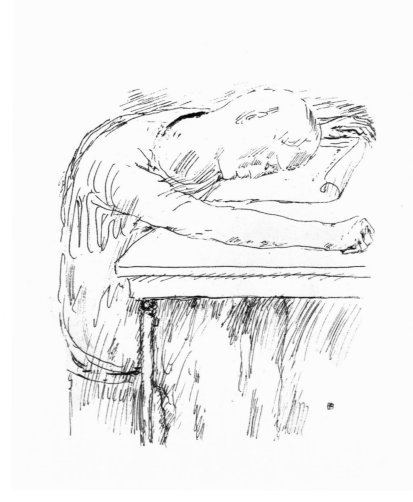

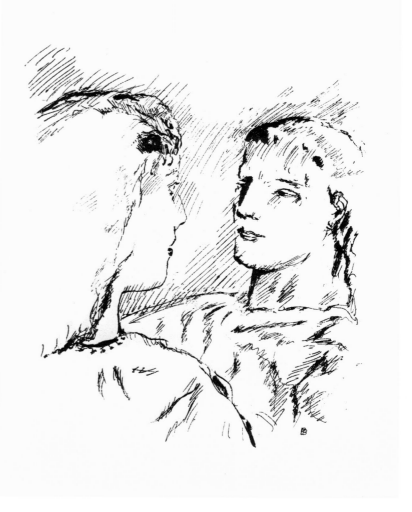

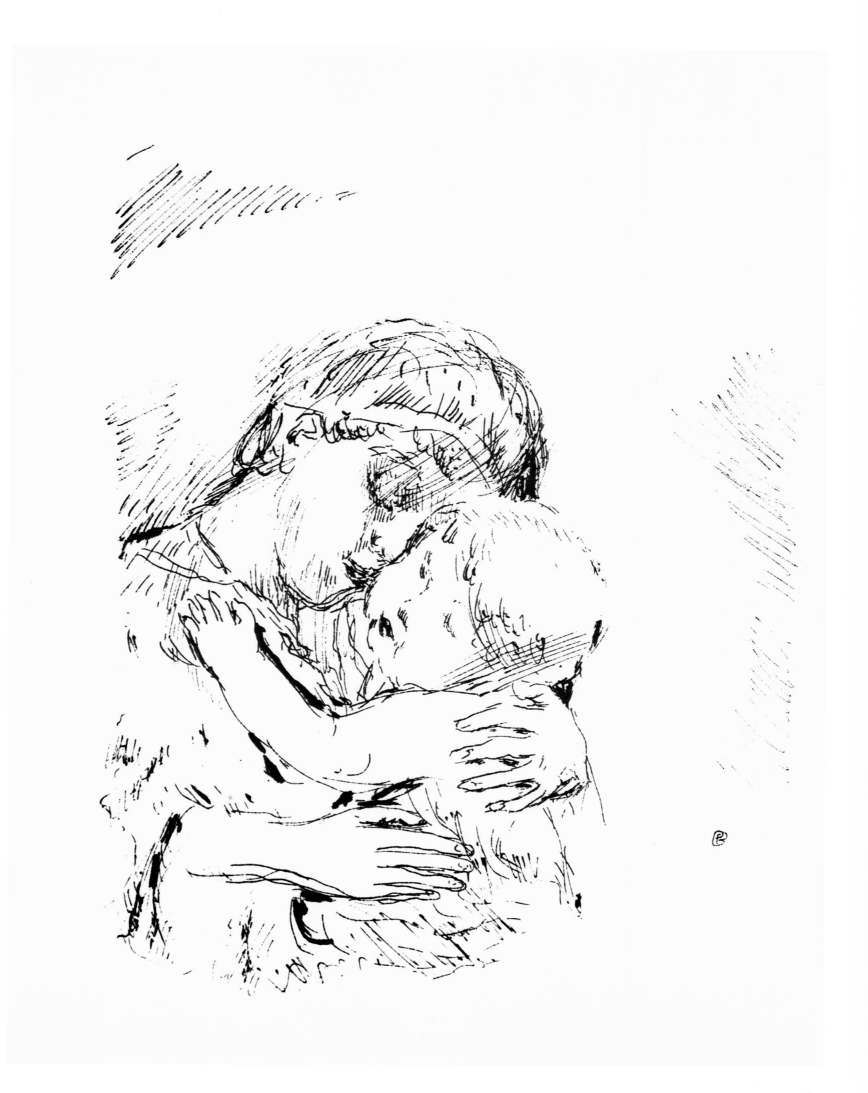

269

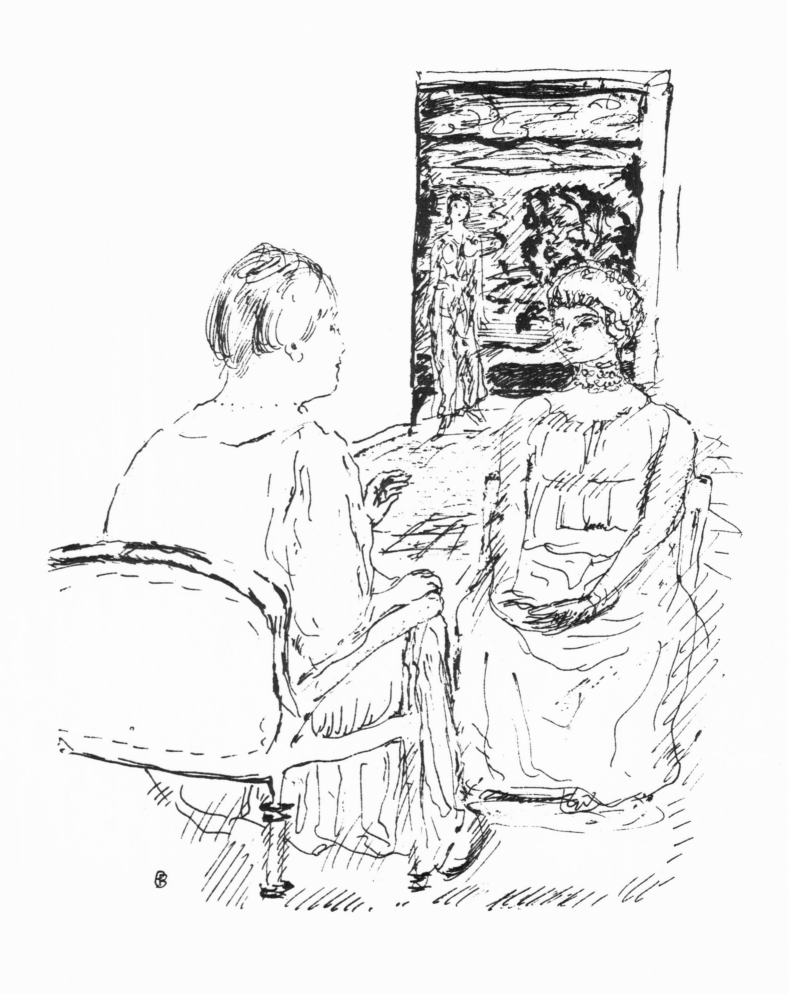

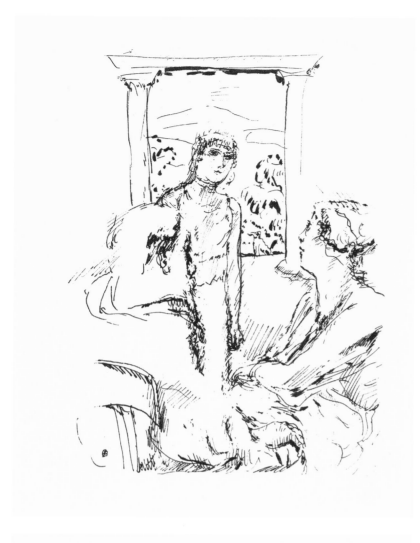

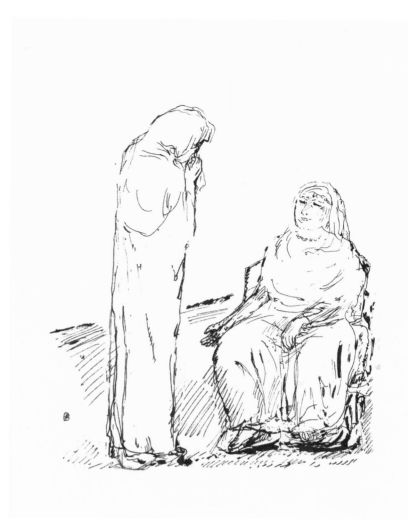

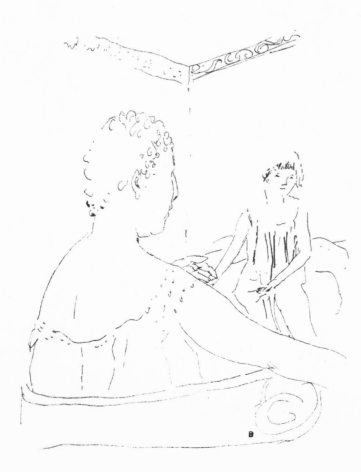

FP.

6

14 20

52

26 48 80

84 90 106 114

3.11 122 108 126

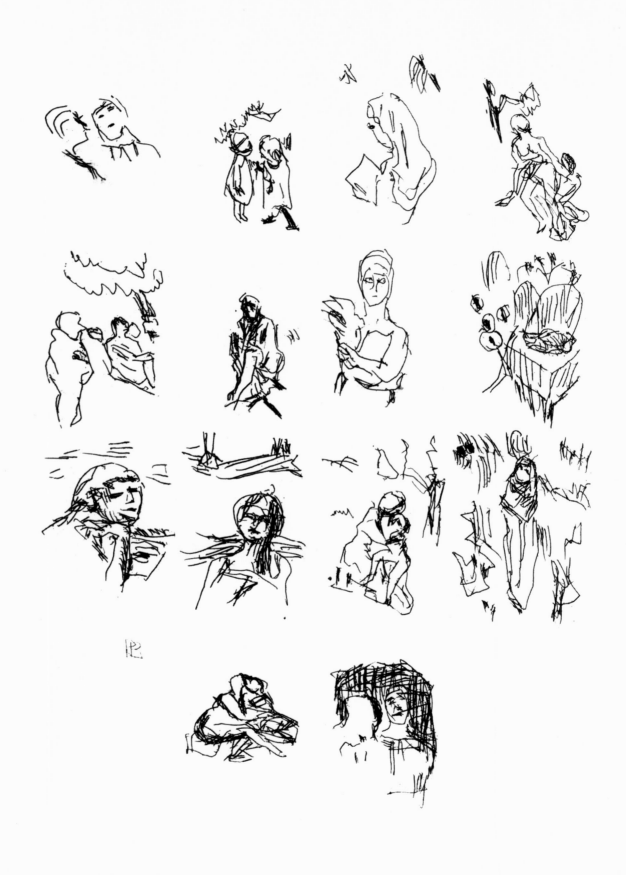

274

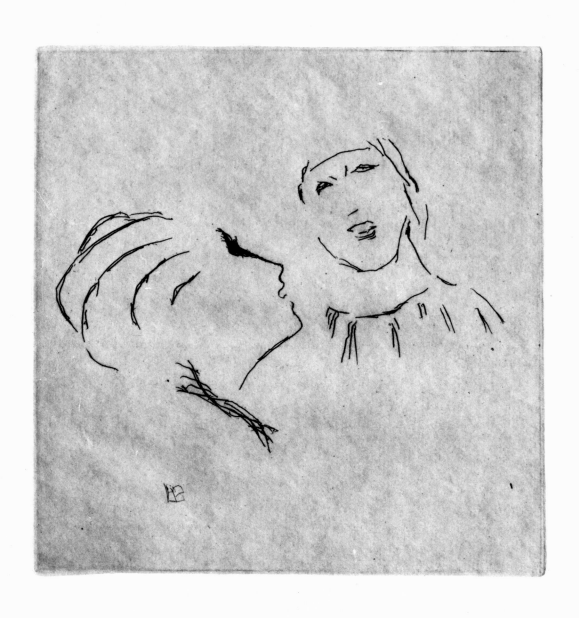

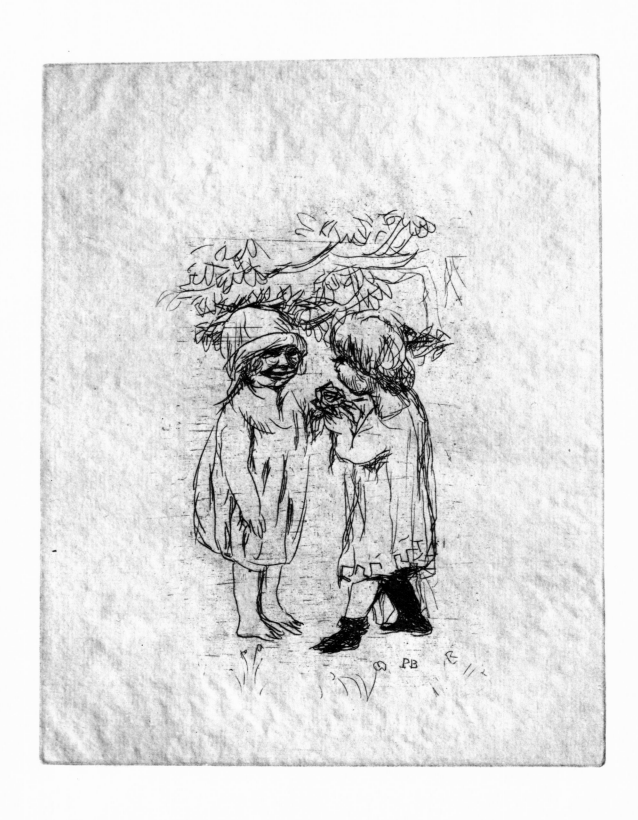

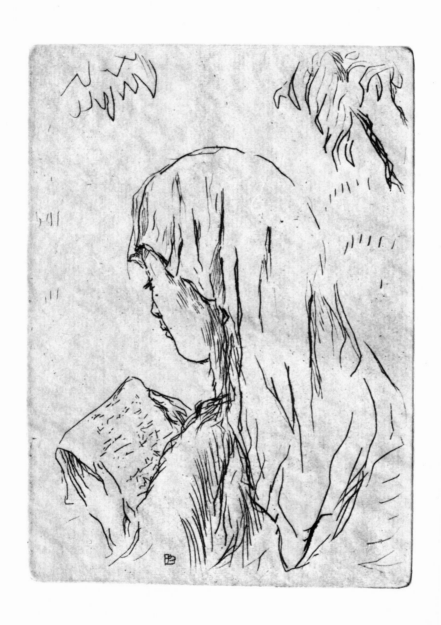

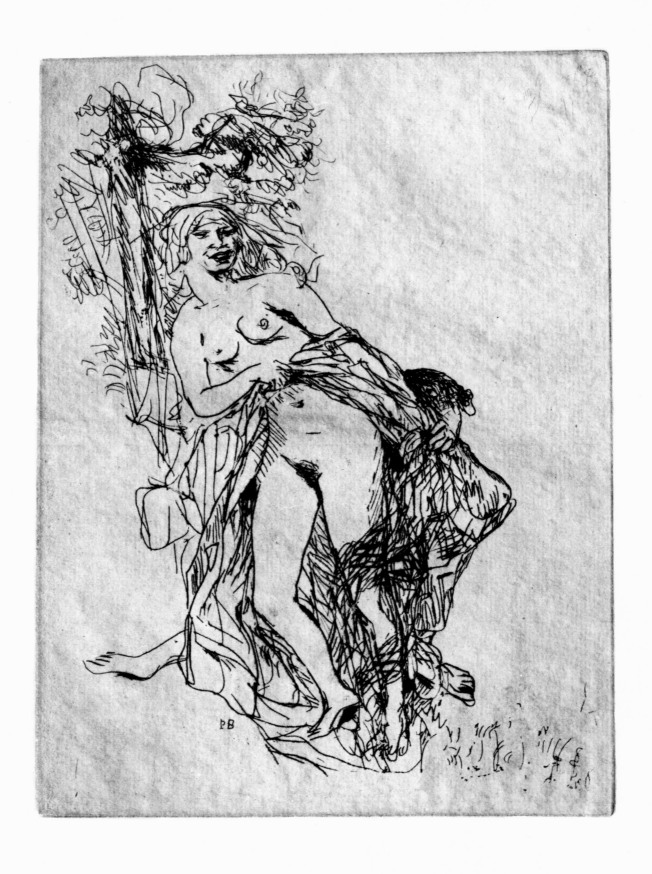

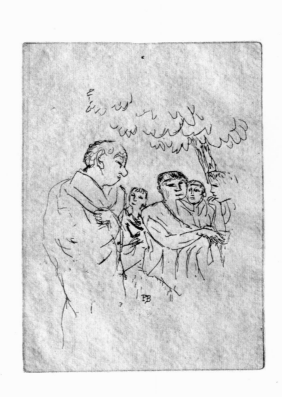

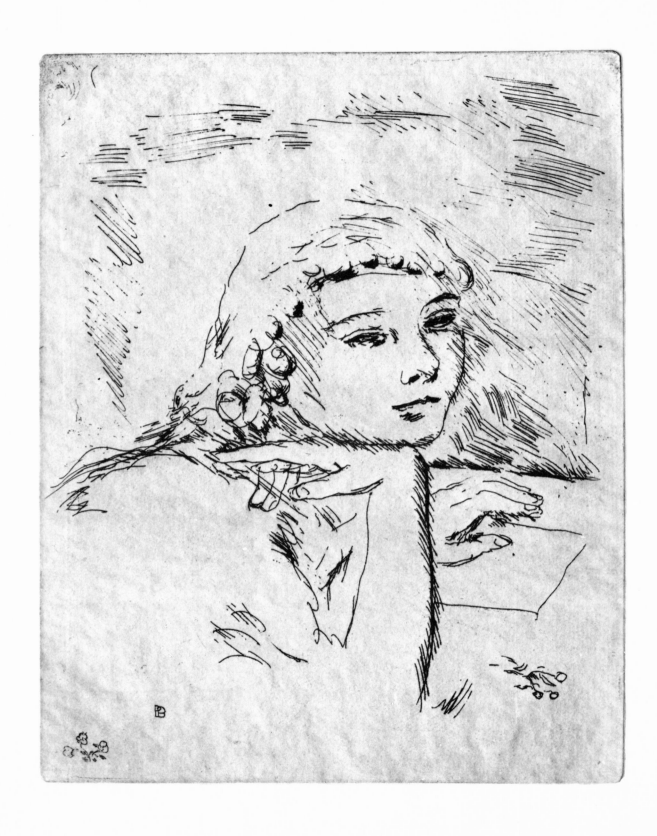

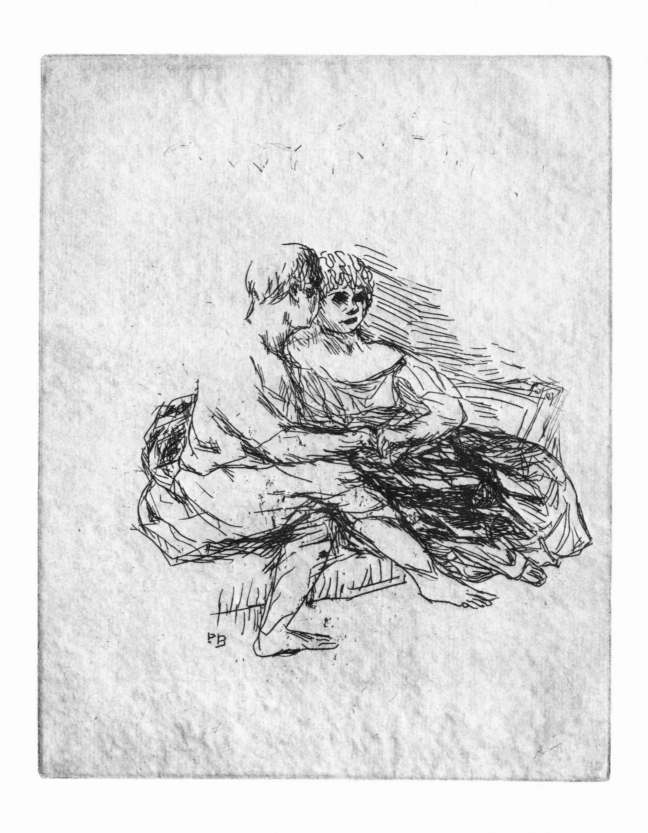

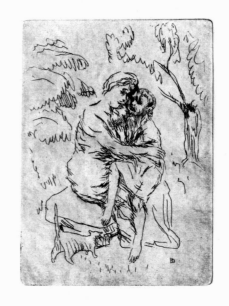

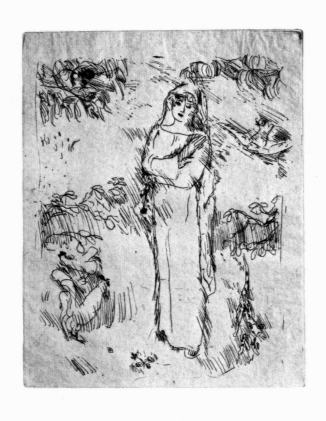

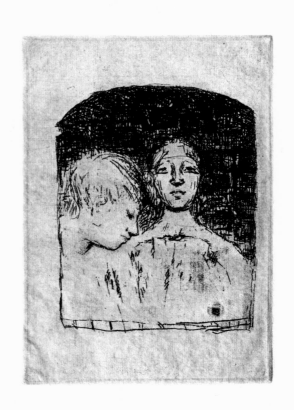

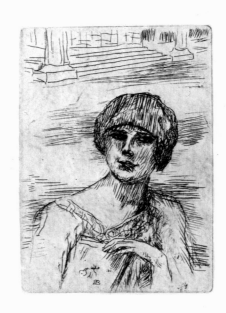

1930

Format of book: 21 × 16 (8¼ × 6¼)

This witty conversation piece, in the manner of Marivaux with overtones of Pirandello (the action is set in a big hotel in Saint-Jean-de-Luz), was written in 1922 by Claude Roger-Marx and presented for the first time at the Vieux-Colombier, on 24 September 1925. The role of Annette was played by Falconetti, that of Raymond by Charles Boyer, and André by Harry Krimer; there is no record of the rest of the cast.

On 15 January 1930 the printed version of the play came off the presses of Robert Coulouma in Argenteuil, the third in the series (16mo) *Laboratoire*, published by Editions du Sans Pareil, Paris. It contained seven dry-points by Bonnard, printed by E. Brunel for Maurice Vernant, and was printed in an edition of 310, of which: twenty-five on Imperial Japanese with two sequences of engravings (1–25); thirty on Van Gelder Holland paper with one sequence of engravings (26–55); and 225 copies of Lafuma wove paper.

In addition, not for general sale: thirty copies on Arches laid paper with two sequences of engravings, exclusively for the Amis du Sans Pareil (I to XXX); and some copies for contributors, signed by the publisher.

It is possible to estimate from this that each engraving must have been printed in an edition of approximately 460, which means that the engraved plates must have been steel-faced. The book colophon does not indicate whether the plates were cancelled or destroyed. There was no signature engraved into the plate.

The plates divide by size into two groups: three vignettes (4.5 × 7.5; 1¾ × 3) at the head of each act (pp. 5, 45, 87); and four plates (12.5 × 7.5; 4⅞ × 3) as frontispiece, preceding the first act, facing p. 42 (end of first act), and facing p. 84 (end of second act).

The style of the dry-points is similar to that of the (contemporary) *Sainte Monique* – not the best of Bonnard perhaps, but the 'art deco' grace of the vignette at the head of the second act (N. 474) redeems the pleasant if uninspired quality of much of the rest.

CLAUDE ROGER-MARX

SIMILI

TROIS ACTES
ILLUSTRÉS DE
SEPT GRAVURES
ORIGINALES DE
PIERRE BONNARD

A PARIS, AU SANS PAREIL

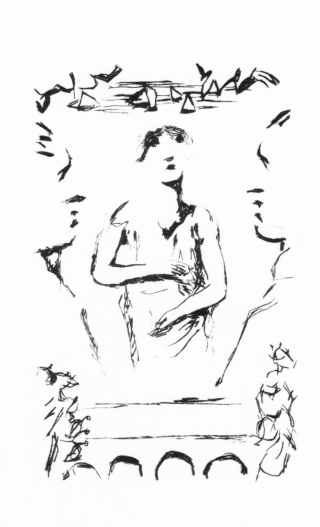

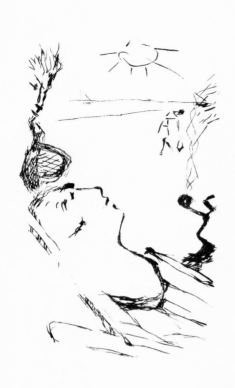

A Saint-Jean-de-Luz. La terrasse d'un hôtel, face à la
mer. À droite, pavillon qui sert de salon. A gauche,
un bosquet de tamaris. Au fond, balustrade en pierre
au centre de laquelle est percé un petit escalier qui
donne sur la plage. Petites tables et chaises éparses
au premier plan.
Derrière une table, qu'un portier achève de desservir,
Annette et Gilbert : Gilbert, dix-huit ans, en pan-
talon de tennis et en veston blanc rayé bleu; Annette,
svelte, blanche, très jeune fille.

ANNETTE, se levant.

*Cinq heures, Gilbert. Suzy vous attend au
tennis. Et j'ai à faire.*

GILBERT

*Mais non, vous n'avez rien du tout à faire.
Vous m'en voulez. De quoi, je n'en sais rien,
mais vous m'en voulez.*

3

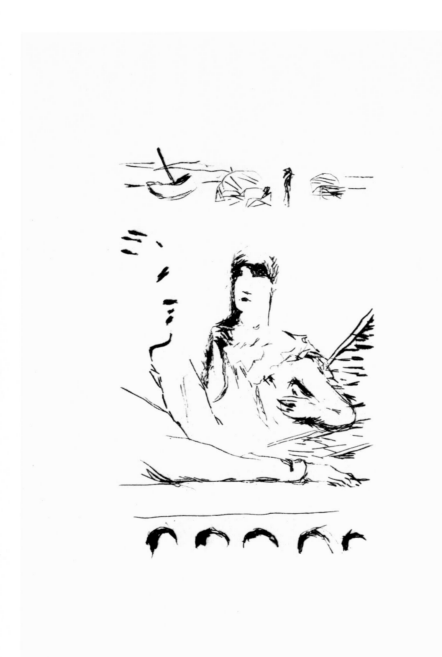

Une chambre d'hôtel convertie en petit salon. A gauche, porte couverte par une tenture et donnant sur le couloir. A droite, porte de communication avec le cabinet de toilette d'Annette. Au fond, la fenêtre grande ouverte laisse voir la mer au travers d'un balcon, comme dans un tableau de Matisse. Une petite table avec une grande gerbe de glaïeuls. Au premier plan, à gauche, un canapé. Accoté au mur droit, un divan-lit couvert d'une étoffe blanche à raies bleues, chargé de coussins.
Annette, au lever du rideau, est assise devant la table.
On frappe.

ANNETTE

Entrez!

RAYMOND, entrant.

On ne vous dérange pas?

ANNETTE

Du tout, j'écrivais.

45

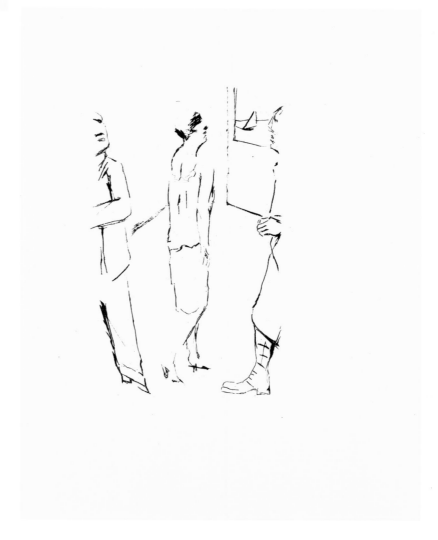

Huit jours après. Même décor qu'à l'acte II. Annette,
en déshabillé, est assise devant une petite table. Ray-
mond, tout près d'elle, tient un guide dont ils exa-
minent la carte dépliée. Au premier plan, un pla-
teau avec une bouteille de porto et deux verres.
Une mallette. Atmosphère d'intimité. Le désordre
qu'apporte un homme.

RAYMOND

Barcelone... Madrid... Cordoue.

Chaque fois, il l'embrasse.

ANNETTE

André, soyons sages.

RAYMOND, l'embrassant.

*Vous voyez bien, c'est un voyage circulaire...
Séville, Mérida, Burgos... Ça ne vous dit rien,
tous ces noms ?*

87

113
Announcement of the birth of Françoise Floury
Billet de naissance de Françoise Floury

1932

Dry-point 11.2 × 11 (4⅜ × 4⅜)
Monogram PB, below l.
One proof before letters, printed in green on China paper with wide
margins (exhibited by Pierre Berès in 1944, no. 122)

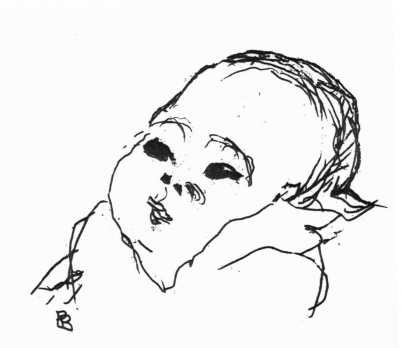

Françoise Marie Claude Antoinette Floury

14 Juillet 1932

114
Le parc Monceau

1937

Etching 33.3 × 25.9 ($13\frac{1}{8}$ × $10\frac{1}{4}$)
Erroneously called *Jardin public* or *Les Champs-Elysées*
Published in the book *Paris*, 1937, printed by
J. G. Daragnès
Book printed in an edition of five hundred
copies; in addition a number of plates with wide
margins

The texts in the book were written by, among others:
Paul Valéry; Raymond Escholier; Léon-Paul Fargue;
André Suares; Jean Giraudoux; Francis Carco; Jean
Cassou; Jérôme and Jean Tharaud; Georges Duhamel
The engravings were by: Daragnès; Jean Puy;
Matisse; Albert Marquet; Edouard Vuillard, and
others
Bonnard's etching illustrates a text by Maurice Bedel,
'Faubourg Saint-Honoré'; it well conveys the view of
the parc Monceau expressed in the following
quotation: '. . . the parc Monceau demands that we
should abandon ourselves to the sweet things of
life . . .' (p. 172)

115
Woman seated in her bath
Femme assise dans sa baignoire

1942

Lithograph printed in nine colours 25 × 29 (9⅞ × 11⅜)
Signed below r.
Cover for the programme of a recital by Maurice Chevalier, Cannes, 14
August 1942
Printed by Arte in an edition of one thousand

Bibliography: CRM 78

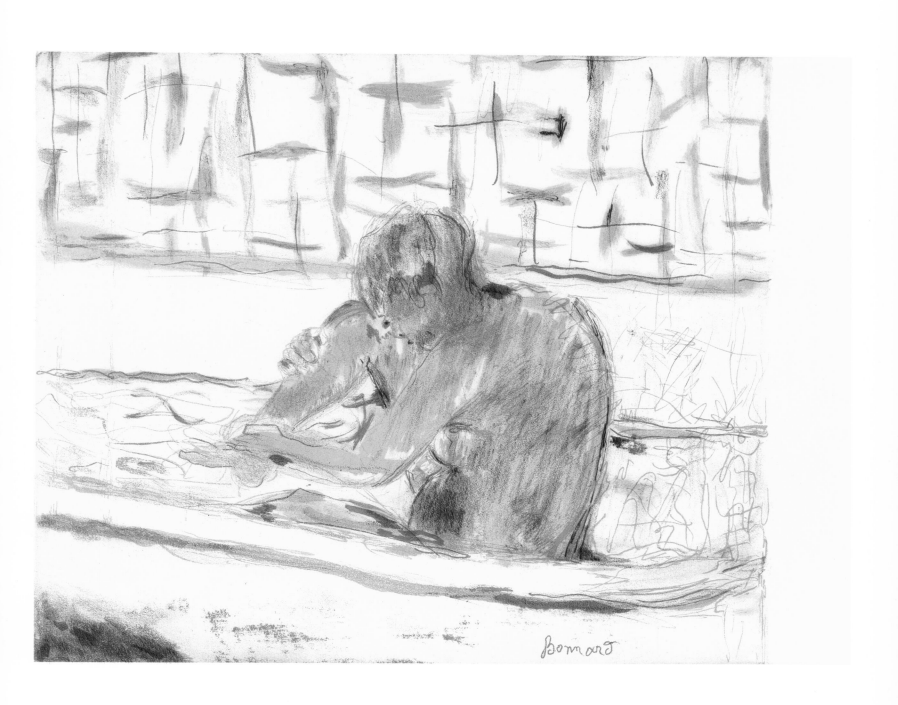

116–126
Bonnard–Villon lithographs

1942–46

These lithographs were put onto the stone by Jacques Villon after original gouaches by Pierre Bonnard. The project was conceived by Louis Carré. Bonnard followed the progress of the work through every state, annotating the colours, and making numerous marginal notes. In this way, between 1942 and 1946, a close working collaboration was established between the two artists.
Printed in an edition of eighty (1–80)
Numbers 1–17 include an additional plate: *Garden at Le Cannet*
Further prints were made of nos. 1, 3, 4, 5, 7

Bibliography: Colette de Ginestet and Catherine Pouillon, *Jacques Villon, les estampes et les illustrations*, catalogue raisonné, A.M.G., 1979

Numerous trial proofs, with corrections in Bonnard's hand, and on occasion annotations by Jacques Villon

116
Grapes
Les raisins

33 × 25.5 (13 × 10)

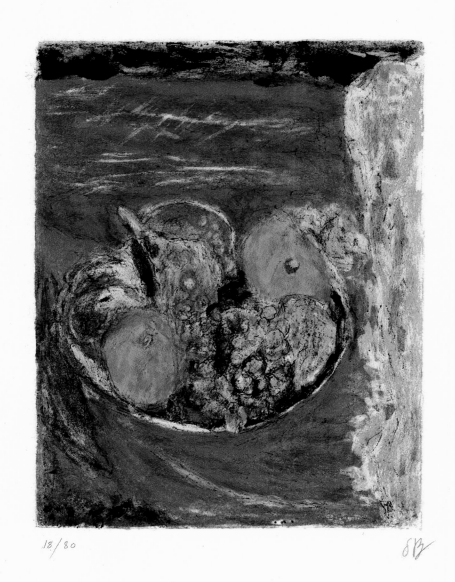

18/80 ᵟᛒ

Fishing Port
Port de pêche

$32 \times 50 \left(12\frac{5}{8} \times 19\frac{5}{8}\right)$

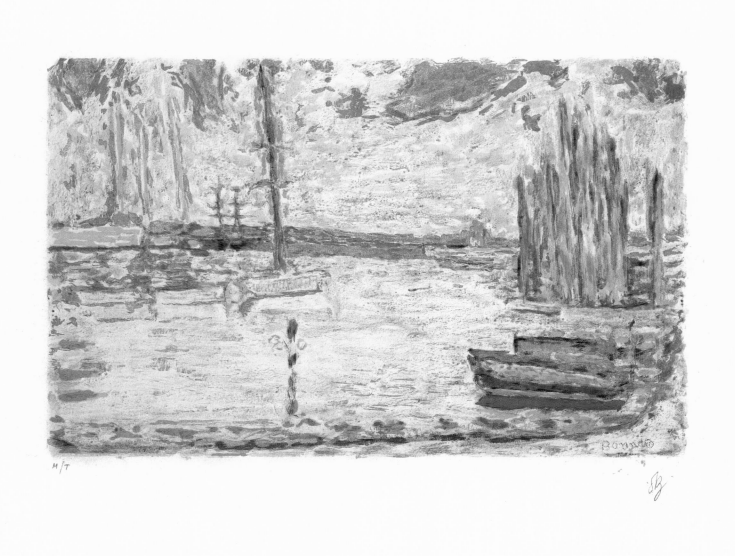

M/T

118
Flowers
Fleurs

$65 \times 40 \left(25\frac{5}{8} \times 15\frac{3}{4}\right)$

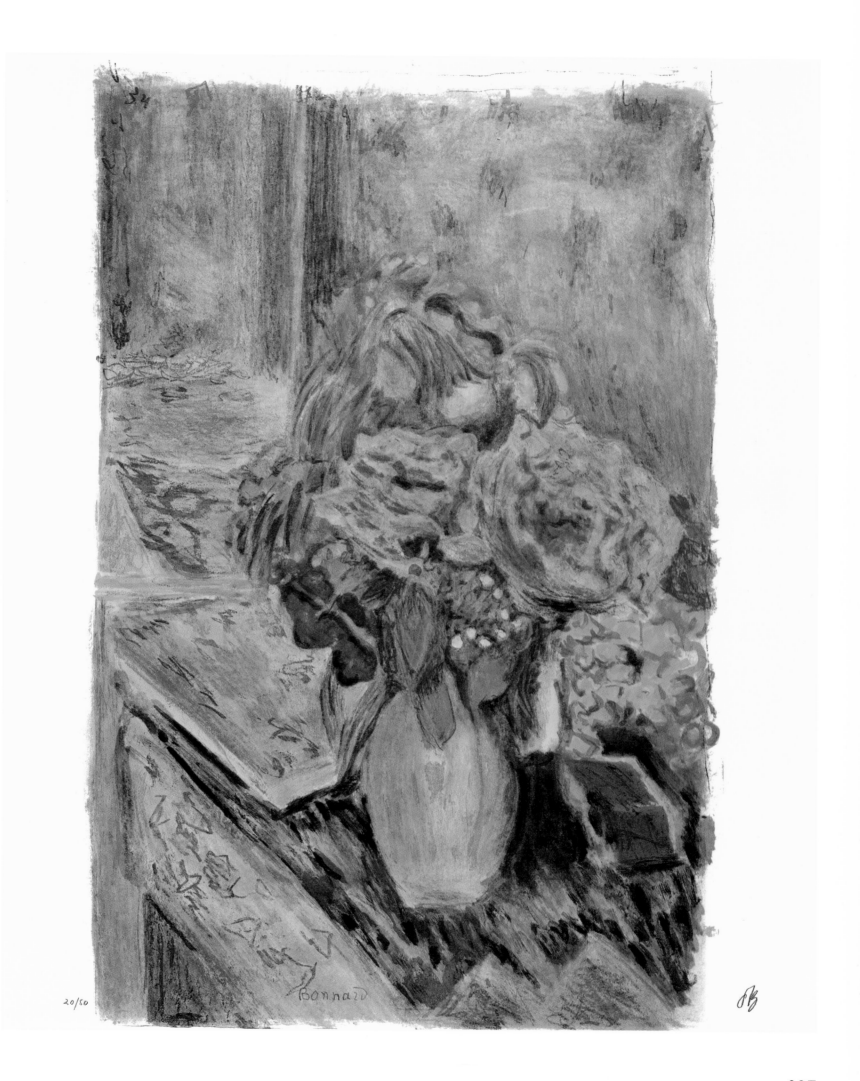

20/50 Bonnard 297

119
The Radiator
Le radiateur

$65 \times 50 \, (25\frac{5}{8} \times 19\frac{5}{8})$

Detail at actual size

120
The Bathtub
La baignoire

50×65 ($19\frac{5}{8} \times 25\frac{5}{8}$)

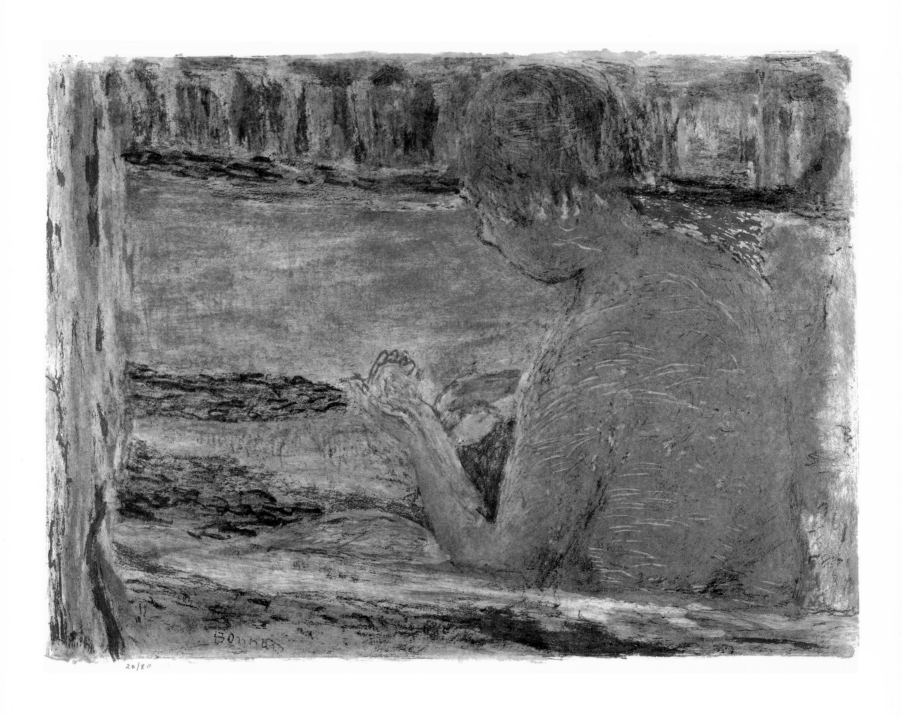

20/80

121
The Beach
La plage

$33 \times 50 \, (13 \times 19\frac{5}{8})$

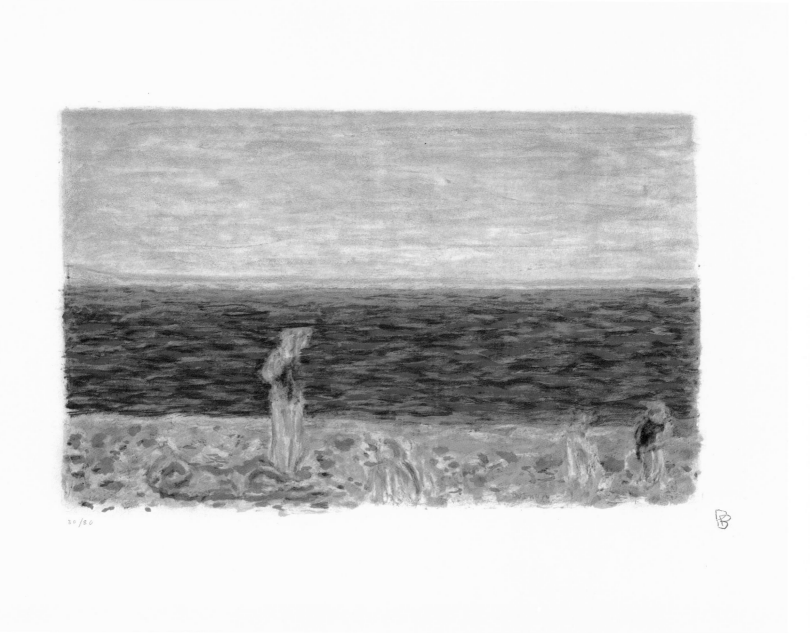

20/80

303

122
The Blue Mountain
La montagne bleu

$33 \times 50 \left(13 \times 19\frac{5}{8}\right)$

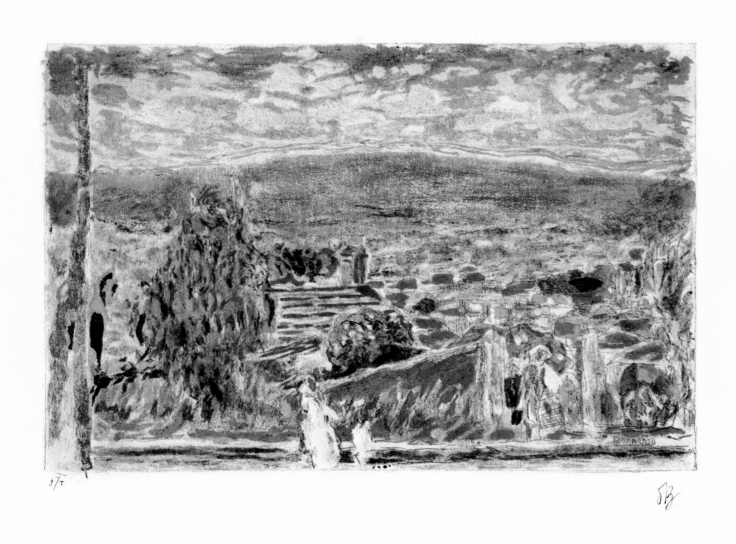

3/T

305

123
Girl seen from behind
Jeune fille vue de dos

$65 \times 52 \ (25\frac{5}{8} \times 20\frac{1}{2})$

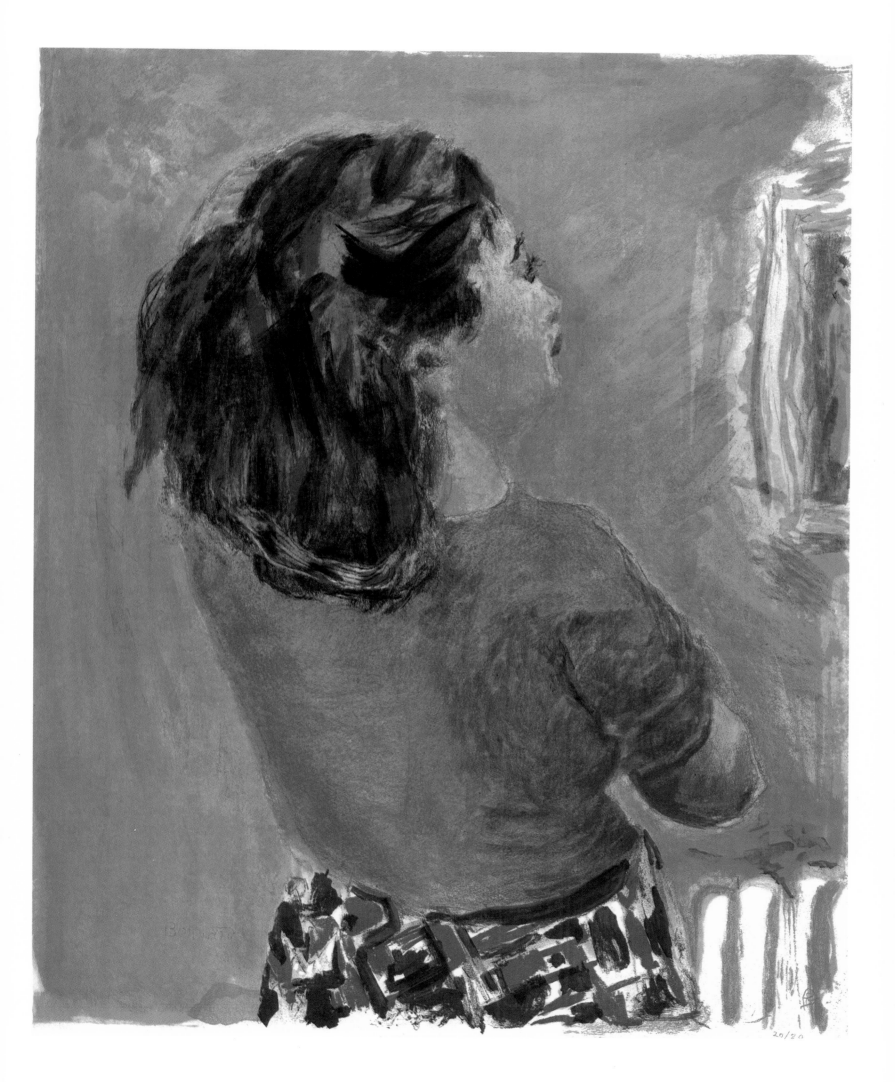

20/30

124
The Yellow Room
La chambre jaune

50×65 ($19\frac{5}{8} \times 25\frac{5}{8}$)

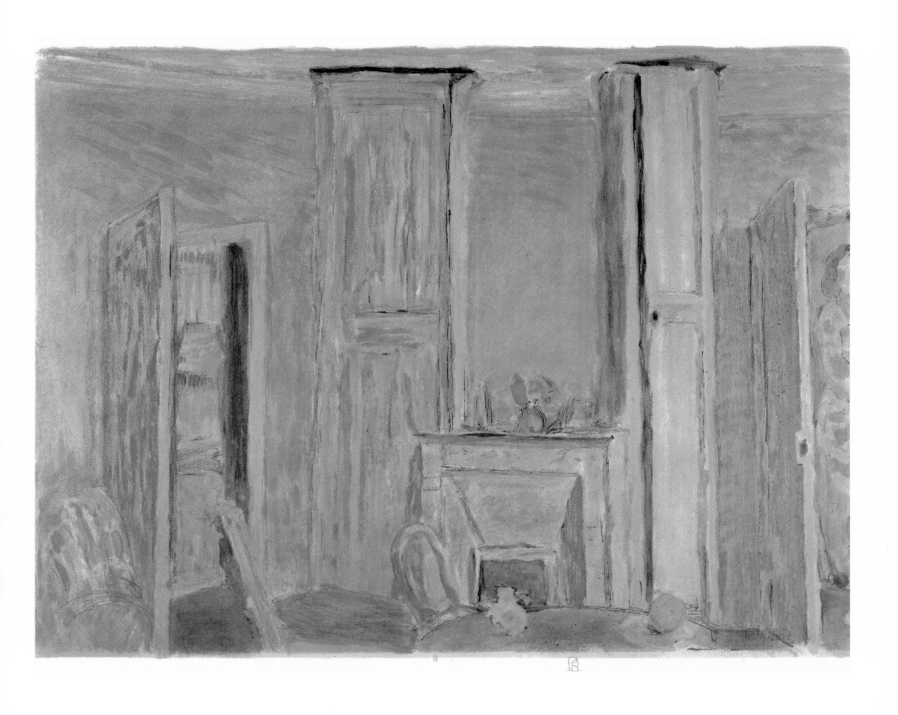

125
The Red Carpet
Le tapis rouge

50 × 65 (19⅝ × 25⅝)

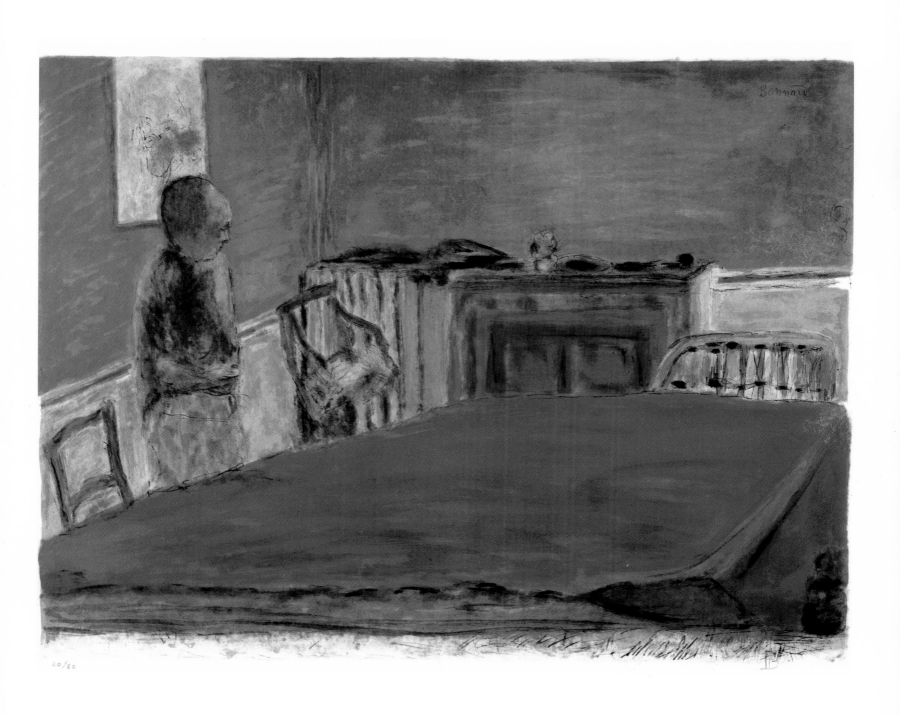

20/50

126
Garden at Le Cannet
Jardin au Cannet

$65 \times 40 \left(25\frac{5}{8} \times 15\frac{3}{4}\right)$
Additional plate,
included in sequences 1–17

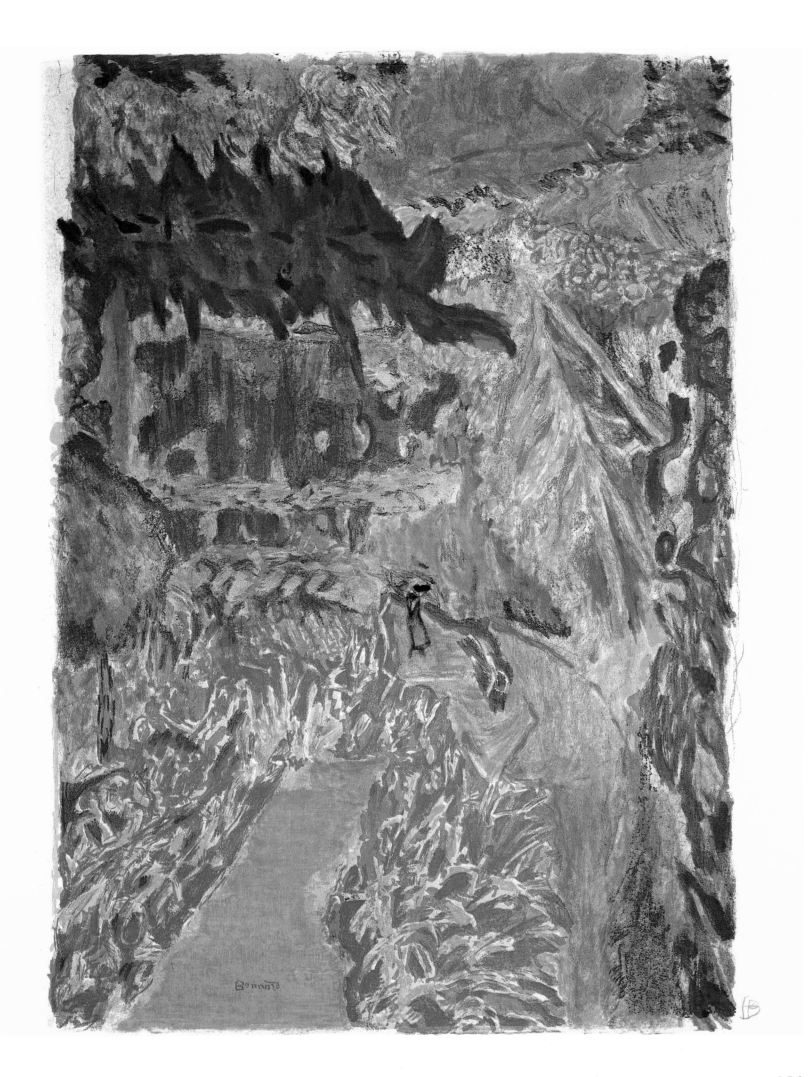

Bonnard

313

127
Two Children on a Bench
Deux enfants sur un banc

1945
Lithograph printed in black 16 × 18 (6¼ × 7⅛)
Monogram PB, below r.
Printed by Mourlot, with the profits going to
charity
Twenty-five prints on Auvergne paper; ten
copies for the artist's use

Bibliography: CRM 93

There is also a very similar drawing

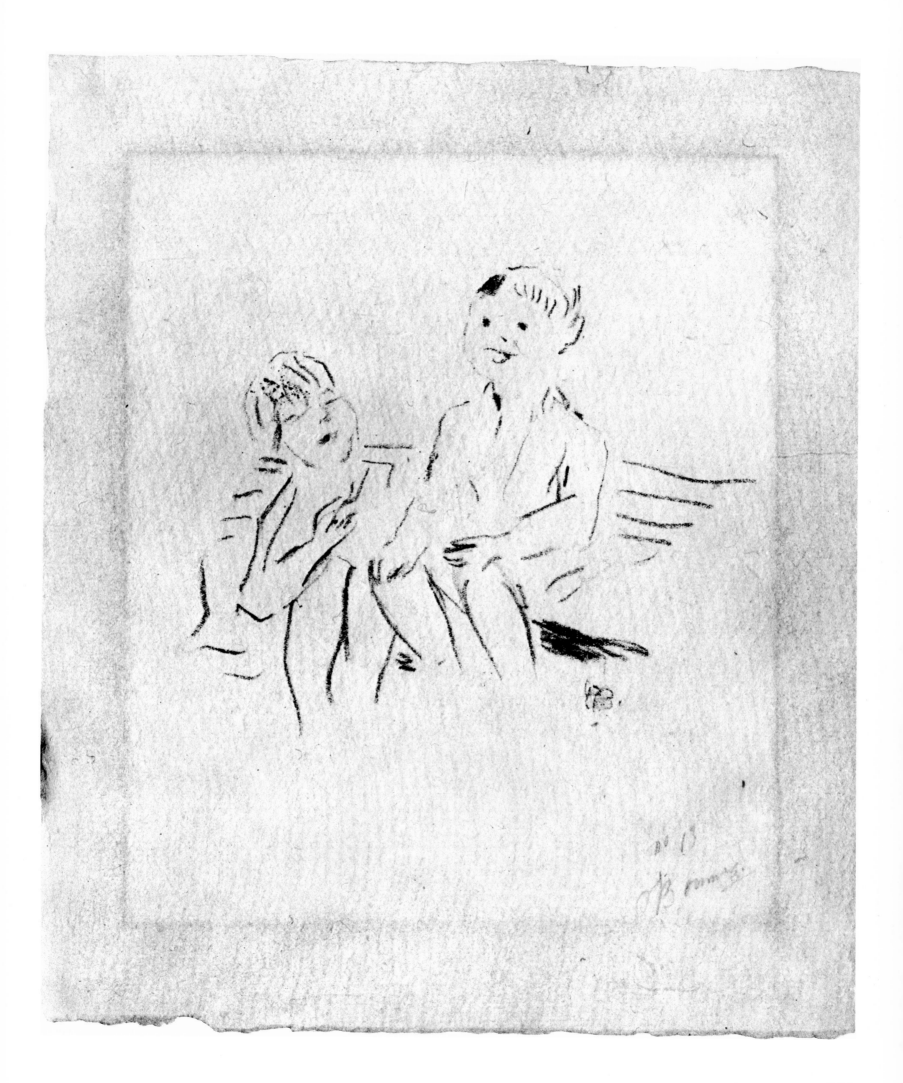

128
Nymphs at Dusk
Le crépuscule des nymphes

1946

Twenty-four transfer-lithographs, illustrations for a book by Pierre Louys
Published by Editions Pierre Tisné
Book printed in an edition of 120 copies on Le Marais wove paper with
watermark (nymphs), of which: thirty copies include the lithographic
sequence printed on China paper (numbered 1–30); seventy copies
(numbered 31–100); twenty copies, not for general sale, marked I to XX
Printed by Féquet et Baudier, typographers, and on the hand-presses of
A. Clot, 20 May 1946

Bibliography: CRM 97

Some preliminary drawings

PIERRE LOUŸS

LE
CRÉPUSCULE
DES NYMPHES

LITHOGRAPHIES DE
PIERRE BONNARD

"GUILLAUME LEROLLE ET SES AMIS"
ÉDITIONS PIERRE TISNÉ

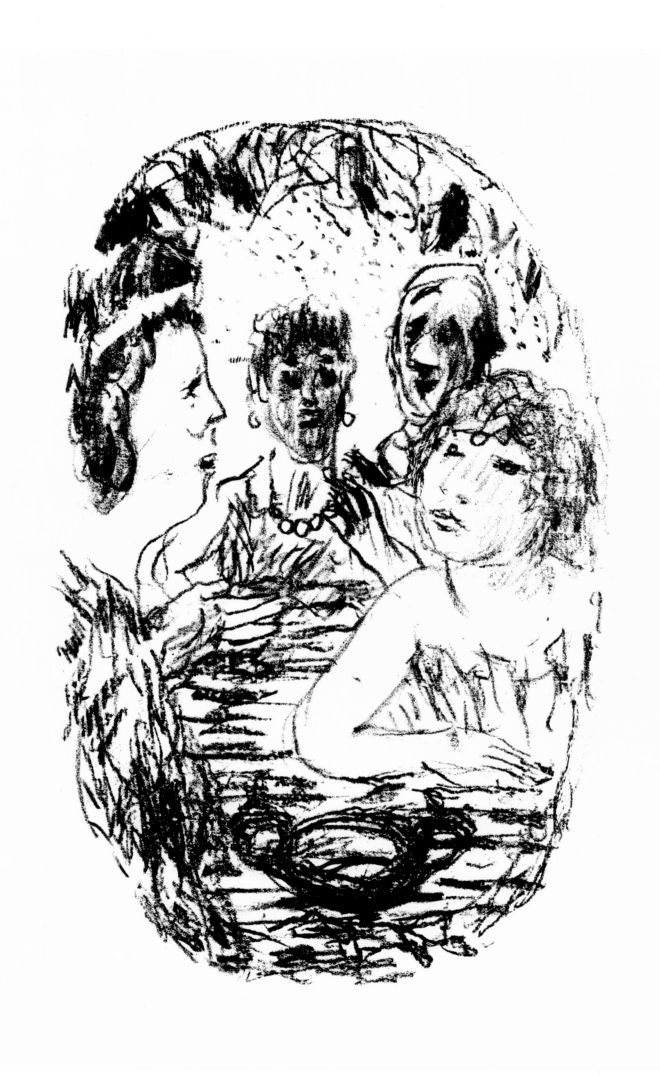

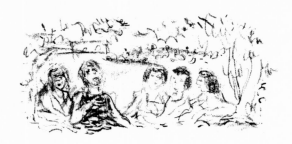

O N N'Y VOYAIT PRESQUE PLUS. UNE invisible Artémis chassait sous le croissant penché, derrière les branches noires qui pullulaient d'étoiles. Les quatre Corinthiennes restaient couchées dans l'herbe près des trois jeunes hommes; et l'on ne savait plus très bien si la dernière oserait parler après les autres tant l'heure était au silence.

Les contes ne doivent être dits qu'en plein jour. Dès que l'ombre est entrée quelque part, on n'écoute plus les voix fabuleuses parce que l'esprit fugitif se fixe et se parle à lui-même avec ravissement.

9

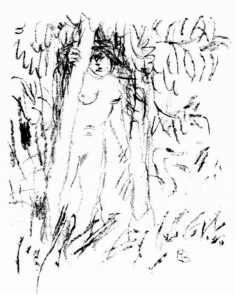

Le bel oiseau était blanc comme une femme, splendide et rose comme la lumière, et rayonnant comme un nuage.

13

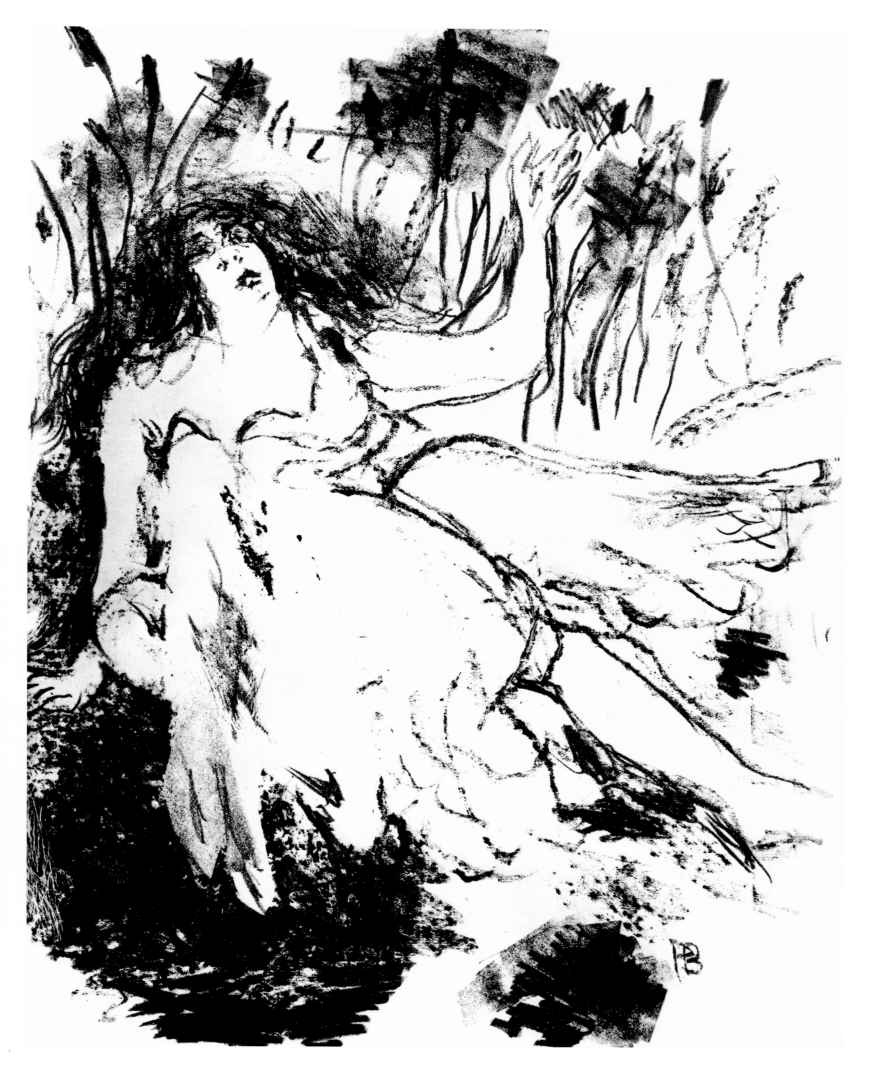

« Il ne faut pas déchirer les Formes, car elles ne cachent que l'Invisible. Nous savons qu'il y a dans ces arbres d'adorables nymphes enfermées, et pourtant quand le bûcheron les ouvre, l'hamadryade est déjà morte. Nous savons qu'il y a derrière nous des satyres dansants et des nudités divines, mais il ne faut pas nous retourner : tout aurait déjà disparu.

« C'est le reflet onduleux des sources qui est la vérité de la naïade. C'est le bouc debout au milieu des chèvres qui est la vérité du satyre. C'est l'une ou l'autre de vous toutes qui est la vérité d'Aphrodite. Mais il ne faut pas le dire, il ne faut pas le savoir, il ne faut pas chercher à l'apprendre. Telle est la condition de l'amour et de la joie.

« C'est à la louange des bienheureuses ténèbres. »

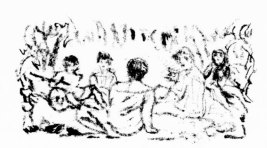

A MARYLLIS S'ÉTENDIT TOUTE LAN-guissante sur la mousse, et du bout de sa branche de saule toucha la main du plus jeune homme. « A toi, dit-elle ; parle à ton tour, Clinias. Je veux un conte de toi. »

Clinias hésita quelque temps.

« J'ai retenu les légendes que tout le monde connaît ; mais je ne sais pas, comme Thrasès, les façonner selon mon esprit, ni comme toi les renouveler par la grâce des mots, Amaryllis. Je dirai ce que m'a raconté mon ami Biôn de Clazomène, à son retour d'Aethiopie.

donné leur forme aux roches que
le ciseau des esclaves a pu enta-
mer mais que le temps ni Dzeus
ne détruiront plus.

C'était l'hiver. Les nuits s'enve-
loppaient de fraîcheur brumeuse.
Les jours éthérés persistaient
dans l'accablement. Biôn cher-
chait l'ombre et les sources dans
les forêts de mimosas où les lions
se retiraient du soleil et dormaient
jusqu'au lever du soir. C'était là
aussi que vivaient les hommes,
barricadés dans leurs cabanes par
des palissades de dattiers. Biôn
était leur hôte, de nuit en nuit, et
les quittait au premier matin.

II

OR un soir...
— Enfin! s'écria Lampito.
— Tu parles bien, dit poliment
Philinna; mais tu es trop pom-
peux. Et puis, pourquoi nous as-tu
donné une petite description de

28

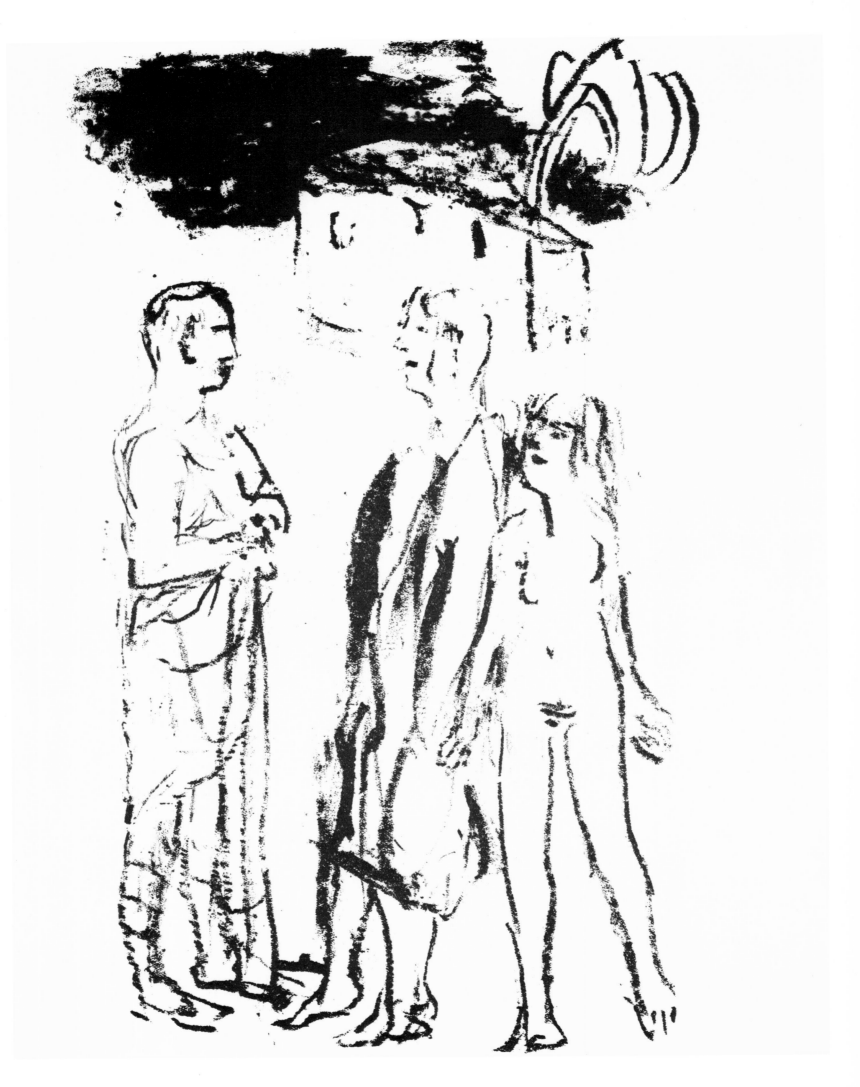

« Ma chère petite, tu raisonnes comme une enfant. Tu
dis toi-même que tu n'as jamais aimé personne et j'en suis

37

aussitôt après, ainsi que j'ai laissé ta sœur ce matin. Dans
l'état où tu es, il vaut mieux n'en rien faire et nous quitter
simplement. Tu avais fait un choix déplorable. Essaye de
l'oublier, et va-t'en tout de suite sans tourner la tête. Dans
la Maison sur le Nil, tu retrouveras ton
père affligé, le foyer de ta famille et les
images des Dieux. Tu reverras ta sœur
aînée et elle t'apprendra la Vertu véritable,
dont tu ne connais que les apparences. »
Il l'embrassa sur la joue et reprit sa route
entre les arbres. Mais il n'avait pas encore
disparu au delà des grands buissons de
fleurs jaunes quand il entendit pour la
troisième fois courir et pleurer derrière lui.
 Alors il s'emporta tout à fait :
 « Je te défends de me suivre!
 — Je ne peux pas te quitter. Ne me
chasse pas. Je ne demande plus à être
femme puisque tu refuses de m'aimer. Je
supplie, pour rester près de toi. Je t'ap-
partiens. Fais de moi quelque chose. Je
serai ton esclave si tu veux. »
 Biôn dénoua froidement sa ceinture,
la serra comme un pagne autour des reins
de l'enfant, accrocha sur l'épaule nue la
courroie du sac gonflé avec la gourde et le
pétase et, d'une voix indifférente :

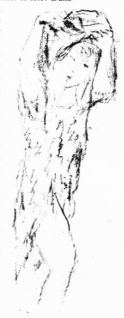

39

— Elle avait le nez court, répondit Clinias, les lèvres lourdes et la peau brune.

— Dans ce cas, il ne fallait pas s'occuper d'elle », déclara Mélandryon.

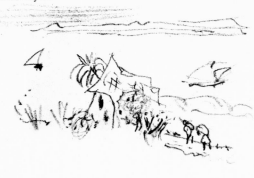

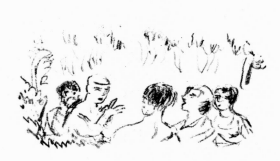

CE JOUR-LA, IL FAISAIT BEAU. LA tristesse laissée par le conte de la veille s'évanouit avec la brume ; les femmes coururent dans les bois ; il y eut sur le chemin de grands éclats de rire. L'exubérance de ce printemps faisait plier les branches des arbres et déborder les prairies le long des sentiers étroits. Les larges fleurs frôlées en passant laissaient des traces jaunes au bas des tuniques. Une mer de violettes baignait le pied des cèdres : les promeneuses s'y couchèrent en rond. Et comme l'heure était venue de peupler cette forêt déserte

45

presque blanc autour du soleil, ou plutôt une couleur dont je ne sais pas le nom : de la couleur de la lumière. »

Le bébé se mit à vagir. Elle le berça. Il se tut.

« Le soir, c'était une grande mer de pourpre où les nuages étendus se baignaient comme de belles femmes, avec des chevelures et des écharpes jaunes. La nuit, c'étaient les étoiles.

« C'est de là-haut, c'est du ciel lointain qu'est descendue en moi la pluie mystérieuse... »

Elle ferma les yeux et sourit mollement, envahie par un souvenir paresseux. Quand elle les rouvrit, l'enfant dormait. Alors elle ne parla plus ; elle ne dit pas comment sa grossesse inexplicable avait soudain réveillé les craintes séniles d'Akrisios, à qui un devin avait prédit qu'il mourrait de la main d'un petit-fils ; elle ne dit pas comment, pendant quarante semaines, elle avait senti croître en elle le fruit de cet amour merveilleux ; ni comment, l'enfant mis au monde, le roi les exposait, elle et lui, à la mort, par la faim, par le froid, ou par les grands mouvements de la mer.

D'ailleurs, y pensait-elle encore ? L'influence surnaturelle qui avait fait

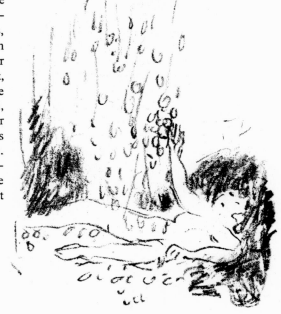

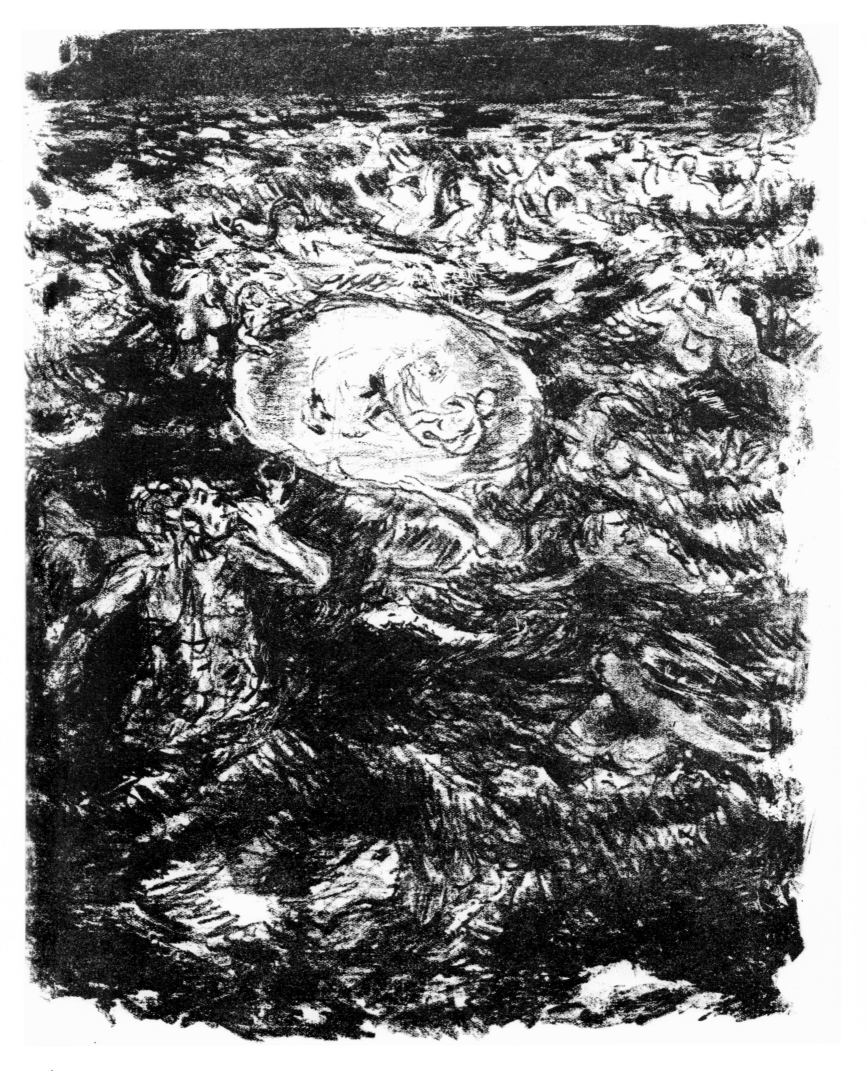

De tous les jardins, de tous
les palais, de toutes les riches-
ses de Polydektès, Danaë
avait la jouissance, hors un
sentier, une porte, un caveau.
Depuis de longues années,
elle songeait à l'interdiction
perpétuelle de ce seul point
de la terre, et elle avait fini par
imaginer que ce petit caveau
défendu renfermait à lui seul
toute la somme de bonheur
qu'elle ne possédait pas, tou-
tes les joies inconnues qu'elle
désirait au delà de sa vie.

Le lendemain de ce jour,
elle pénétra dans le sentier.
Elle ouvrit la porte. Elle des-
cendit la première marche.
La deuxième. Jusqu'en bas.
Et la nourrice accourut. Et
elle cria :

« Danaë ! Danaë ! Vous avez tort de venir ici. Il ne faut
pas descendre, Danaë. On vous l'a défendu, vous le savez
bien. Pourquoi voulez-vous toujours faire ce qu'on vous
défend ? Il n'y a qu'un lieu du monde où vous ne devez pas
aller, et c'est celui-là que vous voulez voir... Vous ne sortez

58

O R, LES CORINTHIENNES ÉTANT
venues jusqu'à l'antre le plus profond, le plus
sombre de toute la forêt, si déserté des bêtes
et des hommes que le silence semblait lui-
même s'y éteindre et laisser place à quelque chose de plus
indicible encore, elles reculèrent d'un pas, levèrent leurs
mains le long des tempes, et, sans voir, ouvrirent leurs pau-
pières, et ouvrirent les lèvres, sans parler. Tremblantes, car
elles se sentaient attirées par la nuit, elles se serrèrent l'une à
l'autre, comme les pauvres petites âmes des morts se pressent

65

père qui est Minos, roi de la Krête. Mais si un autre nom te
plaît, dis-le, ce sera le mien. »

Comme s'il se penchait sur l'orient, il regarda les yeux
d'Ariane. Et sans parler davantage, il pénétra dans le labyrinthe.

70

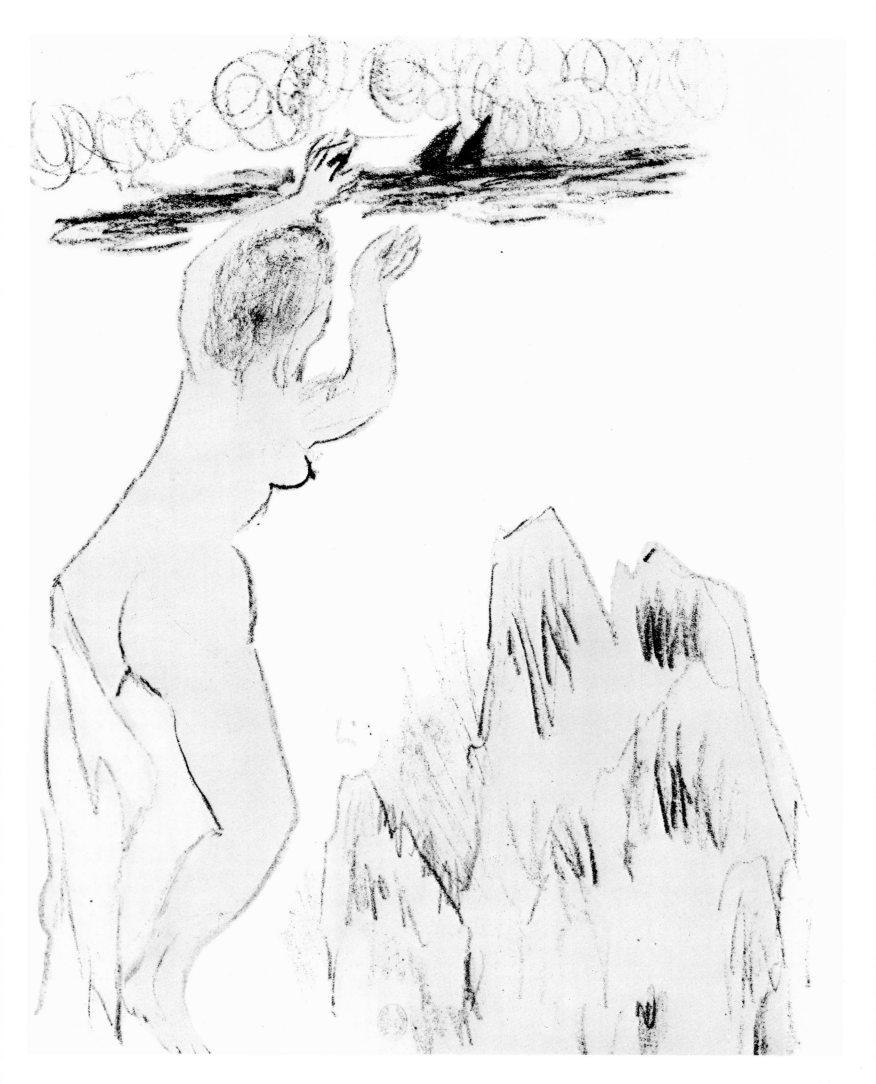

multitude ! Refoule la cohue et les pieds rapides ! Nous sommes à toi ! Nous sommes ton souffle ! Nous sommes tes désirs turbulents ! »

Et voici : soudain elles aperçurent Ariane.

Alors elles se précipitèrent, elles lui prirent les bras et les jambes, elles tordirent ses cheveux désolés ; la première saisit la tête, et pesant du pied sur l'épaule, l'arracha comme une fleur lourde ; et les autres écartelaient les membres, et la sixième déchirant le ventre, en tira la matrice petite, et la septième, fonçant la poitrine, déracina le cœur vomissant.

Le Dieu, le Dieu parut ! Elles se ruèrent sur lui, brandirent leurs trophées... Il était nu, couronné de pampre. Une peau de faon pendait sur ses reins. Il tenait une coupe de buis. Il dit :

« Laissez ces pauvres membres. » Les Bakkhantes les jetèrent sur le sol, et, chassées par un geste, s'enfuirent brusquement dans la montagne, comme un troupeau piqué des taons. Alors, il pencha sa coupe creuse•qui ruissela merveilleusement ; et les membres se réunirent, et le cœur revécut tout à coup, et Ariane égarée se souleva sur la main.

76

mythique, prit à part le narrateur et, le regardant d'un œil pénétrant :

« Tu n'as pas dit ce que tu pensais.

— Non. Quand Dionysos eut ainsi parlé à la fille de Minos, la vérité est qu'il l'anéantit. Mais par le seul récit des bonheurs futurs, ne lui avait-il pas donné plus de joies qu'il n'en promettait ? Je viens de faire pour ces femmes ce qu'il fit pour Ariane. Ne leur dessille pas les yeux. Il vaut mieux donner lá confiance que d'accomplir les serments, car l'espoir est plus doux que la conquête.

— Le regret est plus doux que l'espoir.

— Les femmes ne savent pas cela. »

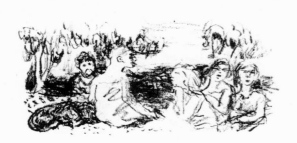

AMARYLLIS, ENTRE LES TROIS JEUNES
femmes et les trois philosophes, conta, comme
à de petits enfants, cette allégorie fabuleuse :
« Des voyageurs que j'ai connus et qui sont
allés en Carie, ayant remonté le Méandre plus loin qu'on
n'est jamais allé, ont vu le Dieu du fleuve endormi, au bord
des eaux ombragées par les joncs. Il avait une longue barbe
verte et son visage était ridé comme les rocs de ses berges
grises d'où pendent des herbes pleurantes. Ses antiques pau-
pières semblaient mortes sur ses yeux à jamais aveugles. Il
est probable qu'aujourd'hui, ceux qui voudraient le voir

83

« Je regarde Byblis. »
Et Cyanée lui demanda
encore :
« Pourquoi ne regardes-
tu plus la forêt ?
— Parce que les cheveux
de Byblis sont plus doux que
les herbes et plus chargés de
parfum; parce que les yeux
de Byblis... »
Mais Cyanée l'arrêta :
« Enfant! Tais-toi! »
Et, espérant le guérir de
sa passion défendue, elle le
conduisit aussitôt chez une
nymphe de la montagne, la-
quelle avait sept filles d'une
beauté plus merveilleuse que
les mots ne sauraient dire :
Et toutes deux lui parlèrent, s'étant concertées :
« Choisis. Celle qui te plaira, Caunos, sera ta femme. »
Mais Caunos regarda les sept jeunes filles d'un œil aussi
indifférent que s'il eût vu sept rochers, car l'image de Byblis
seule emplissait toute sa petite âme, et il n'y avait pas de
place en lui pour une tendresse étrangère.
Pendant un mois Cyanée ainsi conduisit son fils de
montagne en montagne et de plaine en plaine, mais sans

86

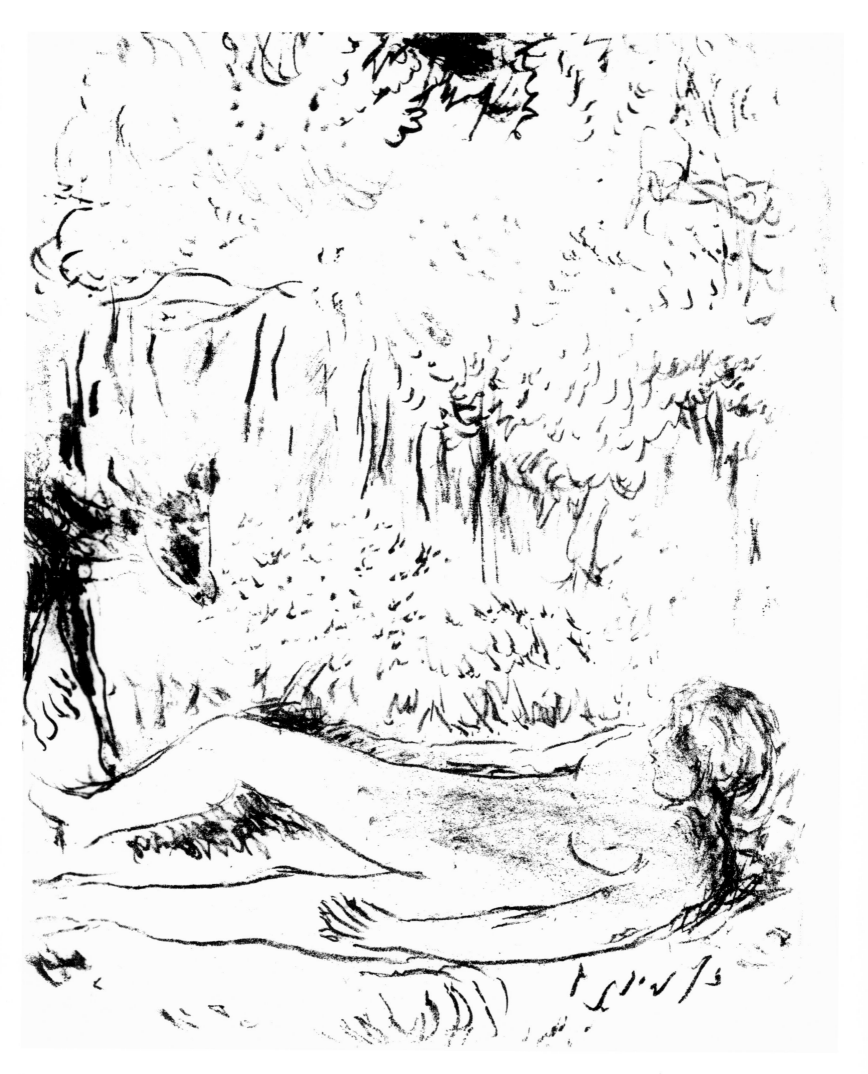

obscurcie éclairait encore sa vision. Tout à coup elle s'éteignit; mais les larmes plus fraîches n'ont pas cessé de couler.

Et c'est ainsi que Byblis fut changée en fontaine.

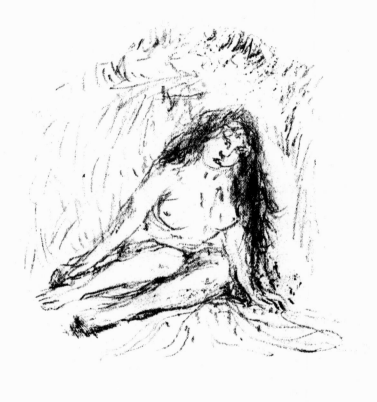

129
Three Birds
Trois oiseaux

c. 1945–46

Seven engravings on zinc plates, illustrations for an unpublished text by
André Beucler
The zinc plates are still in existence

Bibliography: CRM 98

Some preliminary drawings (exhibited by Huguette Berès in 1970)

Select Bibliography in chronological order

ROGER-MARX, CLAUDE *L'Art décoratif et les 'symbolistes'*, Le Voltaire, 1892

MELLERIO, ANDRÉ *Le Mouvement idéaliste en peinture*, Paris, 1896

——'L'estampe en 1896', *L'Estampe et l'Affiche*, 1897

——'La lithographie originale en couleurs', *L'Estampe et l'Affiche*, 1898

——'Exposition: Les éditions Vollard', *L'Estampe et l'Affiche*, 1899

JARRY, ALFRED 'Paul Verlaine: *Parallèlement* illustré par Pierre Bonnard', *La Revue blanche*, 1901

HEILBUT, E. *Lithographien von P. Bonnard*, Kunst und Künstler, 1906

ROGER-MARX, CLAUDE 'Bonnard, illustrateur et lithographe', *Art et Décoration*, 1923

——*Pierre Bonnard, peintre et lithographe*, Paris, 1925

TERRASSE, CHARLES *Bonnard*, Paris, 1927 (incl. catalogue of Bonnard's graphic works by Jean Floury)

GUTMAN, WALTER *Pierre Bonnard*, Art in America, New York, 1928

BASLER, ADOLPHE, and KUNSTLER, CHARLES *Le Dessin et la Gravure modernes en France*, Paris, 1930

ROGER-MARX, CLAUDE 'L'œuvre gravé de Pierre Bonnard', *L'Art vivant*, 1931

CASSOU, JEAN 'Bonnard', *Arts et Métiers graphiques*, no. 46, April 1935

HAHNLOSER-BÜHLER, HEDY *Felix Vallotton et ses amis*, Paris, 1936

VOLLARD, AMBROISE *Souvenirs d'un marchand de tableaux*, Paris 1937

POUTERMAN, J. E. 'Les livres d'Ambroise Vollard', *Arts et Métiers graphiques*, 1938

GOLDWATER, ROBERT J. 'L'affiche moderne, a Revival of Poster art after 1880', *Gazette des Beaux-Arts*, 1942

BOUVIER, MARGUETTE 'Pierre Bonnard revient à la lithographie', *Comœdia*, 23 January 1943

JOHNSON, UNA E. *Ambroise Vollard, Editor, 1867–1939. An Appreciation and Catalogue*, New York, 1944 and 1977

LAPRADE, JACQUES DE 'Gravures, illustrations, dessins de Pierre Bonnard', *Formes et couleurs*, 1944

SKIRA, ALBERT *Anthologie du livre illustré par les peintres et sculpteurs de l'Ecole de Paris*, Geneva, 1946

REWALD, JOHN *Pierre Bonnard*, New York, 1948

MASSON, ANDRÉ *Le Plaisir de peindre*, Nice, 1950

ROGER-MARX, CLAUDE *Bonnard*, London, 1950 (trans. from Fr. by F. A. McFarland)

WERTH, LÉON 'Pierre Bonnard illustrateur', Le Portique, no. 7, 1950 (incl. bibliography by Bernard Thibault)

NATANSON, THADÉE *My Ideas on Bonnard*, Geneva, 1951 (trans. from the Fr. *Tentatives: Le Bonnard que je propose*, 1867–1947)

ROGER-MARX, CLAUDE *Bonnard the lithographer*, Monte Carlo, 1952 (trans. from Fr.)

SUTTON, DENYS *Bonnard* (1867–1947), London, 1957

BUSCH, GÜNTER '*Daphnis et Chloë*' *de Pierre Bonnard*, Munich, 1961

NEW YORK CITY, MUSEUM OF MODERN ART *Bonnard and his Environment*. Texts by James Thrall Soby, James Elliott and Monroe Wheeler, New York, 1964

TERRASSE, ANTOINE *Bonnard*, Geneva and Cleveland, 1964 (trans. from Fr. by Stuart Gilbert)

VAILLANT, ANNETTE *Bonnard*, London and Greenwich, Conn., 1966 (trans. from Fr. by David Britt)

BOURET, JEAN *Bonnard: The Magic Ring*, New York, 1967 (trans. from the Fr. *Bonnard: séductions* by D. Imber)

COGNIAT, RAYMOND *Bonnard*, New York and Milan, 1968 (trans. from Fr. by Anne Ross)

ROUIR, E. 'Quelques remarques sur lithographies de Pierre Bonnard', *Le Livre et l'Estampe*, nos. 53–54, 1968

FERMIGIER, ANDRÉ *Pierre Bonnard*, London, 1970

DAUBERVILLE, JEAN and HENRY *Catalogue raisonné de l'œuvre peint de Pierre Bonnard*, Paris, 1966–1974

PASSERON, ROGER *L'Estampe originale*, Paris, 1972

PERUCCHI-PETRI, URSULA *Die Nabis und Japan*, Munich, 1976

CHAPON, FRANÇOIS 'Ambroise Vollard, éditeur', *Gazette des Beaux-Arts*, 1979–1980

List of illustrations in chronological order

List of illustrations in alphabetical order

Biographical outline

1867 3 October, birth of Pierre Bonnard at Fontenay-aux-Roses.

1875–1888 He excels at school and eventually obtains his *licence* at the Faculté de Droit (law school) in Paris.

1888–1890 Enrols at the Académie Julian, and during the same period studies at the Ecole des Beaux-Arts, where he spends a year.
Meets Sérusier, Maurice Denis, Gabriel Ibels, Paul Ranson, Vuillard and Roussel, the future Nabis.
Decorative works. Influence of Gauguin.

1891 The poster *France-Champagne* appears on the walls of Paris. It makes a great impression on Toulouse-Lautrec, whom Bonnard takes to meet his printer.

1893 Meets Marthe Boursin, whom he is to marry in 1925.

1896 First one-man show, at Durand-Ruel.

1905 Travels to Spain with Vuillard.

1906 First one-man show at Bernheim-Jeune, where he is to exhibit regularly. Travels to Belgium and Holland.

1908 Italy, Algeria, Tunisia.

1910 First journey to South of France. Stays at St Tropez with Manguin; in subsequent years returns there meeting Paul Signac.

1912 Leases a house at St Germain-en-Laye, where Maurice Denis lives. Buys a property near Vernon, of which he is often to paint the scenery.

1913 In Germany with Vuillard.

1925 Buys a villa at Le Cannet, to which he is later to retire.

1926 Short stay in the United States.

1930–1931 Works at Arcachon.

1934–1938 La Baule, Deauville.

1939 Retires to Le Cannet for the whole of the war. Occasional meetings with Henri Matisse, who lives at Nice.

1942 Death of Marthe Bonnard.

1945–1946 Short stays in Paris and Fontainebleau.

1947 23 January, death of Pierre Bonnard, at Le Cannet.

Exhibitions of Bonnard's graphic works

Galerie Pierre Berès, Paris: 5–20 December 1944
Marlborough Fine Art Ltd, London, *Roussel, Bonnard, Vuillard*: 5 May–12 June 1954
Galerie Sagot–Le Garrec, Paris: 9–31 May 1957
Maison Pulliérane, Pully (Switzerland), *Groupe des Nabis, 200 estampes*: 30 May–30 June 1963
Sterling and Francine Clark Institute, Williamstown, Mass., Exhibition 24, *Pierre Bonnard Lithographs*: August 1963
Museum of Modern Art, New York, *Bonnard and his Environment*: 7 October–29 November 1964 (subsequently at Art Institute of Chicago, 8 January–28 February 1965; Los Angeles County Museum of Art, 31 March–30 May 1965)
Royal Academy of Arts, London: 6 January–6 March 1966
Galerie Huguette Berès, Paris, *Bonnard illustrateur*: 9 June–10 July 1970
Galerie Engelberts, *Bonnard, Miro*: July–September 1970
Galerie des Peintres-Graveurs, Paris: 24 January–5 April 1975

We gratefully acknowledge the help of the following:

Mme Huguette Berès	Mlle Claire Lagarde	Mme Anne Moeglin-Delcroix
M. Claude Blaizot	M. Yves Lebouc	M. Jacques Nestgen
M. Patrick Bongers	M. Marcel Lecomte	Mme Gaëtan Picon
M. Claude Bouret	M. Alexandre Loewy	M. Alain M. Prouté
Mlle Paule Cailac	M. Pierre Meaudre	M. and Mme Hubert Prouté
Mme Jean Floury	M. Alain Mazo	M. Jean-Claude Romand
M. Jacques Frapier	Mme Martine Mène	M. and Mme Charles Terrasse
M. Gilbert Gruet	M. Pierre Michel	M. Alain Weill
Mme Margrit Hahnloser	M. Raymond Michell	Mme Françoise Woimant

Sources of illustrations:

Berne, G. Howald: n° 85;
Bremen, Kunsthalle: n°os 106, 114;
Geneva, Slatkine Reprints (excerpts from the fac simile reprint): n°os 31, 33;
New York, Museum of Modern Art: n°os 79, 89;
Paris, Ader-Picard-Tajan: n° 43 bis;
Paris, Bibliothèque nationale: n°os 3, 4, 25, 26, 27, 37, 40, 42, 43, 45, 56, 58, 59, 60, 61, 62, 63, 64, 65, 66, 67, 68, 69, 70, 71, 72, 105, 112, 128;
Paris, Musée des Arts décoratifs: n°os 39, 77, 78.
All the other photographs are from the archives of Éditions Flammarion.

Contents